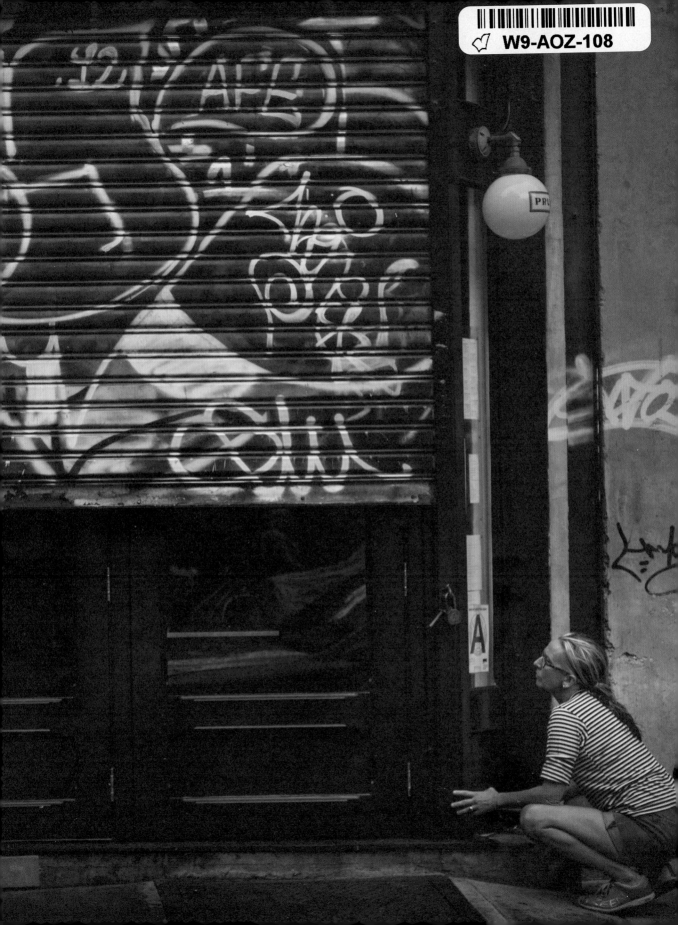

Published in the United States by Random House,
an imprint and division of Random House LLC,
a Penguin Random House Company, New York.

RANDOM HOUSE and the HOUSE colophon are registered
trademarks of Random House LLC.

Library of Congress Cataloging-in-Publication Data

Hamilton, Gabrielle.
 Prune / Gabrielle Hamilton.
 pages cm
 ISBN 978-0-8129-9409-4 (hardback)—ISBN 978-0-8129-9410-0 (ebook)
 1. Cooking (Prune) I. Title.
 TX813.P78H36 2014
 641.3'437—dc23 2014003617

Printed in the United States of America on acid-free paper

www.atrandom.com

9 8 7 6 5 4 3 2 1

First Edition

Cover design: Jessica Ludwig
Book design: Cynthia Warren Design
Layout: Susan Turner

OMFG. Wolfie! best. photos. ever. ♡ ♡ ♡

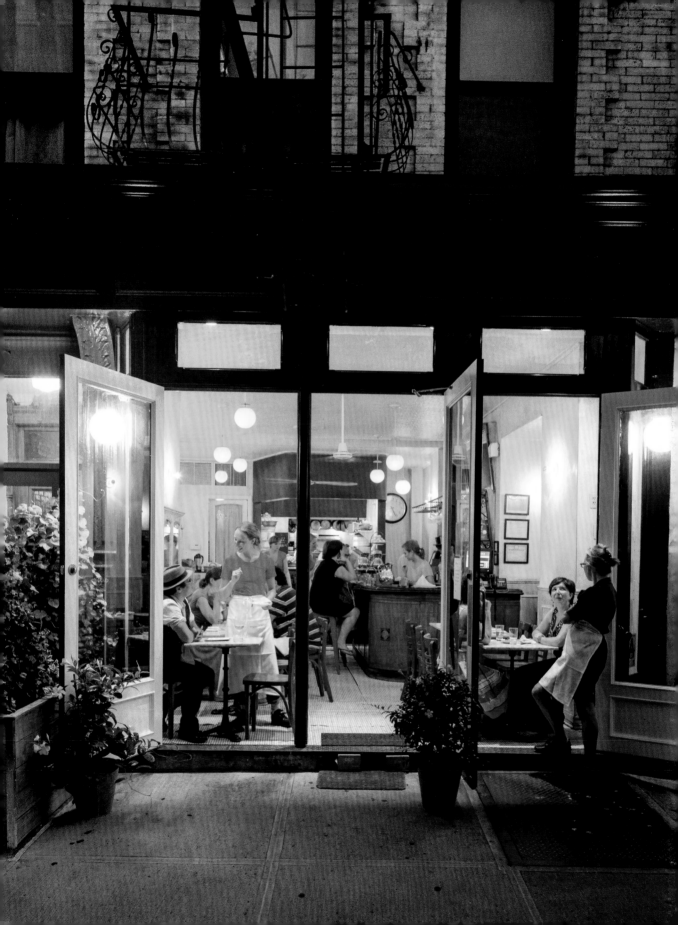

PRUNE

XO,

RANDOM HOUSE | NEW YORK

CONTENTS

BAR SNACKS

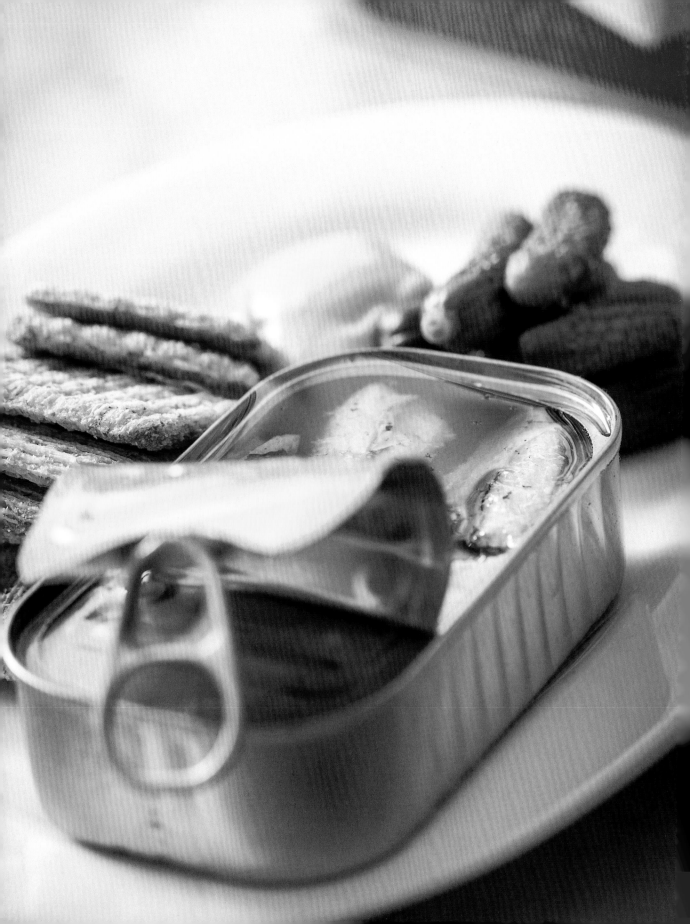

Canned Sardines with Triscuits, Dijon Mustard, and Cornichons

1 can sardines in oil
1 dollop Dijon mustard
small handful cornichons
small handful Triscuit crackers
1 parsley branch

Only Ruby Brand boneless and skinless — in oil — from Morocco

Buckle the can after you open it to make it easier to lift the sardines out of the oil without breaking them.

Stack the sardines on the plate the same way they looked in the can—more or less. Don't crisscross or zigzag or otherwise make "restauranty."

Commit to the full stem of parsley, not just the leaf. Chewing the stems freshens the breath.

Radishes with Sweet Butter
and Kosher Salt

red globe or French breakfast radishes, well washed to remove any sand,
 but left whole with a few stems intact
unsalted butter, waxy and cool but not cold
kosher salt

There is nothing to this, but still . . . I have seen it go out looking less than stellar—and that's embarrassing considering it's been on the menu since we opened and is kind of "signature," if Prune had such a thing as signature dishes.

Keep the radishes fresh with ice and clean kitchen towels.

Cull out any overgrown, cottony, spongy radishes; keep your butter at the perfect temperature; and be graceful on the plate, please.

* SPLIT BIGGER ONES IN HALF. LEAVE THE TAILS. *

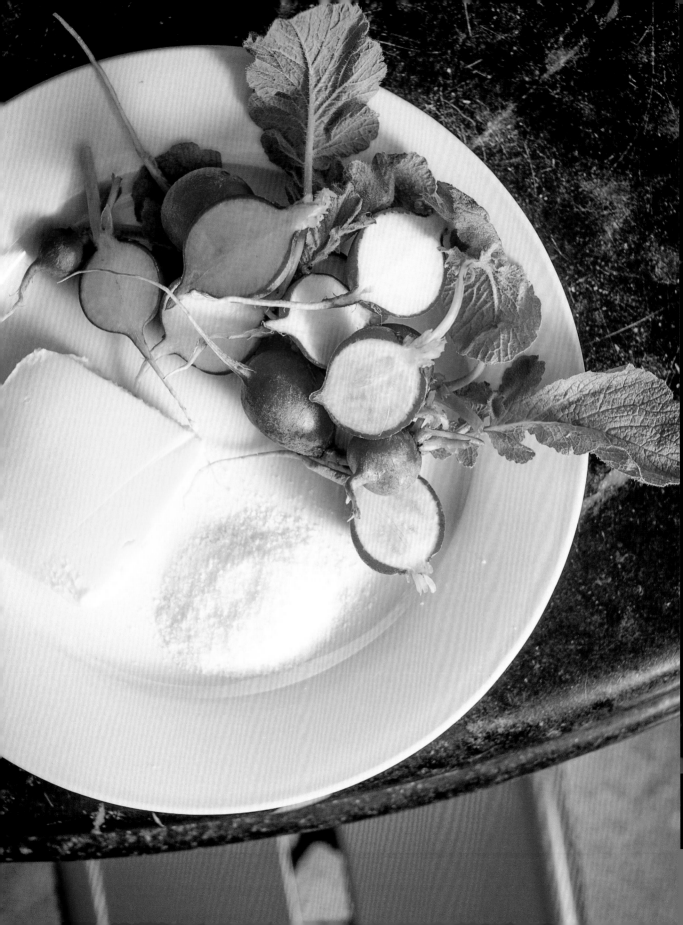

Garrotxa with Buttered Brown Bread
and Salted Red Onion

peeled red onion, halved and thinly sliced into ribbons

kosher salt

brown bread

unsalted butter, cool but softened for spreading

Garrotxa

extra virgin olive oil

freshly ground black pepper

thyme

Liberally salt the red onion and toss with your fingers to break up the ribs. Let sit 10 minutes to weep out some of their bite.

Spread bread with a generous amount of butter, wall to wall. Cut bread in triangles and arrange on plate.

Lay slices of cheese next to bread.

Heap a generous tangle of salted onion on the plate.

Drizzle whole thing—cheese, buttered bread, and onion—with EVOO just before selling. Be light-handed with the oil—3 fats on one plate makes sense here but it's about flavor and texture, not about ostentatious macho eating. Keep it accurate.

One grind black pepper and branch of thyme to finish.

Marinated White Anchovies with Shaved Celery and Marcona Almonds

Per plate:

1 scant ⅓ cup [handwritten: ½ cup] thinly sliced, sweet, tender inner branches of celery, leaves left whole

1 short dozen marinated white anchovies

¼ cup Marcona almonds

good drizzle extra virgin olive oil

brief squeeze lemon juice

lemon cheek

few grinds black pepper

big pinch parsley leaves, mixed into celery and celery leaves

Deviled Eggs

4 orders

8 eggs, still cold from the fridge

3 Tablespoons Dijon mustard

⅓ cup Hellmann's mayonnaise

flat-leaf Italian parsley

× 16

32

¾ C.

1¼ C.

Bring large pot of water to a boil.

Pierce the eggs at the tip with a pushpin to prevent exploding.

Arrange eggs in the basket of the spider and gently lower them into the boiling water. This way they won't crack from free-falling to the bottom of the pot when you are adding them.

Let boil 10 minutes, including the minutes it takes for water to return to boil after adding the cold eggs.

Moving quickly, retrieve 1 egg and crack it all the way open, in half, to see what you have inside. (If center has any rareness larger than a dime, continue cooking half a minute.)

If thoroughly cooked, drain eggs, rough them around in the dry pot to crackle their shells all over, then quickly turn them out into a frigid ice bath to stop the cooking. It helps with the cooling and the peeling to let the ice water permeate the cracked shells. Peel the eggs.

Cut the eggs in half neatly and retrieve the cooked yolk from each. Place the hollow, cooked whites into a container with plenty of cold fresh water and let them soak to remove any cooked yolk from their cavities.

Blend yolks in food processor with mustard and mayonnaise. Make sure the bite of the Dijon can make itself felt through the muffle of the rich egg yolk and the neutralizing mayonnaise.

Scrape all the egg mixture from the processor bowl into a disposable pastry bag fitted with a ⅝-inch closed star tip, but do not snip the closed tip of the bag until you are ready to pipe. Fit the pastry bag into a clean empty quart container like you might

put a new garbage liner into the bin—folding the excess over the lip of the quart—to make this easier on you.

If you don't already know, you can stick your middle finger up into the punt of the processor bowl while scraping out the contents with the spatula, to hold the messy, sharp blade in place.

Remove cooked egg whites from the cold water and lay, cavity side down, on a few stacked sheets of paper towel to allow them to drain. Don't serve the deviled eggs wet, please.

When well drained, turn over eggs to reveal cavities and pipe the mixture in, more like a chrysanthemum than a soft-serve ice cream cone, please. Place on plate and finish with finely sliced parsley.

Make sure that the whites are not rigidly cold from the reach-in. Allow the whites and the yolk mixture to temper a little before serving. The whites get rubbery and hard and the devil-mix has a congealed mouthfeel if you serve them too cold.
Please take care.
It's just temperature but it makes a difference.

Giant Frico

Per order:

½ cup grated Parmesan cheese

x4	x16
2 c.	8 c.

In the 10-inch nonstick sauté pan set over medium heat, evenly spread ½ cup cheese. Leave it alone but stay attentive.
As the cheese melts and gets lacy, watch for golden, toasty edges.

With a heatproof rubber spatula, lift the edges gently to determine color underneath. When you have achieved a uniform golden, lift swiftly and confidently with the rubber spat and drape over an inverted pasta bowl.

As these are not the real deal (they should be made with Montasio cheese) they are a little trickier to handle. Sometimes they aren't crispy enough because you have over-portioned the cheese, not scattered it evenly into the pan, or not toasted long enough. Conversely, if you put too little cheese in the pan, the frico shatters from lack of structure. Finally, if you cook them too dark, they turn profoundly bitter.

Keep in mind that if you lose the frico when you are trying to get it out of the pan and it wrinkles up unmanageably, you can try popping it into the warm oven to regain elasticity and then reshape it with your fingers. Sometimes this works.

Try to get it right, though, on the first shot. It's an expensive ingredient to have to trash.

Grilled Lamb Sausages with Dijon Mustard and Cornichons

4 orders

1¼ pounds coarsely ground lamb shoulder

4 finely chopped garlic cloves

¼ cup roughly chopped parsley

1 Tablespoon + 1 teaspoon kosher salt

1 ounce caul fat

¼ cup Dijon mustard

2 ounces/24 pieces cornichons

4 slices peasant bread

(handwritten margin notes:)
X 16
5#
16
1 c.
5 T.
1/4 #
1 c.
8 oz.
16

For the sausages:

Combine lamb, garlic, parsley, and salt as gently and tenderly as we touch the hamburgers—do not manhandle or overwork.
Cook off a tester to check your seasonings.
Portion 2½-ounce mounds and gently wrap in small sheets of caul fat, just big enough to enclose the lamb patty with a little overlap at the bottom.
Grill 8–10 minutes.

Be careful they don't catch on fire on the grill. Move them around frequently and only cook to medium rare.

To plate each order:

2 sausages per order

1 thick slab peasant bread, grilled, cut in half

1 dollop Dijon mustard

small handful cornichons

full branch parsley

Deep-Fried Shrimp Toasts with Sesame Seeds

4 orders

½ pound rock shrimp

2–2½ Tablespoons tom yum paste

2 scallions, sliced fine

4 slices white bread

¼ cup hulled sesame seeds

X16

2#

8–10 T.

8

16

1 c.

Grind shrimp and tom yum paste in Robot Coupe until smooth and sticky. You want the intensely sticky enzymes in the shrimp to emerge. Taste the mixture—it should be dark orange, with a strong flavor of tom yum. *A small lick of raw shrimp won't hurt you.*

By hand, stir in the scallions, distributing evenly. *If you grind the scallion in the food processor, it makes the mixture spongy and weird.*

Mound shrimp paste high in center of each slice of bread and spread it to edges with a short-handled offset spatula. Paste should be slightly domed in center, but angular, like a perfect squat pyramid. In any event, use the scale and weigh these out—3½ ounces each (total weight) makes perfect bread-to-paste ratio.

Spread sesame seeds out in shallow container and lay shrimp toasts facedown to coat evenly.
Cut into quarters on the diagonal, to make 4 triangles.

Deep-fry, sesame sides down, in 350° fryer. Flip them midway and fry, toast side down, until golden and crispy. They float, so you have to attend to them or else the bread doesn't get crispy enough if they are not flipped during the frying.

Drain in stack of coffee filters; do not season further.

To plate:

Lay in one shingled stack, flipping every other triangle over to make seed-toast-seed-toast pattern.

Scatter with freshly shaved scallion at the pass.

Do not bring back any other brand than Pepperidge Farm Original white sandwich bread even if you have to walk to three different grocery stores! None of the other supermarket white breads hold their structure in the fryer..

And don't use anything better — no brioche! no pain de mie! — in some attempt to make this "gourmet". We are not that kind of restaurant.

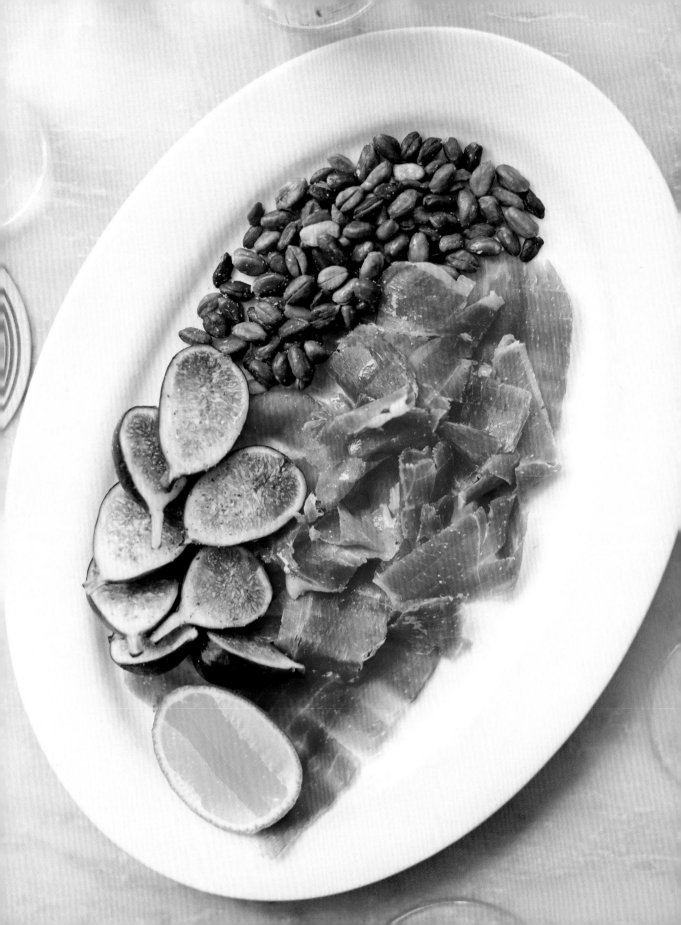

Serrano Ham, Fried Pistachios, and Fresh Figs

properly sliced serrano ham, at room temperature

perfectly ripe figs, halved

Sicilian pistachios, fried in extra virgin olive oil

lime cheek

drizzle frying oil over whole plate sparingly

few grinds black pepper

If Health Department comes, take the serrano off the carving stand and throw in the oven.

Hone your slicing skills.
Butt: in long ribbons; **Butt End:** in thin slices; **Shank:** in petals.

When you've taken all that there is from the ham, make small quantity Serrano Ham Broth (page 524) with the bone and run Spanish Garlic Soup with Smoked Paprika Butter (page 478) as an addition.

Cold Pâté Sandwich

8 orders

for the pâté Louise:

3 Tablespoons olive oil

1 small yellow onion, peeled and diced

4 garlic cloves, peeled and microplaned

1¼ pounds pork liver, cubed, semi-frozen

10 ounces pork belly, cubed, semi-frozen

10 ounces fatback, cubed, semi-frozen

1 Tablespoon + 2 teaspoons kosher salt

¾ teaspoon freshly ground black pepper

2 bay leaves

for the sandwich:

8 slices Pullman bread

Dijon mustard

Hellmann's mayonnaise

cornichons

16 ounces pâté

X16

4 T.
1 lg.
6
2½ #
20 oz.
20 oz.
3 T. + 1 tsp.
1½ tsp.
3

Heat oil and sweat onions and garlic until soft and glassy. Set aside to completely cool.

Pass the liver, belly, and fat chunks through the meat grinder fitted with the fine-hole disk into a bowl with the cooled onions and garlic. Season with salt and pepper and mix well.

Spread mixture into the heavy ceramic loaf pan that accommodates the quantity you are making and lay the bay leaves on top.

Set pâté in a hot water bath that comes halfway up the sides of the pan. Bake for 45 minutes in the oven set at 350°. Check internal temperature and pull at 160°. Allow to cool, then refrigerate in the loaf pan.

For the sandwich:

Per order:

Slather 1 slice of bread with Dijon.
Slather other slice with Hellmann's mayonnaise.
Cut healthy slab of cold pâté right in the pan—about ⅓" thick. Get some of the cold jelly that clings. Put the sandwich together.
Trim the crusts, cut in half on the angle, and garnish with a few cornichons.

For double batch, use the 11"x 4"x 4" pan.
For ½ batch, modify the pan with foil and cardboard to make a false end.
Anyone here who has done it can show you how, or come find me and we'll do it together.

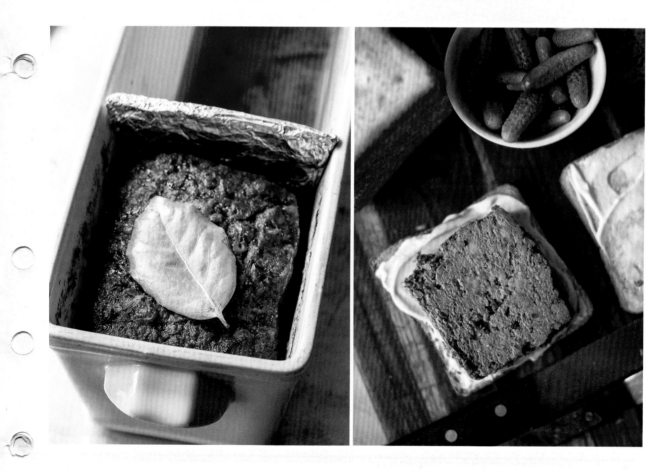

Pickled Shrimp

×16	**8 orders**
4#	2 pounds shrimp in shell (16/20s)

For the boil:

20	10 bay leaves
4T.	2 Tablespoons mustard seeds
2T.	1 teaspoon allspice berries
2T.	1 teaspoon celery seeds
2T.	1 teaspoon cardamom pods
2	1 piece cinnamon stick
2c.	1 cup kosher salt
/2	6 branches fresh thyme
2	1 unpeeled head of garlic
16 c.	8 cups cold water

For the pickle:

	1 cup paper-thin sliced lemons
	1 cup paper-thin sliced red onion
	1 cup thin-slivered garlic
	1 cup beautiful celadon inner celery leaves
	3 Tablespoons celery seeds
	3 Tablespoons yellow mustard seeds
	12 fresh bay leaves
	3 cups extra virgin olive oil
	3 cups rice wine vinegar
	1 cup fresh squeezed lemon juice
	kosher salt and freshly ground black pepper to taste

×16
1 pt.
1 pt.
1 pt.
1 pt.
6T.
6T.
24
6c.
6c.
2c.

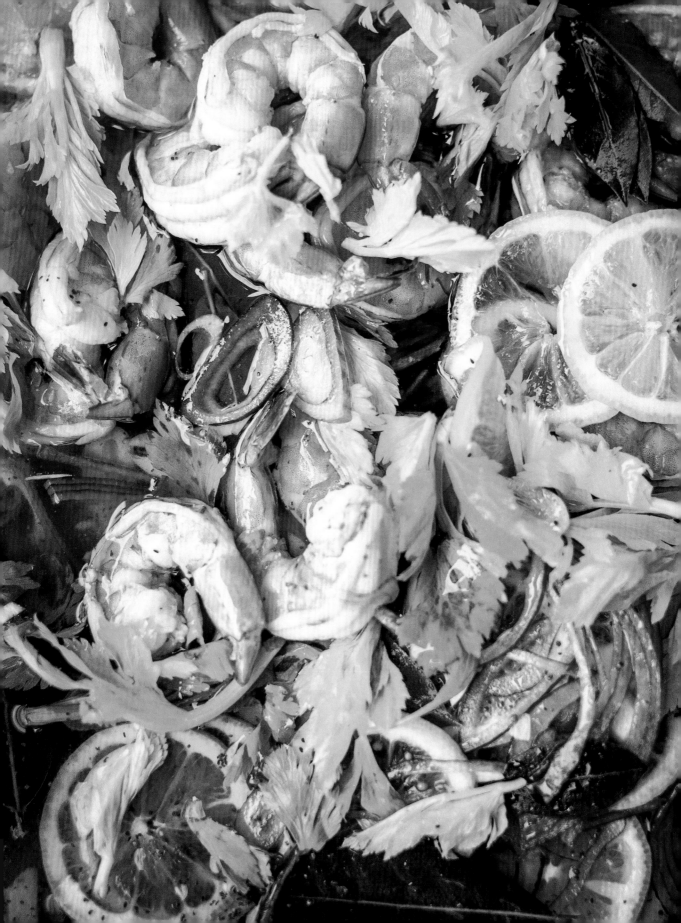

Peel the shrimp, devein, and leave the tails on.

Combine the boil ingredients in a large stockpot with cold water and bring to a boil. Let boil for 5 minutes.

Add the shrimp and cook for just a minute or two until the flesh turns pink/orange. You can pull one out and test if it's finished before you pull out the whole batch. Remove the shrimp with a spider or drain through a colander. Ice down the shrimp to get them to stop cooking, but don't let them soak in the melted ice after they are cooled or you will waterlog them and undo all that nice seasoning you just gave them.

Combine all the pickle ingredients, rub the fresh bay leaves between your hands to open them up a bit, toss with the cooled shrimp, and marinate for 24 hours in the refrigerator.

Let recover to almost room temperature before serving.

To plate:

4–5 shrimp per order and a little of all the goodies, in a neat jumble, in a small shallow bowl.

Only use rice wine vinegar — we want its low acidity.

The shrimp will continue to "cook" a bit in the pickle marinade, so take care in the initial blanch to keep them rare; we don't want to end up with mealy, overcooked shrimp after 24 hours in the marinade.

Gouda Cheese, Aged and Young, and Salted Warm Potatoes

Per order:

1 small wedge 10-month Gouda

1 small hunk 24-month Gouda

5 marble potatoes, cooked to order in heavily salted boiling water

1 Ryvita rye cracker, buttered, broken in ½, shingled on plate

Make sure potatoes are fully cooked, well-seasoned internally, and still hot when they go on the plate. Stack them in a small ramekin so they don't roll around. The marble potatoes take only a few minutes to cook fully.

Baked Mussels with Escargot Butter

2 pounds bouchot or PEI mussels

Escargot Butter (page 26)

any garlic peels, shallot skins, and parsley stems left from preparing the escargot
 butter

**** 10-pound bag yields 200 mussels +/- ****
20 orders +/-

dry white wine

baguette

The bouchots are usually very clean when they come in because of the way they are grown on ropes. Still, soak them for 10 minutes in very cold water sprinkled with a little cornmeal to get them to spit out their beards. Tug forcefully and pull out whatever beards emerge. Rinse well.

It is your responsibility to account for the vitality of every single mussel. Be vigilant and toss any that are listlessly gaping open, broken, or cracked. Make utterly certain that each mussel is lively and winning the fight to stay tightly closed. To be sick from bad shellfish—as you may know from personal experience—is a holy hell of wretched despair. Let's never inflict that on anyone. Ever. The tags that track the beds for all of our shellfish are kept in the bin on top of the ice machine and must be kept for 90 days.

Set a heavy-bottomed pot on a burner over medium-high heat and let it get super hot. Make sure you grab a pot that has a tight-fitting lid and that is ample enough to contain the quantity of mussels in a layer just 2 or 3 deep.

Pour in the mussels and any clinging water.

Add the scraps and stems and quickly pour in white wine in a steady stream just until the hissing is silenced. That will be as much wine as the mussels need.

Cover the pot and let the mussels steam open, about 4–5 minutes. Give the pot a shake and a swirl occasionally.

When all the shells have opened and the meats look opaque but still tender, uncover and remove from the heat.

Drain the mussels, reserving all that liquid for the Pernod Mayonnaise if we are running Cold Mussel Salad at lunch. Label and date and freeze for future use.

Split open the shells, pull the meats, and return them to the clean half of the mussel shell that doesn't have the hard eraser-like adductor muscle attached. Get rid of any clinging parsley stems, or shallot or garlic skins. Lay out all of your mussels on the half shell and spread escargot butter generously but neatly over each.

Use a small offset spatula and leave a clean edge.

Refrigerate between sheets of parchment.

Per order, lay out 10 cold buttered mussels on a sizzle plate and set under the broiler until just bubbly and melted. Take care not to undo your good work by sizzling your tender mussels into tough and chewy bits—that salamander goes from zero to burnt as soon as you are not looking.

Arrange attractively on a small plate with several thin slices of baguette in a deep ramekin.

for the Escargot Butter:

yield: 2 cups

2 peeled garlic cloves

1 peeled shallot, small

½ packed cup clean flat-leaf parsley leaves,
 stems removed

freshly ground white pepper to taste

1 Tablespoon cognac

fresh grated nutmeg to taste

8 ounces unsalted butter, at room temperature

kosher salt to taste

	x1#	x2#
	4	8
	1 lg.	2
	1 c.	2 c.
	2 T.	3 T.
	1#	2#

Place shallot, garlic, parsley leaves, and a pinch of salt in food processor and pulse until roughly chopped.

Add butter and cognac and grind until emerald green and purely smooth, with a glossy texture.

Season to taste with white pepper, fresh grated nutmeg, and, as needed, kosher salt. Be sure to label the white pepper mill properly; we use it so rarely.

Fried Oysters with Tartar Sauce

4 orders

8 shucked select Blue Point oysters
2 beaten eggs
½ cup all-purpose flour
1 cup panko bread crumbs
kosher salt and freshly ground black pepper
Tartar Sauce (page 481)

x8
16
4
1 c.
2 c.
s+p

x16
32
8
2 c.
4 c.
s+p

Season flour with salt and pepper.
Beat eggs well.

Have three bowls ready, one with seasoned flour, one with beaten eggs, and one with panko.

Dip the oysters, one by one, into the flour, shaking off the excess, then into the eggs, allowing the excess to drip off, and finally into the panko crumbs, tossing to coat.

Lay the breaded oysters on a baker's rack so the coating can set.

Deep-fry at 350° until golden brown, about 2 minutes.

Season with salt while hot.

To plate:

2 oysters, stacked, per order on small oval plate
1 small ramekin Tartar Sauce
1 lemon cheek
1 sprig parsley

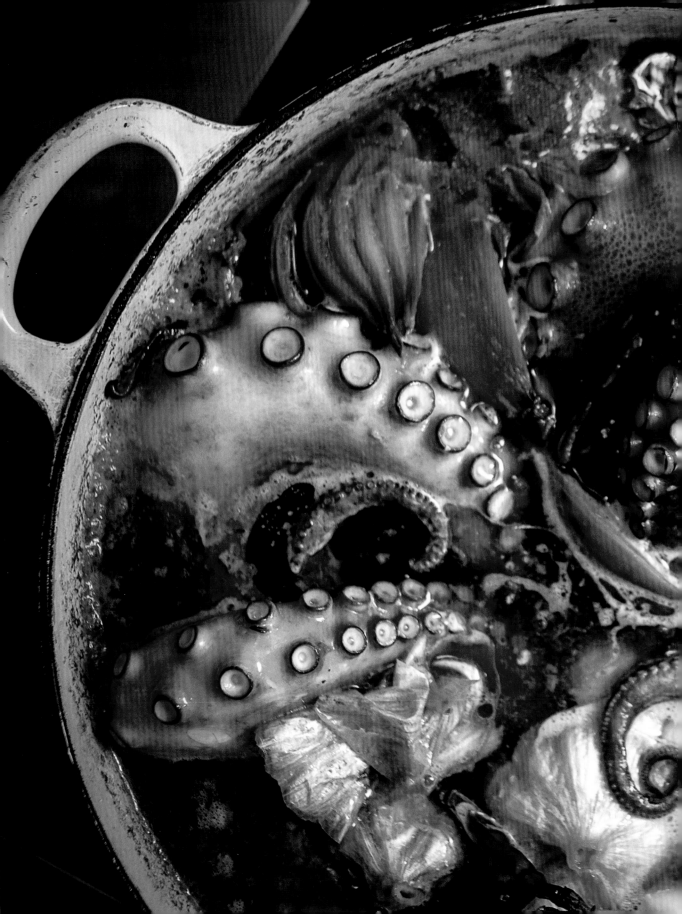

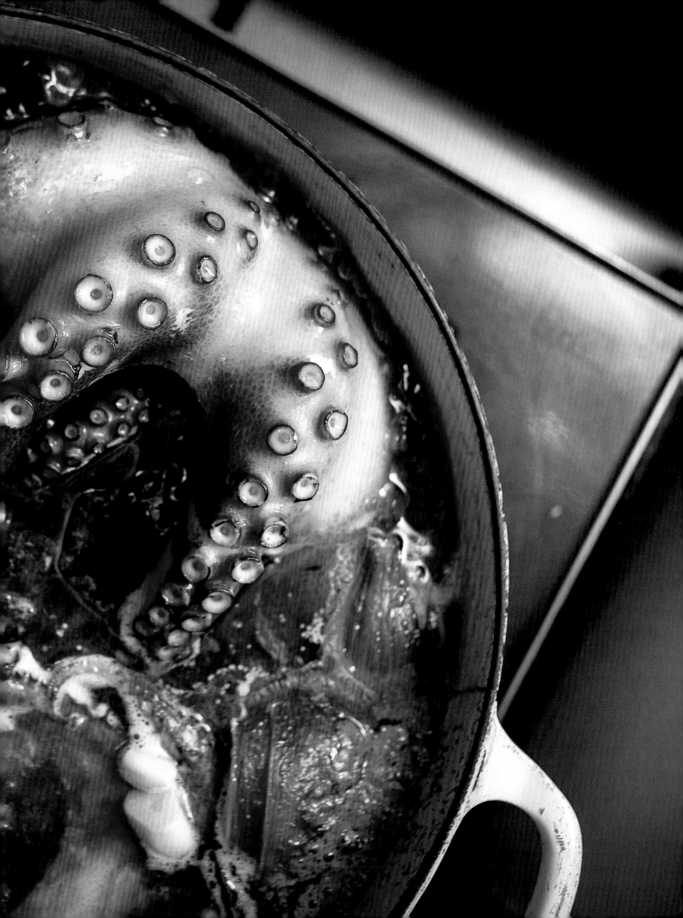

DINNER SMALL PLATES

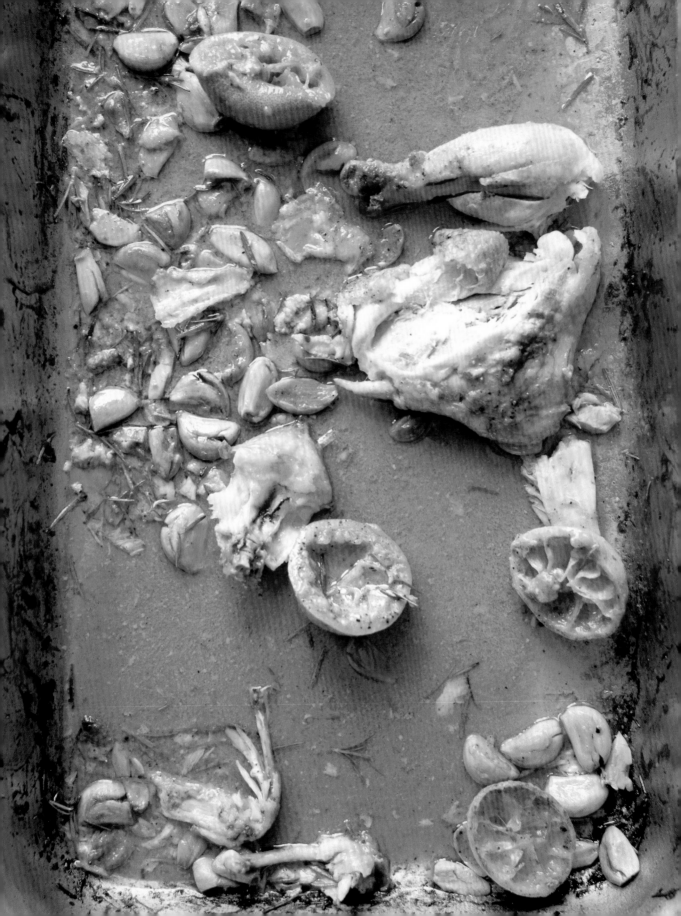

Bread Heels and Pan Drippings Salad

Yield: 4 orders

	×8	×16
1 chicken (4–5 pounds)	2	4
1 lemon	2	4
10 garlic cloves	20	40
rosemary leaves from 2 sprigs	4 sprigs	9 sprigs
¾ Tablespoon EVOO	EVOO +/-	EVOO +/-
2 Tablespoons Dijon mustard	1/4 c.	1/2 c.
kosher salt	s+p	s+p
freshly ground black pepper		

Prune Vinaigrette (page 458)

Bibb lettuce, washed and dried

collected day-old bread heels—with plenty of life;
 don't unload rock-hard 2-day-old bread here

Rinse and dry the chicken thoroughly. Use paper towels.

Set 2 chickens in each hotel pan, and squeeze lemons over each, leaving spent lemon halves in the pan. Season the birds highly with salt and pepper. Smear them with the Dijon mustard and scatter the rosemary around evenly and the garlic cloves equally between each hotel pan. Drizzle them with olive oil and massage all of the ingredients into, around, and all over the chickens.

* If you are only roasting 1 chicken for some reason, follow same protocol but use a 1/2 sheetpan or a 1/2 hotel.

Set in 350° ovens. Separate the hotel pans—if you can—between the 2 ovens. If you don't have that luxury of space to spread out in, keep the pans side by side on the upper rack in one oven rather than above and below each other.

Roast, turning and basting once, to 160° at the deep part of the thigh. Depending on what's going on around here with the ovens this day, opening and closing incessantly, fellow line cooks shoving your pans around, etc., the chickens should be done in an hour, more or less. Remove from oven when they look irresistible, and let cool on a rolling rack. Try to keep an eye out that everybody walking by doesn't rip off a wing or pick at them all day.

When just cool enough to handle with a doubled-up pair of latex gloves, pull the birds apart right in the hotel pans, letting the juices flow out into the pans. Set the legs and breasts aside and contribute to family meal. Pick the "oysters" of meat from backbone, and pick all the meat from the wings and leave in hotel pan. Discard lemon halves. Save the bones for stock. Save every bit of juice, garlic, pan dripping, burnt rosemary leaf, fat, skin, pope's nose, and picked meat and keep warm.

To plate:

Per order, put a few leaves of torn Bibb lettuce in a wooden salad bowl and slightly overdress. Set in a hot spot on a shelf above the grill until the salad looks sad and wilted. Set a couple of torn heels or crusts of bread on top of the salad in the bowl and spoon over a generous soaking of chicken pan drippings and a spoonful of vinaigrette.

4 chickens yields 16 orders' worth of drippings, more or less.

Tongue and Octopus with Salsa Verde and Mimosa'd Egg

For the braised beef tongue:

Yield: 4 orders

	×8	×16
1¾ pounds tongue, rinsed	3½#	7#
2 stalks celery	3 stalks	6 stalks
1 peeled carrot	2	4
neutral oil		
½ large yellow onion, peeled	1 onion	2
6 parsley stems	1 doz.	2 dz.
1 teaspoon black peppercorns	½ T.	1 T.
1 dried bay leaf	2 bay	4
4–6 cups water	8–12 c.	16–24 c.
2 Tablespoons red wine vinegar	4 T.	8 T.
½ Tablespoon kosher salt	1 T.	2 T.
¼ cup colatura	½ c.	1 c.
water to cover	h₂0	
kosher salt to taste	salt	

Clean up the celery and cut for mirepoix. Cut the carrot and onion for mirepoix. Even for mirepoix, prep vegetables that you would want to eat, so you don't have brown, ratty crap going into the pot. Cut the blackened tops off the carrots and peel them. If it looks very good going into the pot, you can probably count on it being quite good when it comes out of the pot. Don't confuse the stockpot for the compost pile; it still matters.

Put the deep, heavy 7-quart Le Creuset Dutch oven on medium-low heat and add a glug of neutral oil. Sweat onion, celery, carrot, peppercorns, parsley stems, and bay leaves.
Cover and let the veg steam briefly.

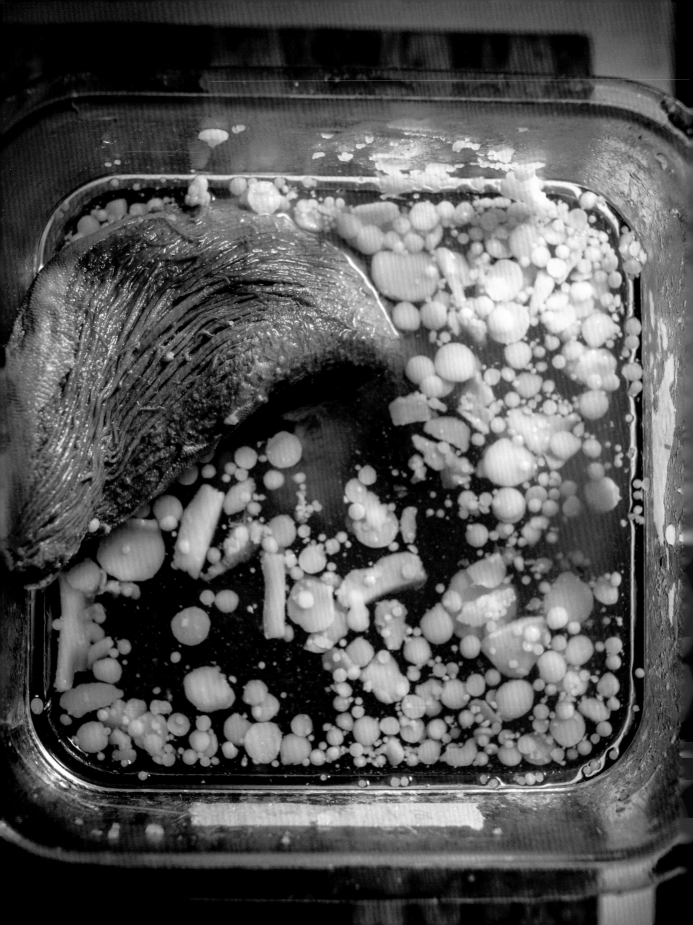

Add water, tongue, red wine vinegar, and salt. The tongue should be just barely covered by the liquid. TASTE THE LIQUID! KNOW WHERE YOU ARE HEADED!
Cover and bring to a boil, then reduce heat as low as possible as soon as it starts to hiss.
Lay in a parchment round, re-cover with lid, and simmer 4–4½ hours.
Add colatura at the end, when tongue is tender and off the heat, but still hot.
The tongue sucks up a lot of water quickly and becomes engorged. Be sure to keep track of the pot and add water as needed, usually an additional 4 cups by the time the tongue is tender.
Also, this is not a set-and-forget project. Simmering pots around here get pushed to the side constantly by other cooks looking for burner space. Your gentle simmer goes from dead still to a hard boil if you don't protect it.
Add salt to the pot if you add a full 4 cups of additional water.
✗ Peel tongue while it's warm; it's impossible to peel when cold.
Store peeled tongue in its braising liquid; strain out the mirepoix and discard.

For the octopus:

Yield: 4 orders

1 2- to 3-pound octopus,
 cleaned, head and beak removed

2 Tablespoons extra virgin olive oil

½ cup sliced red onion

3 garlic cloves, smashed

2 chiles de árbol

½ bunch fresh thyme

water to cover

kosher salt to taste

×8	×16
1 @ 4#	2 @ 4#
⅓ c.	⅔ c.
1 c.	2 c.
6	12
3 arbol	6
½ bn.	½ bn.
h₂0	
salt	

** don't multiply Thyme in large batch. too strong.

In the 7-quart Dutch oven, gently heat the EVOO and warm the onions, garlic, chilies, and thyme.
Stir the vegetables until they start to give up steam and look alive.
Sweat down a bit but do not get any color, just 2–3 minutes.
Nestle the octopus neatly in the pot.

Add enough cool water to not quite cover the octopus. She will float a bit like a croco-dile at a river's surface.

Season accurately with salt, *keeping in mind that the octopus will render its own sea-watery liquid into the pot during cooking.*

Cover with the heavy, tight-fitting lid and bring up to a boil, then immediately reduce heat to the gentlest simmer possible—and let the octopus go undisturbed for 45 min-utes.

Check in on the octopus then, stir things around, feel the firmness/tenderness of the thickest part of the legs, re-cover, and let it continue to simmer.

Check occasionally for doneness by piercing the creature with a skewer.

At first she will turn bright purple-red and swell up considerably, but when she is nicely tender, she will have shrunk and become bluish purple. Cooking times vary widely.

This can take up to 3 hours, so check along the way and use your judgment. We want tender not mushy; a little "tooth" but not chewy.

When cool enough to handle, separate the legs, and if the skin and suction cups look good, leave them. If they have become stringy and unattractive, slip them off.

Strain the liquid of the aromatics and store the legs in the liquid.

For mimosa'd egg:

1 hard-boiled egg, peeled

To pick up:

Slice tongue directly across at base, then on slight increasing bias toward thinner tip. In small sauté pan, add 2 or 3 slices of tongue per order depending on their size—and a few spoonfuls of the braising liquid. Bring to simmer until heated through and the broth slightly reduced to have body but not yet sticky.

Grill 1 leg of octopus per order on the hot grill until nice dark grill marks form on both sides and leg is hot throughout. Use 2 legs if they are very small.

To plate:

Spoon judicious pool of Salsa Verde (page 480) onto plate, set tongue out in stacked domino fashion, and then set octopus on top.

Let the dish rest a moment and allow the juices to commingle on the plate. Drizzle with extra virgin olive oil.

Press hard-cooked egg through fine-meshed sieve to neatly shower over the dish.

Pastrami Duck Breast with Small Rye Omelette

Serves 4

4 duck breasts, raw, trimmed, split

Ingredients for the pickling spice: (yield: ½ cup)

	x1 cup	x2 cup
1 Tablespoon cracked black pepper	2 T.	¼ c.
1 Tablespoon toasted mustard seeds	2 T.	¼ c.
1 Tablespoon toasted coriander	2 T.	¼ c.
1 Tablespoon red pepper flakes	2 T.	¼ c.
1 Tablespoon allspice berries	2 T.	¼ c.
1 small cinnamon stick, broken	2	3
1–2 bay leaves, crumbled	2-4	4
1 Tablespoon whole cloves	2 T.	¼ c.
1½ teaspoons ground ginger	1 T.	2 T.

Ingredients for the brine:

	x1 gallon
6 Tablespoons kosher salt	3/4 c.
1 Tablespoon granulated sugar	¼ c.
2 Tablespoons light brown sugar	¼ c.
3 garlic cloves, smashed	5
2 Tablespoons pickling spice (above)	4 T.
2 quarts water	4 qts. H_2O

Ingredients for the rub:

1 : 1

1 Tablespoon freshly ground black pepper

1 Tablespoon ground coriander

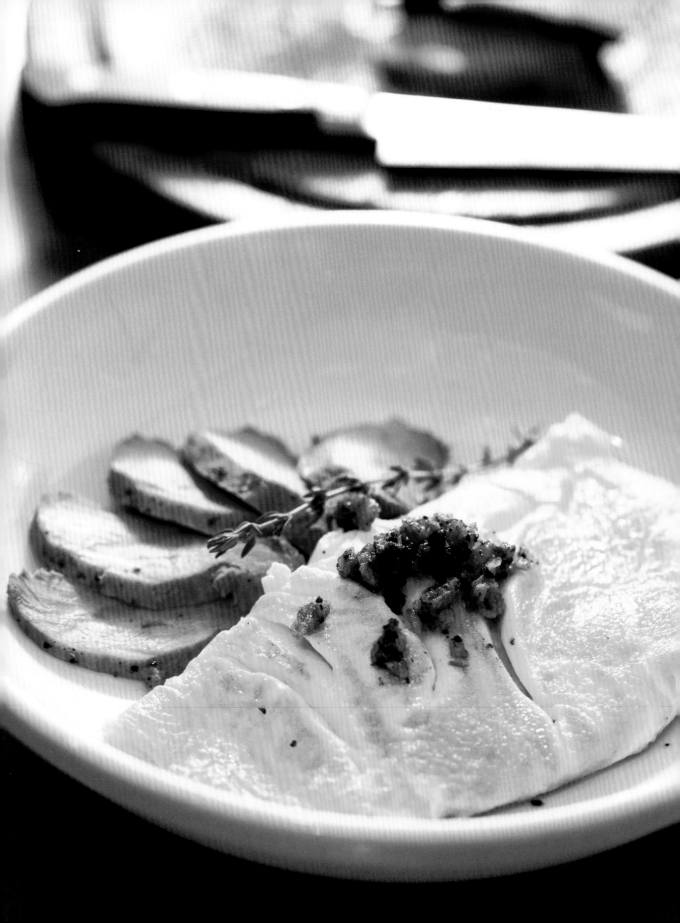

Ingredients for the omelette filling:

4 duck skins, gently separated from the 4 breasts
 after smoking/pastrami process

2 shallots, peeled and thinly sliced

1½ Tablespoons thyme leaves

1 Ryvita dark rye cracker, crushed into
 pea-size pieces

8 eggs

[handwritten marginal notes]
× 8 × 16

4 shallots 8
3 T. 6 T.
2 4

Directions for the brine:

Make pickling spice by combining all ingredients.
Bring brine ingredients to a boil. Cool completely.
Submerge skin-on, trimmed, split duck breasts and leave for 2 days in walk-in.
Remove from brine, lay on baker's drying rack, and let sit out of brine for 1 day, un-covered, in walk-in.

LABEL AND DATE PROPERLY PLEASE!

To smoke the duck breasts:

Massage spice rub into skin only of each duck breast, making sure it adheres. Don't be sloppy.
Place duck on rack that fits inside deep hotel pan, skin side up, flesh side down.
Set up our makeshift deep hotel pan contraption with full but single layer of chips and start to smolder directly on the burner on the stove. Make sure exhaust hood is on!
Lay in rack of duck breasts, cover tightly, smoke ducks for 30–45 minutes until medium rare.
Remove from smoker. Gently separate skins from breasts using your fingers and a knife. Set breasts aside and use skins for the filling.

To make the omelette filling:

Place skin quill/spice side down in a cold cast-iron skillet and place over low heat.

Let fat render *slowly,* occasionally draining it off and reserving; this will take almost an hour. When skin is shrunken and brown, turn and cook on the fat side. When all fat is rendered, remaining skin will be a thin, caramelized, very dark crackling. Remove skins and cut to medium dice when cool enough to handle.

In same pan, heat 1 tablespoon of the reserved fat over gentle low flame. Add shallots and thyme, and sauté briefly, collecting fond as you stir the mixture around in the pan. Add crackling pieces and sauté until shallots are completely soft, 2–3 more minutes. Set aside.

To pick up:

Per order

Warm duck breast in gentle oven.
Make quick, 2-egg omelette, with 1 generous spoonful of duck skin–shallot mixture and one generous pinch of Ryvita crumbs inside.
Fold in half. Set on plate. Let contents reveal themselves a little, so it looks luscious.
Slice warm duck breast and lay out beside omelette.
Season with salt and pepper, very lightly.
Lay 1 thin thyme branch across to garnish.

Toasted Manti with Garlic Yogurt and Cayenne Pepper Butter

Yield: 4 orders

For the manti:

4 ounces (10 sheets) square fresh wonton skins, yellow not white

4 ounces (40 thimblefuls) ground lamb

1⅓ cup College Inn beef broth

× 16

1 #
1 #
1 qt. +/−

For the yogurt:

1 cup plain full-fat Fage brand Greek yogurt

1 fresh, sticky, burning garlic clove

1 splash extra virgin olive oil

kosher salt to taste

× 16
2 c.
3 cloves
2 T.
salt

Microplane garlic into yogurt; season with salt and EVOO, and whisk until smooth and blended. Let sit to see how garlic emerges. Add garlic or yogurt, depending. We want it very assertive.

For the cayenne butter:

4 Tablespoons butter, softened

1 teaspoon cayenne pepper

1 teaspoon salt

× 16
½ #
1 T.
+/− salt

Blend well. Chill.

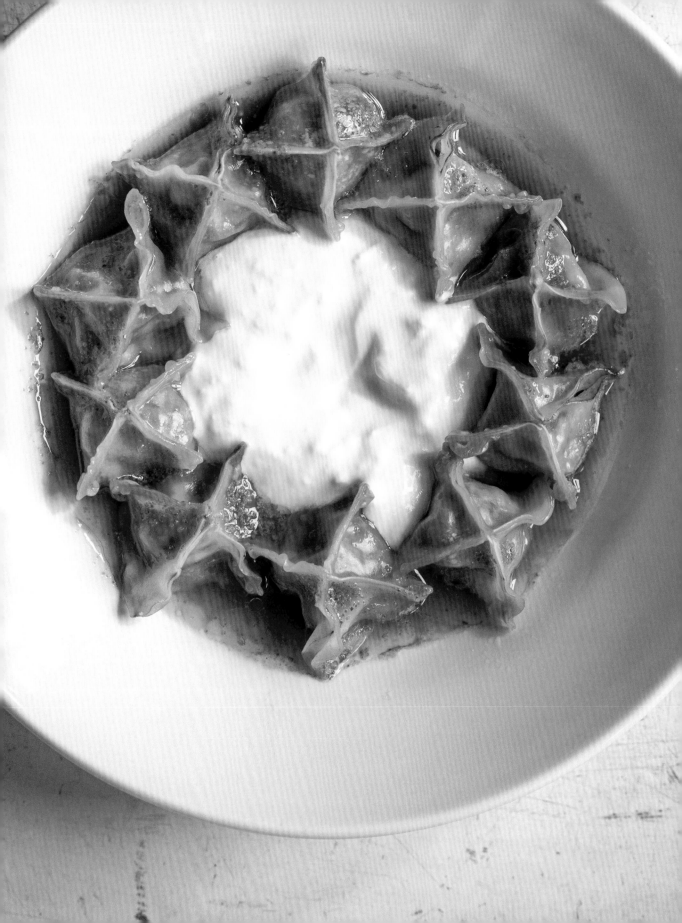

To assemble manti:

Roll tiny lamb meatballs, no larger than a rounded ¼ teaspoon. Do not season the meat. Pack them in orderly rows on parchment in shallow fish tub. Get ahead. Get externs and trailers to join you. This whole deal is labor intensive. Ask for helpers.

Keep wonton skins fresh and do not let them dry out. Keep a small stack in front of you at a time, kept under ultra clean, barely damp cotton dinner napkin.

Have in front of you a very narrow pastry brush, a pint of cold water, a knife.

Cut short stack of wonton skins into 4 exactly equal squares. One cut north-south; one cut east-west.

Lay out the squares, set a tiny lamb meatball in the center of each, brush the edges with water to dampen, and fold into perfect purses, enclosing the meat and sealing the seams securely. Gently and subtly push down on each one after you have formed it to flatten the bottom so it will sit steady later in the pan during pickup.

Pack in neat and orderly rows on parchment in shallow fish tubs. Store in freezer.

Get ahead. Get externs and trailers to help whenever they are in the building. On slow nights, send a line cook downstairs during lulls to keep going on these. They're a real bitch, I recognize, but stay at it.

Lay frozen manti on parchment in ½ sheet pan and toast in 375° oven until golden on their bodies and deeply toasted at the star-like seams, 12–15 minutes.

10 ORDERS / 100 PIECES

To pick up:

In sauté pan, heat beef broth to simmer.
Add toasted manti, seams up.
Continue to simmer until broth reduces and becomes full-bodied and has taken on what starch there is from the wonton skins.
The manti will turn glossy and swell slightly, 5–6 minutes in total.

To plate:

Dollop of room-temperature garlic yogurt in center of small shallow bowl.

Manti in neat garland, seams up, around yogurt. We are not this kind of restaurant, but the tweezers really work well here.

Spoon the glossy beef broth into the bowl to pool up around the manti. Don't drip on the yogurt—that stays white and pristine.

Melt cayenne butter quickly, to foaming, and drizzle around into the broth, making reddish beads in the broth. Don't drip on the yogurt.

Sell quickly. Do not let this sit in the pass.

**** PLEASE do not "improve" the dish by using our homemade pasta sheets or our homemade beef broth. Always use wonton skins and College Inn.**

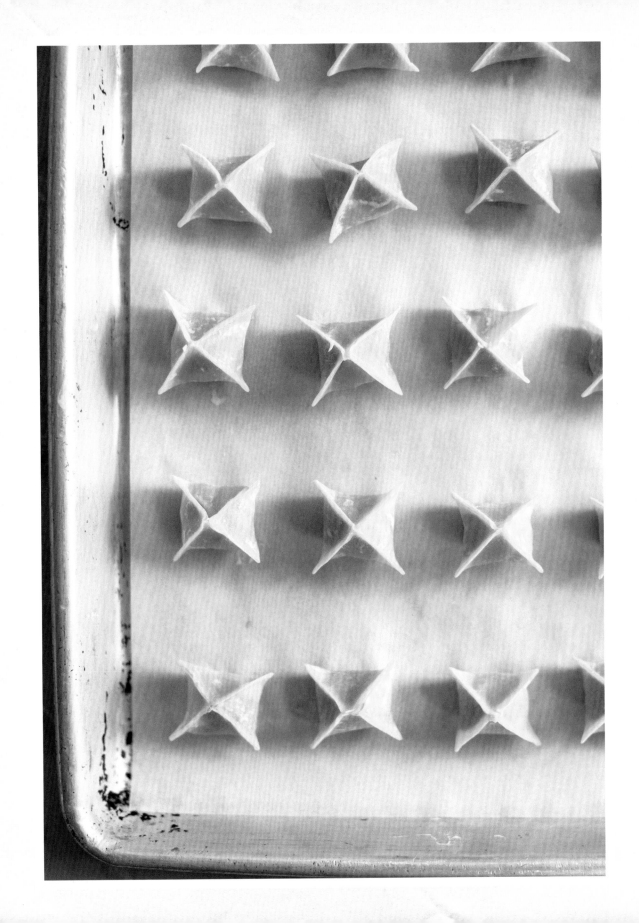

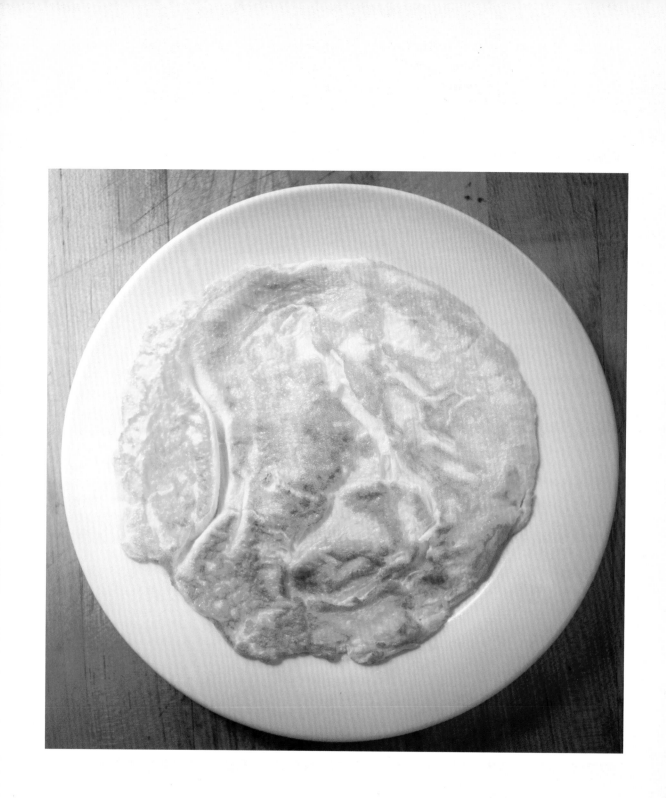

Omelette with Parmesan

1 order

2 eggs, at room temperature

Parmesan cheese, shaved

sweet butter

Maldon sea salt

Beat eggs.

Melt a knob of butter in 7-inch nonstick omelette pan over medium flame.

When butter foams but before it colors, add eggs.

With heatproof rubber spatula, drag eggs into center from noon, 3 o'clock, 6 o'clock, and 9 o'clock. Repeat in opposite direction, from center of omelette to outer edge, but move ahead an hour so you are not cutting the same path—1 o'clock, 5 o'clock, 7 o'clock, and 11. Let loose egg run into the path of the spatula cuts until all is set. When moist but not raw/wet, add Parmesan evenly, and allow omelette to set and get a slightly golden exterior while cheese softens.

Turn out by fully inverting onto plate and season with Maldon salt. Don't fold in half.

There's nothing to hide behind here, so please keep it tight.

Make sure your pan is the right temp, your butter is foaming and not sizzling, your eggs are fully beaten to their greatest volume, and that your Parm is neatly shaved and distributed evenly. Some of your omelettes have been greasy and flat and over-Parmed. Take care.

Monkfish Liver with Warm Buttered Toast

4 orders

1 pound monkfish liver

6 inches non-sourdough baguette

extra virgin olive oil

low-sodium soy sauce

fresh lemon juice

Maldon sea salt

freshly ground black pepper

unsalted butter

grapeseed oil or blended olive oil

Soak liver in very cold water overnight to draw out blood.

Cut away fatty tissue or stringy membrane. Check for small spiral worms and remove with tweezers or paring knife. Cut slabs of the raw liver—approximately 4 ounces per portion.

Put the liver on a sizzle plate brushed with grapeseed or blended oil, then drizzle the liver with oil and season lightly with black pepper only. Broil for a few minutes under the sally at the lowest setting. The liver will tighten and swell up slightly, and a barely golden crust will form on the tops. Keep them medium rare. Rare is too bitter, medium starts to get grainy/chalky. Check every 60 seconds.

Slice baguette and toast slices. Spread sweet butter generously onto warm toast.

To plate:

Per order:

Spoonful of soy and a squeeze of fresh lemon juice.
Broiled liver slab on top of soy-lemon.
3 slices warm buttered baguette, shingled.
Decent drizzle of EVOO over livers AND toasts.
Few flakes of Maldon salt over the liver and the toasts.
Serve quickly, while warm.

** Only order 3 pounds at a time. Don't stockpile.
Keep in cold clean water but not longer than 2 days —
the h₂0 starts to degrade the flesh.

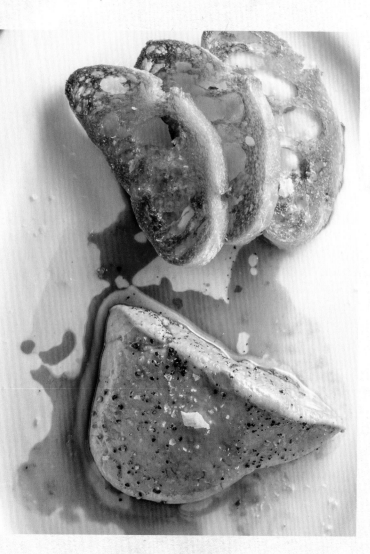

Grilled Head-on Shrimp with Anchovy Butter

4 orders

12 giant head-on shrimp (10/20 count)

6 anchovies packed in oil

1 Tablespoon heavy cream

½ pound cold sweet butter,
 cut into ½-inch cubes

x Weekday	x Weekend
✓	✓
12	20
2 T.	¼ c.
1 #	1½ #

In wide deep-sided sauté pan, add anchovies and a few drops of their oil and set over medium heat. Let the anchovies sizzle and start to fry a little and dry out. Mash them and break them apart with your whisk until they disintegrate completely into a coarse paste. Continue to cook until the mashed anchovies are toasted, very dry, and dark brown in color. Whisk in cream, which will sizzle and bubble and start to reduce immediately. Shut off the burner!

The cream is there only as a stabilizer to facilitate the slightly tricky mounting in of the cold butter. Don't be tempted to use more cream than called for because it quickly dulls this rich, briny butter sauce into a salty cream sauce, which is not what we are after.

Vigorously whisk in the butter, a few cubes at a time. Stay near the heat of the pilot light, the heat of the grill, the general ambient heat of the 10 burners in front of you, but do not open up a burner—it will break your sauce.

Pour into cylindrical metal bain set inside another metal bain of water and keep warm in your station during service.

Lay dry shrimp on hot section of grill.
Brush the shrimp on both sides with a few strokes of the anchovy butter.
Turn once or twice during cooking, until the shells have nicely charred spots and the liquids in the heads are bubbling.

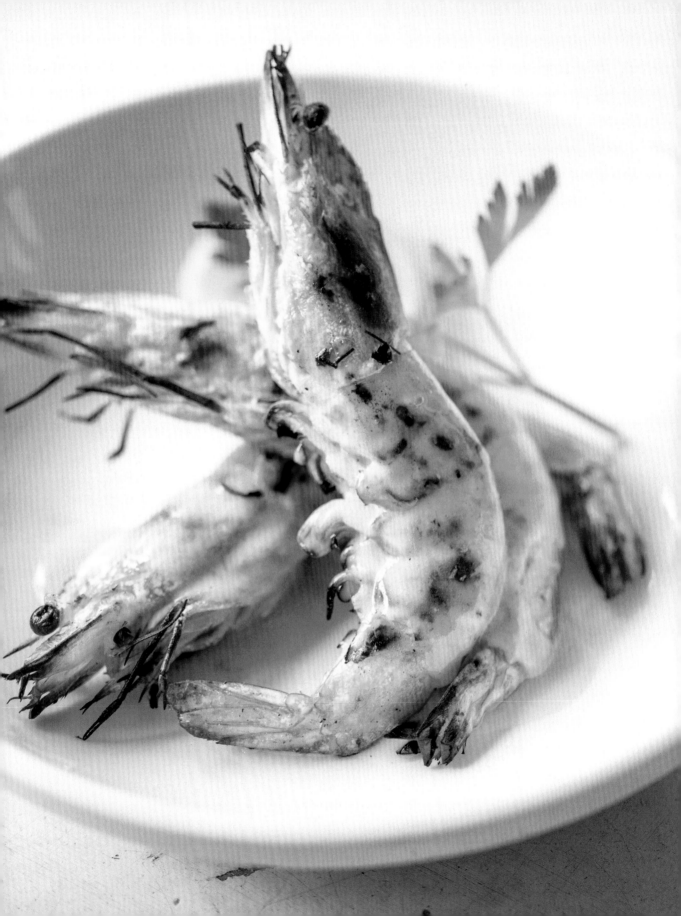

To plate:

2–3 per order
Stacked attractively, heads up, on plate.
1-ounce ladle of anchovy butter pooled over them.
Lemon cheek.
Full branch leafy parsley.

Shaved Celery, Fennel, and Radish Salad with Buttered Valdeón Toasts

Yield: 4 orders

1 head celery, tough outer stalks removed,
 well rinsed

2 medium heads fennel,
 stalks and fronds removed

2 bunches scallions
 (approximately 15 pieces),
 root ends removed and 1st outer layer
 peeled off with your fingers

⅓ pound sugar snap peas,
 stem removed and the
 thread at the seam peeled

2 bunches red radishes, tops removed
 and well washed

5 fresh sticky garlic cloves, peeled

¾ cup extra virgin olive oil

¼ cup + 1 Tablespoon fresh lemon juice

kosher salt and freshly ground
 black pepper to taste

8 ounces Valdeón cheese,
 crumbled or shaved

4 ounces sweet butter, at room temperature

4 long thin slices of fresh peasant bread

×8	×16
2 qts. shaved	4 qts.
1 qt.	2 qts.
4 bns.	8 bns.
2/3#	1#
4 bns.	8 bns.
10	20 cloves
1½ c.	3 c.
½ c.	1¼ c.
s + p	s + p
1# valdeon	2#

With a sharp knife, thinly slice the celery and then the fennel and toss together. Sliver the scallions and sugar snap peas on a bias and add to the fennel and celery. With a sharp knife or mandoline, thinly slice the radishes and add to the salad.

Grate the garlic on a microplane. Mix together garlic, oil, and lemon juice and dress the salad. Season with salt and pepper to taste and toss well. Let stand.

Toast the bread slices and spread each with an ounce of the butter. Divide the cheese among the 4 buttered toasts.

Toss and taste the salad again before portioning, add salt if necessary. Plate with the Valdeón toasts.

You want a bright, assertive, unafraid dressing on clean, crunchy, crisp, and lively vegetables. Keep your mise fresh each day, pay attention to the potency of the garlic as it changes from head to head, and make sure the Valdeon toast is still warm when the plate hits the pass.

Mackerel Escabeche, Sliced Sweet Capicola, Buttered Rye Crackers, and Celery Leaves

4–6 orders

Ingredients for the marinade:

½ Tablespoon kosher salt

¼ cup neutral oil

¼ cup extra virgin olive oil

¼ cup red wine vinegar

1 garlic clove

1 fresh bay leaf

1 stem thyme

¼ red onion, thinly sliced

¼ cup whole blanched almonds

2 teaspoons smoked Spanish pimenton

Ingredients for the rest of the dish:

3-pound mackerel, filleted

¼ pound thinly sliced sweet capicola ham

Ryvita dark rye crackers

sweet butter

bright green and yellow celery leaves from the heart

Use nonreactive stainless steel pot.

Combine all the marinade ingredients and bring to a simmer, then turn off and allow to steep for 1 hour.

— totally delishuss.
from matt hamilton

x30 +/−

2 T. salt
2 c. oil
2 c. evoo
2 c. RW vin
8
8 bay
1 branch
2 onions
1 c.
1/3 c.

x30 +/−
12 #
2 #
——
——
——

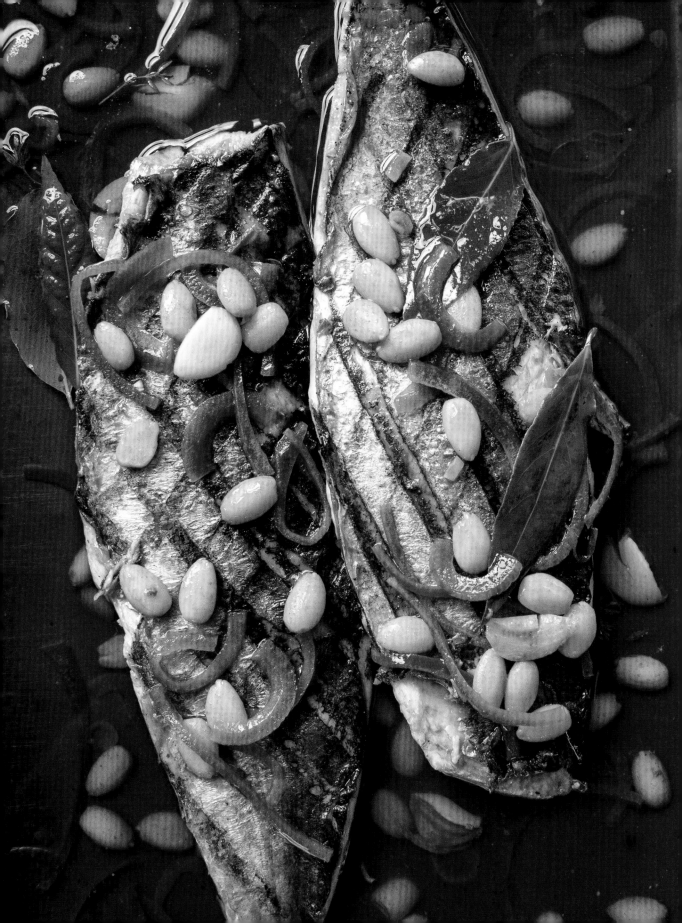

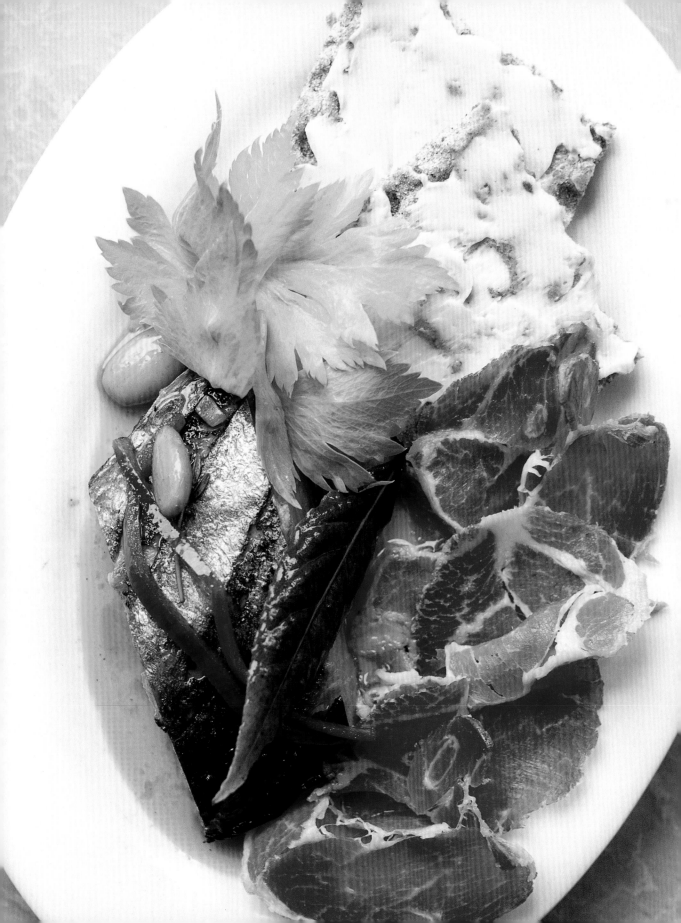

Brush the fish on the skin side with lightest possible film of neutral oil, then mark the mackerel fillets on the hot side of the grill, on skin side only. Move with confidence—the fillets will tear if you are timid about it.

Place the fillets in a hotel pan, flesh side down, and pour the warm marinade over them.

Let stand 1 day in the marinade.

> * use a deep hotel pan for the X30 batch and find the matching lid. Don't use plastic wrap. It loses its cling, falls into the oil, and then drips all over the walk-in floor.

To plate:

Per order

Drain fillet briefly.

Cut portion at 3 ounces more or less, and set on plate.

Spoon a little bit of the marinade plus goodies over fish—include some of the onions and almonds. (If the bay leaves are small, you can add one to the plate, but otherwise leave the big ones in the marinade; they tend to dwarf the dish.)

Butter the cracker "wall to wall," then crack in half and stack on plate. Take care that butter is cool and waxy and not warm and greasy.

Loosely fold 3 slices capicola, set next to buttered cracker.

Scatter clean, lively celery leaves.

Pinch of Maldon salt and a grind black pepper on mackerel to finish.

Make sure you stir the marinade up when plating to get the vinegar onto the plate, too. Sometimes I've seen it go out too oily.

Stay ahead on your prep—the mackerel needs a full day in the soak.

Reuse marinade, but pay attention to viability and date. When the onions and bay lose their vitality, dump the marinade and make new. Do not send this down the drain. It clogs the grease trap. Discard into the dirty fat drum in the garbage area, please.

Grilled Veal Heart with Red Wine-Braised Shallots and Watercress

Yield: 5–6 orders

1 veal heart (about 1 pound, usually)

10 small shallots

½ cup red wine

2 Tablespoons + 1 Tablespoon EVOO

kosher salt

black pepper

1½ cups beef stock

1 bunch cress, large woody stems removed

Trim the fat cap at the top of the veal heart.

Keeping the heart as intact as possible, trim out the tough ventricle lining that bores down through the chambers of the heart. The heart will look a little like the bullet chamber in an unloaded gun when you have finished cleaning it. Butcher with care; don't hack at it.

Freeze the clean heart for an hour.

Then slice into ¼" rounds on the meat slicer. Obviously, the slices from the top will have holes. Lay out in a 1/6 pan with 2 tablespoons olive oil drizzled over and in between the slices.

Caramelize shallots in 1 tablespoon olive oil in a stainless steel deep-sided sauté pan over medium heat, large enough to hold the shallots in a crowded but single layer. Roll them around periodically. Season with salt and black pepper during the cooking. Get good color all over. Take a full 20–30 minutes to let the color develop slowly. Don't blast and scorch in a hurry, please.

When golden, with occasional dark brown spots of deepening char and caramelization, deglaze with red wine.

Simmer until the wine no longer tastes raw—a couple of minutes—then add the beef stock and braise, covered, on the stove until collapsing and tender but still whole, more or less. The inner layers start to slip out, which is fine.

Season to taste, but **taste before you season**—the added wine and stock have made a difference.

Salt the heart before grilling.

On hot section of grill, flash the heart slices on both sides, not more than a minute per side.

Arrange cress on plate, spoon warm shallots and their liquid over to wilt the leaves a bit, then arrange rare heart slices on top.

One quick drizzle of EVOO and a grind of black pepper to finish.

Keep the heart rare and tender; overcooking by even a minute makes it tough.

Duck Liver Garbure with Toasted Chestnut

4 orders

Double Stock (page 449)

4 2-ounce pieces D'Artagnan foie gras, frozen

4 chestnuts, peeled and toasted

1 large parsnip, cut in bâtonnets

4 Brussels sprouts, leaves separated

4 baby white turnips, neatly peeled, blanched, halved

[handwritten note:]
x 16

2#
16 pc.
5 pc.
16 pc.
16 pc.

For the pickup:

Heat double chicken stock to simmer.
Drop in Brussels sprouts leaves and foie gras.
Simmer 1 minute. Leaves turn bright green and foie starts to swell.
Add turnip halves and parsnip bâtonnets, simmer 1 minute.
Add chestnut, simmer 2 minutes.

To plate:

Per order:

Use slotted to retrieve all the goods and place them in small shallow bowl, casually but aesthetically. Use solid to spoon broth over until everything just floats and is half submerged, more like a nage than a soup.
Few flakes of Maldon to finish. It needs the crunch of the salt crystals.

Reuse the same broth all night long, poaching the ingredients for each order in a service-long continuous broth, though switch out pans frequently. Every time you spoon out some of the broth, add more double stock to the pot.
It's certainly good at the get-go, but by the last few orders of the night that broth is outrageous.

Also, this is not really a garbure, so if you leave here and go on to work at a real restaurant, don't make the error of presenting this as garbure—this was an

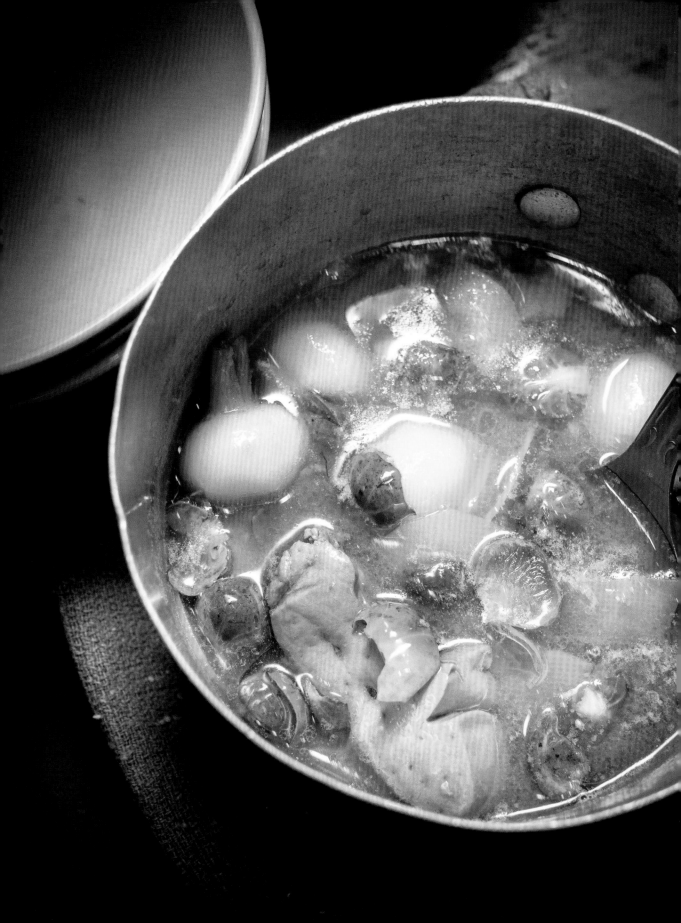

interpretation we did for a weeklong festival in NYC celebrating the foods of the Aquitaine and in collaboration with Jean-Claude Xiradakis. I ended up loving it and keeping it on the menu in spite of its "restauranty" look. The only thread between this and a true garbure is the cabbage.

Shad Roe with Bacon and Smoked Paprika Butter

4 shad roe sacs

4 slices bacon

Smoked Paprika Butter (page 478)

Wondra flour

butter

lemons

kosher salt and freshly ground black pepper

4 Bibb lettuce leaves

Bring 4 inches of water to a gentle simmer in a deep-sided sauté pan. Season with salt and squeeze ½ lemon into the water.

Rinse the roe sacs gently, taking care not to split the sacs or break the fragile membranes that encase them.

Slip roe briefly into poaching bath, just to set the sacs from bright red to drab gray, 90 seconds.

Pull them before they burst. If they burst, use them anyway. It's not ideal, but it happens; it's unavoidable, and this is too precious an item to discard just because a sac bursts. Poach as gently as you can.

Once set, allow the sacs to cool on a baker's drying rack. Pick off the cooked large vein that runs between the lobes.

Cook bacon in flat-bottomed sauté pan until golden and crispy.

Remove bacon but leave fat in pan.

Dredge shad roe in Wondra flour and fry in bacon fat until golden and crispy.

Turn gently with fish spatula and fry on the other side. Sometimes you will need to add additional fat to the pan—use a nut or two of butter.

Cook to medium rare—but closer to rare than medium. Depending on size of lobe, 2 or so minutes per side.

Set on a few Bibb lettuce leaves on plate. Season with salt and pepper, briefly. Smear generously with smoked paprika butter—enough that it drips lusciously down onto the plate. Set the bacon on top. Finish with lemon cheek.

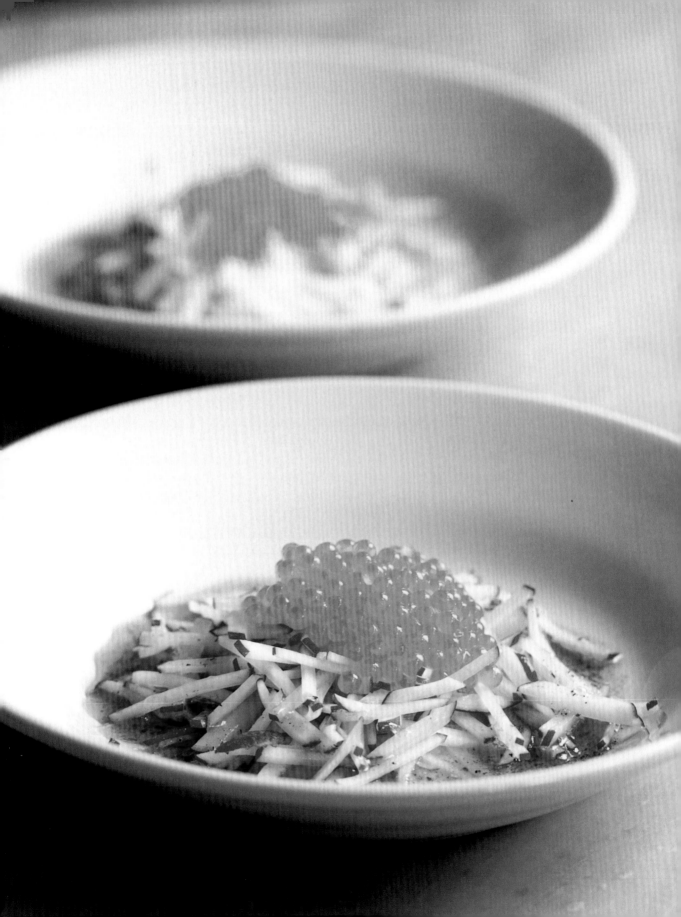

Grated Radish with Trout Roe and Brown Butter

Yield: 4 orders

8 red globe radishes, top and tail removed

4 Tablespoons sweet butter

4 ounces trout roe

With very sharp knife, make fine slices—as thin as potato chips—of the radish.
Stack the slices and make fine julienne. *Don't use the mandoline.*
Store radishes covered with damp paper towel to keep fresh *Keep your knife skills in shape.*
and lively during service.
Make casual nests in the bowl with the radishes.
Top each radish salad with a heaping tablespoon of trout roe.

To pick up:

Brown sweet butter to fragrant and nutty.
Immediately spoon hot browned butter around and over the radishes, but avoid the roe
so you don't "fry" or collapse the fish eggs with the hot butter.

Don't let this sit in the pass. Get it to the table immediately.

Bagna Cauda

Yield: 4 orders (½ pint)

¼ cup extra virgin olive oil

8 Tablespoons unsalted butter

3 fillets (½ ounce) anchovies in oil

4 garlic cloves, finely minced

¾ teaspoon caper brine

freshly ground black pepper

× 1 pt.	× 1 qt.
½ c.	1 c.
½ #	1 #
6	12
8	16
1½ tsp.	1 T.

Heat oil and butter in saucepan over low heat.

Add anchovies and garlic and cook 3–4 minutes, stirring and mashing with wooden spoon, until anchovies dissolve into sauce.

Raise heat to medium, whisk in caper brine.

Turn off heat. Season with black pepper.

Keep warm next to stove in steel bain.

Stir contents well before portioning.

Ideal:

Freshly cut sweet and cold raw common green cabbage wedges.

Neatly arranged Belgian endive leaves.

Perfectly blanched and internally seasoned cold cauliflower. (Salt the blanching bath well—taste it before cooking the vegetable so you know what you are dealing with and remove from shocking ice bath as soon as possible so you don't waterlog the cauliflower after cooking it. Drain well so the customer doesn't taste any water.)

This one is my favorite—sweet, crunchy, bitter, and cold—in perfect counterpoint to the salty, buttery, warm bagna cauda. And I prefer the monochromatic—-the white, pale yellow, and even paler green all together on the plate.

But you can also run this with:

Blanched broccoli stems—peeled and beautifully cut, please.
Raw peeled baby white turnips—only if they are from the farm and looking very lively, and no bigger than a Ping-Pong ball. Use your judgment: sometimes the skin is so thin and tender they don't need to be peeled. If you have to peel them, use long strokes from stem to tail, hold the peeler like a paring knife, don't chip/hack away at them, and try to keep that long tail intact.
Raw scallions, stripped to their tenderest cores, roots trimmed.

And I don't mind:

Treviso or radicchio.
Those beautiful dark purple sweet bell peppers.
Radishes.
Please don't use the cherry or grape or Sun Gold tomatoes—-the sauce won't cling to their shiny skins and the customer can't get a good purchase on them for dunking into the warm bath.

And please plate the veg first and don't call for the anchovy butter until you are ready to walk the dish—customer should receive *cold* veg and *hot* sauce.

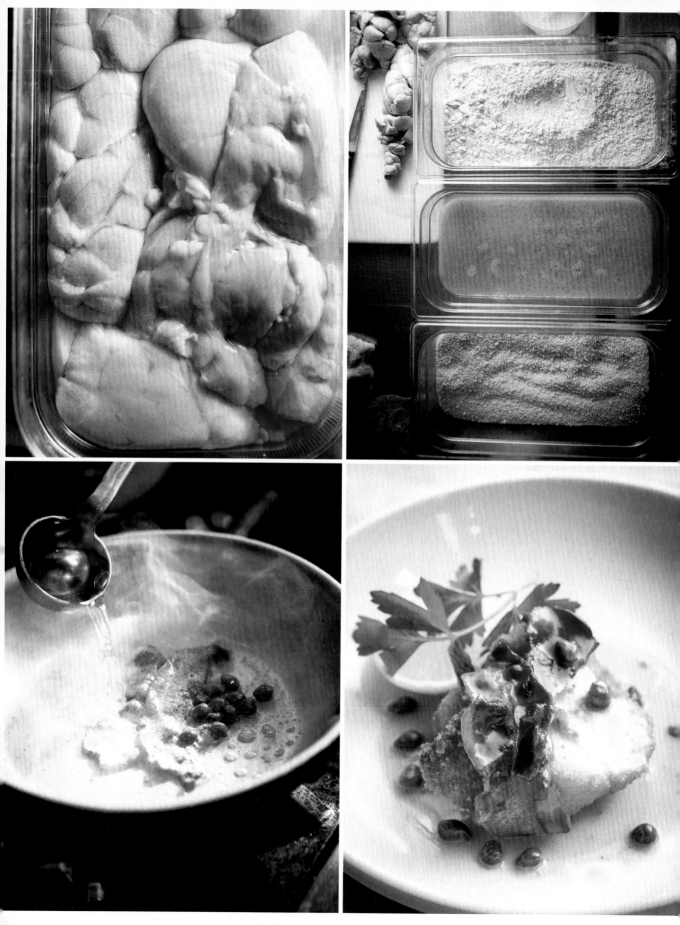

Deep-Fried Sweetbreads with Bacon, Capers, and Brown Butter Sauce

Yield: 4 orders, 3–4 ounces per portion

	×8	×16
1 pound veal sweetbreads, from the heart side	2#	4#
3½ cups cold water	7c.	14c.
½ cup hot water	1c.	2c.
¼ cup kosher salt	½c.	1c.

¼ cup all-purpose flour

1 egg, well beaten

1 cup panko bread crumbs,
 ground to fine in the food processor

	×8	×16
½ Tablespoon unsalted butter	1 T.	2 T.
4 slices bacon, cut on the thin side, cooked to golden and crisp	8	16
1½ Tablespoons butter	3 T.	6 T.
1 Tablespoon + 2 teaspoons capers in brine	⅓ c.	⅔ c.
1 Tablespoon water	2 T.	4 T.
7 Tablespoons cold butter, cut into cubes the size of your thumbnail	7 oz.	1# +/-
¼ teaspoon freshly ground black pepper	½ tsp.	1 tsp.

lemons for garnish

To prepare the sweetbreads:

Dissolve salt in the hot water and then add to the cold water.

Soak whole raw sweetbreads a full 24 hours in the brine, refrigerated. This will draw out some of the blood and season the gland internally.

Bring 3 quarts of water to a boil. Drain and rinse brined sweetbreads, then gently submerge in the boiling water. Let the water come back up to a boil and immediately turn down to a slow simmer. Poach the lobes gently, uncovered, for up to an hour but check at 20-minute intervals. The water should very gently roll. Remove the cooked sweetbreads and place in an ice bath to stop cooking. Let chill thoroughly. (They should be firm and opaque throughout, with no raw, rosy center. Raw sweetbreads are bitter and gelatinous and unpleasant. Conversely, overpoached sweetbreads become chalky and mealy. There can be a significant variation in cooking times, as much as 20 minutes, so keep an eye and use your wits. But it's a pretty generous protein and gives you a wide berth between perfection and ruin, so don't feel daunted by the task of properly poaching. Just keep the pitfalls in mind.)

Thoroughly and neatly peel the membrane—the thin, slippery, translucent "skin" that encases the gland—which will come off in a rather neat sheet. Trim off any waxy fat clusters, which tend to cling to the underside of the gland, and gently tug out any egregious muddy brown veins. Try to pull out the tubular-looking arteries as well. If you've made it this far and are not retching into a garbage can, leave the minor little capillaries intact in order not to have the lobe fall apart into nuggets.

Portion into 4-ounce pieces, as possible.

To bread:

Dredge the blanched sweetbreads in the flour and pat off any excess. Dip them thoroughly in the well-beaten egg, then drop them into the ground panko and thoroughly coat. Set the coated sweets on a baker's rack to let the coating dry a bit. There should be no open patches revealing flour or egg wash, but instead an evenly and thoroughly coated lobe.

You can stab the sweetbreads with a skewer to bring them through the messy egg-flour breading process without getting your hands so unpleasantly caked up. It's a neater, more finessed way to bread, if you want.

Deep-fry sweetbreads at 350°. Slice with a sharp knife into clean medallions as thick as a slice of bread and finish with the sauce.

For the sauce, per order:

Heat ½ tablespoon butter in a small sauté pan. When butter is foaming, place cooked bacon slices in the pan and swirl around over medium heat until heated through and fragrant.

As soon as the butter in the pan is brown, quickly add the capers in brine and the water in order to stop the butter from blackening, and bring the fatty, briny liquid to a full boil until it reduces to 1 Tablespoon. This will happen almost instantly. Remove the pan from the heat and turn down the flame.

Over the lowest heat possible, and sometimes even lifting the pan off the heat if necessary, swirl in cold butter, a couple of cubes at a time, while constantly stirring and agitating and swirling the pan until the cold butter melts into an unctuous, creamy-looking sauce that should taste rich from the cold butter, deep and sweet from the browned butter, and just nicely balanced by the acidic brine of the perfume-y capers. Taste it.

Spoon sauce liberally over the fried, sliced sweetbreads; lay 1 bacon slice over the portion.

This sauce requires your attention as it is easily broken. Pay attention to the heat when you are mounting the cold butter—and keep it low, low, low. Careful when bringing the brown butter/water/brine to the boil that you don't allow it to evaporate. Be sure to start to mount the cold butter right away.

Lemon cheek garnish and full parsley sprig.

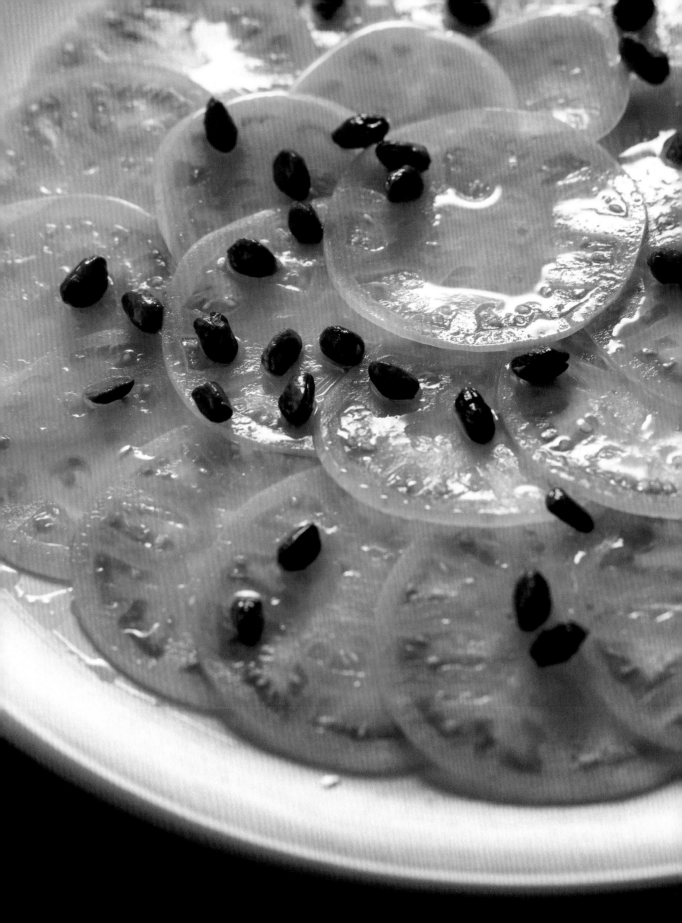

Salt and Sugar-Cured Green Tomatoes with Fried Sicilian Pistachios

firm tangy green tomatoes

kosher salt

sugar

Sicilian pistachios

extra virgin olive oil

orange blossom water

Slice tomatoes on meat slicer as thin as possible without shredding—⅛" ideal.

In ceramic or in glass, lay out 1 layer of slices neatly without overlapping.

Season very carefully with salt and tiniest pinch of sugar to quick-cure them.

Build another layer on top and repeat the cure, until you have stacked all of your tomatoes.

Get this done early in your prep so the tomatoes can cure for at least an hour before service.

Tomatoes will weep so make sure your vessel has a rim to collect the "tears."

To pick up:

Arrange good-looking, shingled, circle of tomato slices in bottom of small shallow bowl, leaving ½" of white plate perimeter where the green oil will pool up. About 8 slices per order.

Fry Sicilian pistachios in EVOO in small pot on stove. Reuse the same oil all during service.

Very sparingly splash some drops of orange blossom water over the tomatoes. You want to smell it and taste it, but in a fleeting way.

Scatter small spoonful of fried pistachios on the tomatoes and then spoon the warm olive oil they were fried in around the empty white perimeter left on the plate.

We should figure out something to do with the interesting cured tomato water that accrues in the bottom of the plate by the end of service. Maybe the bartenders have an idea?

Razor Clams with Smoked Paprika Butter and Hominy

Yield: 4 orders

¼ cup coarse sea salt

¼ cup cornmeal

24 razor clams, looking lively and obscene

2 teaspoons kosher salt

2 cups dry white wine

1⅓ cups cooked hominy, drained

6 Tablespoons fino sherry

½ cup finely sliced parsley leaves

Smoked Paprika Butter (page 478)

×8	×16
½ c.	1 c.
½ c.	1 c.
4 doz.	8 doz.
1 T. + 1 tsp.	2 T. + 2 tsp
4 c.	8 c.
2–3 c.	1 qT. ⁺⁄₋
¾ c.	1½ c.
1 c.	1½ c.

To prep the clams:

Combine 1 gallon water with sea salt and cornmeal. Add clams and soak for 2 hours to get them to disgorge grit and sand. Keep refrigerated during the purge.

Rinse thoroughly. Be vigilant about culling any clams that are not vital and doing that unbelievably uncanny dog-penis thing. Be sure to put the shellfish tags in the bin on top of the ice machine and save for 90 days for the Health Department.

don't just slam them into the pan and manhandle — their shells are extremely soft and brittle and they splinter easily

To pick up:

Heat a large dry sauté pan with a good-fitting lid over high heat until blistering hot. Be orderly and gentle and add clams without breaking their shells, then quickly add the wine, which will hiss and steam violently. Cover and cook until clams stop hissing (shells will be slightly open) and are just cooked through, 2–3 minutes.

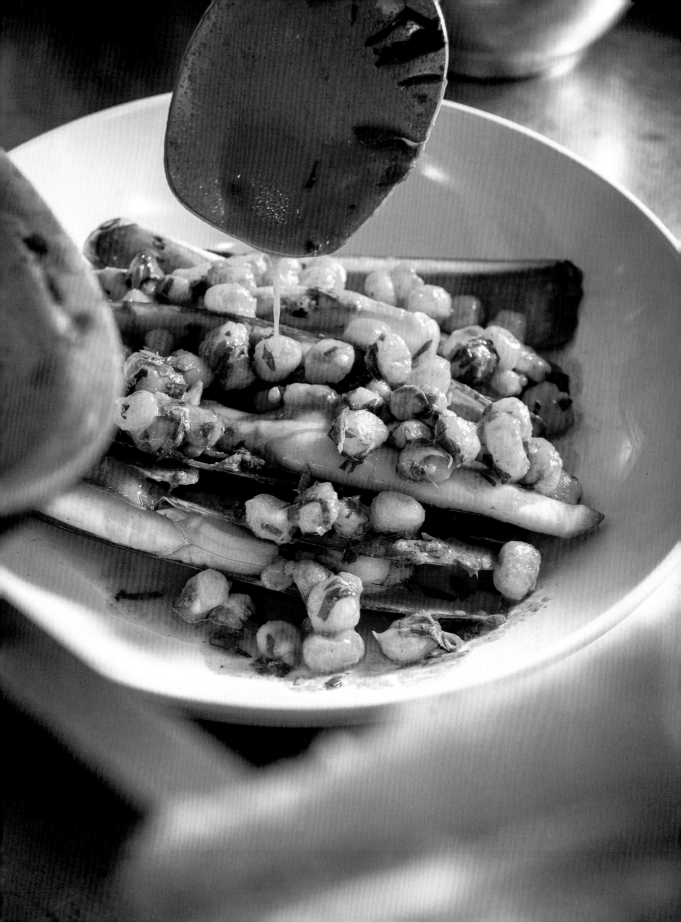

Lift the cooked clams out with a slotted fish spatula onto a ¼ sheet pan and return the sauté pan of liquid to the burner.

Let the liquid reduce by half, and in the meanwhile, arrange 6 clams per plate, hinges down, flesh up, in a neat stack prone to receive the sauce. If there is residual liquid from the cooked clams in the sheet pan, add it to the reducing sauce.

Add hominy to the reduced liquid and keep boiling, swirling to coat hominy, until liquid turns syrupy. Reduce heat to very low or turn off completely and rely on the ambient heat of your other 10 burners, and swirl in cold paprika butter a tablespoon at a time; sauce will thicken up a little too much, heading toward gluey. Sprinkle in sherry to loosen and bring back to luscious and glossy.

Taste it. If the sherry taste is too raw, let the sauce rest just a minute in the heat to tame the boozy hit.

Spoon hominy sauce over clams evenly, slice parsley just before finishing, and sprinkle liberally over each plate.

Parmesan Dumplings in Capon Broth

x ½
3/4 c.
½ c.
¼ tsp.
2

Yield: 15 orders

1½ cups grated Parmesan

1 cup dried coarse bread crumbs, not panko

½ teaspoon nutmeg, freshly grated on microplane

4 eggs, lightly beaten

8 cups Capon Broth (page 452)

some of the capon meat from making capon broth

x 30 (150 dumpling)

3 c.

2 c.

1 tsp.

8

For Parmesan dumplings:

Combine bread crumbs, Parmesan, and nutmeg.

Make a mound with a well in the center. Pour beaten eggs into well and knead all ingredients together.

Form into ½" balls. This is a messy task and the dough sticks unpleasantly to your hands. If you like how it helps, you can dip your hands repeatedly in ice water and then spray your hands with cooking spray to get through it a little more neatly.

To pick up:

Bring capon broth to hard simmer in small saucepot. ½ cup per order.

Drop in dumplings and simmer gently for just a few minutes, until dumplings swell to almost double their size. Adjust flame as needed. Don't let them split or explode by cranking the heat in haste. 5 dumplings per order.

Taste broth for seasoning.

Retrieve dumplings with slotted spoon and arrange in small shallow bowl. Spoon broth over and bury them ⅔ of the way up.

Leave an inch or two of broth in the pot.

After soup goes to table, drop one nice hunk of torn capon meat into remaining broth, warm through, and send out to table on a tiny side plate with a few grains of grey salt. The delay is so it comes as an unexpected pleasantness for the guest. A cook's treat shared with the guest rather than saved for the cook.

Calf's Brains Fritto Misto

Yield: 4 orders

2 full sets calf's brains

milk

1 dozen cippolini onions, peeled but left whole

Gala apple, cored and cut into ⅛'s

8 Tablespoons unsalted butter

2 Tablespoons salt-packed capers, rinsed

1 cup all-purpose white flour

3 eggs, beaten

2 cups panko bread crumbs, briefly ground finer in the Robot Coupe

Soak the brains in milk overnight in the walk-in. Try to get a 24-hour soak.
Soaking brains in milk helps to draw out the little bit of blood that circulates through all that membrane and to draw in white, inoffensive milk in its place.

Given the challenges already inherent for the customer in the very idea of eating brains, as well as the textural challenge of brains' custardy nature, let's not further burden customers with the third challenge of unsightly dark blood threads. Soak twice in clean, refreshed milk if you have to. The milk really helps with a consistent white complexion.

Discard pink-tinged milk (or discover an interesting and tasty use for it and run it by me) and rinse brains well.
Poach brains in gently simmering, generously salted water for approximately 5 minutes until firm and set.
Remove gently and submerge in ice-water bath to stop cooking.

Drain on a baker's rack.

Keep the full set of the lobes intact through the soaking and poaching steps as possible. Once they have set and been shocked, split them apart at the natural cleavage and discard the creamy, soft white brain stem.

Gently peel the very thin membrane off in one sheet as best as possible. Use the sharp tip of a paring knife to get started, then pull the rest of the way with your fingertips.

Dredge the brains in flour, patting off excess—then dip in beaten egg, then coat with panko bread crumbs, and set on baker's rack to dry.
Commit the apples and onions to this same process.
Deep-fry (350°) the fritto misto ingredients at the same time—they will cook approximately evenly—and all should be ready after 4–5 minutes in the hot fry.
Drain in a stack of coffee filters. Lightly season with salt.

In a stainless steel pan that allows you to track color more reliably than in a black pan, brown a healthy chunk of butter until fragrant, nutty brown, and foamy and pour into a ramekin with the rinsed capers. (This goes quickly—we want beurre noisette, not beurre noir. Take care.)

Arrange fried ingredients on butcher or parchment paper on a plate and serve with brown butter–caper ramekin for dipping and lemon chunks for squeezing.

One lobe per order is as much as any human can consume—these are very rich. Arrange 2 onions and 2 pieces of apple to accompany each lobe.

Sorrel Soup with Salted Lemon Whipped Cream

Ingredients for the soup:

Yields 5 cups/4 orders

10 ounces sorrel, washed, any heavy stems removed

1 large shallot, thinly sliced

8 Tablespoons unsalted butter

1 large russet potato

kosher salt

2 cups chicken stock

½ cup heavy cream

[handwritten annotations:]
× 12
shy 3 qts.
2 #
3
3/4 #
3
salt
6 c. stock
1/2 c. h. cr.

Ingredients for the salted lemon whipped cream:

1 lemon

1½ cups heavy cream

kosher salt

[handwritten annotations:]
2 whole
3 c. h. cr.
salt

For salted lemon whipped cream:

Peel lemon with Y-peeler in long wide bands. Take all there is; there is no logic in leaving stripes and bald patches on the lemon.

Grind the lemon peel in the spice mill with a pinch of salt to get traction and to pull out the oils.

Clean out every last fleck of lemon zest puree from the grinder and add it to heavy cream in a clean quart container and stir well. Taste now to see how powerful the lemon flavor is. Add salt to bring it out further.

Put a lid on the container and shake well, then refrigerate and allow to steep like a cold tea until lemon flavor fully emerges.

Strain and whip as needed, in small batches. Whipped cream doubles in volume so only whip a cup of cream at a time during service to give you what you need per seating. You don't need to waste the cream by over mis-ing in the first place. Whip only to soft peak, when it hits its greatest volume but the peaks can still flop, according to the will of gravity, to whichever direction you tilt the whisk.

To plate:

Arrange potatoes in soup bowls and ladle hot soup over until they are barely submerged. Top with big, fun dollop of soft-peak salted lemon whipped cream and sell quickly—the cream starts to deflate instantly.

To make the soup:

Peel the potato and discard the peel.

Square the potato and cut into perfect ½" dice. Save the trim. Hold the diced potato in cold water so it won't discolor. Melt butter in soup pot over medium-low heat and sweat shallots with the potato trim until soft and turning translucent. Season lightly with salt. When potato trim is soft, add the sorrel to the pot and stir around briefly until the sorrel turns drab and collapses, which is almost instantly.

Add chicken stock and bring to simmer. *Needs no more than 10 mins on the burner once you've added the stock.*

Season with salt to bring it alive.

Add heavy cream in "doses," tasting after each. Tame but don't deaden the tartness. Transfer to blender and drop in one good chunk cold butter and blend to silken texture.

In small pot, boil water and season assertively with salt.

Drop in diced potato and blanch to perfect doneness. Drain and spread out on sheet pan to cool quickly.

Serve hot at dinner, in a bowl. Cold at lunch in a water tumbler. Adjust salt accordingly to account for dulling effect of the cold.

Smokey Eggplant, Parsley-Sesame Flatbread, Grilled Lemons

For smokey eggplant:

Yields: 4–5 orders

(approximately 1 quart)

1½ pounds standard purple-black
 eggplant

2 teaspoons fresh lemon juice

2 garlic cloves, microplaned

1¼ teaspoons kosher salt

5 Tablespoons extra virgin olive oil

1 Tablespoon finely chopped parsley

x 2 qts.

3 #

x 1 lemon
4 cloves
salt +/-
1/2 c. evoo
parsley

x 4 QTS.

6 #

x 2 lemons
8 cloves
salt
1 c. evoo
parsley

For the rest of the dish:

Flatbread (page 487)

lemons

EVOO

Set the eggplants directly on the burners of the stove and turn the flames to high. Allow the eggplants to char on all sides, turning intermittently with kitchen tongs, taking care not to puncture or split them when turning. They will do that on their own when they are cooked. The eggplants will smoke and spark and give off terrific aroma. Char eggplants over open flame for approximately 14 minutes, or until cooked through. When the skin splits and the eggplants start to collapse, place in a large stainless steel bowl and cover tightly with plastic film.

Let sit for 15 minutes to steam in their own blackened jackets, then uncover and let cool enough so you can handle them.

On a cutting board, with a sharp knife, split the eggplants in half from stem to base. Do not discard the bowl in which the eggplants steamed. With a large spoon, scoop out all the flesh and put it in a clean bowl, taking care not to carry along any of the bitter, charred black skin. Discard all the blackened skin.

In the bottom of the bowl in which the charred eggplants steamed there will be a rich and slightly viscous dark brown liquid with many flakes and bits of burnt and blackened eggplant skin swimming in it. Through a fine-mesh strainer, pour all of that delicious smokey liquid over the eggplant flesh, keeping all the blackened bits out.

Gently break down any large pieces of the eggplants by cutting it in the bowl with the sharp edge of the spoon or by taking a knife in each hand and giving the flesh a few scissors-like passes. The eggplant should be a little chunky but manageable.

Gently add in the olive oil, lemon juice, garlic, parsley, and salt, taking care not to overstir, lest you end up with a kind of unattractive muddy and gluey appearance. A fork, gently combed through when adding the final ingredients, is the best tool.

All of the beautiful varieties of eggplant work well, but the skinny Japanese kind are tedious to work with since they don't yield as much flesh—use the larger varieties for efficiency. It tastes best at room temperature, so be sure to remove from the refrigerator in advance to allow it to shake off the dulling chill.

For the lemons:
Boil the lemons for 5 minutes.
Drain and cool, then cut each into thin rounds.
Set a few slices per order on hot side of grill and let them caramelize and collapse a little, on both sides.

To plate:
Good spoonful of eggplant, 2 slices of flatbread, and grilled lemon slices.
Drizzle with EVOO to pool up slightly at the rim.

Stewed Tripe Milanese with Gremolata

6–8 orders

2–3 pounds honeycomb tripe

1 cup white vinegar

kosher salt

2 stalks celery, trimmed and peeled

1 yellow onion, peeled and finely chopped

3 garlic cloves

1 medium ripe tomato, peeled, seeded, diced

2 carrots, peeled and trimmed

3 zucchini, trimmed

3 russet potatoes, peeled

freshly ground black pepper

2 cups white wine

4 cups Beef Stock (page 443)

4 tablespoons cold sweet butter

grated Parm

Gremolata (page 476)

x 24
8 #
2 c.
salt
4
2 lg.
6
3 toms.
3 c. baton
3 c. baton
3 c. baton

3 c. ww
8 c. +/−

To blanch the tripe:

Bring large pot of water to boil. Add salt to season well. Add vinegar.
Add tripe, bring back to boil, and let go for 15–20 minutes. **Try to do this early in the day when there are no patrons in the restaurant because of the offensive smell.**
Drain tripe and rinse under cold water.

To braise the tripe:

Slice the blanched tripe into ¼" x 4" ribbons.
Finely chop celery, onion, and garlic.
Cut carrot, zucchini, and potato into 1-inch batons.
Set medium rondeau on medium heat, add big chunk butter, and sweat the onions, garlic, and celery all the way through to golden stage of caramelization. Take your time and let the sugars develop.

Add the tomato and wine and bring to simmer.
Add the blanched tripe and just enough beef stock to cover the contents of the pot. It wants to be crowded and brothy, not sparse and washed out with too much braising liquid.
Season briefly with salt and pepper, keeping in mind that it will cook and reduce for the next 4 hours, concentrating the seasoning. Cover with tight-fitting lid or parchment *and* lid if warped/buckled.
Let tripe cook over gentlest heat possible over the next several hours, checking doneness along the way. Add half of the potatoes and half of the carrots halfway through the braise, after 90 minutes or so. Add any remaining beef stock.
Add the rest of the carrots and the rest of the potatoes and all of the zucchini for the last 45 minutes of the braise. When all the contents of the pot—tripe and vegetables alike—are tender, sticky, soft, and almost creamy, remove from heat and chill down quickly.

For the pickup:

Reheat portion gently in small saucepot, and when very hot stir in good nut of cold butter, off heat.

To plate:

Use a wide shallow bowl. At the pass, finish with good spoonful of gremolata, shave of Parmesan, drizzle of olive oil.

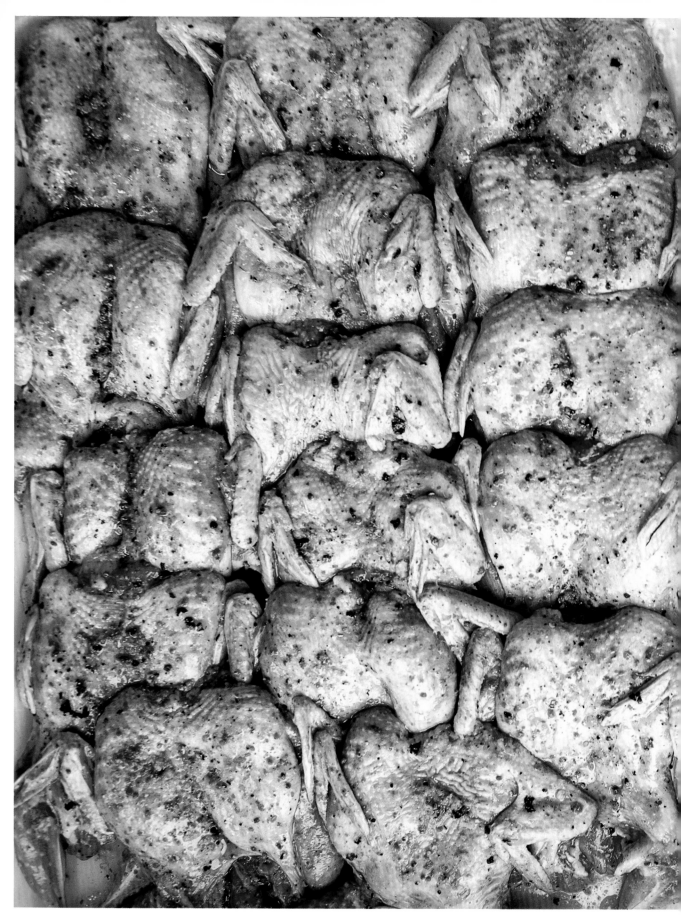

DINNER MAINS

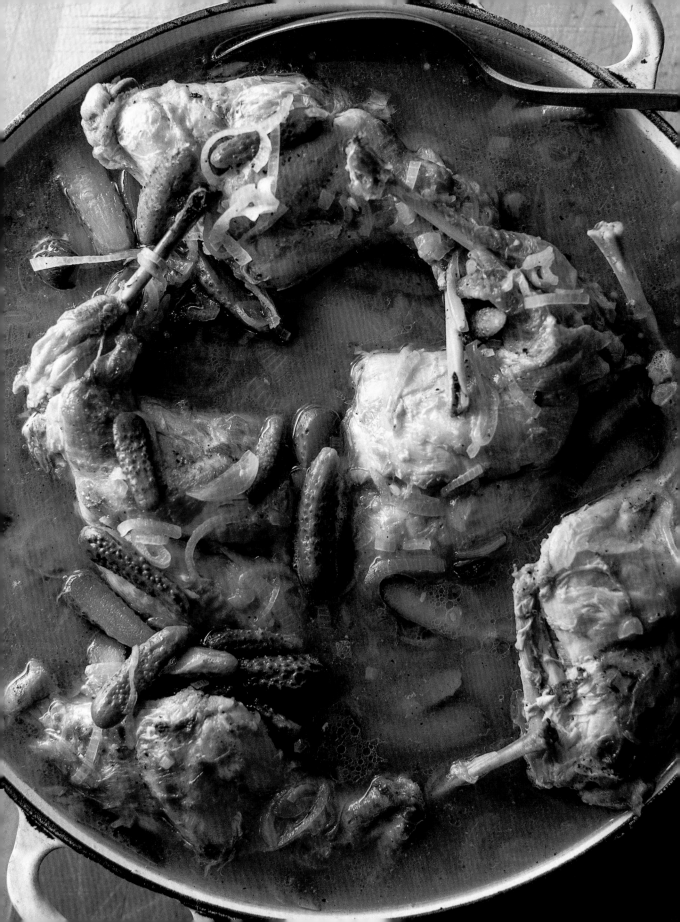

Braised Rabbit Legs in Vinegar Sauce

Yield: 4 orders

8 rabbit legs

4 shallots, thinly sliced

1 pint cornichons, sliced on bias in halves or thirds

1 pint brine from the cornichons

1 cup white wine vinegar

2 quarts Chicken Stock (page 448)

3 Tablespoons blended oil

1 Tablespoon sweet butter + more for serving

chopped flat-leaf parsley

x 16
32
16
4 pts.
4 pts.
4 c.
4 qts.

x 20
40
1 qt.
3/4 qt.
3/4–1 qt.
1 1/2 c.
4–5 qt.

Pat the rabbit legs dry and season with salt and pepper. In a flat-bottomed rondeau large enough to fit the legs in one layer without crowding, heat mixed fats—more oil than butter. Brown the legs, both sides. Keep flame between medium and medium-high but be gentle; there is no skin to protect the flesh.

Remove the browned legs and deglaze the pan and minimal fond with the shallots; sweat for 2–3 minutes. Add a knob of butter if the pan seems dry.
Add the cornichons, the brine, and the white wine vinegar and bring up to a simmer.

Return the legs to the pan and nestle them in a neat and organized fashion.
Add the chicken stock just short of covering; the legs should look like crocodiles at the surface of the swamp.
Cover the pot with a tight-fitting lid; if they are all warped and ill-fitting, then lay in a parchment circle, cover with plastic film and foil for a tight seal.

Set in a 350° oven and braise for 35–45 minutes until they are tender and the small leg joint is flexible.

To plate/finish:

Place legs and vegetables in bowl.
Whisk cold butter into braising liquid until full-bodied and the high acidity tamed but not fully sedated. Shower with freshly chopped parsley on the way to the pass.

Whole Grilled Fish with Toasted Fennel Oil

branzino, 1½ pounds each, scaled and gutted

fennel fronds

lemon slices

Toasted Fennel Oil (page 102)

blended oil

kosher salt and freshly ground black pepper

Rinse fish well under cold running water, and run your fingernail up in the cavity to break the bloody vein that runs along the spine. Rinse well.
Drain fish well after you have rinsed them.
Neatly dress each cavity with a few sprigs of fennel frond and a few very thinly sliced ½ moons of lemon.
Brush both sides with blended oil and season well with salt and pepper from high up to rain down evenly.
Grill on hot section of grill 4 minutes per side, crosshatching at 2-minute intervals.
Do not lift the fish before you have set a good initial mark on it or you will tear the skin.

Set on large oval and spoon fennel seed oil generously over fish, stirring up the seeds from the bottom of the quart. Stick your finger up into the cavity to be sure you have cooked the fish long enough. It should be hot enough in there to make you quickly draw back your finger.

Expediter will finish with lemon cheek and Maldon sea salt.

When you have a ticket rail full of whole fish orders and all are fired at once, do not waste any real estate on your tiny grill or you will slow down the line.
Line them up on the grill just 1" apart, heads toward you and angled to the left, like back slashes on a computer keyboard. After 2 minutes, mimic the action of wind-shield wipers on a car, angling the fish in the opposite direction—forward slash on a computer keyboard—leaving the heads of the fish in virtually the same location they were in when you dropped them on the grill, and by just shifting their bodies and tails to the opposite angle. After 2 minutes, flip in place and repeat on the second side.

Toasted Fennel Oil

x 2c.
1 T.
1 T.
1 c.
1 c.

5 quarts

½ cup fennel seeds

½ cup black peppercorns

8 cups blended oil

8 cups extra virgin olive oil

x ½ batch
¼ c.
¼ c.
4 c.
4 c.

Cover the bottom of the largest cast-iron skillet with fennel seeds and peppercorns.

Over medium heat, shake and swirl the pan and warm the seeds through until fragrant and just barely starting to smoke.

Immediately remove from heat and add 2 cups of the blended oil and 2 cups of the virgin oil, then evenly distribute the seeds and their oil among 5 clean quart containers.

Top off each quart with equal parts blended and virgin oil.

Keep in walk-in for the week.

Braised Lamb Shoulder with Lemons, Tomatoes, and Cinnamon

Yield: 6 orders (+/−)

3 pounds lamb shoulder, bone out

2 cinnamon sticks

¾ cup garlic cloves, lightly crushed

1 cup lemon wedges, quartered or cut into sixths

½ (750 ml) bottle red wine

1 (28-ounce) can Muir Glen whole peeled tomatoes, reserve juice

x 20 H —

2 whole (12 – 14 #)

6 cinn.

3/4 qt.

1 qt.

1½ bottles

#10 can

burnt toast?

Look over the lamb shoulders to see if they need any trimming. What Pino sends us rarely, if ever, needs additional work, but on the outside chance that there is some leathery or dark yellow fat, trim it. Generously season with salt and pepper all over.

Brown the lamb shoulder well on all sides in a hot rondeau with a glug of blended oil. Brown one at a time, giving them room to lie open and flat in the rondeau.

Remove the well-browned lamb shoulder from the pan and pour out the dark fat.

Add the cinnamon sticks and garlic cloves and stir around in the pan, kind of toasting and picking up the fond in a way.

Add the lemons and deglaze, loosening and scraping up the fond with the juice of the lemon wedges as you crush them with your wooden spoon.

Pour in red wine and let it hiss and boil, stirring the bottom of the pan with your wooden spoon to get any last recalcitrant bits.

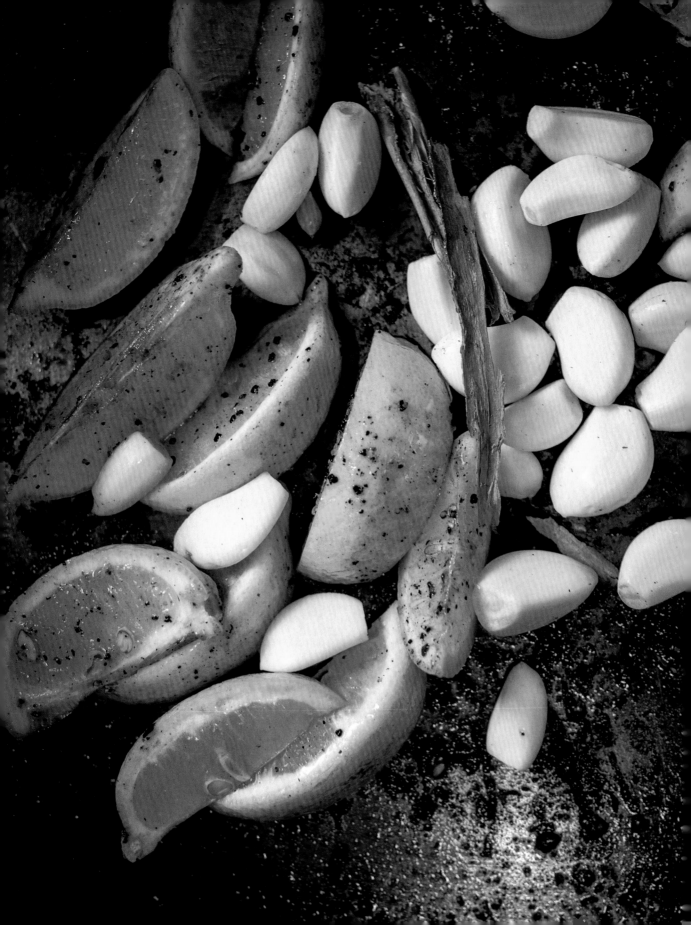

Add the tomatoes, crushing each one briefly in your fist to release juices. Add the juice they were packed in as well. Bring liquid to simmer.

Fold the lamb shoulders back into the shape they had before they were boned out, and nestle both of them into the braising liquid, side by side. Cover with parchment round cut to exceed the circumference of the rondeau so that it really seals in the steam. If you are working with a new pot in good shape, covering with its corresponding lid will do. If you are working with one of the dented, warped ones, seal with film, foil, and a lid for good measure.

Set in middle of 350° oven and braise 3–4 hours until the meat separates easily with just the prodding of a wooden spoon.

This is a heat and serve, but take care. On the pickup, make sure each portion gets a nice soft, cooked lemon, if you can. And take a good look to see that you haven't given anyone an all-fat portion.

** Taste the braising liquid at the end of The braise. Sometimes it can be too astringent from The tomato and lemon, especially if The meat was lean.

If it tastes too bright, heavily char — almost burn — 2 slabs of peasant bread on The grill, and add Them to The lamb. Push The burnt toast down into The liquid to soak it, soften it, and eventually break it down. It will add body to The braise and soften The astringency. Taste again later. **

Grilled Ribeye Steak with Parsley-Shallot Butter

prime, dry-aged (30 days) rib-eye steak

kosher salt and freshly ground black pepper

Parsley-Shallot Butter (page 467)

lemon cheek

parsley sprig

Butcher ribeye to 14–16 ounces each. Don't shingle, saw, or hack. Use the appropriate tools for the different parts of the job. I often see you using a too-big knife for the finer work of trimming, and a too-small knife for the critical part of portioning.

Try to yield 13 orders from a whole #109; if you can get 14, even better. Sometimes the 7th rib is too thin to yield a full order.

Discard only the funkiest of funky trim, the truly inedible leathery and moldy parts, but leave anything very dark and as close to the edge of palatable as possible.

Save bones and viable trim and contribute to family bin or stock bin.

Rain salt and pepper on each side before grilling. Move steak around the grill a lot to get full crusty brown surface—we do not want the impossibly unnatural Outback Steakhouse crosshatched grill mark weirdness.

Take it from grill to plate and let it rest with the expediter, not in your grill station. She will finish it with healthy schmear of ps butter, lemon cheek, and parsley branch.

This is too expensive to fuck up; know your temperatures—and get a more senior fellow cook's second opinion if you are new to the station. I'd rather you ask for help than ruin the meat by overcooking.

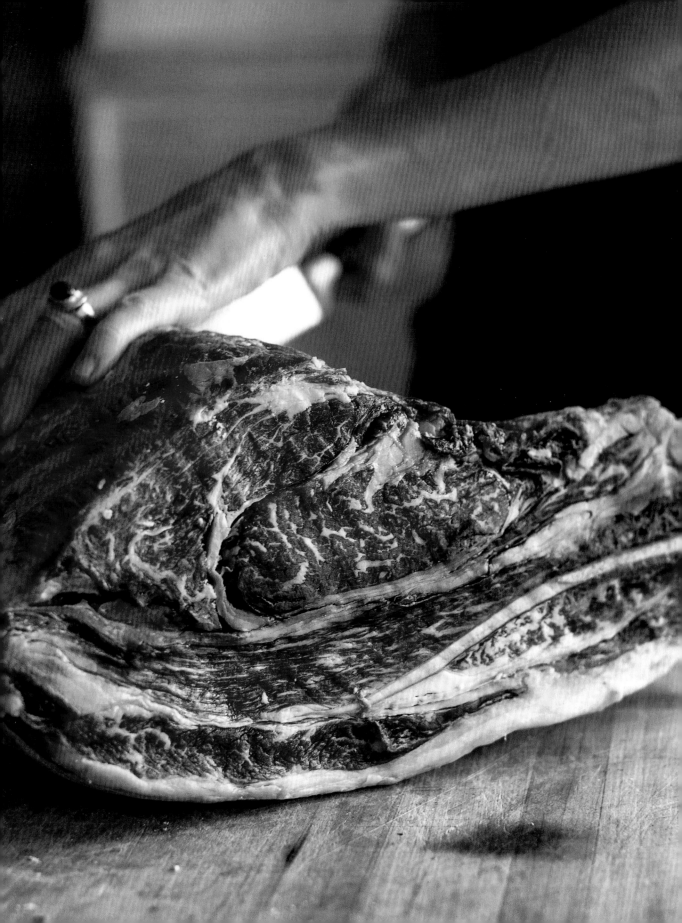

Cod in Saffron Broth with Leeks, Potatoes, and Savoy Cabbage

Yield: 4 orders

2 pounds cod, filleted, skin on, and butchered to 5 ounces

2 Tablespoons Berbere Spice Mixture (page 477)

1 cup Fish Stock (page 457)

1 medium shallot, finely diced

3 small pinches saffron

3–4 Tablespoons cold unsalted butter

clarified butter

2 medium leeks, sliced to ½" disks as far up into green as viable, completely free of sand

generous ½ pound savoy cabbage, cut into attractive wide ribbons

1 dozen Yukon gold baby potatoes, scrubbed, skin on, sliced into ½" disks

1 cinnamon stick

2 thyme branches, long and thin, not the bushy, woody ones

For the vegetables:

Bring 8 quarts of well-salted water to a boil in a large pot. Have a baker's rack set inside a sheet pan ready at your station.

Add potatoes to boiling water and cook until nearly done, keeping in mind they will carry over residual heat while they drain. Gently remove with a spider and lay out on baker's rack to cool.
Repeat with the leeks.
And then the cabbage.

When vegetables are cool, pack separately.

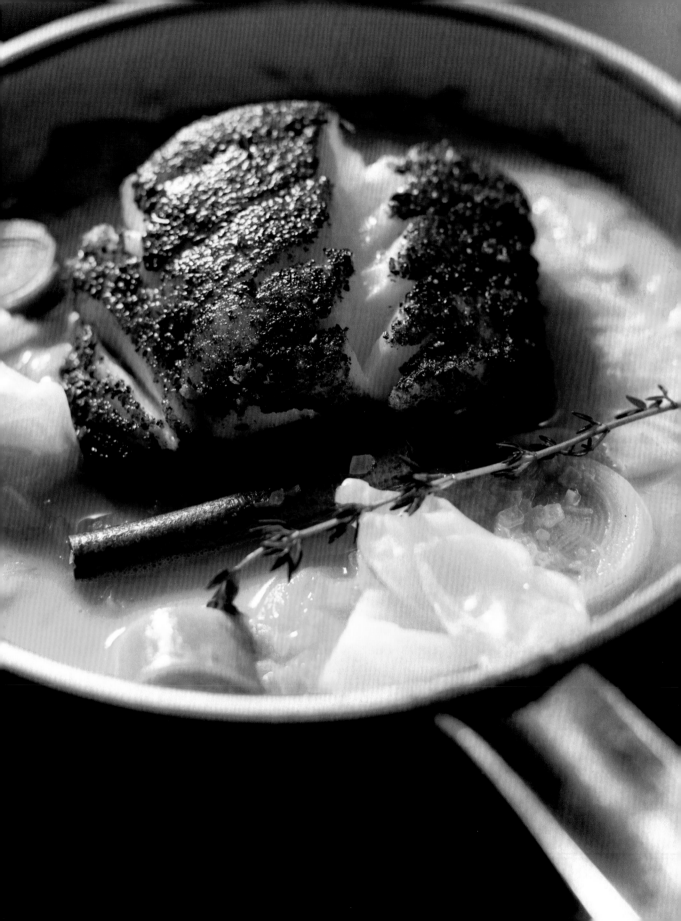

For the pickup:

Bring fish stock, minced shallot, thyme, saffron threads, and cinnamon stick to a simmer in a saucepan over medium heat. Let it slightly reduce and come together while you cook the fish.

Heat moderate ladle of clarified butter in flat-bottomed sauté pan over medium-high heat. Weed out the warped and buckled pans before service or they will kill your game all night long.

Season portioned codfish on both sides with the Berbere spice rub. Take care with your seasoning—it wants to be bold and have a point of view, but not aggressive or unbalanced.

Sear codfish, skin side down, in the hot pan with clari and take it all the way on the stove top, flipping once. Get good, crisp, golden brown skin, with opaque flesh. You want the natural flake line to start to open, but don't take it so far that you lose all that milky enzyme as it weeps into the pan.

To finish broth:

Look at what you have in your saucepot—further reduce or build back up slightly with more fish stock, depending on what you see. You want fragrant, full-bodied, slightly viscous saffron broth that can still receive a few nuts of cold mounted butter, and is still hot and brothy enough to be able to warm through a few ribbons of juicy cabbage, several coins of watery leeks, and a few waxy potato slices without totally thinning out into body-less liquid.

Spoon the finished broth and all the veg into the wide bowl; leave nothing in the pan. Center cod, flesh side up.

Fish out the cinnamon stick and the thyme branch and make sure they are visible in the bowl, like a garnish.

Roast Suckling Pig with Black-Eyed Peas and Pickled Tomatoes

For the pig:

1 small pig, not under 30 pounds and not larger than 40 pounds,
at the very last stage of suckling

only order the little little guys — 20-pounders — for smaller private parties. For regular service, get the 40-pounders.

15 garlic cloves, peeled

kosher salt

blended oil

For the black-eyed peas:

2 pounds black-eyed peas, dried, picked through

1 yellow onion, quartered

3 bay leaves

10 black peppercorns

kosher salt

olive oil to taste

red wine vinegar to taste

½ cup cilantro, cleaned, chopped

1 red onion, peeled, neatly diced

freshly ground black pepper to taste

Pickled Tomatoes (page 463)

For the pig:

Bard generously with garlic cloves, some of the cloves cut in half to be inserted more easily.

Rub pig with blended oil.

Season generously with kosher salt. Sprinkle evenly and liberally—it helps crisp the skin—but take care not to make it prohibitively salty as we collect the juices and drippings that form in the bottom of the roasting pan.

Set pig in largest roasting pan or on sheet pan, front legs straight in front, back legs also facing front, exactly like a deep-seated forward bend in yoga.

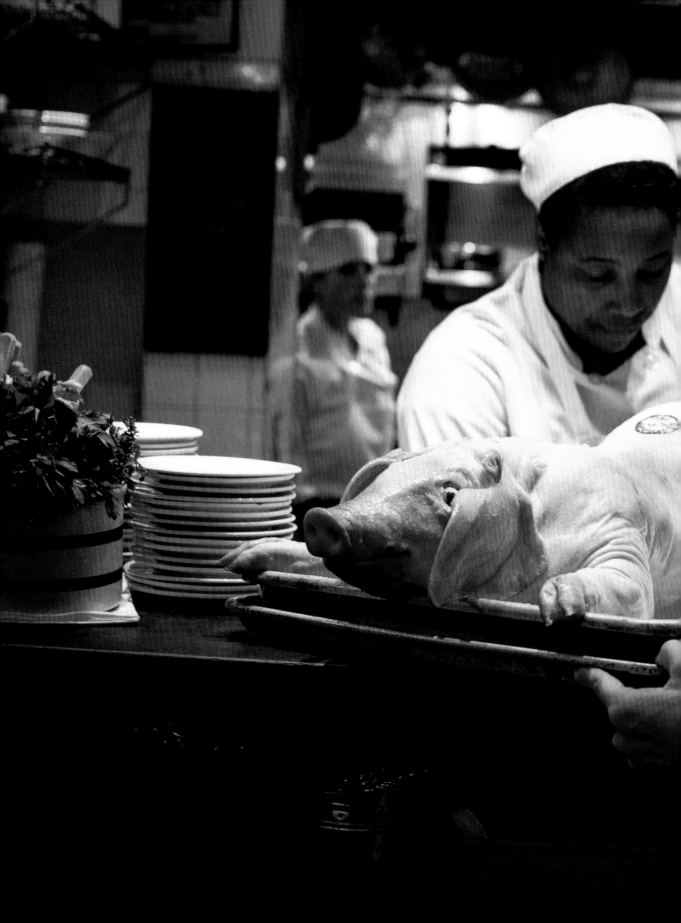

Roast at 350° in a dry oven until you reach internal temp of 160° in the deepest part of the hind leg, about 3½ hours. If ears start to blacken during roasting, tent them with foil.

When skin is crisp and mahogany, and meat in deepest part of haunch is at 165°, legs are loose at the joints—remove from oven and allow to rest 30 minutes–1 hour.

If roasting overnight, set the ovens to 250° and put the pigs in at midnight so that morning crew can retrieve them at 7 a.m.

✱ LEAVE A BIG NOTE ON THE OVEN DOOR FOR THE MORNING CREW ✱

For the black-eyed peas:

Soak peas in double their water in walk-in overnight.

Drain and cook in triple their water, at a constant simmer, until perfectly tender.

Make sure water is seasoned well with salt and a simple cheesecloth sachet of diced yellow onion, black peppercorns, and a couple of bay leaves. I don't like the way they taste bland if you season them at the end, like a lot of people recommend, and I can't discern any "toughness," which supposedly salting at the outset inflicts. But when you go on to work at another restaurant in the future, check how the chef prefers the beans cooked before starting.

Drain when cooked, and while warm, season with oil, vinegar, chopped cilantro, fine diced red onion, and black pepper.

To plate:

Sticky hot suckling pig, pulled with your fingers from the carcass but not shredded. We want slabs and segments, not pulled pork, please.

A spoonful of the pan juices collected from the roasting pans, mixed with a little water if too intense and too salty. Be vigilant not to overdilute in attempt to stretch your mise—I really dislike that trick.

A small raft of crispy skin set on top of the meat.

One large spoonful of room-temperature black-eyed peas, one chef's spoon of pickled tomatoes, and all of their piquant juices.

Pigeon with Parsley Vinaigrette and Seeded Toasts

Yield: 4 orders

8 pigeons, breastcage and backbones
 removed, keep livers if attached
2 Tablespoons + 1 teaspoon
 extra virgin olive oil
generous sprinkle aleppo pepper
generous sprinkle urfa pepper
spare sprinkle chile de árbol
salt
freshly groung black pepper
zest of 1 grapefruit, microplaned

For parsley vinaigrette:
Yield: 4 orders

2 medium shallots, thinly sliced
1 cup Italian parsley leaves
2 cups Pigeon/Quail Stock (page 450)
¼ cup cider vinegar
8 Tablespoons sweet butter, cut in ⅛'s
1 teaspoons aleppo pepper
1 teaspoons urfa pepper
¼ teaspoon chile de árbol
kosher salt to taste

Handwritten marginal notes (on torn paper strip):

x 16
32 birds
½ c. evoo
aleppo
urfa
d'arbol
s+p
zest

x 16
4 small
2 c.
12 c.
½ c.
2 #
4 tsp.
4 tsp.
1 tsp.
salt t/_

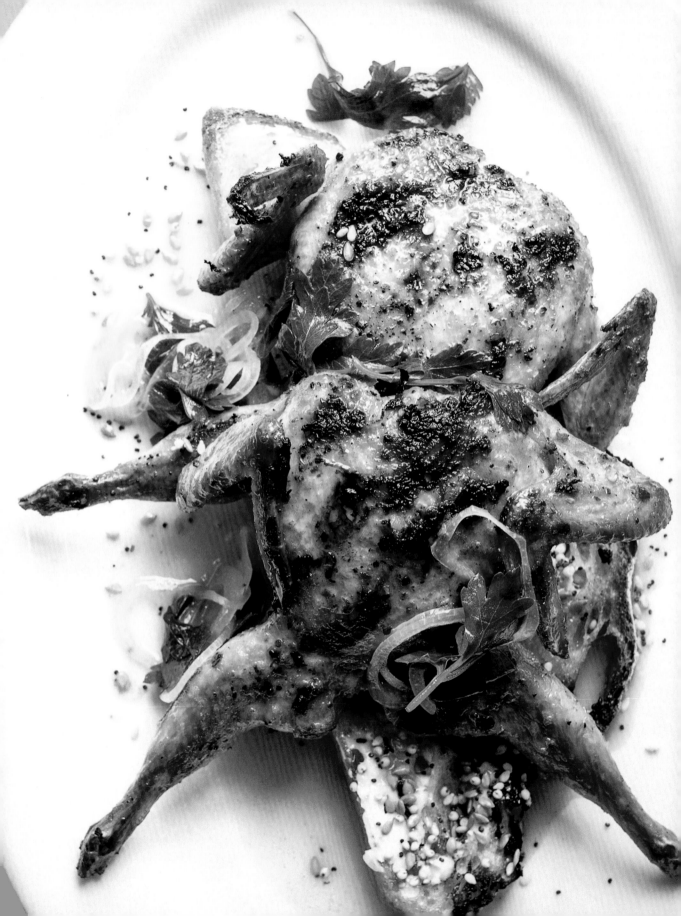

For the toast:

8 long slices peasant bread, sliced thin

2 Tablespoons toasted sesame seeds

2 Tablespoons toasted poppy seeds

2 Tablespoons toasted millet

2 Tablespoons toasted flax seeds

Butcher birds, removing wishbones first, then proceeding with rib cage and back-bones. Leave wings and legs intact. Make stock with collected bones when you have accumulated 15 pounds of bones. *★ SAVE WISHBONES FOR BIRTHDAYS ★* Collect livers when attached, and marinate collectively, in the same container and manner as with the birds.

Season pigeons with the oil, salt, aleppo, urfa, árbol, and grapefruit zest, and allow to rest overnight in refrigerator. Stay a day ahead on your prep so they have time to take the seasonings.

To pick up:

Grill bird, gentler side of grill, starting breast side down.

Turn gently a couple of times during cooking, for a total of 8–12 minutes. Keep breasts between rare and medium rare but pay attention to leg and wing joints.

Remove birds from grill and let rest on the plate while you make dressing and toast.

If there are livers culled from the butchering, drop one set quickly on the hot grill now and give it a quick 90 seconds to medium rare while you finish the toast and the dressing.

Boil pigeon stock in nonreactive saucepot until reduced by almost half.

Add cold butter and continue to boil until melted and stock becomes "creamy."

Put shallots and parsley in small stainless bowl and toss briefly with the aleppo, urfa, and árbol.

Pour hot stock-butter mixture over shallots and parsley and let steep briefly.

Season with cider vinegar and seasonings until perfectly balanced.

Toast peasant bread.

Butter generously.

Coat liberally with all the seeds plus Maldon sea salt flakes.

To plate:

Buttered, seeded toasts.

Grilled pigeon liver, if they were attached.

Grilled pigeon on top of toast and any juice from the resting.

Spoon dressing over and around, include the parsley and shallots.

Panfried Softshell Crabs, Jersey Shore Style

softshell crabs—primes or hotels

Wondra flour

chopped garlic

unsalted butter

blended oil

chopped flat-leaf parsley

dry white wine

lemons

kosher salt and freshly ground black pepper

Heat large sauté pan over medium-high heat.
Add mixed fats—butter and blended oil—generously.
Snip off eyes and gills of live crabs—2 per order.
Dredge in Wondra and when fats in pan are hot and foamy, slip in both crabs, shell side down.

Protect yourself. This is not the time to be wearing a short-sleeved disher's shirt—make sure you are in a proper chef jacket with the sleeves unfurled to your wrists. Get the clear safety glasses from the toolbox downstairs. Be very careful with your eyes. The liquid boils inside the crabs and inevitably explodes, driving streaking hot fat right at you. Please don't be macho—I think a cook with too many burns looks like an amateur and does not reflect well on our skills. Take care of yourself.

When crabs are crispy and golden on the shell side, use a fish spatula and flip over onto the belly side. About 2 full minutes per side. Baste with a spoon, over and over.

Remove crabs to the plate. Again, use a slotted fish spatula and not tongs—we don't want to squeeze or mangle the delicious juices out of the crabs.

Pour out the cooking fat and return sauté pan to the flame.

Add cold butter, chopped garlic, salt, and pepper and quickly swirl around to melt the butter and release the aroma of the garlic. Don't get color on the garlic.

Hit the pan with white wine until the hissing stops. Swirl and swirl and scrape up the fond from the bottom of the pan. Use a spoon; if I see you doing this with tongs like some hack, you are fired. Look at what you have in the pan—if it's too loose and bright from the wine, let it reduce a minute until it has body. If it's already got body, pull it off the heat and finish with a couple more knobs of cold butter, a squeeze of lemon juice, and a good hit of freshly chopped parsley.

Taste your sauce. We want summer at the Jersey shore—that ubiquitous scampi sauce they pour over all the seafood indiscriminately at those bad but great boardwalk restaurants.

Spoon over softies.

Lemon cheek and parsley branch garnish.

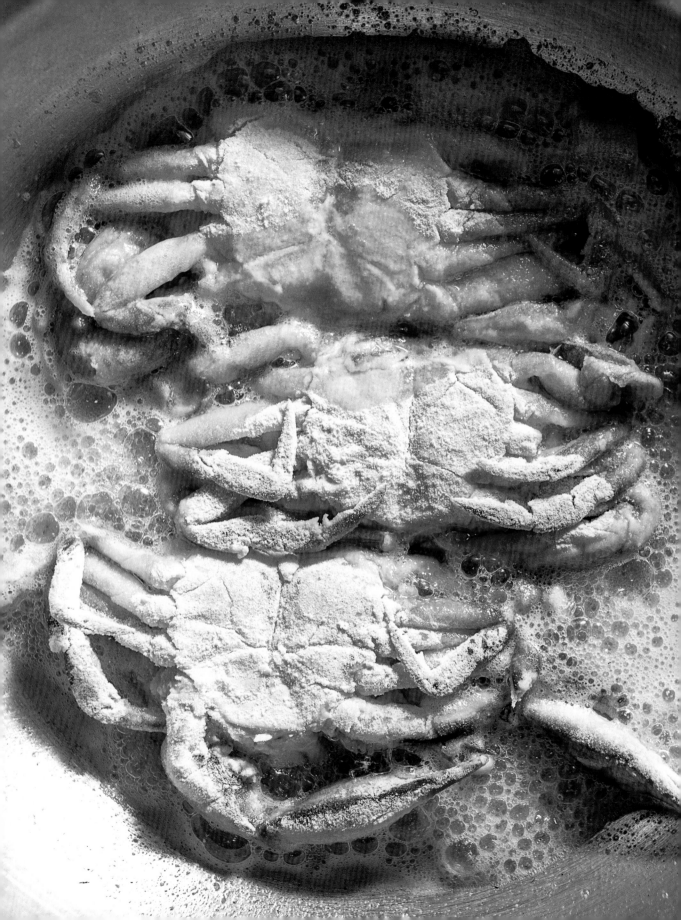

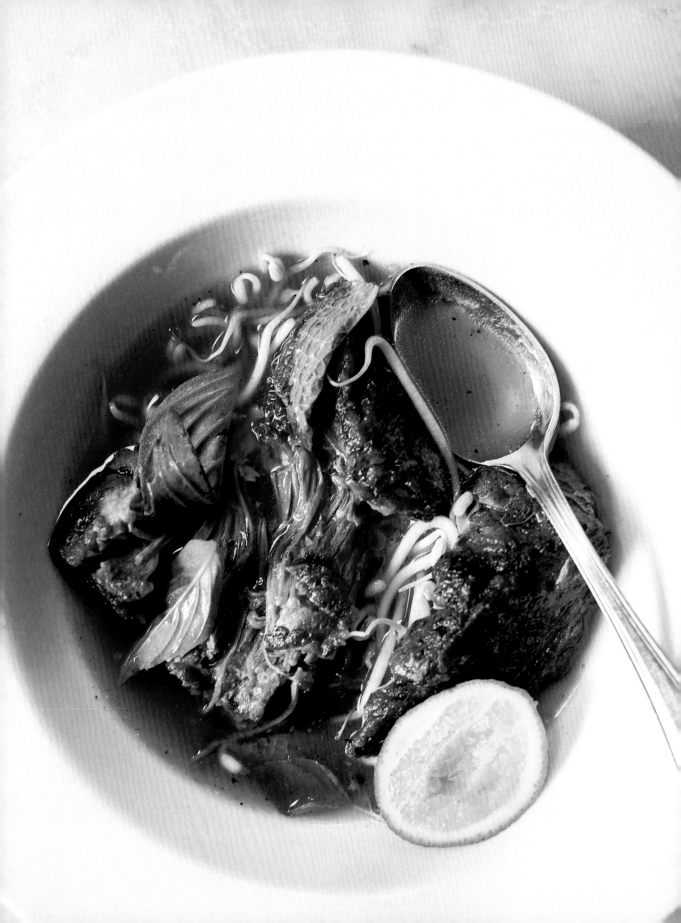

Beef Short Ribs Braised in Pho Broth with Condiments

Yield: 4 orders

Pho-Style Oxtail Broth (page 446)

8 beef short ribs, cut at 4 inches

kosher salt

white pepper

braising liquid from ribs

Thai basil

mung bean sprouts

mint branches

limes

For the beef short ribs:

Season ribs with salt and white pepper.

Brown on all sides, evenly and well, in rondeau on stovetop.

Remove ribs, pour off fat.

Deglaze rondeau with defatted pho broth, return ribs to rondeau in neat and organized fashion, and add pho broth just to barely submerge. Crocodiles in a swamp.

Cover with parchment round, foil, and lid.

Braise in 350° oven for 2–3 hours. Check at 2 hours.

We want luscious and tender—return to oven or remove from oven, accordingly.

When you can, lift ribs out of broth and let cool on a baker's drying rack.

Discard any bones that have fallen off completely, but leave the heavy flap of connective tissue attached to the short rib.

Strain the braising liquid.

Pack ribs away overnight in the walk-in and tidy them up the following day when they are rigid from cold so they won't shred and fall apart when you cut away the connective tissue and remove any bones that have remained intact.

Yield meaty, full, tidy squares of short rib that you can handle elegantly later in the pickup.

Contribute shreds and lean, inferior ribs to family meal.

To pick up:

Reheat ribs simply and gently in their braising liquid on stovetop, in covered pot.

Reduce broth just enough to give it curves—we want it to remain brothy and full-bodied—not sticky.

Serve in large wide bowl.

Add cold, fresh Thai basil branch; crisp, clean, watery mung bean sprouts; mint branch; and freshly cut lime cheek at the pass.

*Take care with The quality of The sprouts. Keep The water crystal clear and cold and fresh. Do not stick your dirty line cook fingers in There to retrieve Them. Use a fork.
AND WASH YOUR HANDS, PEOPLE!

Live Crayfish Boil with Potatoes, Corn, Sausage, and Onions

Yield: 8 orders

1 quart Homemade Old Bay (page 476)

5 quarts water

4 pounds live crayfish

1½ pounds small potatoes, blanched

1½ pounds sweet Italian sausage, parcooked

3 large red onions, cut in wedges

3–4 ears yellow corn, husked

1 cup Smoked Paprika Butter, softened (page 478)

1 cup sweet butter, softened

[handwritten note:]
×16

8# ruby
3# pots.
3# ital.
6 onion
5-6 ears
—
—

Boil water with Homemade Old Bay at least 30 minutes before service. Like a savory, powerful tea.

Drop potatoes and corn in first. Let simmer 4 minutes.

Add sausage and onions. 1 minute at full simmer.

Then add crayfish until just cooked through—bright red tails, springy when you squeeze them. 2–3 minutes.

Use a slotted spoon to retrieve and pile attractively but casually into bowl—arrange crayfish, sausage, and onions evenly. Make sure vivid yellow corn is near top.

Slather whole mess with both smoked paprika butter and plain sweet butter, in a kind of luscious marbled effect, and drench the goods with a ladleful of the cooking broth to finish.

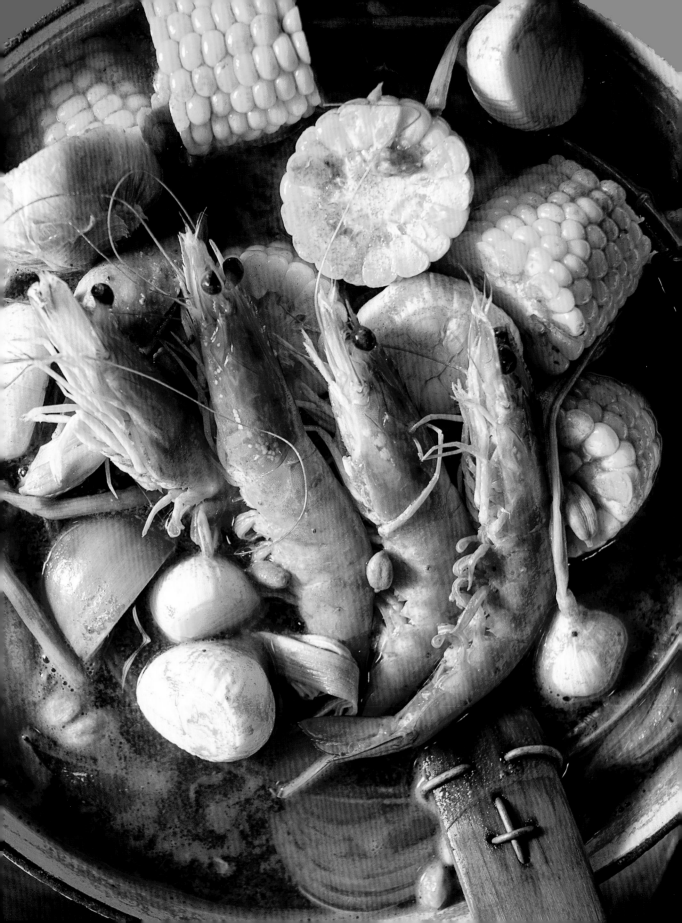

* Don't pick out The seasoning bits from The boil mixture That end up in The bowl — just leave whatever stray garlic clove or cardamom pod as is. It's part of The deal.

* Taste The boil liquid Throughout The night. After too many orders, it gets too salty and powerfully condensed. Start fresh with new batch but be sure to let it simmer 30 minutes before using.

 ** Run with ruby shrimp from Cape Cod when live crayfish are unavailable but change price on menu accordingly **

Boiled Beef Dinner

Yield: 4 orders

2 pounds oxtail, browned, braised,
 meat picked—bones/cartilage discarded

8 cups Oxtail Broth (page 444)

1½ pounds trimmed beef tenderloin, cut into
 4 equal portions at 6 ounces each

4 small sheets caul fat

4 ounces veal heart, thinly sliced

4 ounces cooked veal tongue, in
 ¼-inch slices across the tongue

4 veal marrow bones, cut in 1" pieces

8 carrots, neatly peeled

12 pearl onions, blanched and peeled

8 baby turnips, neatly peeled

4 leeks, split lengthwise and triple soaked
 in clean water to remove any lingering sand

1 cup fresh or frozen peas (asparagus tips,
 peeled fava beans, or fiddlehead ferns)

4 small stems fresh thyme, leaves stripped,
 stems discarded

fresh horseradish root

kosher salt and freshly ground black pepper

grey sea salt

Handwritten note on attached paper strip:

x16
8#

8 qts.
6#

caul fat
1# ♡
1# tongue

16 bones
32 carrot
48 onion
32 turnip
2 qts. coin

1 qt. peas
+/−
thyme

Bring oxtail broth to a simmer in a 4-quart pot.

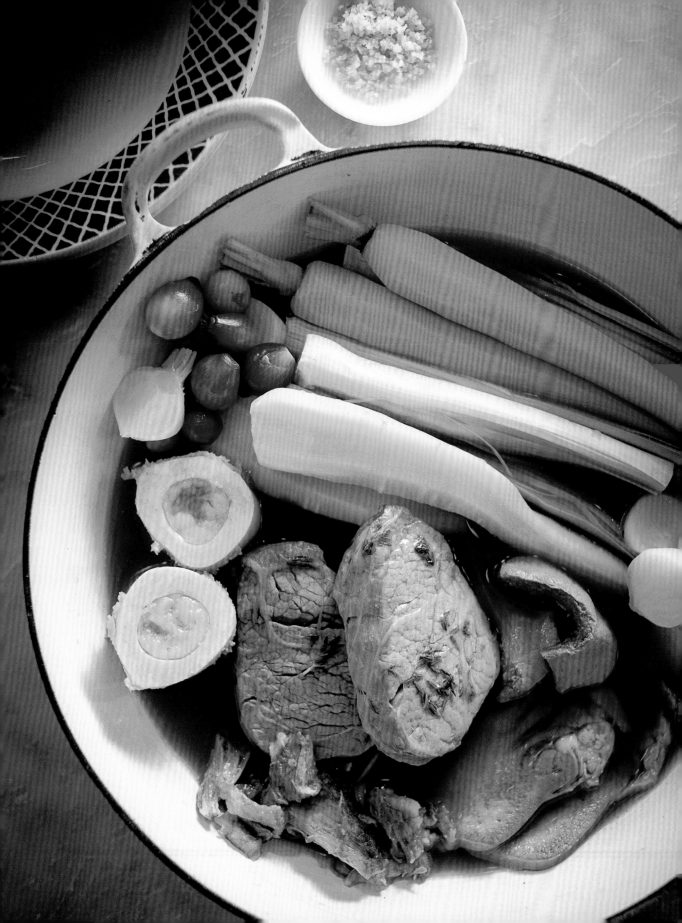

Season beef tenderloin on both sides with salt and pepper and a few leaves of fresh thyme and wrap each in a small sheet of the caul fat, creating neat bundles.
Add beef tenderloin and marrow bones to simmering broth and let cook 2 minutes.
Add onions, carrots, and turnips to simmering broth.
Add the oxtail meat to the simmering broth.
Add leeks to the simmering broth and continue cooking for 4 minutes.
Add peas, sliced tongue, and veal heart and cook for 1 minute.

The beef tenderloin takes about 15 minutes to cook from its raw state to a perfect medium rare. The rest of the ingredients have different cooking times; add them in stages from longest cooking to shortest cooking, ending with the peas, so that when the tenderloin is finished, so is everything else, and the finished dish is ready to be served with all of the ingredients accurately cooked.

Place the meats and vegetables with care and grace in the large bowls and ladle the broth around evenly. Reserve the rest of the broth for the next batch.
Season with a few grains of grey sea salt.
Grate a light dusting of fresh horseradish over each bowl.

* Depending on where we are in the frustrating season, use: fiddleheads
asparagus tips
fava beans
if they are coming in.
During those weeks when the first crops have tapped out, and the second are not yet available, you can happily revert to the frozen peas. I love them and am not embarrassed (sp?) to use them.

Grilled Lamb Blade Chops

Yield: 6 orders

6 lamb blade chops, 1½ inches thick

2 cups kosher salt

6 branches rosemary

¼ cup black peppercorns

1 gallon water

extra virgin olive oil (Kalamata olive varietal)

dried Greek oregano

Dissolve salt in ½ gallon warm water.
Add ½ gallon very cold water.
Add fresh rosemary, roughed up briefly in your hands to release the oils a bit.
Just crush or bruise the black peppercorns under a cast-iron skillet, then add to brine.
Submerge the lamb chops in brine and refrigerate 24 hours.

Remove lamb from brine.

Rinse and dry.
Let chops rest at room temperature, 20 minutes.

Run with skordalia and Piyaz in cold months.
" with braised dandies in spring.
" with Greek Salad ONLY IN SUMMER.

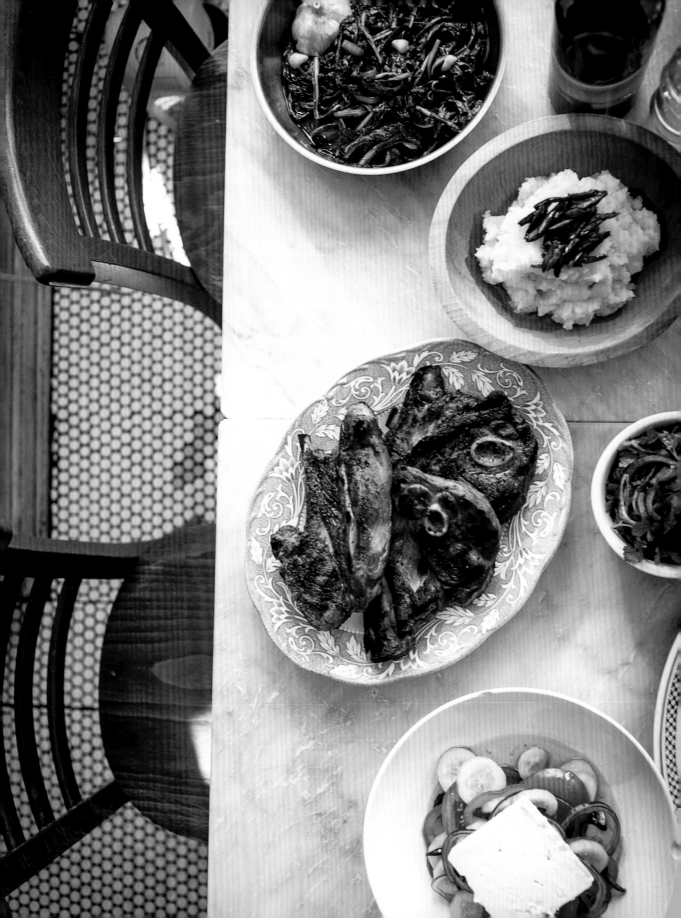

To pick up:

Rub chops with olive oil sparingly.

Season with salt and pepper and dried Greek oregano.

Grill blade chops until solidly medium rare. (Because of all of the muscles that come together across the shoulder, these chops are too tough and chewy any rarer.)

Plate the chop when cooked, let it rest on serving plate for juices to collect. Don't hold these on a sizzle in your station—I like the rested juices to make their way to the customer, like they would at home.

when you rest your meats on a sizzle plate in The midst of all that greasy soot coming off The grill, the juices mostly evaporate and get crusty on The sizzle plate and I am really repulsed by That. Please get The meat from The heat to The plate without any intermediary shuffling around in your station.

Even though you are a line cook in a busy restaurant, try to cook like you would at home.

Nobody rests their meat at home over a hot, burning, dirty grill and we shouldn't either.

PLEASE DO NOT:
 pre-mark
 misfire
 poorly time
 weight down/press down
 flash under the sally
ANY OF THE MEAT HERE.

Skordalia

2 russet potatoes

3 garlic cloves

¼ cup Kalamata olive oil

¼ cup Kalamata olives, pitted, slivered

kosher salt

x 16
8
12
evoo +/-
Kalamatas
salt

Peel and boil potatoes in seasoned water.

When a knife easily pierces the potato all the way to the center, remove and leave to cool. Don't throw away the cooking water.

Grate the cooled potatoes by hand into a bowl, using large teardrop side of the box grater.

Microplane garlic into the potatoes and add olive oil and a little of the cooking water. Mix thoroughly. Check for garlic and salt, adding more if necessary. Garnish with olive slivers.

These are not mashed potatoes. They are more like a condiment and should taste strongly of raw garlic. The word for garlic in Greek is *skordo*. The Greeks soften their *d*'s into gentle *th*'s so at the table, waiters should say "score-thal-ya." Also, the skordalia should glisten and be nearly translucent due to its olive oil content. Keep mixing and adding olive oil—and a few spoonfuls of cooking water, if needed—until the skordalia reaches this point.

Greek Salad

3 pounds ripe red tomatoes, not refrigerated

1 cucumber with small seeds

1 medium red onion

homemade red wine vinegar, even if still
 rough and winey

1 firm green bell pepper, seeds removed

12 ounces Greek or Bulgarian feta cheese
 in fresh salted water

small handful Kalamata black olives, split,
 pits removed

Cut tomatoes into even, good-looking chunks, without removing the slightly tart cores.

Season tomatoes with kosher salt. Set aside.

Peel the cucumber and slice into thin rounds, then lightly sprinkle with homemade red wine vinegar.

Peel and very thinly slice red onion into rounds.

Remove core and seeds from bell pepper and slice into thin rings.

Combine onions and peppers with tomatoes and add the cucumbers.

Retain all of the juices that have accumulated—this is the "dressing." Meat juices from the lamb chops will commingle also and tame the vinegar bite.

Cut the feta into slabs and set 1 on top of salad. Drizzle with Kalamata olive oil and a few split olives and a light sprinkle of dried oregano.

Braised Dandelion Greens with Mastixa and Feta

Yield: 4 orders

2 pounds dandelion greens, well-washed, trimmed at stem end

2 whole heads of garlic, as is, paper skin intact, halved horizontally

extra virgin olive oil

salt

1–2 mastic crystals

6 ounces feta cheese

Set large wide pan over medium heat and add a full ¼" of EVOO.

Place garlic halves in, cut side down, and leave them undisturbed. Sizzle until golden.

Add dandelion greens and all of their clinging water from the washing.

Add cold water to just barely cover and drizzle a little more EVOO over the surface.

Season with salt and taste the liquid before proceeding.

Cover with parchment round and lid and simmer on medium-low heat until the toughest end of the stem is tender, 25–35 minutes.

Taste the dandies. If they are incredibly bitter, add more fat and let them steep in it, while still quite warm.

Grind mastic crystals in clean spice grinder with a few grains of salt for traction, and season dandelions with 1–2 teaspoons of ground, powdered mastic. Sprinkle it evenly throughout to try to mitigate the inevitable way it re-forms into crystals.

Hold warm, in batches, in your station.

To pick up:

In small sauté pan, add heap of braised dandelion and some of the braising liquid.

Nestle in several chunks of feta, broken apart with your hands.

Cover and warm through; let feta barely soften.

Tip pan and slide into shallow bowl just as is, without overturning.

Turkish Piyaz

1⅓ cups loosely packed flat-leaf parsley

1 small red onion, *paper*-thin slices

¼ cup extra virgin olive oil

2 teaspoons sumac powder

½ teaspoon kosher salt

Tear parsley leaves, mix with red onions, and break up all the rings.

Season with salt and sumac first and allow to draw the moisture from the onions and wilt the parsley.

Add olive oil and stir together. Mound on top of hot lamb chops as soon you take them from the grill and plate.

Whole Roasted Rabbit with Pan Drippings Salsa Verde

1 (2½–3 pound) whole rabbit
½ cup Salsa Verde (page 480)
EVOO
Dijon mustard
dry vermouth
1 sparse rosemary stem
kosher salt and freshly ground black pepper
butter

Tug out the little fatty sac of kidneys from the chest cavity; reserve.

Splay the rabbit out on a ½ sheet pan, legs out front and back. Crack the little front chest plate to get her to lie flat. Just a firm quick push with your hand, like a chiropractor.

Slather with a little Dijon mustard, then drizzle with EVOO and season liberally with salt and pepper.

Set on top rack in the hot oven—400°. Leave it alone for 25 minutes.

Season kidneys with salt and pepper and sauté in mixed fats over medium-high heat, 2–3 minutes; baste along the way. Get some color on them—don't let them steam to drab gray, and keep them medium rare. Spoon onto small side plate.

Pour off fat, drop heat to medium, and make quick pan sauce with rosemary stem, 1 dab mustard, and 1 hit of dry vermouth. Get all the browned bits up with a wooden spoon, stir in 1 knob of cold butter, and pour over kidneys.

Send kidneys to the table for them to snack on while they are waiting for the rabbit.

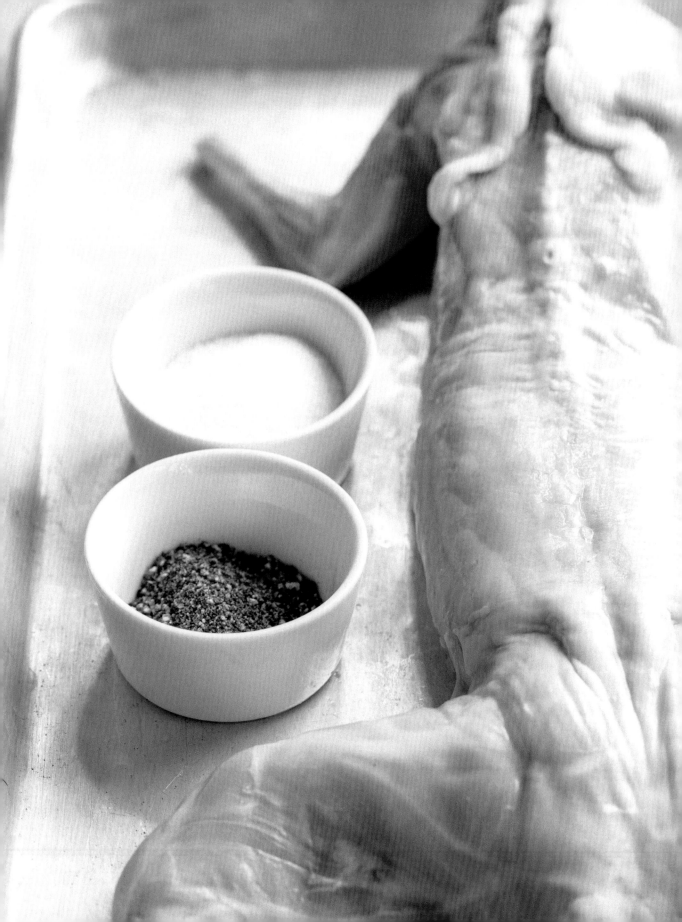

Pull out rabbit and check color and mobility in the back legs: No pink. Getting limber.

Slather with a good spoonful of salsa verde and return to hot oven for 10 more minutes. She wants to be moist, opaque, a little golden in spots, and you could almost pull her apart at the joints without using a knife, though with resistance.

Lay out whole rabbit on presenting wooden board. Scrape pan drippings into large ramekin with fresh spoonful of salsa verde and mix together. Set on board.

After waiter presents and returns, break down into 2 shoulders, 3 saddle cuts straight across, and back legs split at the joints. Put back on serving board, neatly but casually—like when they hack up the whole ducks in Chinatown.

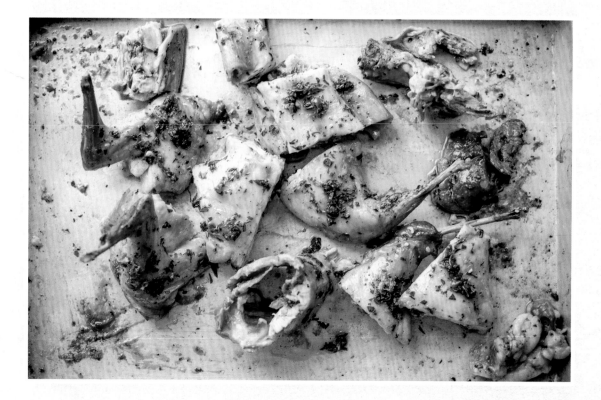

Stewed Pork Butt with Creamed Hominy and Salsa Verde

Yield: 4 orders

2 pounds pork butt

½ bunch cilantro, washed

2 garlic cloves, peeled

½ bunch scallions, cleaned

6 Tablespoons Chili Paste (page 475)

5 cups Mixed Meats Stock (page 454)

4 cups Creamed Hominy (page 142)

6 Tablespoons Salsa Verde (page 480)

× 16

10#
1 bn.
10 cloves

2 bns.
2 c. paste
12 c. stock
—
—

Pulse cilantro, garlic, and scallion in Robot Coupe until fine and even textured, but not a completely smooth paste.

Remove any hard rind or skin that might be attached to the meat, but keep the loose fatty connective tissue and white streaks. Cube pork into 2-ounce pieces.

Season meat generously with salt and pepper and brown on all sides in a bit of blended oil. Use a wide flat vessel for browning—there is a lot of meat to be browned—then you can deglaze and braise right in the same vessel. Brown in batches. Remove browned meat to a container to collect all the juice that bleeds out while you are browning each batch.

When all meat is browned, turn it back into the pot with the collected juice.

Add cilantro paste and stir into the meat, scraping bottom of the pan for brown bits. Allow cilantro paste to get warm and fragrant. Then add chili paste and stir in, allowing it, too, to become warm and fragrant before you continue.

Add the meat stock to just barely cover the meat. Bring up to a gentle boil and then reduce immediately to simmer. Cover and let simmer for 60–90 minutes, until meat is tender but still has integrity. Keep in mind it needs to hold up in the reheat during service.

Chill overnight and defat the following day when the thick layer of orange fat has congealed and is easier to remove.

To plate:

Big spoonful hominy—don't allow to become greasy, separated, or otherwise gross by reheating too hot, too fast. Gentle and finessed reheat, please.

Good spoonful hot stewed pork spooned over, let juices run and pool up.

At the pass, finish with liberal drizzle salsa verde, spooned over meat.

Creamed Hominy

x ¹/₂
BATCH

1¹/₂ qrs.
1 c.
2 c. h. cr.
4 T.
salt +/-

Yield: 6 quarts

1 10 can cooked small kernel white hominy, drained and rinsed in colander

2 cups diced poblano peppers, seeds removed

1 quart heavy cream

½ pound sweet butter

kosher salt

Sweat poblanos in half the butter in small rondeau over low heat.
Add drained, rinsed hominy.
Add cream and remaining butter. Stir well and simmer for 30 minutes uncovered over low flame.
Grind ⅔ of creamed hominy in processor briefly, add back to remaining whole kernel batch, stir well to integrate.
Season with salt if needed.

Roasted Wild Salmon with Avgolemono Rice, Two Kinds of Peas, and Scallions

Yield: 4 orders

4 fillets wild salmon, skin on, cut at 5 ounces

1 cup kosher salt

½ gallon hot water

½ gallon cold water

1¼ cups jasmine rice

2 cups Avgolemono (page 146)

1 bunch scallions

½ cup shelled fresh or frozen peas

½ pound sugar snap peas

extra virgin olive oil

kosher salt

freshly ground black pepper

(handwritten note, right margin)
x 16
10–12# whole
2 c. salt
1 gal. hot
1 gal. cold

rice
argo
full pint
full pint
full pint
evoo
s+p

Rinse the jasmine rice and cook pasta-style in plenty of lightly salted boiling water. Ratio of water to rice doesn't matter when you are cooking it this way, as long as there is plenty of boiling water.

Drain into a colander when exactly cooked, and immediately spread cooked rice out on a sheet pan lined with parchment to cool quickly. Do not pat down or pack the rice—you want it fluffy and able to cool and dry quickly.

(handwritten note)
* Day-old rice is good here — you can carry your mise to following day if you have extra.

Dissolve the salt in the hot water, then add the cold water and mix well.
Submerge the salmon in the brine for 30 minutes and not longer than 1 hour. Remove salmon and pat dry.

Destring the sugar snaps and cut on the bias into ⅓'s or ¼'s.
Clean and trim the scallions and cut on sharp bias, using all of the white and as far up into the green as is viable. For me, viable is pretty much the whole scallion except for the hollow, fibrous ½" at the top.

To pick up:
Brush the salmon with olive oil, on flesh and skin alike. Season fish with salt and pepper. Set salmon, skin side down, on sizzle plate and put in gentle oven.

Remove when fish is pale pink and opaque at the edges with a ½" swath of translucent orange flesh down the center. 10-15 minutes, but check along the way.

In a small saucepot add full 4-ounce ladle of avgolemono sauce, set on medium-high heat.

Add handful each of scallions and shelled peas; simmer a minute or two until raw bite is gone but both are still bright green.

Stir in ⅓ to ½ cup cooked rice and warm through.

Add handful of sugar snap peas; stir in and simmer just a minute or 90 seconds until they are bright green and their sugars have opened up.

Add another spoonful of avgolemono if needed—we want creamy, luscious, loose Venetian-style rice and peas—not sticky risotto, and not cafeteria soup, either.

Season with salt and pepper.

To plate:
Spoon rice and peas into pasta bowl.

With fish spat, slide salmon off of its skin, and place in center of pooled rice. Skin will stick to sizzle. Drizzle any of the delicious fatty salmon juice off the sizzle plate over the salmon.

Obviously, take care with the temperatures. Keep this beautiful salmon, which only comes once a year, between rare and medium-rare.

* Keep one of the ovens gentle during service for the salmon — no more than 350°.

WHEN YOU BUTCHER THE FISH, PLEASE:
 don't shingle.
 leave skin on; tweeze pin bones out.
 reserve skeletons and heads for family meal.
 donate last 4" of flat, tail-end portions to family.

For the Avgolemono:

Yield: 2 cups

4 egg yolks

2 cups stock

½ cup fresh lemon juice

¾ teaspoon salt

freshly ground black pepper

x 1½ QT.

8 yolks

4 c.

1 c.

s+p +/-

* LUNCH *

PAR

x 2½ QTS.

16

8c.

2c.

s+p

DINNER

PAR

Bring stock to a simmer.

Whisk egg yolks with lemon juice in stainless steel bowl.

Temper with a ladle or two of simmering stock, whisking constantly. Then whisk egg-lemon mixture back into simmering stock.

Whisk constantly until full-bodied.

Remove from heat immediately; season with salt and pepper.

Farmhouse Chicken Braised in Hard Cider

Yield: 4 orders

4 large whole chicken legs

unsalted butter

extra virgin olive oil

¾ cup slivered garlic

1 cup thinly sliced shallots

½ cup cider vinegar

1 cup hard cider

1 Tablespoon honey

1 Tablespoon tomato paste

1 cup Chicken Stock (page 448)

kosher salt and freshly ground black pepper

	×8 10#	×16 20#
slivered garlic	1½ c.	3 c.
shallots	2 c.	1 qt.
cider vinegar	1 c.	2 c.
hard cider	2 c.	4 c.
honey	2 T.	4 T.
tomato paste	2 T.	4 T.
Chicken Stock	2 c.	1 c.

Season chicken legs all over with more pepper than salt.

Brown chicken legs in mixed fats, more butter than oil.

Brown perfectly, on both sides; don't crowd and don't crank it, either. Keep heat at medium-high and do a careful job.

Remove chicken, pour off fat.

Add a good hunk of butter, the garlic, and shallots to the same pan, reduce heat, and sweat.

Add tomato paste and stir to fully blend, melt, even toast a little.

Deglaze with cider vinegar and hard cider.

Add the honey.

Simmer to cook off alcohol and reduce slightly, by no more than ⅓. Stir in chicken stock.

Neatly nestle the chicken legs in the pan and be sure to taste the braising liquid for salt, acidity, sweetness. Adjust now or never.

Cover with parchment and tight-fitting lid, if you can find one that isn't too warped.

Check after 25 minutes. You want loose joints but not falling off the bone.

At pickup, reduce sauce per portion, to have body, but not to become viscous.

One leg per portion. Good bit of sauce. Shower with parsley, freshly chopped, at pass.

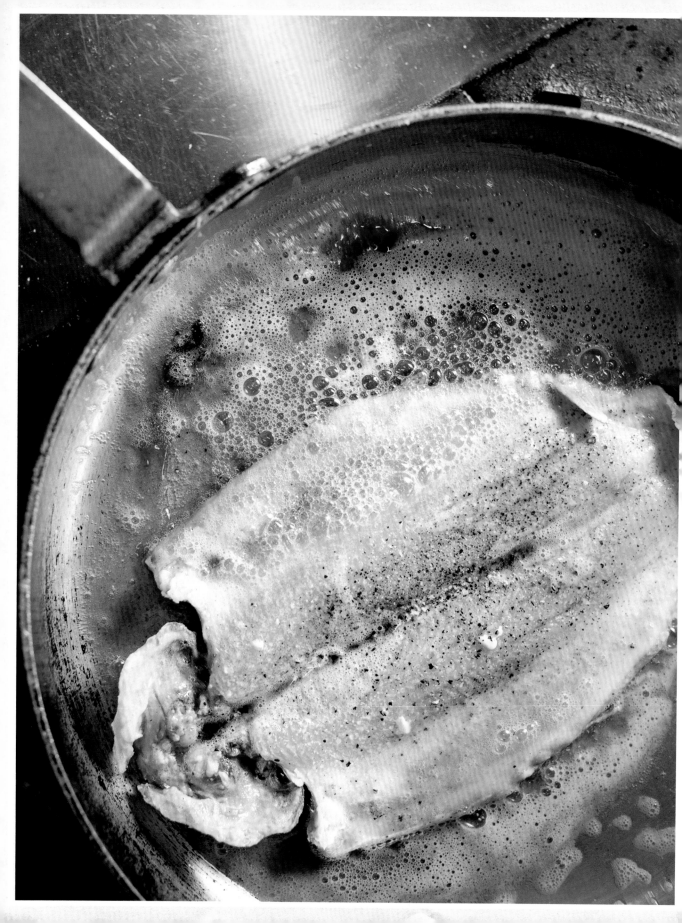

Panfried Trout with Brown Butter Vinaigrette

butterflied trout, 10–12 ounces each

Wondra flour

unsalted butter

blended oil

Brown Butter Vinaigrette (page 459)

kosher salt

Rinse trout; keep head and tail intact.

Pat fish dry, both sides. Drape trout over inverted stainless bowl to more easily tweeze out pin bones.

Season gently—salt only—both flesh and skin.

Dredge in Wondra (skin side only—don't get flour on the inner flesh) and tap off excess.

Heat largest deep skillet over medium-high heat with equal parts butter and blended oil—don't skimp, you need 4 tablespoons each +/−. (Take a minute before service to find the good flat-bottomed pans and cull out the warped ones.)

When fats are really foaming and headed toward sizzle, lay in trout perfectly flat: skin side down, belly wide open.

Keep flame between medium-high and high, but don't burn. Press down very gently but firmly with fish spat to be sure skin is making contact with the pan and getting crispy. Let the initial crust form before you start to baste. When you feel the beginning crust form and the limp, floppy nature of the boneless flesh starts to get a little rigidity—about 2 minutes—and you see that the fish can slip around in the pan loose, start to baste the flesh with the fat in the pan, 2–3 more minutes. Lift up the whole fish with your spat and really look to see where you are. We want crisp and golden brown skin—like good toast—not pale blond, undercooked flour.

Use the large slotted fish spat to invert onto plate. And don't double up: 1 fish per 1 pan. Keep your pans moving on the burners, and when you get many orders called at once, strategize your burner space efficiently.

Slather with brown butter vinaigrette at the pass and finish with lemon cheek.

* only order the farmed stuff from Idaho — it has no muddy taste.
Be specific with Bobby/Pierless when calling in fish order.

Roasted Capon on Garlic Crouton

Yield: 8 orders

1 8-pound capon

1 cup kosher salt

½ cup sugar

blended oil

1 gallon water

freshly ground black pepper

2-day-old peasant bread

garlic, peeled

> × 20
> 2× capon
> 2 c. salt
> 1 c. sugar
>
> 2 gal. H_2O

In an immaculately clean white bucket—place the sugar and the salt. Add half the water from the hot tap to dissolve the salt and sugar and whisk until completely dissolved. Add rest of water—very cold. Stir the brine and submerge capon in it. Let brine for full 24 hours in the walk-in.

If you get behind or deliveries are late, you can "supersoak" by doubling the salt and sugar, keeping the water quantity the same, and brining the birds at room temperature for 4 hours—*but only if you are in the weeds and are going to put them directly into the oven as soon as they come out of the brine.*

After 24 hours, remove capon from the brine. Set capon in a hotel pan and glug a little blended oil over, rubbing to coat until slick and slippery. Season all over with black pepper only.

Set the birds in 350° oven directly onto the oven rack—breasts side down. Quickly fill the oily hotel pan ½ way with water and set on oven floor directly under the birds. Take care to place it well to collect the fat and juice that drips down throughout the roasting. **＊Let's not set a fire in the ovens, please!**

You can fit two capons, front to back, so you only take up ½ the oven and leave some oven space for other prep needs. Roast for 2 hours and 10 minutes, until the juices run clear when pierced with a skewer.

While roasting, cut thick slices of 2-day-old peasant bread and lay them out on a baker's drying rack. Rub each one on both sides with raw cloves of garlic until you have worn the cloves down to nothing—use one whole clove per slab of bread. For the last 40 minutes of roasting, set the croutons still on their rack into the oven, directly under the birds, and directly above the hotel pan of water collecting juices. They will toast here and absorb fat and juice. Check them occasionally to see they aren't burning and conversely, *to see that they are in fact toasting*. Some birds are so juicy that the croutons can sog out before they have a chance to toast.

Remove the capons from the oven, carefully. I think it's best to pull out the rack as far as you can without it tipping and confidently grab them with a clean dish towel folded up in each hand. Place them directly into a waiting hotel pan and let all the juice that has accumulated in the cavity pour out into the hotel pan.

Remove the croutons. Remove the hotel pan of accumulated water/juice and fat from the oven floor and pour through a strainer into a metal bain. Add any juices from the capon cavities. Skim the fat off the top and keep warm in your station.

Butcher birds into 10 parts—2 wings, 2 legs, 2 thighs, 2 breasts cut in half creating 4 pieces of breast meat. It's tricky, but leave skin intact to the best of your ability. Only butcher one bird at the beginning of service. Leave the second bird until second seating, and butcher as needed.

To plate:

Crouton on bottom.
1 dark piece, 1 white, set on top.
1 ladel warm, defatted capon jus over all.
Full sprig parsley.

Obviously, this would be best if we could truss the birds on a slow-turning rotisserie set in front of a wood-burning hearth, and toast the bread in the coals. It is my purplest envy when I see other kitchens—that we work in such a horrible, basement kitchen in a 115-year-old East Village tenement building, with prep tables set up under a bank of electric meters. But do the best you can with what we've got—the succulence that we manage to eke out of these birds, under these ridiculous circumstances, is not insignificant.

DINNER
VEGETABLE SIDES

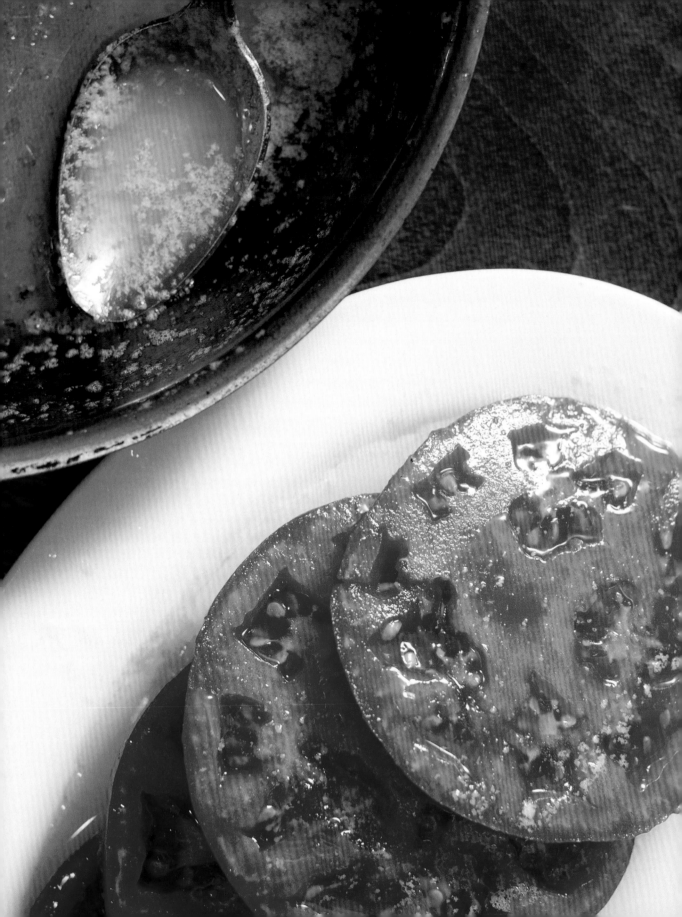

Sliced Jersey Beefsteak Tomatoes with Warm French Salted Butter

perfect Jersey beefsteaks
salted French butter
Maldon sea salt flakes

Score bottoms of tomatoes with a small X with a very sharp paring knife.
Drop tomatoes into boiling water and retrieve as soon as the skin blisters—30–60 seconds.
Shock the tomatoes by giving them a 5-second dunk in an ice bath and then setting them on your cutting board; don't let their sunny interiors run cold by forgetting them in the ice water. *In and out,* please.
Peel and core. Save peels, lay out on Silpat mat, and dry in slow low oven until papery. Grind in spice mill to flecks.

To plate:

Slice in thick slabs, 1 whole tomato per portion, about 3 cuts per tomato.
Shingle on the plate.

Heat small saucepan on stove. Add rather generous hunk of salted French butter and quickly bring to the foamy stage of melted.

Spoon butter all over tomatoes and allow it to pool up on the plate—it will turn slightly pink-tinged from the juices of the tomato commingling with the butter. Scatter a few Maldon flakes and dried tomato skin flakes to sell.

Take care not to have cold tomatoes. And don't bring back heirlooms from the farmer's market. This is all about the plain, fantastic Jersey beefsteak.

Celery Hearts Victor

Yield: 6 orders

6 celery heads ** 1 whole heart per order/portion **

2 bay leaves

8 black peppercorns

3 quarts College Inn chicken broth

6 oil-packed anchovy fillets, minced by hand

4 fresh, sticky, burning garlic cloves, <u>minced</u> *not microplaned*

½ teaspoon chili flakes **use commercial, not our homemade ones*

⅓ cup fresh lemon juice

1 cup extra virgin olive oil

kosher salt to taste

½ teaspoon freshly ground black pepper

parsley, to finish

Remove big, fibrous outer stalks of each head of celery and shave off dirty, browned bit at the root end to reveal clean white flesh. Keep head intact.

Trim the tops without losing the interior bright yellow leaves.
Wash thoroughly, rinsing deep into the heads by holding directly under the faucet.

Place celery heads in single layer in hotel pan and cover with commercial chicken broth. <u>Don't use our homemade stock.</u>
Scatter with peppercorns and add bay leaves. Don't salt. The celery itself has some salinity.

Cover with parchment and foil and bring to a simmer on the stovetop over 2 burners, if necessary. Lower heat to barest flame possible and let braise for 15–20 minutes on the stovetop until tender when you pierce deep into the base with a blade or skewer.

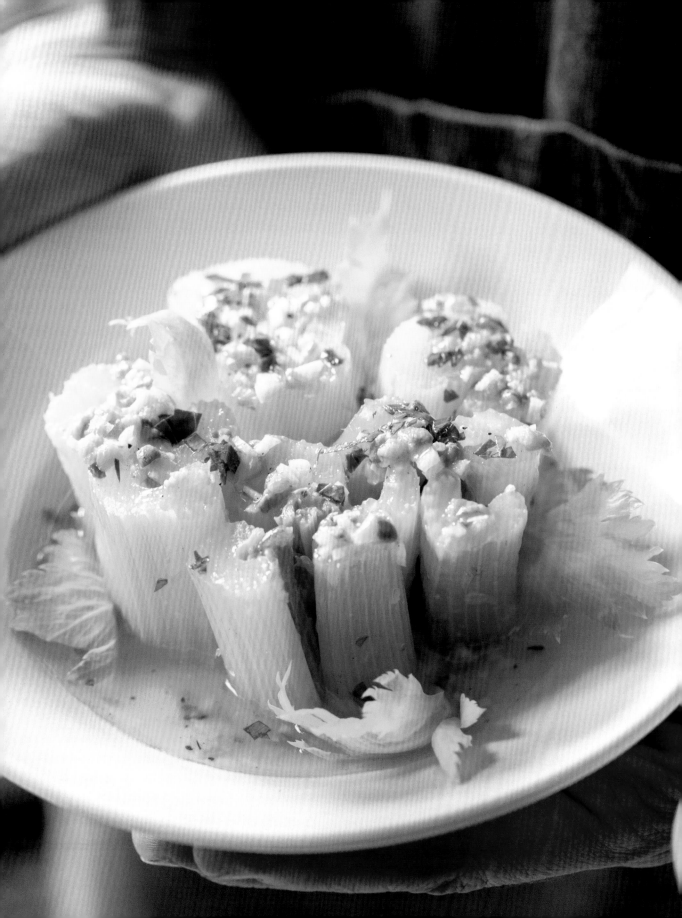

Remove seal and lift cooked celery out onto a baker's drying rack set over a sheet pan to fully drain and cool. Save the celery braising liquid from batch to batch, well labeled and accurately dated.

When cool enough to handle, pull off any green outer stalks that may have over-cooked. Contribute green outer stalks to family meal.

Leave the hearts as natural and "as is" as possible. Cut crosswise into 2½" medallions, and pack neatly and tightly into shallow container to be marinated. Don't let them fall apart.

Whisk together the olive oil, lemon juice, minced anchovy, and garlic and season with the chili flakes, kosher salt, and freshly ground black pepper.

* *Make it bright, assertive, and bracing. Make sure the marinade saturates the hearts evenly.* *

To plate:

Arrange 1 heart's worth of medallions per order in the shallow small bowl, keep nestled close together so they hold their shape without falling open. Be sure much of the dressing is spooned over and really drenching the cold celery. Add freshly chopped parsley as you plate and allow to temper briefly to shake the dulling cold from the reach-in before you send to the table.

Roasted Beets and their tops
with Aioli

Yield: 4 orders

2 pounds small beets (red, mixed variety, or
 mixed color) with their greens attached
1½ Tablespoons extra virgin olive oil
¼ teaspoon kosher salt
½ cup Aioli (page 483)

handwritten note:
$20
10 #
croo
salt
1 qt. +/–

Remove the beet greens and wash thoroughly. Set aside.
Scrub the beets in a sinkful of cold water; *use the vegetable brush.*
Rinse the beets and arrange them in a single layer in a shallow hotel pan—you want
them wet from the washing. The few drops of water will help during the roasting; this
is not a dry roast. Don't use a sheet pan; we've noticed that the beets get dry and hard
and don't peel well when they are spread out too far away from each other.

Season the beets with a gentle glug of olive oil and sprinkle with the salt.
Cover tightly with foil, shiny side out.
Roast in 400° oven for 1 hour but check at 40 minutes, by inserting skewer, cake tes-
ter, or thin blade of your knife tip to see if they are tender.
Remove from oven, remove foil, and allow to cool enough to handle.

Wear gloves and slip the skins off of the beets. Leave the long tails when possible.
If the skins are not slipping off easily, they may be undercooked. Rewrap them and
continue to cook until perfectly done—don't try to forge ahead with a product you
know is not properly done.

If you have mixed color beets, take care to store them separately when you are
peeling as the red are powerful stainers and they obliterate the gorgeous paler hues of
the cioggia, yellow, or candy cane beets when you throw them all together—you just
end up with universal crimson. On the other hand, you can sometimes add a red beet
to a tray of yellow to create gorgeous color.

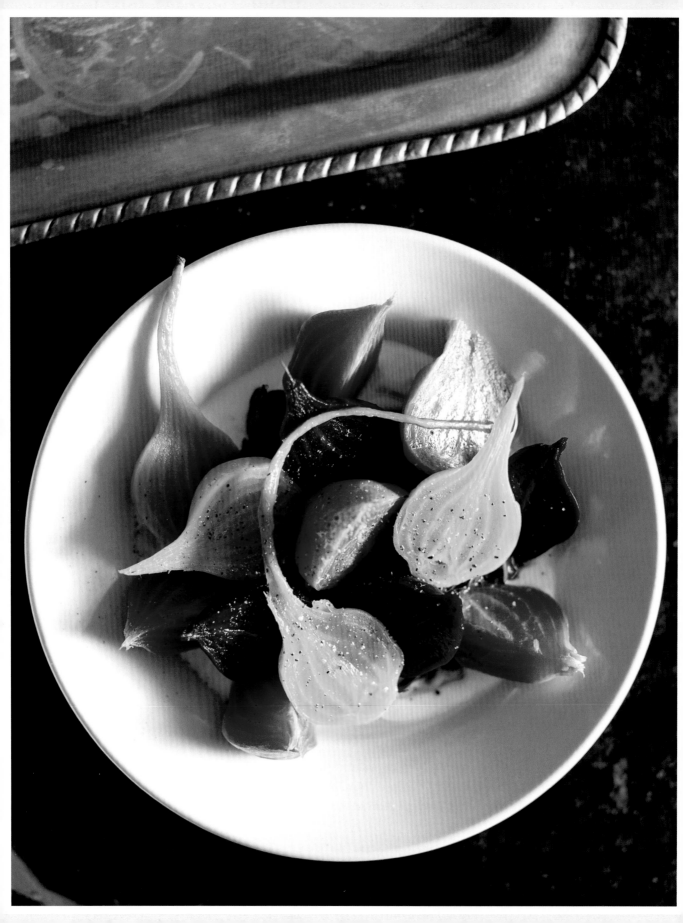

For the greens:

Blanch the clean beet greens—stems and all—in perfectly salted, boiling water. Cook until just tender, shock in ice water, and lay out on a baker's rack over sheet pan to drain thoroughly.

To plate:

Generous hearty dollop aioli, spread out a little with the back of the spoon.
Loose nest/tangle of cooked greens, centered on aioli.
Cooked mixed colored beets, cut in half, neatly arranged on top of greens.
Healthy drizzle of EVOO to just slightly pool in bottom of dish.
Fresh grind pepper. Do not salt.

Soft-Cooked Zucchini with Green Onion and Poblanos

Yield: 4 orders

1½ pounds firm, tightly pored,
 and shiny green zucchini

¼ pound new green onions or conventional scallions

3 cloves fresh sticky garlic
 with plenty of "burn"

1 small glossy, firm poblano pepper

¼ pound sweet butter

kosher salt

[handwritten notes on torn paper:]
×16
6 #

1 #
1 head

3 lg.
1 #
salt

Wash zucchini well under cold running water and wipe dry and thoroughly with a clean kitchen towel.
Cut the zucchini into ¾" disks, and include the delicious and tender stems at the tops that attach the fruit to the vine. (But shave off the dry and discolored tips.)

Wash the scallions or green onions thoroughly in a cold-water bath, letting the dirt and sand settle down to the bottom of the sink. Wash multiple times if necessary. Trim the roots if they have browned and look old and unappealing, but if we are lucky enough to have fresh and vital roots still attached, leave them on, making sure they are free of sand.

Cut the scallions/green onions into ¼" rings, cutting as far up into the green of the stalk as you possibly can. In some cases, you can get 100 percent yield from the onion, but others get a little too fibrous and unappetizingly hollow at the very top. Trim according to the condition of the onion in front of you.

Peel the garlic, trim the hard dry tips, and cut across the grain into thin slices.

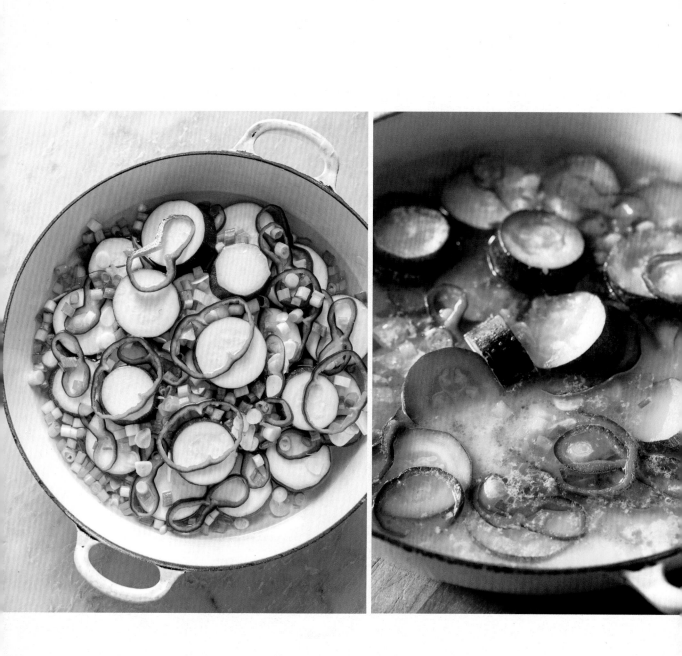

In a heavy enameled cast-iron Dutch oven, melt one third of the butter over gentle heat.

Add onions and peppers and garlic, season with salt, and let sweat 2–3 minutes, with the lid on, letting the accumulating steam run back into the pot.

Add the zucchini and season again with salt to taste.

Add another knob of butter. Stir well to coat the zucchini and sweat briefly, uncovered.

Add the remaining butter and cover with a tight-fitting lid and allow to braise in its own liquid approximately 20–25 minutes, until soft and nearly falling apart.

Fresh Shell Bean Ragout with Cardoons and Mint

X20 +/-

8#

8#

4 qts.

1# +/-

12 oz.

S+P

Yield: 4–6 orders

2 pounds shell beans—see if we can get a few varieties in addition to borlotti
and cranberry, and ask for those picked young if he has them

1–2 pounds cardoons

4 cups Chicken Stock (page 448)

⅓ pound butter

mint—1 large bunch

salt and freshly ground black pepper

Shell the beans and measure your yield—it's usually a little less than half of what you started with in weight after you shuck. 8 pounds of shell beans yields a shy 4 pounds of shucked beans, approximately.

Trim the tops and bottoms and shave off the leaves of the cardoons until you have good substantial stalks to work with. Take care with the little prickles and also wash your hands immediately after handling to remove the intense bitter film they leave on your skin. Switch out your cutting board as well for a new clean one after you have finished the cardoon prep.

Cut directly across the stalks in ¼" to ⅓" slices.

Clean and yield an equal amount of cardoon as your shell bean yield.

Boil plenty of salted water in pot large enough to hold the cardoons.
Blanch the cardoons for a couple of minutes and drain.
Taste a slice to determine how profound the bitterness is.
If it's still tremendously off-putting, boil more fresh water, season with salt, and do a second blanch.

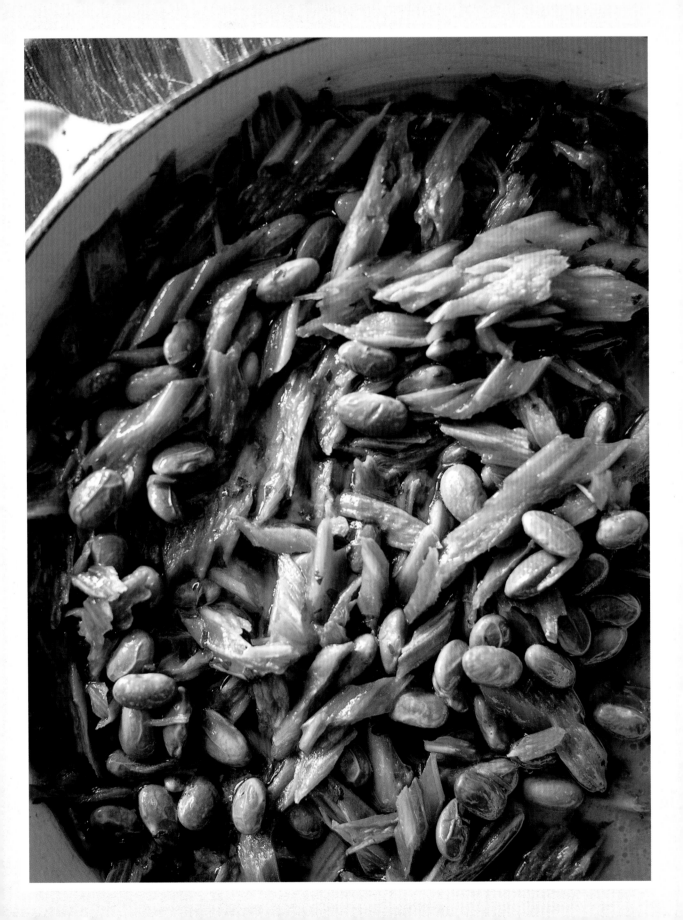

More or less, you want equal parts shell beans, cardoons, and chicken stock to start with.

To build:

Melt a healthy slab of butter slowly in a sauteuse, and add the blanched cardoons. Stir until coated and glossy.
Add the shell beans and stir and heat through until glossy.
Just cover with chicken stock and bring to simmer.

Chop a generous amount of mint and stir in.
Add another healthy slab of butter and stir in.
Season with salt and pepper and simmer until beans are cooked through, cardoons are tender, and their high bitterness is tamed, 20–30 minutes.

Stir in another big handful of freshly chopped mint just before serving.

The butter is there to tame the high bitter of the cardoon, not put it to sleep entirely. Please keep the ratio of butter to chicken stock such that the final dish is brothy but rich and full-bodied, and that it allows the cardoon to retain some of its personality. It shouldn't be challengingly bitter; just pleasantly bitter.

Artichokes Barigoule with Lemon Aioli

Yield: 6 orders

6 large globe artichokes

1 whole head garlic as is, paper skins
 intact, split in half horizontally

1 onion, coarsely chop

1 celery stalks, 1½" pieces

1 carrot, peeled, 1" rounds

1 fennel bulb, quartered

¼ cup extra virgin olive oil

1 Tablespoon fennel seeds, toasted

1 Tablespoon whole black peppercorns

kosher salt

1 lemon, rinsed under warm water
 to remove wax, halved

1 bay leaf

3–4 sprigs fresh thyme

3–4 sprigs fresh parsley

½ cup white wine

½ cup fried bread crumbs

thin lemon slices

4 Tablespoons cold sweet butter

¾ cup Lemon Aioli (page 484)

olive oil for packing and frying

[handwritten marginalia:]
x 18
18
2

2 onion
2 celery
2 carrot
1½
¾ c.
2 T.
¼ c.
2 T.
2

3 bay
6
6
1 bottle @ 750 ml.

Place whole artichokes into salted boiling water, weighing down with kitchen towel
and undersized lid or dinner plate. Do not worry about trimming or cleaning.
Cook until just tender where stem meets thistle. *— CHECK AT 10 MINS. **

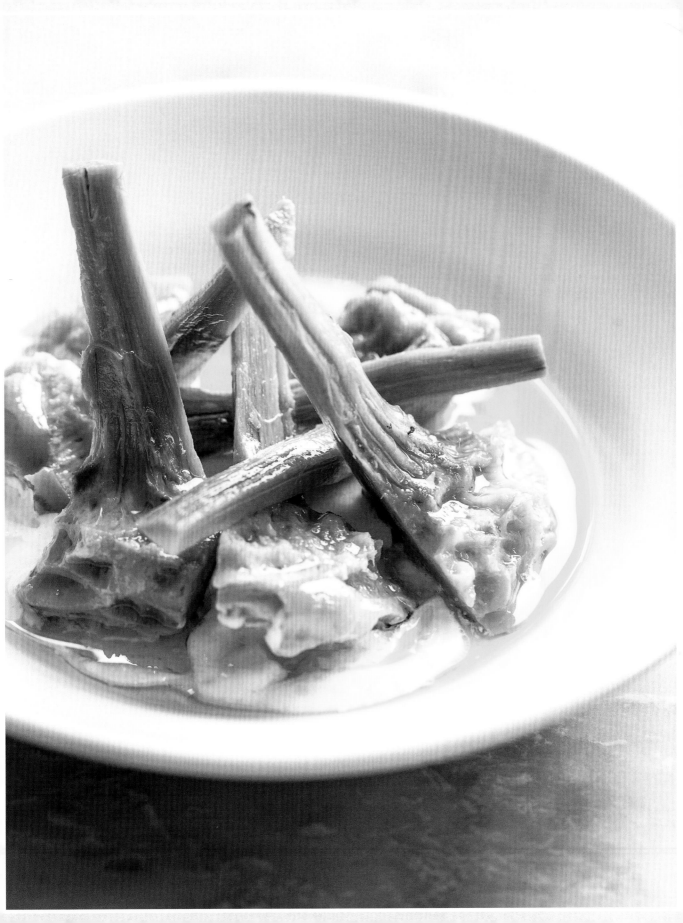

Remove from water and drain—stems up, leaves down—in perforated hotel pan or use the flat silverware dish rack if prepping large batch. Let cool until you can handle them with your bare hands. Doubled-up pairs of latex gloves vaguely help if you are in a rush and they are too hot to handle.

Peel tough outer leaves of artichoke away from top and down toward stem, peeling fibrous stem "naturally" in process.

Remove in one handful the remaining cone of good tender leaves and pack in quart containers for service.

With your fingers, remove the hairy, prickly choke from the heart and discard. I like the natural goose bumps look of the heart's flesh when you do this by hand more than the smooth look that often leaves the track of the spoon's edge when you scrape out the choke with a spoon. This also is a way of telling you how perfectly you have cooked them; if you can't pluck the choke with your fingers and are obliged to scrape with a spoon, you have probably undercooked them and they will be prone to blacken.

Cut discolored tip off bottom of the stem.

Cut hearts in ¼'s and pack in olive oil for service.

Bring vegetables, herbs, spices, white wine, and EVOO to boil in a stainless steel, nonreactive stockpot and then reduce to simmer. One day I am going to weed out and trash every piece of aluminum we have in the house and splurge on all stainless and all enameled cast-iron cookware—and maybe some beautiful copper as well if we ever make any lavish money—but in the meantime, please know when to only use stainless. Anything with wine, citrus, tomatoes, pineapple . . . never in aluminum, please.

Simmer 30 minutes until vegetables are totally soft and spent and broth is aromatic and flavorful. Strain broth and set aside. Chuck the aromatics.

To assemble:
Heat barigoule liquid in a stainless sauteuse. Add artichoke hearts. Simmer until just heated through.

Heat the oil the hearts were packed in in a small pot to 350°; fry the tender inner leaves until crispy and golden brown like potato chips.

Drain the leaves in small stack coffee filters; lightly and evenly salt while warm.

In the same oil, fry ultra-thin lemon slices; drain and lightly salt.

Remove the artichoke hearts with a slotted spoon and hold warm in your station. Return barigoule to burner and whisk in cold sweet butter until emulsified and the off-putting, astringent acidity of the barigoule is tamed but not docile.

To plate:

Pool nice spoonful of lemon aioli in bottom of shallow bowl.
Stand artichoke hearts up.

Spoon barigoule sauce all around.

Garnish with fried lemon slices, warm bread crumbs, and fried artichoke leaves.

For the bread crumbs:

1 cup real homemade bread crumbs; panko as a backup if we are out
3–4 Tablespoons extra virgin olive oil
salt and freshly ground black pepper

Toast bread crumbs in a sauté pan with olive oil until golden brown. Season well.

Fresh Flageolets with Braised Baby Leeks and Chanterelle Mushrooms

Yield: 8 orders

1 pound shelled fresh flageolets

10 baby leeks

1 pound chanterelle mushrooms

8 cups Chicken Stock (page 448)

3 garlic cloves

1 cup loosely packed parsley leaves

2 medium shallots

butter

salt and freshly ground black pepper

EVOO

Simmer the flageolets in water seasoned with just salt, bay leaf, and a few black peppercorns. Fresh beans are a different game—they will only need 30 minutes +/- to lose their raw quality and start to show their true waxy nature. Strain when cooked.

Clean baby leeks but leave whole.
Clean chanterelles with a few brisk dunks in sinkful of cold water.
Chop garlic.
Chop parsley.
Slice shallots into thin rings.

In mixed fats, sauté the chanterelles over medium-high heat; season with salt and pepper.

When the water they release starts to reduce and have body; add a little more fat and the chopped garlic and reduce the flame just a tap.

Let the garlic soften but not take on any color.

Push the mushrooms into a ring at the edge, clearing space in the center of the pan, and add one more knob of butter.

Lay in the leeks in one layer and sweat them until their exteriors are bright green and turning translucent; roll them around a bit; season briefly with salt during the sweating. You want to take the hard raw edge off of them and let some of their sweetness start to develop before adding the stock to fully braise them.

Scatter parcooked flageolet generously in and around the pan, to create a more or less equal ratio of beans:leeks:mushrooms.

Ladle in chicken stock to not quite cover but to flood the contents.

Season with salt and pepper to taste, and bring to a gentle simmer.

Lay the handle of your wooden spoon across the pan with the bowl of the spoon resting beyond the lip, and set a lid down on the pan to loosely cover during the simmer. The spoon handle gives a better gap to allow steam to escape than just setting the lid askew. We want the weak watery condensation to escape but the chicken stock and the sweet, earthy juices of the leeks and mushrooms to continue to commingle and reduce together.

Stir in chopped parsley and one nut of cold butter before plating.

* Take care That your leeks are fully cooked. Make sure There is no raw bite at the center and no "al dente" texture. Leeks should be slippery and silken when perfectly cooked.

Creamed Corn, Fresh and Dried

4 orders

For fresh corn:

3 ears sweet yellow Jersey corn

⅓ pound butter

1 cup heavy cream

salt

freshly ground black pepper

sugar

x20

24

2# +/−

3 c.

S+P

sugar
+/−

For fresh corn:

Shuck and shave the ears of corn. Save a few of the cobs.

In a rondeau, gently melt the butter. Add the cobs and sweat briefly.

Add the shaved corn. Stir to coat with butter. Add more butter, if not glossy and slick.

Allow to steam and sweat and turn bright yellow.

Add heavy cream.

Season well with salt and pepper.

Add sugar, carefully, sparingly, depending on the initial sweetness of the corn.

Bring to simmer over medium-high flame until the corn has turned bright yellow and is soft but not mushy. Remove the pot from the heat. Remove the cobs.

In the Robot Coupe, grind 60% of the corn, about 3–4 long pulses until coarse puree. Combine with the rest of the corn; stir well. Check seasoning again.

Run this as an addition when any corn on the cob in house has been in walk-in more than 2–3 days and has lost its incredibleness.

6 orders

For creamed dried corn:

1 pound John Cope's Pennsylvania Dutch dried yellow sweet corn

6 cups milk

1 cup heavy cream

8 Tablespoons sweet butter

sugar

salt

freshly ground black pepper

x 12

2 #
3 qt. milk
2 c. h. cr.
1/2 #
sugar t/_
S+P

For creamed dried corn:

Soak corn in milk and cream overnight in walk-in.

Transfer to rondeau and bring to boil.

Season with salt, pepper, and sugar once milk mixture is hot.

Simmer for approximately half an hour, partially covered.

Keep an eye on it and stir occasionally so it doesn't scorch on the bottom.

Stir in butter at the end until fully melted.

Grind 60/40 in Robot Coupe and recombine.

*Only John Cope's. If we have failed to order/ inventory properly and run out, do not substitute anything from Whole Foods or any Goya product.

Fried Zucchini Agrodolce with Chilies and Fresh Mint

4 orders

6 clean, firm medium zucchini

kosher salt

olive oil

agrodolce

mint leaves

For the agrodolce:

1 cup cider vinegar

⅓ cup sugar

2 garlic cloves, slivered

2 pinches homemade chili flakes

Slice zucchini into ¼"-thick rounds or long ribbons, or both, and lay out in single layer on a baker's rack set inside a sheet pan.

Salt lightly and evenly and set in turned-off oven to dry in the warmth of just the pilot lights for about an hour. We are looking for a papery, slightly leathery quality.

This is our ridiculous makeshift way of approximating sun-dried zucchini.
But if you ever get the chance to do this the right way, under the extraordinary heat of the southern Italian sun, you will see a big difference.

To pick up:

Fry pieces of dried, salted zucchini in ample olive oil in a small sauté pan. Make sure oil is hot when slices go in. Attend to it with a slotted spoon, flipping and dunking as needed, until zucchini is blistered and pale gold.

Arrange fried zucchini in shallow bowl allowing whatever hot olive oil that clings to your slotted spoon to drain off into the bowl as you plate.

Scatter a loose handful of small picked mint leaves over the warm fried zucchini.

In stainless steel, nonreactive saucepot, simmer cider vinegar and sugar until mixture begins to turn syrupy, 5–10 minutes. Add chili flake and turn off heat. Drop in slices of raw garlic, and spoon while piping hot all over and around the zucchini and mint until you smell the mint bloom under the hot liquid exactly like a tea.

Fire this early when the order comes in so that it has time to settle, permeate the fried zucchini, and also be mellowed somewhat by the oil that will leach out of the zucchini as it rests.

Pumpkin in Ginger Beer with Brewer's Yeast

Yield: 6 orders

⅓ pumpkin (5 pounds) pumpkin (red kuri, cheese, or white variety)

⅓ can (4 ounces) Gosling's ginger beer

⅓ pound butter, in cubes

kosher salt

brewer's yeast

> x 18
> / whole /
> 15#
> 1 can
> 1 # +/-
> salt
> yeast

Set oven at 400°.

Rinse and split the pumpkin into large wedges, about 2 ribs per wedge. Clean out seeds. Place points up (like Viking boats) in a shallow hotel pan, lightly salt. Dot liberally with butter, and pour the ginger beer over the wedges.

Sprinkle nutritional yeast over the pumpkin and the braising liquid generously.

Roast in oven until pumpkin is cooked through, about an hour. Baste frequently throughout the cooking time to be sure ginger beer and butter and unique flavor of yeast penetrate the flesh of the pumpkins. *ok if the tips of the wedges char slightly.*

To plate:

Reheat in oven with some of the liquid from roasting.

Pour liquid over the wedge; season with salt and a generous dusting of brewer's yeast.

Braised Green Cabbage
with Anchovies and Garlic

4 orders

2 pounds heavy, firm regular
 green cabbage, cored, halved,
 and then cut into 1-inch wedges

8 anchovy fillets in oil

½ head whole garlic, peeled
 but leaving cloves whole

¼ pound sweet butter

salt to taste

freshly ground black pepper to taste

x16
8-10#

30
2 heads

1½#

s+p

In a large, heavy-bottomed rondeau, heat the butter over medium-low heat. Add the anchovies and garlic and stir around until the garlic softens slightly and the anchovies dissolve a bit. Do not fry or otherwise brown the garlic and anchovy; we want it to just soften and take on a sweet quality rather than a nutty one. Stir frequently and let the garlic and anchovy cook gently and slowly.

Rinse the cabbage ribbons under cold running water in a colander and allow to drain without shaking the colander. Whatever water remains in the crevices is desired.

Turn the colander of cabbage out into the rondeau and stir well with the garlic and anchovy, coating all the ribbons with the fat. If this pot has a tight-fitting lid, cover the rondeau and turn down the heat and let the cabbage gently cook over low heat, retaining its own moisture and letting whatever condensation forms on the lid to drip back into the pot. This wants to be a true braise. If the pot does not have a tight-fitting lid, use both parchment and foil to create a tight seal.

This can take an hour to braise but sometimes less depending on the cabbage itself. Some heads are sturdier than others.

Keep an eye on it and cook until soft watercolor green color; the cabbage should still hold its shape and there should be a rich "broth" formed from the anchovy, the sweet liquid of the cabbage, and the now very soft cloves of garlic.

Into this, stir in a good chunk of cold butter with a wooden spoon and shake the pot a bit as well. This will turn the cabbage a bit creamy and take off any of the hard saltiness of the anchovy. Hold warm, gently.

Charred Okra and Mixed Onions
with Berbere Spices

4 orders

⅓ pound mixed types of onions, peeled
 and cut into uniform wedges
⅓ pound okra, split in half stem to tail
extra virgin olive oil
cold butter
Berbere Spice Mixture (page 477)
salt to taste

Dredge cut side of okra in berbere spice mixture, tap off excess, and allow to dry cut-side up on baker's rack.

Arrange onions on sheet pan, rounded sides down, and drizzle with olive oil. Season briefly with salt.

Roast onions in a hot oven until soft and tips start to blacken. Set aside and separate two or three of the onions for the butter sauce.

Set a large cast-iron skillet on a medium-high flame and let heat up 5 full minutes.

Into the dry pan, efficiently arrange the seasoned okra cut-sides down, and let the okra char slightly. Remove with a spatula.

Reduce heat under skillet and add a half cup or so of water and a good knob of cold butter, and blend together. Add the charred okra. When the okra is perfectly tender and rounding the corner toward soft, 15 minutes +/-, add the onions, and with extreme gentleness, stir together to integrate. Turn off heat, but keep warm.

In a small saucepot, boil ½ cup of water with the reserved pieces of charred onions and a pinch of salt. When the water is truly oniony, discard the onions and reduce the remaining water to just a few tablespoons and then quickly whisk in a few knobs of cold butter until you have a viscous, light onion-butter sauce.

Spoon okra and onions into shallow plate attractively.

Drizzle the onion beurre fondue over the onion-okra mixture to finish.

Roasted Mixed Onions with Onion Butter and Toasted Seeds

6 orders

4 pounds torpedo onions, cipolline onions, red onions, shallots, scallions, in
 approximately equal parts.

butter

water

EVOO

salt

1 teaspoon flax seeds

1 teaspoon millet

1 teaspoon sesame seeds

1 teaspoon poppy seeds

Toast seeds in a dry pan on the stovetop or on ¼ sheet pan in the conventional oven.
Don't use the convection oven downstairs unless you want to see a bee swarm of
seeds blow around the oven and be ruined.
Peel all the onions, cut in halves, quarters, sixths, or leave whole depending on natural
state of onion.
Save all of the trimmings, but discard all the skins.
Use a little oil and salt and roast at 400° to get nice blackened tips here and there, but
be sure bodies have softened and released their sugars.
Roast onions separately, keeping like with like so they cook uniformly.
Make a strong onion tea by boiling all the onion scrap in 1–2 cups of water until all
onion flavor is completely extracted. Discard the spent solids and keep the onion tea.
Per order, arrange some of each onion on sizzle plate and reheat in hot oven.
In small saucepot, boil 4 Tablespoons onion water.
Mount in 2 Tablespoons of cold butter to make glossy full-bodied oniony beurre
fondue—season with salt to bring out full sweetness of both the onion and the butter.
Plate onions in shallow small bowl.
Spoon onion butter over generously.
Sprinkle with a healthy pinch of the toasted seeds and a few Maldon flakes.

We want the uncanny taste of an everything bagel.

Don't psych yourself out over This — you can practically let it boil and it still won't break, as long as there is more h2O than butter.

Roasted Garnet Yams with Brown Butter Vinaigrette and Deep-Fried Skins

4 orders

4 medium sized garnet yams, firm
 and in good shape
Brown Butter Vinaigrette (page 459)
kosher salt

Wash yams and then roast directly on oven rack in hot oven (400°) until tender throughout and softened. *★ Don't use a sheetpan — right onto the rack itself, please. Also, don't pierce.*

Remove the yams from the oven when they are cooked and when they are just cool enough to handle but still quite warm; slit the skin from tip to tip without cutting into the flesh. Sometimes a sharp pair of scissors is good for this job but stop stealing scissors from the office! You should have a pair in your knife kit as part of your discipline as a line cook, please.

Remove the yams from their jackets and set aside in a warm place under plastic film so they stay warm and moist. Cut or tear the skins into wide ribbons.

Deep-fry the skins until crispy. Drain in a short stack of coffee filters.

Season evenly with kosher salt while still warm.

To plate:

Slice the yams into thick coins, slather with generous amount of brown butter vinaigrette, and scatter the fried skins on top.

Please don't use the jewels or the beauregards, and never the standard sweet potatoes, in place of the garnets; I love their water content, which makes them downright juicy, and their relatively lower sugar content, which in most of the sweet potatoes I barely find palatable. If you can't get the garnets, seriously, *86 the dish.*

Celery Root with Caraway Butter and Caraway Seed Gastrique

4 orders

2 pounds whole celery roots, trimmed of their beardy bottoms,
 scrubbed meticulously—not a grain of sand, please
3 cups Diamond Crystal kosher salt
8 egg whites
Caraway Butter
Caraway Seed Gastrique

For the gastrique:

1 cup sugar
¼ cup water
½ cup apple cider vinegar
1 Tablespoon finely ground toasted caraway seeds

× 12
2 c.
½ c. h2O
1 c. vin
1 T. r/ tsp.

Combine water and sugar in saucepot. Bring slowly to boil, reduce to simmer.
Bring steadily to dark amber caramel, about 8 minutes. Quickly remove.
Carefully add cider vinegar. Stir in caraway.
Let cool.

For the caraway butter:

½ pound sweet butter
1 Tablespoon plus 1 teaspoon toasted
 ground caraway seeds
¼ teaspoon salt

Blend completely. Chill.

× 2 Pints
1 #
2 T. r/_
salt r/_

For roasting the roots:

Whisk egg whites past foamy to true soft peaks. Fold in all the salt.
Encase celery roots completely in salt-egg mixture on ½ sheet pan.
Bake in hot oven (400°) for 2 hours.
Hold warm, above grill, during service.

Save all whites from prep and use here. Do not crack new eggs — we have so many extra whites floating around!

To plate:

Crack salt crust, remove celery roots.
Cut into thick rounds and smother in softened caraway butter.
Spoon gastrique all over.
Do not salt!

8 whites = 1 cup +/-

Whole Roasted Cauliflower with Fried Capers and Brown Butter Bread Crumbs

Per order:

1 medium cauliflower, whole but cored **✱ save all the cores for waxing ✱**

1 Tablespoon capers in brine

3 Tablespoons unsalted butter

3 Tablespoons bread crumbs (ours, not panko)

kosher salt

½ cup extra virgin olive oil

Start early and don't get behind. Each head will take a full 50 minutes. If service is bogging down, blanch heads for 10 minutes and then finish as usual in oven.
I can eat a whole one of these myself—no sweat—but tell servers to try to only sell one per table, please.

Put whole head in sauté pan just big enough to hold it. Drizzle with ¼ cup EVOO.
Season with salt rained down evenly.
Roast in oven at 375° for 25 minutes. Leave it alone.
Flip upside down, add another ¼ cup olive oil. Return to oven for 25 minutes.

On stovetop, fry capers in butter until butter browns and capers burst open, about 2 minutes.
Quickly add bread crumbs and toast until golden brown.

Plate cauli in large wooden bowl. Spoon buttered caper bread crumbs all over.

Make sure you have a soft core—use cake tester or skewer or knife tip. Sometimes the crumbs have been too dry. Make sure they are luscious with brown butter. *But not greasy.*

Stewed Yellow Lentils, Cardamom-Braised Chard, and Gunpowder

Yield: 4 orders

For the lentils:

½ pound toovar dal

4 cups water

2 teaspoons salt

1 teaspoon turmeric

¼ cup clarified butter

1 cup sliced shallots

1 Tablespoon clarified butter

1 pinch asafetida

1 teaspoon cumin seeds

1½ teaspoons garam masala

½ teaspoon cayenne pepper

3 dried curry leaves (no stems)

For the braised chard:

2 pounds chard leaves

1 small yellow onion

½ cup cream

½ cup milk

1 large pinch ground cardamom from whole toasted pods

kosher salt to taste

2 rounded Tablespoons solid cold-pressed coconut oil

For the gunpowder:

¼ cup cornmeal

1 teaspoon salt

½ teaspoon cayenne pepper

¼ teaspoon ground cumin

handwritten note
x 16
2 # dal
16 c. h₂0
2 T.
1 T.
1 c. clari
1 qt. full
1/4 c. clari
1/2 tsp.
1 T.
2 T.
2 tsp.
10 leaves
10 # chard
1 large
2 c.
1 c.
1 T. +/-
salt
coconut
x 1 QT.
1 qt.
3 T.
1 T.
1 T.

For the dal:

Wash dal in several changes of water until water runs clear. Often the legumes from our Indian store have a faint taste of sandalwood incense because they sell so much of it and they don't sort their products very effectively. It's gross to have that flavor in the food. Rinse well, multiple times.

Bring dal, water, salt, and turmeric to a boil, then simmer for 45 min–1 hour, stirring often to keep dal from sticking to bottom of pot.
Remove from heat.

Caramelize shallots in ¼ cup clarified butter until they are dark like copper. Keep them sweet and do not cross over into bitter from burning, please. Strain out fried shallots and set aside. Add the fat they were fried in to the stewed lentils.
In another smaller pan, warm 1 Tablespoon clarified butter and add asafetida, cumin, garam masala, and cayenne before butter gets hot.
When spices begin to sizzle, add curry leaves and swirl in pan until leaves become fragrant.
Add spice mixture to dal; include all the fat.
Dal will thicken as it cools. Taste and adjust for seasoning. We want a sure presence of garam masala and to feel some cayenne heat.

For the braised chard: DON'T THROW AWAY THE STEMS. Run as wax of addition.

Wash and ribbon chard leaves.
In rondeau, melt coconut oil and sweat diced onions slowly to translucent.
Add chard leaves and any water clinging to them.
Sweat and wilt and add another spoonful of coconut fat if needed to get chard slick.
Use a lot of chard; it reduces significantly.
Add cream and milk and bring to a boil. Season with cardamom and salt.
When chard is collapsed and tender but still lively, pull from the heat and transfer to processor. Pulse until creamed, but with a little texture.

To plate:

Generous pool of lentils in shallow bowl.
Generous spoonful of hot creamed chard, set on lentils. Don't swamp the lentils; let them be seen.

Sprinkle with toasted gunpowder.
Finish with crispy shallots.

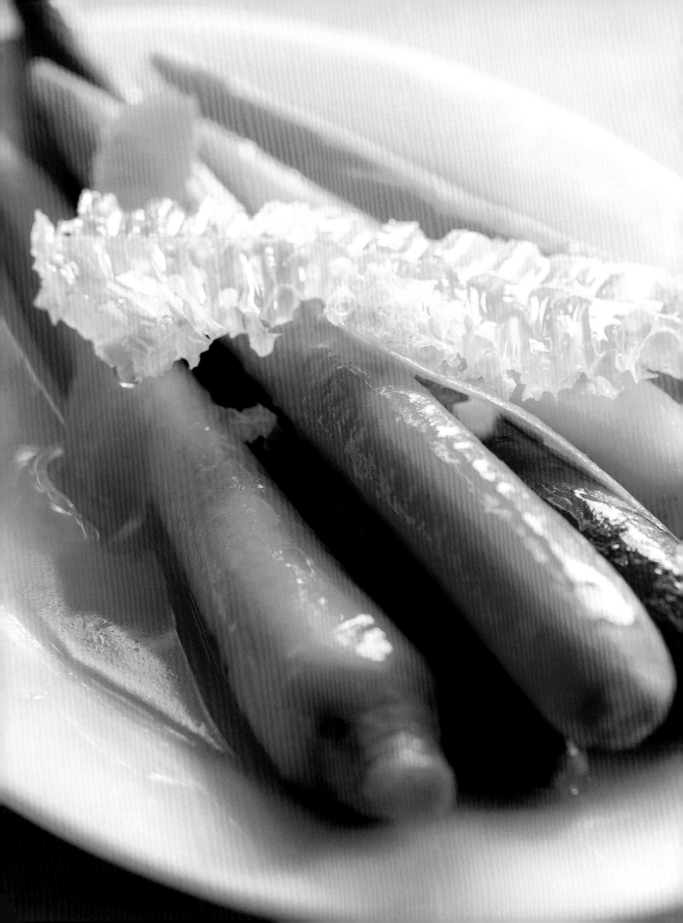

Mixed Colored Carrots with Preserved Lemon Butter and Honeycomb

Yield: 4 orders

2 pounds beautiful mixed color carrots
Preserved Lemon Butter (page 468)
honeycomb
Maldon sea salt

Peel the carrots with Y-peeler. *Long fluid strokes please — do not chisel away at them.*

Parcook briefly in salted boiling water; drain gently through a perforated hotel pan, taking care that they don't get nicked and dented.

We have nothing here but carrots and butter, so let's show we know how to work in a kitchen and take care of our ingredients.

During service, keep a dinner napkin draped in your hot water bath and lift the carrots out at each order by using your napkin as a kind of gurney or stork's bundle. Turn them out into a shallow ⅓ pan and roll them in a generous spoonful of preserved lemon butter. Tip and slide the carrots right onto the plate without using a utensil. Arrange with your fingers into an organized casual pyramid.

Cut a drippy, oozing tablet of honeycomb and set on top at the pass.

A small pinch of Maldon to finish—be careful with the salt-sugar balance, keeping in mind the carrots themselves are sweet.

Pole Beans Braised in Kalamata Olive Oil with Anise Hyssop

6 orders

5 pounds mixed beautiful pole beans from Zone 7 or the market or Guy Jones

1 head sticky, fresh burning garlic, separated into cloves, peeled, gently crushed/
 bruised

equal parts water and kalamata EVOO

kosher salt

white pepper

2–3 good leafy branch anise hyssop

Use purple and yellow and green beans in a good-looking/equal-parts mix.
Trim stems but leave tails. Wash and lay out in hotel pan and scatter garlic around.
Cover in equal parts EVOO and water—don't be stingy. Season with salt and white
pepper, drop hyssop branch on top.
Cover with film and foil and bring to simmer on stovetop, but finish in 350° oven,
45 minutes to an hour.

We want them really soft-cooked, drab, lusciously oily—like they would do at a
village restaurant on a remote Greek island.

Don't refrigerate, and don't reheat to serve. Let them sit at ambient temperature
through service.

Asparagus
with Sable Butter

4 orders

3–4 pounds asparagus

Sable Butter (page 470)

Snap stems at natural breaking point, then trim ends to neaten.

Boil in salted water, "au point." I know we talk about this ad nauseam all season long, but let's get it right, people! Hit the point every time.

Give them close to a whole pound per order; it's a short season and it only comes once a year!

Put 2 disks of sable butter on small football, lay hot drained asparagus on top, lay 1 final disk of sable butter on top to melt on the way to the table.

I can't believe I have to say this but please arrange on the plate with all of the tips facing the same direction — not in a chaotic jumble.

Grilled Asparagus with Salsa Verde

4 orders

3–4 pounds asparagus
Salsa Verde (page 480)
EVOO

Leave spears as long as you can but trim any woody bottoms.

Cook asparagus, dry, *across* the grids on grill. *With* the grids will drive you mad all night long trying to retrieve them from the deep crevices.
Get good black char spots all over, until kind of mottled green and black.
Spoon salsa verde on bottom of small football, lay asparagus on top, and finish with one more spoonful over top.

Light drizzle EVOO at the pass.

Be generous with portion.

Braised Escarole with Raisins-on-the-Vine

4 orders

1 pound leafy escarole, cored and washed, toughest outer leaves removed

½ cup homemade rough and sweet white wine vinegar if we have it; otherwise, cider vinegar

4–8 ounces cold, unsalted butter, cut in cubes

8 small sprigs of on-the-vine raisins

freshly ground black pepper

1 whole nutmeg

kosher salt

In a large sauté pan, melt a very generous chunk of sweet butter. When it foams, add the escarole and sauté quickly over medium-high heat until it thoroughly wilts and releases its water, about 3 minutes. Continue to sauté until the water evaporates and the pan seems dry but for the slick of fat from the butter, 2–3 minutes.

Crowd the escarole over to one side of the pan, add the raisins and the vinegar to the empty space and simmer, covered, until the raisins swell and the vinegar reduces by half.

Integrate everything in the pan, then stir in the remaining cold butter, one chunk at a time. Use a microplane to grate the nutmeg to taste over the escarole. Nutmeg should be present but not overbearing. Season with pepper and salt.

Fresh English and Sugar Snap Peas with Wasabi Butter and Honeycomb

4 orders

½ pound shelled fresh peas

½ pound sugar snap peas, stemmed, left whole

6 Tablespoons Wasabi Butter

4 slices honeycomb

kosher salt

Cook shelled peas in an inch of salted water until starchy raw centers turn sweet and slippery on your tongue—90 seconds–2 minutes.
Add sugar snaps, stir around and cook for 60–90 seconds.
Drain off remaining water.
Slather in wasabi butter.
Spoon into shallow bowls. Cut oozy tablet of honeycomb and set on top.

For Wasabi Butter:

¼ pound unsalted butter, softened

1 Tablespoon + 1 teaspoon wasabi powder

2 teaspoons water

¼ teaspoon salt

Mix wasabi powder with water to make a paste.
Mix all ingredients together to thoroughly combine.

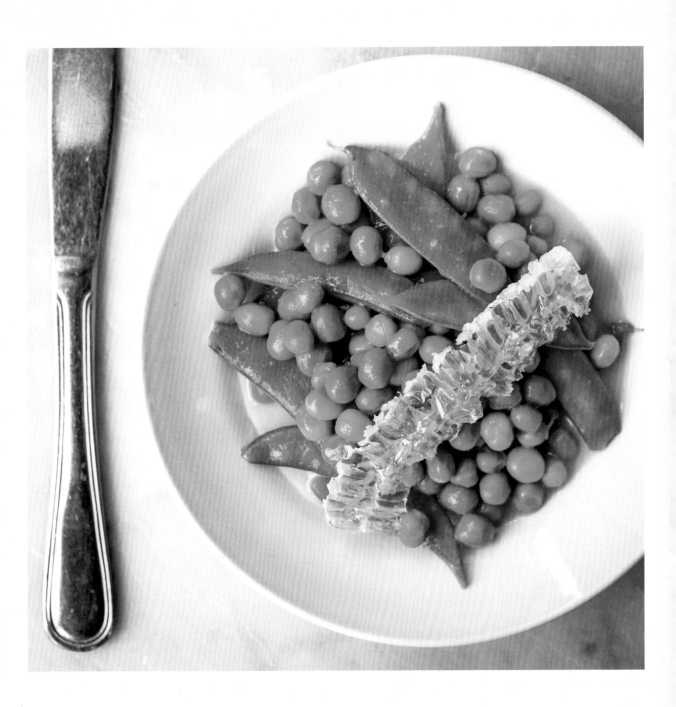

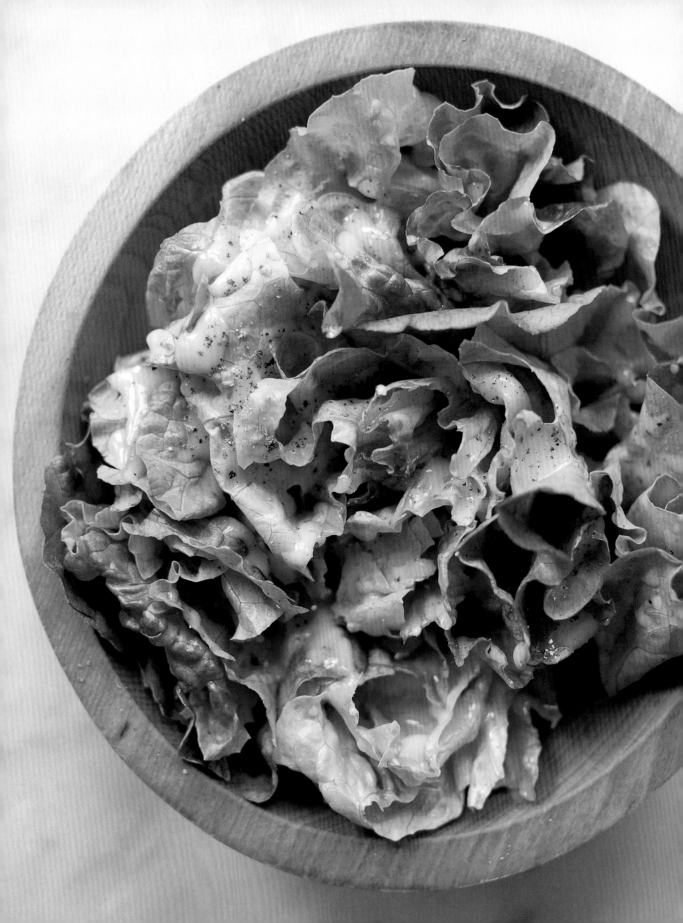

Soft Lettuces Vinaigrette

Well-washed Bibb, Red Leaf, or Little Gem lettuce.

Prune Vinaigrette (page 458)

** Perky. Lively. Fresh. Seriously. Pay attention. I have seen some wilted crap come out of this kitchen.*

Tear only once, by hand, and toss leaves in vinaigrette in stainless bowl before mounding into our wooden bowls to serve.

This way you can see if you have properly dressed. Over = sodden and the leaves can't "stand up." Under = dry patches and lack of glistening.

Reuse the same metal bowl for multiple orders but be aware of the dressing that builds up in there and contributes to overdressing. *Change out your bowl every 3 orders.*

Season with final sprinkle of salt and few grinds of black pepper once in bowl—and rain from on high, both salt and pepper. Keep the portion serious—we want a real salad, please, not a garnish.

Bitter Greens Salad Without Acid, Only Oil and Salt

arugula

cress

turnip greens

radish leaves

EVOO

kosher salt

Stay on the porters to save all of the radish and turnip leaves from daily vegetable prep and ask them to label and date the containers properly. It's crazy to let them throw away all those good bitter greens because they are in a hurry and don't want to be bothered.

Leave a bit of the cress stem intact—I love their peppery-watery contribution—but cull out the intensely large woody ones when you come upon them.

Also, because there is deliberately no acid in this salad, the stems kind of contribute in that way too.

Drizzle EVOO pretty liberally over the tangle in the wooden bowl. Rain gently with salt only.

Really fill the bowl. Not messy and overflowing, but like we mean it.

Grilled Spring Onions with Romesco Salt and Lime

spring onions, with tops left long

romesco salt

hojiblanca olive oil

lime

Trim roots of the onions and slip off one layer of the outer skin—like pulling off an evening glove. Rinse the onions well.

Lay the onions horizontally on the hot grids and grill until relaxed and charred in spots. Leave them dry and plain (undressed) when grilling to avoid flare ups. Remove when the bulbs have softened and the water in the onions sizzles and bubbles.

Depending on their size and condition, use 4–5 onions per order.

Lay them on the large oval plate, and let them be a little unruly.

Drizzle generously with the hojiblanca olive oil, and sprinkle evenly, liberally with the romesco salt.

Garnish with a lime cheek.

for the romesco salt:

x 1 packed pint = 4 oz.

¼ cup hazlenuts, toasted, skinned, and completely cooled

2 Tablespoons piment d'espelette

1 Tablespoon kosher salt

2 cloves fresh peeled garlic

2 Tablespoons fine ground breadcrumbs—our homemade ones, not panko

1 Tablespoon smoked paprika

zest of 1 lime, taken with sharp microplaner

Grind nuts with garlic and breadcrumbs in clean spice mill until very fine.

Stir nut mixture together with rest of ingredients. Use a fork or a small whisk to integrate and thoroughly blend—and then let dry briefly, before packing. Keep refrigerated and make fresh every other day.

Grind a piece of soft fresh bread in the spice mill when you are finished to remove any lingering garlic scent.

DINNER DESSERT

Breton Butter Cake

Please find me. We have to make this one together if it's your first time; it's tricky. Also, keep in mind, this isn't even a real kouign amann—it's Prune's streamlined and shortcut version of a real one—and even so, it's still impossibly difficult. Be sure to find me before you start and let's make it together.

Also, here more than any other thing we make, be sure to have all of your ingredients and all of your equipment at the ready in front of you before you start.

1 cake

10½ ounces all-purpose flour

1 pinch kosher salt

1 teaspoon and 1 splash orange flower water

1 teaspoon and 1 heaping ¼ teaspoon dry granulated yeast

1 cup tepid water

8 ounces salted French butter from Normandy (plus a few Tablespoons for melting
 and for preparing baking dish)

1 cup sugar (plus a couple of Tablespoons for finishing cake before baking, and for
 preparing the baking dish)

Equipment:

small stainless bowl

2 medium stainless bowls

glass pie plate

clean dry rolling pin

clean dry pastry brush

bench scraper

1 Tablespoon measuring spoon

curved plastic dough scraper

pint container of bench flour

½ sheet pan fitted with ½ sheet of parchment

Proof yeast in ½ cup of the tepid water in the small stainless bowl.

Mix flour and salt together in a medium stainless bowl.

Add bloomed yeast and the rest of the tepid ½ cup water and a splash of orange flower water to the flour/salt.

Work into a soft, sticky dough—I usually do this with my hands and with the round plastic dough scraper. Scrape all the dough off of your hands.

Spray a medium stainless bowl with Pam.

Use the plastic curved dough scraper and scrape entire contents of your sticky dough into the greased stainless bowl. Set on top of espresso machine until it has risen to double its size.

Set in refrigerator for half an hour.

While it is retarding, butter and sugar a 9-inch glass pie dish. Line a half sheet pan with parchment.

Lightly dust work surface with a little bench flour and set 8-ounce butter block on the dusted surface.

Lightly pound the butter with a rolling pin into a 6" x 8" rectangle, using the bare minimum of flour to keep it from sticking to the work surface and the rolling pin.

Retrieve starter dough from refrigerator.

Using plastic round scraper, get dough out of the bowl and onto the lightly floured work surface.

With your fingers, tenderly press and stretch the dough into a 9" x 11" rectangle as best as you can.

Use the metal bench scraper and lift the butter rectangle, center it inside the dough rectangle and, using your fingers, fully enclose the butter inside the dough, as if you were hastily wrapping a Christmas present.

Seal the seams as best as you can where the dough comes together, lift gently, and place seam-side down on the ½ sheet pan.

Return to the refrigerator for 5 minutes.

Be sure now to have at your work surface: a clean metal dough/bench scraper, a clean dry pastry brush, a small container of flour for dusting the work surface, a Tablespoon, and the 1 cup of sugar. Have a glass pie dish at the ready which has been buttered and sugared.

Make sure both your work surface and the rolling pin are absolutely clean and free of debris.

Lightly dust work surface and rolling pin with flour.

Retrieve dough from walk-in, and set seam-side down on floured work surface.

From here to finish work clean, work fast, and touch the dough with your bare warm hands as little as possible. Scrape the sticky bits that cling to the rolling pin often, incorporate them back into the dough, and keep your pin clean, dry, and dusted with flour. That being said—you want to use as little flour as possible from start to finish, so that this ends up more like a confection—butter and sugar barely held together with flour—and less like a cake or bread—butter and flour seasoned with sugar, if you follow me.

Roll dough to 8" x 14" rectangle. Immediately you will notice the butter enclosed inside start to bind with the dough.

Fastidiously sprinkle two Tablespoons of sugar over entire surface of sheet—but without spilling out onto work surface. (Any errant sugar on the work surface melts and makes the already fragile dough that much harder to handle.)

Using metal bench scraper fold top of dough down by ⅓, like a letter. Brush any bench flour off of dough.

Fold bottom ⅓ of dough up, like a letter, overlapping by an inch in the middle.

Brush off any flour.

Lift the dough with the metal bench scraper, rotate dough clockwise so seam is now north to south in front of you.

Roll out to 8" x 14" rectangle and repeat process of adding sugar in 2-Tablespoon increments.

Turn the dough a total of 8 times until all of the sugar is incorporated and the dough is sticky and almost unmanageable.

(This is like all laminated doughs—puff, croissant—and a "turn" is to roll out to legal-size sheet, fold like a letter, then rotate so the seam goes from north to south. This rushed, bastardized Prune version, though, skips the process of refrigerating between each turn. Maybe someday when we have a real pastry chef on staff . . .)

Between each turn, scrape bench clean, scrape pin clean, lightly dust both with flour, and move fast to keep dough as cool as possible.

Carefully get the finished dough, now weeping and pockmarked from all the sugar and also the salt in the butter—-seam side down, into the prepared pie dish and refrigerate for 1 hour.

Before baking, set on top of espresso machine until the rectangle shape of the cold dough has softened and ballooned to fill the pie dish, about 30 minutes.

Brush lavishly with the melted butter, sprinkle with remaining orange flower water, and sprinkle generously with sugar.

Bake in 425° oven for approximately 45 minutes.

Cover with foil if top is browning too fast and bottom of cake is not yet properly "candied."

Lift the pie plate up over your head so you can really scrutinize the bottom of the dough to see if there is a raw or undercooked center area, as happens often. You want an entirely "candied"-looking surface on the bottom, a bit like a socarrat in paella-making—that light crusty layer of rice that forms on the bottom of the paella pan.

Ricotta Ice Cream with Dark Caramel Croutons

Yield: 6 pints +/-

4 cups heavy cream

2 cups milk

18 egg yolks

2 cups sugar

6 cups ricotta, blended in Vita-Prep until silken

1/2 batch
2 c. cream
1 c. milk
9 yolks
1 c. sugar
3 c. ricotta

Scald milk and cream.

Whisk egg yolks and sugar in Kitchen Aid with whisk attachment until ribbony, thick, and satiny.

Season with pinch salt in final turns of the whisk.

Temper sugar/yolks mixture with some scalded milk. Be sure to scrape down sides of bowl and also bottom of bowl.

Return tempered egg to hot milk mixture and heat, over medium-low flame, stirring constantly with a heatproof rubber spatula, being sure to drag the bottom fastidiously to prevent scorching and scrambling the eggs.

Keep an Insta-Read with you and cook to 180°.

Move fast and remove custard from heat immediately, strain through fine-mesh sieve into waiting cold stainless bowl set over ice bath. That pot of custard is heavy and requires two hands to lift, for me at least. The tamis is useful here as it sits atop the waiting bowl conveniently and frees up your hands to lift and pour the hot custard. The chinois is a pain.

Spin the bowl in the ice, holding your rubber spatula stationary like a rudder in a boat, and bring the temperature down quickly.

Whisk in ricotta until fully integrated. Transfer to cylindrical bains and when chilled, give it a good buzz with the immersion blender.

Chill the custard overnight.

Churn in batches to machine capacity. *Set chill element for 30 mins before you churn.

Take care to taste for texture along the way, pulling out of the machine before any butter granules form.

Scoop into already labeled metal ⅓ pans and freeze. The tape label won't stick to a cold/frozen pan.

For the caramel:

Yield: 1 quart

2 cups sugar

½ cup water

4 teaspoons fresh lemon juice

½ pound butter

½ teaspoon salt

1½ cups cream

×2

4 c.

1 c. H_2O

8 tsp.

1 #

1 tsp.

3 c.

Heat lemon juice, sugar and water in heavy-bottomed stainless steel pot over low heat until sugar satisfactorily dissolves.
Raise heat and bring syrup to a boil. Hold the boil, without stirring, until syrup begins to turn golden, then reduce heat to low.

Combine butter and cream in saucepot and heat until butter has melted and the mixture is hot. Stir together well.
When sugar passes a deep golden color and is headed toward dark mahogany brown, immediately remove from heat and rest on countertop.

Whisk in butter/cream mixture.
Be careful. It really hisses and splatters when you add the cream.
Season with salt.
When cool, pack in quart containers.

For the croutons:
Remove crusts from 1 pound brioche Pullman loaf.

Cut brioche into 1½" square croutons. Show some knife skills, please. Sometimes I have seen them wildly uneven.

Arrange in single layer on parchment on sheet pan and toast slowly in 325° oven until golden on all sides and fully desiccated. You will have to turn them during the toasting to get undersides. Store in airtight container.

To plate:

Heat caramel very gently in small saucepot over lowest flame. Keep a small pot of this warm all through service, without letting it cook or separate. You'll have to shuffle it around a bit throughout the night.

Soak 5 croutons in the warm caramel while you temper your ice cream. Let the caramel penetrate the croutons without dissolving them.

Spoon croutons and caramel into bottom of bowl, place large, pleasing well-rounded mound of ice cream in center.

Please don't quenelle—we don't want to send that message.

Finish with just a few flakes Maldon sea salt.

Individual Apple Galettes with Whipped Mascarpone

20#

2 c.

1 pound apples per portion—only Rome, Braeburn, or Granny Smith

1 Tablespoon orange-scented sugar per portion, plus more for
 preparing the ramekins

unsalted butter for preparing the ramekins

1 5-ounce disposable aluminum ramekin per portion, buttered and sugared
 with orange-scented sugar

parchment collars cut and taped around outside of each to extend height
 of ramekins by 2 inches

1 2-ounce ceramic ramekin per portion

This is hands down the most labor-intensive, tedious production of anything we have ever made here throughout the history of time. And it's nothing but apples. I apologize for the tedium but, as ever, please take the time to do it right. Don't hack it, rush it, jack up the oven temperature, skimp on the portion size, decrease the height of the tower, or shortcut in any other way. Most important, do not forget to ask the morning crew to pull them when they arrive and don't ever forget to put a large sign on the oven door when you leave them overnight. I have seen some very real heartbreak.

!!!

Zest one orange, taken in full ribbon, and twist into 2 cups sugar to release as much of its oil as possible into the sugar. Store the orange peel in the sugar.

Peel the apples whole and core up through their centers, leaving hollow middles. Get all the seeds and all the sharp, plasticky pods.

Then cut the apples in ½ and slice thin ½ moons, ⅛" thick. Keep the apples organized neatly in front of you so you can keep track of portioning—it's just shy of two whole apples per ramekin.

Lay out sugared, collared ramekins in front of you.

Place two halves of apple into the bottoms of the ramekins, re-creating the circular shape they had when they were whole, by overlapping their cut edges slightly.

Sprinkle with ⅛ teaspoon orange sugar.

Turn ramekins a quarter turn and lay in 2 apple slices, re-creating a circle, by overlapping the cut edges slightly. Your seams will now be ¼ turn apart from the first layer. Sprinkle with ⅛ teaspoon of orange sugar.

Repeat in this way until you have filled the ramekin all the way to the top and exceeded the rim of the ramekin by a full inch, allowing the parchment collar to hold your tower of apple rings.

At a certain point, you will need to use three ½-moon slices per layer to make the circles complete as the circumference of the ramekin widens a bit. Each layer needs to be solid apple—you can't have a hollow center or the towers will cave in.

Sprinkle ⅛ teaspoon of sugar over every layer, including the final one.

When they are all built, set 2-ounce ceramic ramekins directly on top layer of apple inside of parchment collar to weigh down the apples during cooking.

Set the ramekins on a sheet pan and place in 175° oven and bake overnight—give them 8–10 hours.

Put a huge note on oven door so morning prep crew does not come in and crank ovens unwittingly. �належ ✶

Let them cool. Remove the collars.

They will be gorgeous, syrupy, juicy, and will have shrunk to almost ½ their original height.

Remove the ceramic ramekins carefully, making sure no apple has stuck to the bottom.

To plate:

Turn out into center of small shallow bowl. Allow all syrup to drain out.

Spoon or pipe a casual, glossy small dollop of plain whipped mascarpone in center.

Zest of 1 orange per 2 cups sugar is enough. Keep it subtle. Make in larger batches and store.

If you are hand-shopping apples at the farmer's market, be sure you know what variety you are selecting and only buy apples that retain their shape during cooking.

To assemble 20 of these is a formidable task. Plan your prep day accordingly or you will be seriously weeded.

Calvados Omelette

Yield: 4 orders

For the batter:

4 eggs

⅔ cup cream

1 Tablespoon plus 1 teaspoon granulated sugar

1 Tablespoon plus 1 teaspoon all-purpose flour

½ teaspoon vanilla extract (use Madagascar or
 Tahitian, not the Mexican)

pinch salt

4 teaspoons unsalted butter

x 12

12 eggs

2 c.

1/4 c.

1/4 c.

1½ tsp.

salt

4 T.

Combine the ingredients for the batter in a stainless bowl and whisk until thoroughly blended.

For finishing:

4 Tablespoons Calvados

4 teaspoons butter, softened

2 teaspoons sugar

Per order:

Heat 1 teaspoon of butter in a nonstick 6" pan. When foaming, add 2½ ounces batter and let set briefly. With a rubber heatproof spatula, pull omelette into the center from noon, 3, 6, and 9 o'clock and then do that again, from 1, 4, 7, and 11 o'clock until all the loose batter has run into the empty spaces and the omelette is set.

Lift up an edge of the omelette to see the color and when it is golden brown, flip the omelette.

Pour in a generous Tablespoon of Calvados and tip the pan to the flame to ignite the alcohol. Be sure that the Calvados you are using is at room temperature and not been refrigerated.

Remove the pan from the stove and let the flames burn out, then quickly slide onto a plate.

While warm, spread a teaspoon of softened butter over the surface of the omelette and sprinkle with ½ teaspoon of sugar to finish.

Butter and Sugar Sandwiches

Per order:

2 slices of Pullman bread, sliced ½-inch thick

¾ ounce unsalted butter, cool, waxy, but spreadable

1 teaspoon sugar, plus more for edging

2 ounces heavy cream

Spread half the butter on one slice of bread and half on the other slice.

Sprinkle ½ teaspoon sugar over each buttered slice. Press the two slices together and cut in half on the diagonal.

Put some sugar on a plate and dip cut edges of sandwich in it. Tap off excess for neat presentation.

Pour cold cream into a small coffee cup or large ramekin for dunking.

Nothing to hide behind here, so make sure the bread is ultra fresh, the butter-to-sugar ratio accurate, the temperature of the butter soft but not greasy or melted, and the cream fresh and cold.

Cornmeal Pound Cake with Rosemary Syrup, Candied Rosemary, and Poached Pear

For the cornmeal pound cake:
Shallow loaf

	x 1 deep	x 2 deep
1 cup all-purpose flour	1 c.	4 c.
1 cup cornmeal	2 c.	4 c.
5 eggs	10	20
1 teaspoon vanilla extract	2 tsp.	1 T. + 1 tsp
½ pound butter	1 #	2 #
1⅓ cups sugar	2½ c.	5⅓ c.
¼ teaspoon salt	salt +/-	salt

Set oven to 325°.

Prepare pans with spray, then parchment, then spray again and light dusting of flour on top of the parchment.

Use whisk attachment and beat butter in mixer until creamy.

Add sugar and salt, beat on high for 3–5 minutes. Let it get fluffy and opaque and nearly white and scrape down sides a couple of times during beating.

Add vanilla to eggs, then add eggs one at a time, more or less, to the creamed butter and sugar with the motor running on medium high.

Scrape down sides with rubber spatula and make sure all is incorporated a couple of times during the adding of the egg. Keep it light and fluffy; 3–4 minutes.

While butter mixture is creaming, whisk together the equal parts flour and cornmeal and turn out onto a full sheet of parchment.

Lift the parchment by the two long sides, creating a convenient chute, and add the flour mixture to the butter, ⅓ at a time, with the motor running on low.

Again with the rubber spatula! Please make sure you scrape down the sides and incorporate all of the material after each addition.

Neatly pour/spoon the batter into the prepared pan or pans. *✱ use the 4" x 13"*
that we use for banana bread

Spread the batter around with an offset spatula to make a smooth top, and tap the pans a few times gently to let the batter settle evenly in the pans.

Bake at 325° for 1 hour and 10 minutes. Test for doneness with a wooden skewer—the crumb of this cake is coarse enough that the wooden skewer is fine, preferred even—don't use the metal testers.

Cool in pan for 10 minutes, then turn out and cool on rack. Peel off parchment during the cooling.

For the pears poached in rosemary syrup:

6 Forelle pears, 1 day short of perfectly ripe

a few black peppercorns

½ vanilla bean, split

3 branches rosemary

1 cup Riesling

3 cups water

2 cups granulated sugar

Peel the pears in long gliding strokes, from stem to bottom, with a very sharp vegetable peeler, held like a paring knife. Don't chip away at them with short ugly strokes. Leave stems intact if you can swing it; it looks better on the plate.

Combine the water, wine, sugar, vanilla, rosemary, and peppercorns in stainless steel heavy-bottomed saucepot, large enough to just contain the pears.

Bring to a boil, then reduce to a gentle simmer.

Add the pears and cover with a double circle of parchment cut to the same diameter as the pot, and cover with a lid one size too small for the pot.

Poach the pears for just 10 minutes, or until a skewer inserted at the deepest center of the pear meets little—but some—resistance. To test the doneness, go up through the bottom and use a cake tester so you don't leave such a big hole from the wooden skewer.

Remove from the burner and let the pears cool in the syrup, keeping in mind that they will continue to cook from the residual heat.

Take care with your cooking time so that the pears can cool—and "cure"—in the syrup, like we do with all of the syrup-poached or candied fruits here. But if you've accidentally taken them too far, remove the fruit with a slotted spoon—and set them on a baker's drying rack over a ½ sheet pan—and get them in the walk-in quickly to cool down. Make sure they have some room around them for the cold air to circulate.

Rapid cool the syrup in an ice bath, return the fruit to the syrup when both are cool, and store in the syrup.

For the candied rosemary:

6 beautiful branches rosemary with thin leaves, not the tight bushy kind, 4" in length
½ cup cold water
1 cup granulated white sugar (check first to see if there is rosemary-scented superfine
 from previous batch and use that instead if so)
superfine sugar for dredging and storing

Thoroughly mix together sugar and water in small saucepan and set over medium-high heat.
Bring to a simmer.
Add rosemary sprigs and, without stirring, allow to simmer for just a few minutes, no more than 5. We want the syrup perfumed with the rosemary but the branches to retain their color, which will brighten in the hot syrup.
Remove from heat and with a fork retrieve rosemary sprigs from syrup, draining well. Make sure the rosemary is sticky but not dripping; you want the sugar to adhere in a light dusting and not like heavy snow weighing down the boughs of a Christmas tree.

Drag sticky rosemary spears through a good pile of superfine sugar, completely coating each sprig, and set them to dry on a baker's rack.
When completely dry, pack sprigs in superfine, and keep airtight. The rectangular take-out containers are good.

If the basement prep area is too humid, take them upstairs to pastry station and let them dry there. Otherwise they don't dry properly and they look amateur.

Reserve rosemary syrup for finishing the pound cake. And save the superfine for next batch of syrup.

On the plate:

Slab of cornmeal pound cake, approximately as wide as your thumb, cut in half on the diagonal.
Stack halves artfully.
Place pear beside pound cake, stem up.
Spoon substantial amount of rosemary syrup over pear, and allow to pool up a bit on the plate. Not swimming or drowned but generous.
Garnish with a candied, sugared rosemary sprig.

** Remind servers to tell customers the seeds are still inside the pears.**

Trou Normande

Per order:

In short-stemmed glass:

1 small well-packed scoop green apple sorbet from Il Laboratorio.

Make a small well in the sorbet with back of espresso spoon.

Pour over 1 ounce Calvados Pays d'Auge.

Set on espresso saucer.

Frozen Milk Punch with Sesame Biscuits

Yield: 20 orders

For the milk punch:

2 cups sugar

2 cups Gosling's black rum

1 cup Christian Brothers brandy

4 Tablespoons pure Tahitian vanilla extract

2 quarts milk

For the sesame biscuits (from *Foods of Greece* by Diane Kochilas):

¾ cup olive oil

¾ cup sugar

1 Tablespoon baking powder

½ teaspoon baking soda

pinch of salt

1 Tablespoon ground cinnamon

½ cup dry red wine

3 cups flour

1 cup sesame seeds, toasted

plastic mister bottle with clean cool water

For the milk punch:

In a large stainless bowl, whisk together all of the ingredients, making sure that the sugar has completely dissolved by running your finger across the bottom of the bowl and checking that there is no grit of sugar.

Divide among 4 heavy-duty quart containers, leaving room at the top for the mixture to expand when frozen. Cover with lids and freeze for at least 24 hours.

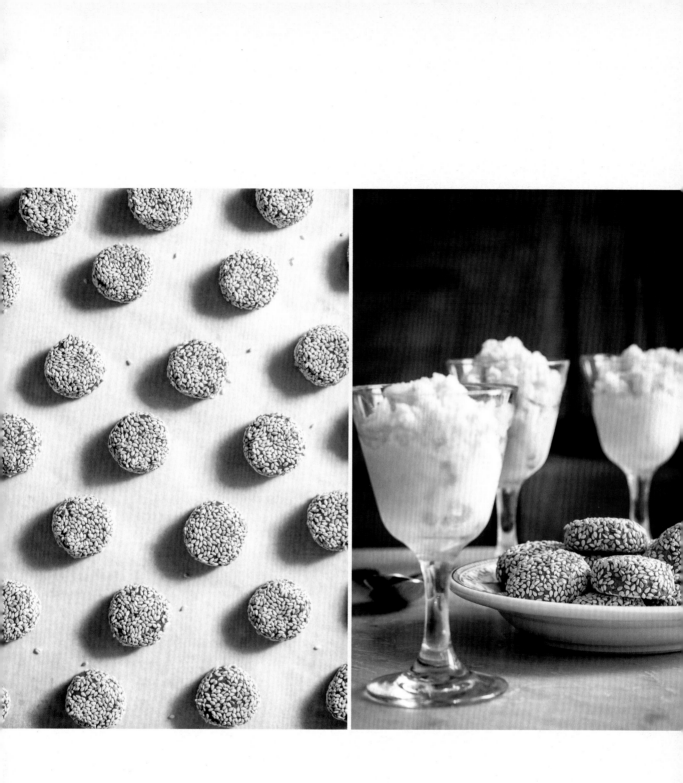

Remove 1 quart at a time—as needed—and, using a sturdy fork or the Parmesan spade, chop up the mixture right in its own container until it becomes slushy. Re-freeze.

For the sesame biscuits:

Set oven to 350°.

In a large stainless bowl, whisk together the sugar and the olive oil until dissolved and creamy.

Add the baking powder, baking soda, pinch of salt, cinnamon, and red wine and whisk until thoroughly combined.

With a sturdy spoon, stir in the flour and beat vigorously until the dough comes together, then knead by hand a moment to a smooth consistency.

Scoop 1-inch balls of dough and roll into perfect spheres between the palms of your hands, then press each cookie between thumb and forefinger to make a thick button or puck shape.

Dip in toasted sesame seeds to fully coat and lay on sheet pan lined with parchment. (You do not need to leave much space between them as they do not flatten during baking.)

If you have difficulty getting the sesame seeds to stick, mist them super gently on the finest setting with the water before tossing in the sesame seeds.

Bake for 20 minutes.

When completely cool, pack in airtight containers.

To plate:

3 sesame-red wine biscuits, small glass frozen milk punch, long-handled iced-tea spoon.

Lemon Panna Cotta with All the Summer Berries, Cooked with Cassis

Yield: 8 orders

For the panna cotta:

3½ cups heavy cream

1 cup milk

½ cup sugar

grated zest of 2 lemons

1 scant Tablespoon granulated gelatin

¼ cup water

Sprinkle gelatin over water in thin, even film to bloom.

Scald milk and cream with the sugar and lemon zest.

Dissolve the softened gelatin in the scalded milk.

Strain through fine-mesh china cap into stainless bowl set over ice bath and chill until starting to become viscous, but don't let it gel.

Give it a go with the immersion blender, then portion into nine 4-ounce ramekins.

Chill overnight.

Taste the 9th panna cotta to know how the other 8 are.

For the berries:

4 pints mixed berries—try to include 1 pint of red currants if they are available

¼ cup crème de cassis (use the beautiful stuff from Dijon—ask bar manager to order extra when this is on the menu)

¼–½ cup sugar (depending on the sweetness of the fruit)

Briefly rinse berries. If there are excellent small strawberries, hull them and leave whole or cut in half, depending on their size.

Cook down berries with sugar in stainless steel pot until the berries swell and release a ton of juice but still retain texture and shape. Maybe 10 minutes over medium heat, but keep an eye on it.

Cool quickly over ice bath, but stir very gently. Don't manhandle. When cool, stir in cassis.

To plate:

Spoon berries into the dessert bowl first and then turn out the panna cotta into the center or vice versa, whichever you find easier. I don't need to micromanage how you get it into the plate, but be sure the panna cotta is a pristine white glorious blob in the center and that you do not stain it or drip on it with berry juice.

A flat of berries costs 50 bucks.
★ DO NOT OVERCOOK ★

Mastic Fondant in Ice Water

Yield: 1 full pint:

2 cups sugar

⅓ cup glucose

½ cup water

1 full teaspoon mastic crystals

In clean spice grinder, grind mastic crystals with 1 Tablespoon of the sugar to powder.

Combine rest of sugar and water in small clean stainless pot with tight-fitting lid and bring to simmer. When sugar is completely dissolved and liquid is clear, add the glucose. Bring mixture to 240°—lid on, lid off—as needed to prevent sugar crystals.

Stir in ground mastic powder; remove from heat.

Set a couple of hotel pans filled with ice and a little water and a good shower of salt (to bring temp way down) on your work surface and chill a nice section of the stainless steel worktable in front of you, about 3 feet wide. Chill your work surface for as long as you can while the syrup cools to 110°.

Get the sturdy metal dough scraper with the wooden handle—the syrup is hot and hard to work.

Remove the ice pans; make sure the counter is dry and clean, and cold.

At 110°, pour syrup directly onto cold counter, and go at it: big, sweeping figure eights with the dough scraper. Move fast and give it muscle. Work the paste over and over and over like this. You will bring it from a syrup to stiff soft taffy, from clear glass liquid to opaque glossy white paste.

Use the dough scraper to transfer the fondant to a glass Ball jar with a lid; does not need to be refrigerated, but can be. Scrub down the table immediately with hot soapy water and the metal pot scrubbers. The mastic will leave a sticky film for a couple of days, but continued daily scrubbings eventually get it all off. Make sure you clean out the spice mill container with a dry cloth—once mastixa gets wet, it's a nightmare to remove.

To plate:

One healthy spoonful neatly scooped up with a long-handled parfait spoon, dropped into tall glass of ice water. Set the glass on an espresso saucer to serve.

Pear Tarte Tatin

Yield: 8 orders

4 (2½ pounds) Bosc pears, peeled, halved and cored
1 cup sugar
¼ cup unsalted butter, cut into small cubes
2 Tablespoons light corn syrup
1 sheet puff pastry
Brown Sugar Ice Cream with Balsamic Syrup Swirl (page 248)

Sprinkle sugar evenly over bottom of heavy 9" cake pan with 2"-high sides.

Scatter butter cubes over sugar, then drizzle with light corn syrup.

Arrange the pear halves in the sugar in an attractive circle, round bottoms at the edge, pointed tips at the center, and the hollow core side up with the rounded bottoms down on the sugar.

Place the pears in a 375° oven and let them cook for about 2 hours and 45 minutes, until they become candied orbs, translucent and gorgeous. Don't turn them or touch them. Just leave them in the oven.

Cut a full 9" circle from the puff pastry and place on ½ sheet pan fitted with a ½ parchment sheet.

Bake in the 375° oven for approximately 15 minutes until the pastry disk is golden brown and puffed up like a pillow. Remove and let cool.

When the pears are cooked and the sugar has started to become caramel and the juices from the pears have become part of the sugary caramel, remove the pears from the oven and place the cake pan directly onto the stovetop burner. If the pears were not ripe and juicy enough at the outset, pour in a little liquid to help the caramel along. Use pear juice, apple cider, or if there is pear water from brunch pancake prep, use that.

Over low heat, cook the syrup just a few minutes until big soapy bubbles form and the syrup becomes a true amber caramel. Remove from heat immediately.

Place the puff pastry pillow directly on top of the pears—domed-side down. It should fit snugly and perfectly within the diameter of the cake pan.

Place a clean ½ sheet pan lined with parchment over the tatin and very carefully—but swiftly—invert. Tap the pan to be sure all of the pears have dropped down, then remove the cake pan.

Portion into eighths—allowing full ½ pear per slice.

Serve warm with the Brown Sugar Ice Cream (page 248).

Brown Sugar Ice Cream with Balsamic Syrup Swirl

For the ice cream:

6 egg yolks

¾ cup brown sugar

1½ cups heavy cream

1½ cups whole milk

½ vanilla bean, split and scraped

1 cup balsamic vinegar (use the bulk crappy jug kind,
 not our expensive aged stuff in bottles)

x 2 QTS.
+/-
———
12 yolks
½ c.
3 c.
3 c.
1 bean

Reduce balsamic at a gentle simmer in a stainless steel
saucepot by exactly half. Allow to cool.
Beat yolks with ½ cup of the brown sugar in stand mixer with whisk attachment until
ribbony and doubled in volume.
Whisk together cream, milk, and remaining ¼ cup of the sugar, and vanilla bean and
then bring to scald over medium-high heat.
Add hot milk mixture to yolks slowly in a steady stream with the mixer on low speed
to temper.
Return custard to pot and cook over medium heat, constantly stirring and dragging
the bottom with a heatproof rubber spatula to prevent scorching/curdling. Don't use a
whisk. Bring to 180°.

Remove from heat and strain immediately into a cold bowl set in an ice bath to cool
rapidly. Spin bowl round and round inside the ice bath, holding your spatula still in
the cooling custard like a rudder in a boat, until the temperature significantly drops.
Transfer to lidded containers and refrigerate overnight.
Buzz chilled custard base with immersion blender before churning.
Churn in batches to machine capacity.
Drizzle in balsamic syrup in the last turn of the blades to swirl and shut off machine
before the syrup loses its distinct swirl. Transfer to metal pans and freeze immedi-
ately. Allow to freeze overnight before using.

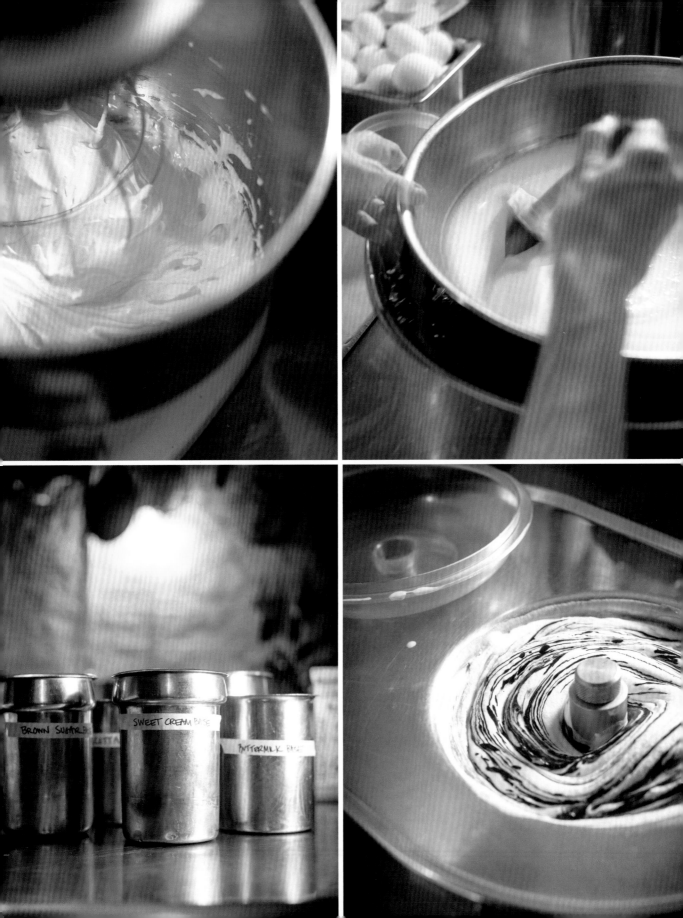

Cornmeal Cookie with Candied Rhubarb and Cold Almond Cream

Yield: 8 cookies

For cornmeal cookie:

12 Tablespoons butter

¼ cup 10X sugar

½ teaspoon vanilla extract

pinch salt

1 cup all-purpose flour

½ cup cornmeal

x16

12 oz.
½ c.
1 tsp.
½ tsp.
2 c.
1 c.

Cream butter, sugar, and vanilla at medium speed for a full 5–6 minutes. Use the paddle attachment.

Add flour, salt, and cornmeal and mix on low setting until blended; 3 minutes. It's a stiff dough; don't overwork the machine!

Turn out onto counter and flatten into manageable disk or rectangle, then wrap with film and refrigerate 1 hour.

Spot-spray the table with Pam to secure a sheet of parchment so it doesn't slip around. Roll chilled dough out directly on the parchment to even ⅛" thickness.

Lift parchment onto sheet pan and cut large circles, but do not remove trim or cookies themselves—dough is too fragile. Use the 5" fluted-edge cutter.

Chill in freezer or walk-in for 20 minutes before lifting off the excess dough. Reroll scrap to get full yield.

Bake cookies 18–20 minutes in conventional oven. Rotate once halfway through.

When cool, dust evenly with 10X sugar rained down through fine-mesh sieve.

** Don't need much space between — they do not spread during baking. **

For the candied rhubarb:

8 orders

1 pound crimson/pink ripe rhubarb, cut into
 1-inch slices

1 cup superfine sugar

** order hothouse/conventional NOT THE ORGANIC STUFF FROM THE FARM, PLEASE.*

Macerate rhubarb with superfine sugar in a stainless steel bowl for 45 minutes or an hour, until sugar has dissolved and syrup has formed.

Turn out in single layer into hotel pan.

Crumple a sheet of parchment paper, run it under cold water, then uncrumple it and drop it loosely on top of rhubarb and set in 300° oven until tender, about 40 minutes.

I forget who taught us this trick but it lets the rhubarb steam ever so slightly during the roast and it retains its shape without dissolving into mush.

For the almond cream:

2 cups

5 egg yolks

3 Tablespoons sugar

1½ cups milk

pinch of salt

1½ teaspoons pure almond extract

x 1 qt.
10 yolks
6-8 T.
3 c.
salt
1 T.

Whisk together yolks, sugar, and salt just to blend.

Scald milk.

Temper yolks with some of the hot milk, then add all milk to yolks. Mix well. Return mixture to pot and stir constantly with large rubber heatproof spat over *medium* heat. Do not crank the heat to make it go faster. Drag the bottom fastidiously to prevent any scrambled egg bits. Cook to 175°. Stir gently and continuously. Don't walk away.

Pour through fine-mesh chinois into waiting chilled bowl set over ice bath. Add almond extract. Spin the bowl, using rubber spatula like a boat rudder, to rapidly chill.

This crème anglaise base is Emily Luchetti's from the old *Stars* book. Don't use any other! Don't grab recipes from the Web willy-nilly. There is so much unreliable crap out there.

To plate:

Nice pool of cold almond cream.

Neat spoonful of candied rhubarb set in center.

Cap with giant cookie.

Be careful not to leave your fingerprints in The powdered sugar when plating.

Zucchini Fritters, Whipped Greek Yogurt, Toasted Almond Sugar

Yield: 8 orders

For the fritters:

2⅓ cups shredded zucchini

1 teaspoon ground cinnamon

¼ cup sugar

¾ cup almond or pistachio flour

all-purpose flour, as needed to bind batter

3 eggs

1 cup Greek yogurt

honey

For the toasted almond sugar:

x shy 1 pint

¼ teaspoon ground cardamom

⅓ cup skin-on almonds

⅓ cup sugar

grated zest of 1 lemon

Toast the almonds on a sheet pan in the oven until fragrant and just turning color but not thoroughly brown. Let cool *completely*.

In the pastry-only bowl of the Robot Coupe, combine the cool nuts with the lemon zest, cardamom, and sugar and grind until fully blended—like sand.

In a large nonstick pan over medium heat, spread out the sugar-almond mixture in one even layer. Allow the sugar to melt and then start to toast—tend it obsessively with your heatproof rubber spatula—until a kind of brittle candy forms. (Take care: This can go from raw to totally burnt in a flash. But it takes almost 10 minutes to start to

candy; don't lose focus and don't hasten by cranking the flame.) As soon as the candy forms and is amber, turn it out onto a cool tray lined with parchment to immediately stop cooking and cool down.

When it is cool and dry and brittle, run the heavy rolling pin over it a few times to break up into crunchy bits.

For the fritter batter:

Beat the eggs with the sugar and cinnamon. Stir in shredded zucchini and almond flour and blend thoroughly. Add AP flour as needed if too wet.

To pick up:

Use 2-oz. ice cream scoop and drop batter directly into hot fat (350°) on pastry side of deep fryer. 3 not-dainty fritters per order. Pull when puffed and golden, 2 minutes +/-.

Drain in stacked coffee filters.

Whisk yogurt to loosen a little.

To plate:

Casual dollop yogurt in center of shallow bowl.
Fritters nested on it.
Drizzle generously with honey, but from on high, in thin threads.
Sprinkle with toasted almond sugar candy.
Sell with Mastic Fondant in Ice Water (page 244).

Black Licorice Granita
with Orange Cream

Yield: 2 pints

For the black licorice granita:

1 cup sugar

2 cups water

1 cup black strap molasses

pure anise extract

pinch of salt

[handwritten note on torn paper:] x 3 qts.

3 c.
6 c. H_2O
3 c.
anise
salt

For the orange cream:

zest of 1 orange

1 quart heavy cream

2 Tablespoons sugar

[handwritten note on torn paper:] x ½ batch

zest
2 c.
1 T.

For the black licorice granita:

Boil water and sugar for 10 minutes.

Flavor with molasses and anise and add more/less accordingly—we want uncanny taste of black licorice candy.

Focus the story with one pinch of salt.

Pour into hotel pan and freeze.

Scrape with fork intermittently all day. Be sure to drag up the bottom, where the heavier, denser molasses tends to settle—so we don't have wan ice on top and cloying ice at the bottom when you portion.

If you set the pan in the freezer and totally forget it for the rest of the day, neglecting to rake the fork through at intervals, it can be easily recovered by grinding big chunks in the processor and refreezing.

For the orange cream:

Combine orange zest, cream, and sugar in quart container with tight-fitting lid and shake well until sugar totally dissolves.

Steep cream for 24 hours. Strain out zest and whip to order, to soft peak stage. Only whip what you need and keep the rest as backup during service.

To plate:

Spoon granita into short-stemmed glass, pack tightly.
Spoon soft dollop orange cream on top.
Set glass on small saucer.

this works better if you grind the zest with the sugar in the spice mill before you combine with the cream.

Fresh Currants in Sugar

Rinse a few stems per order. Gently shake off water drops. Set on serious bed of granulated sugar.

Concord Grapes in Shaved Ice

Rinse grapes. Bury loosely in shaved ice. Garland with fresh bay leaves around the rim.

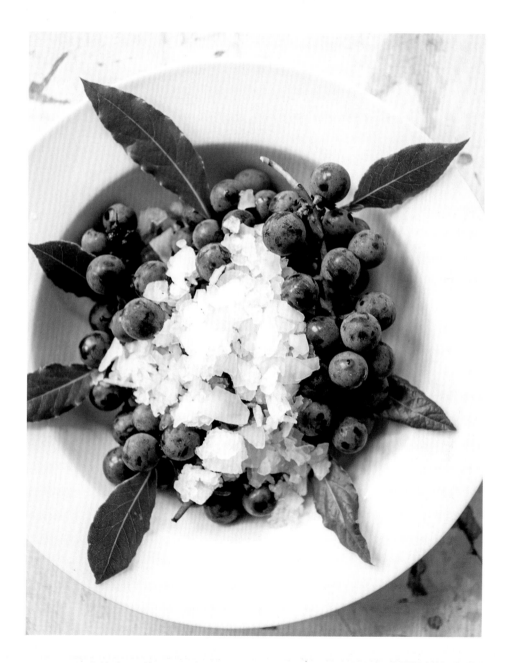

LUNCH

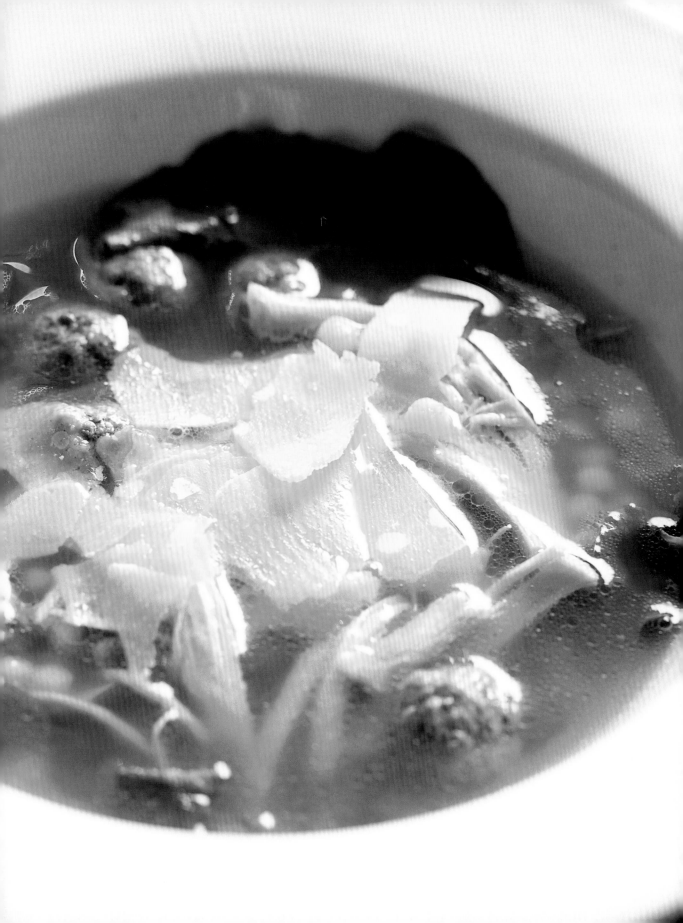

Italian Wedding Soup

Yield: 4 orders

3 cups Capon Broth (page 452)

1 cup shredded capon meat from making Capon Broth

½ cup fregola pasta, toasted and parcooked

bitter greens—radish tops, turnip tops, arugula, cress leaves

shaved Parmesan

1 pound ground lamb shoulder

2 Tablespoons finely chopped parsley

2 garlic cloves, microplaned

salt and freshly ground black pepper to taste

Combine ground lamb, parsley, and garlic and season with salt and pepper. Gently form mixture into 1" meatballs.

In small soup pot, bring capon broth to simmer.
Add toasted fregola to simmering capon broth and cook for 5 minutes, until chewy but pleasant, with tiniest raw quality remaining.
Add meatballs to stock—simmer them 5 minutes.
Drop in the capon meat to reheat.

Place a small handful of mixed bitter green leaves in each bowl.
Spoon out meatballs and chicken meat and pasta and broth all over the greens to wilt them and submerge them in hot soup.
Season with salt and pepper.
Garnish with shaved Parmesan at the pass.

Ajo Bianco

Yield: 3 quarts

1 quart whole blanched almonds

1 quart cold water

½ quart panko, soaked in just enough water to make it swollen and flabby and wet

7 garlic cloves

½ cup sherry vinegar

½ cup Hojiblanca olive oil

salt to taste

1 full pint homemade grape juice (puree green grapes in the blender and strain through a sieve)

In the Vita-Prep, grind the garlic and almonds with the cold water. Add vinegar and salt to taste.

With the motor running, add the olive oil in a steady stream until incorporated.

Add the soaked panko and blend to creamy, white, and smooth.

On very low speed, stir in the grape juice. Taste the soup. Add vinegar, salt, more ✳ ✶ garlic, or oil as needed. Keep it balanced and refreshing.

Serve cold, in glass tumblers from the freezer, each set in a coffee saucer.

Garnish with sliced green grapes and Hojiblanca olive oil—you can do beads or drizzle; I am fine either way.

Taste for seasoning every day, every time you plate it—-I have been amazed at how the bread continues to dumb down the soup long past what I would have anticipated.

Gazpacho

Yield: 2 quarts +/–
Base:

	x 8 qts.
46 ounces Sacramento tomato juice	3 tomato
15 ounces clam juice, strained through	1 clam
clean, dampened cheesecloth	
2 large garlic cloves, microplaned	6 cloves
1 Tablespoon jalapeño, grated on microplane	1 jalapeno
—do not include the seeds	
¼ cup extra virgin olive oil	¼ c.
¼ cup red wine vinegar	¼ c.
1 Tablespoon Tabasco	4 T.
salt to taste	s + p
freshly ground black pepper to taste	

Measure by weight AFTER prepping:

⅓ pound brunoise of yellow pepper	1#
⅓ pound scallions—thinly sliced	1#
⅓ pound brunoise of yellow tomato	1#
⅓ pound brunoise of radish	¾#
¼ pound peeled and seeded cucumbers, brunoise	1# cuke
¼ pound brunoise celery hearts	¾# ♡'s

Mix all together and chill very well.

I know this one is a bitch to prep. Sorry. Think of it as a good way to keep your knife skills in shape and be glad we only serve it one month a year.

Expediters, please remind servers about the clam juice in case of customer allergy/restriction.

1/2 Ripe Avocado with Hojiblanca Olive Oil and Meyer Lemon Juice

perfect avocado
Hojiblanca olive oil
small Meyer lemon
Maldon sea salt

Split avocado pristinely. Drop heel of knife into pit and twist to remove.

Fill cavity with Hojiblanca.
Squeeze ½ lemon—about 1 teaspoon juice—into cavity.
Sprinkle all over with Maldon flakes.

Obviously, nothing to hide behind here. Any avo's with dark spots/imperfections, save for family meal.

*store cut avocado in quart container of ice water during service to keep color fresh.

Fried Whole Baby Artichokes with Saffron Aioli and Fennel Pollen

Yield: 4 orders

20 whole baby artichokes
EVOO
1 Tablespoon fennel pollen
1 Tablespoon kosher salt
Saffron Aioli (recipe follows)

Clean up chokes as minimally as possible. Trim black tip of stem, strip any black leaves or heavy fibers from stem. Use veg peeler.
Use your fingers to pry open the tight buds and make the heads look bloomed.
Don't worry about chokes; these are young and edible throughout. Only the mature ones need to be treated differently.

Blend salt with fennel pollen.

In small saucepot, heat EVOO to 335°; use thermometer. Don't ever do this in any other restaurant—no one on earth recommends frying in olive oil. Make sure you have enough oil to deep-fry, without overcrowding the chokes.

5 per order. Fry whole artichokes until golden and crispy—solid 5 minutes.
Remove with slotted and drain in coffee filters.

To plate:

Ample and generous spoonful of saffron aioli spread in a wide swath the length of the small football plate.
Artichokes artfully "strewn" in a casual arrangement on top.
Sprinkle with fennel salt—be sure to season each arti.

* Reuse olive oil 2-3 services only. *

For the Saffron Aioli:

Yield: shy 1 quart

1 yolk

1 whole egg

3 Tablespoons fresh lemon juice

2 garlic cloves

salt

big pinch saffron, steeped in 2 Tablespoons warm water

3 cups blended oil

Grind garlic and salt in Vita-Prep. Use low speed until there is enough material to catch the blades, then add yolk and whole egg and turn motor up. Puree to ultra-smooth.

Add lemon juice and saffron water and puree to smooth with uniform color—not stained and blotchy.

Medium-high motor, add oil in swift, steady stream to emulsify.

Adjust acid/salt as needed.

Chicken Broth with Dumplings and Parsley-Radish Garnish

Yield: 4 orders

For the dumplings:

1 pound chicken livers (partially frozen)

2 thick slices peasant bread, crusts removed

2 egg yolks

2 egg whites

½ teaspoon cream of tartar

¼ cup unsalted butter, at room temperature

¾ cup finely diced yellow onion

½ cup finely chopped flat-leaf parsley
 (yield after chopping)

¼ cup all-purpose white flour

1–2 cups panko

salt

freshly ground black pepper

For the garnish:

¼ pound chicken skin

1 lemon, washed

2 shallots, small dice

6 lively sprigs flat-leaf parsley

4 red globe radishes, thinly sliced

For the soup:

4 cups Chicken Stock (page 448)

2 cups parcooked egg noodles

Column (× 8):

x 8

2 #
4
4
4
1 tsp.
½ c.
1½ c.
1 c.

½ c.
panko

s + p

½ #
2
4
parsley
radish

———

2 qts.

Column (× 16):

x 16

4 #
8
8 eggs,
separated
2 tsp.
1 c.
3 c.
2 c.

1 c. AP

panko

s + p

1 #
4 lemons
8 shallots

1 gal.

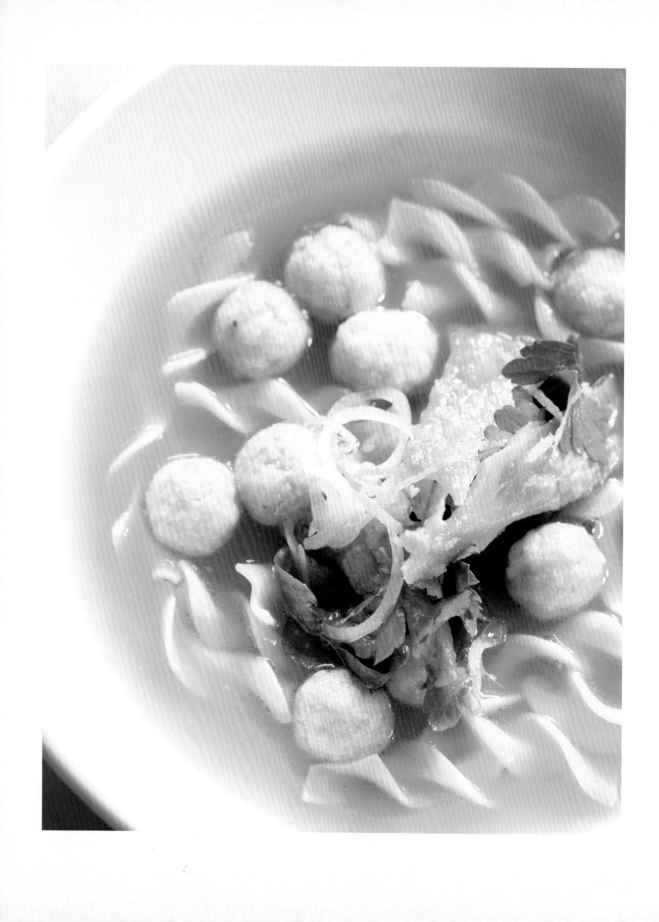

To make the dumplings:

Soak bread in cold water.
Grind chicken livers in food processor until pureed.
Squeeze crustless bread as dry as you can, and mix with ground livers in stainless bowl.
Stir in yolks, onion, parsley, salt, pepper, flour.
Add softened butter and stir until the mixture is flecked/marbled with soft butter.
Beat egg whites with cream of tartar until stiff, like shaving cream.
Fold egg whites into dumpling mixture, and gently incorporate until there are no more streaks or blobs of egg white.
Add panko as needed, using a light hand. The mixture should be firm enough to hold a shape but delicate and not too heavy with breading.
Refrigerate.

To make the garnish: *(from Chris Borunda — total deliciousness!)*
Slowly render the chicken fat from the skins until all the fat has liquefied and you are left with crispy, delicious fried chicken skins. Save the fat.
Remove the crispy skins with a slotted spoon and salt while warm. Set aside.
Zest the clean, dry lemon into a small bowl, then cut the lemon in thirds and squeeze the juice into the same bowl, taking care to catch the seeds.
Toss into this bowl the radish slices, the parsley sprigs, the diced shallot, and a small spoonful of the rendered chicken fat; season with salt and pepper and set aside.

To finish:

Bring chicken broth to a boil, then reduce to lively simmer.
Form dumpling mixture into very small balls and poach until they are tender through.
Add noodles to heat through.
Neatly and attractively portion the soup.
Add the fried, salted chicken skins to the parsley-radish mixture, toss together briefly, and garnish each soup with a portion of the "salad."

Bacon and Marmalade Sandwich on Pumpernickel Bread

Per order:

5 slices cooked bacon
sweet butter—plenty
2 slices pumpernickel toast
2 Tablespoons bitter orange marmalade
freshly ground black pepper
Crunchy Lunch Potato Slaw (page 330)

Hold cooked bacon warm near the grill.

Toast pumpernickel under sally—both sides.

Butter generously, "wall to wall," both slices. Spread thin layer bitter marmalade on one slice only, also wall to wall.

Lay out bacon on top of marmalade. Grind black pepper on top. Close with other buttered pumpernickel slice.

Cut straight in half and stack neatly, casually, on large football.

Slaw goes in monkey dish next to sandwich.

♡ Brendan Keegan ♡ (Jr.)

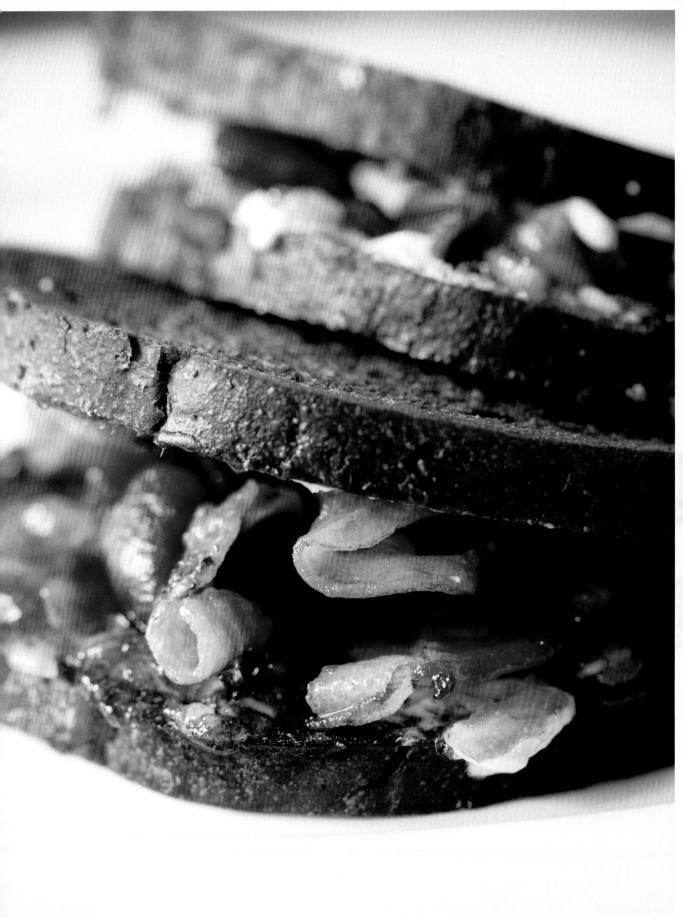

Ratatouille Sandwich with Aioli and Fried Capers

Yield: 3 quarts

2 large, black, standard eggplant, cut into 1" dice, salted for ½ hour, then rinsed and
 drained

1 yellow squash, ½-inch dice, seeds removed

1 zucchini, ½-inch dice, seeds removed

12 garlic cloves, peeled, smashed

1 medium yellow onion, peeled, medium dice

4 small red raw beets, peeled, small dice

1 sprig rosemary leaves, stripped off branch

¾ cup Kalamata olives, pitted, neatly ¼'d

3–4 Tablespoons capers in brine

4 oil-packed anchovies

10 Muir Glen whole peeled tomatoes

2½ cups extra virgin olive oil

peasant bread

Aioli (page 483)

toasted poppy seeds

brined capers, drained

To remove the seeds of zucchini and summer squash, cut the bodies in half length-
wise, then in ½ again, leaving 4 long spears. Slice horizontally to remove the pocket
of seeds from each quarter, then continue to mise for the ratatouille.

In large rondeau, over medium-high heat, sauté the zucchini and yellow squash in
1 cup of the olive oil about 15 minutes.

Remove with a slotted spoon to a hotel pan.

Add another ½–1 cup evoo and sauté eggplant until it starts to take on nice golden color.

Remove eggplant with slotted to same hotel pan.

Add rest of evoo to rondeau and sauté onion, garlic, anchovies, rosemary, and capers until soft and luscious.

Add tomatoes and their juice to the pan, crushing them a bit through your fingers, and heat through, stirring well. Combine all the cooked veg, as well as the raw beets, in the hotel pan and stir well.

Season with salt and pepper.

Cover tightly with foil and finish in 350° oven for 45 minutes–1 hour, until beets are tender and ratatouille is soft and unctuous but not collapsed to mush.

Keep ahead on your prep, to give the ratatouille a couple of days to really meld before using.

To plate, per sandwich:

1 10" slab peasant bread, no thicker than your pinky—toasted.

Several spoonfuls of loose aioli, evenly and lusciously spread the length and width of the toast.

1 full cup ratatouille at room temperature, gently spread out over aioli toast.

One loose stripe of aioli down the center of the ratatouille; use your spoon and let aioli drip off in a ribbon without touching spoon to sandwich.

Toasted poppy seeds sprinkled over sandwich.

Fry a teaspoon of capers in a teaspoon of olive oil until they burst and get a little papery. Scatter over sandwich while still warm.

★ Remind waitstaff There is anchovy in the ratatouille for vegetarian concerns ★

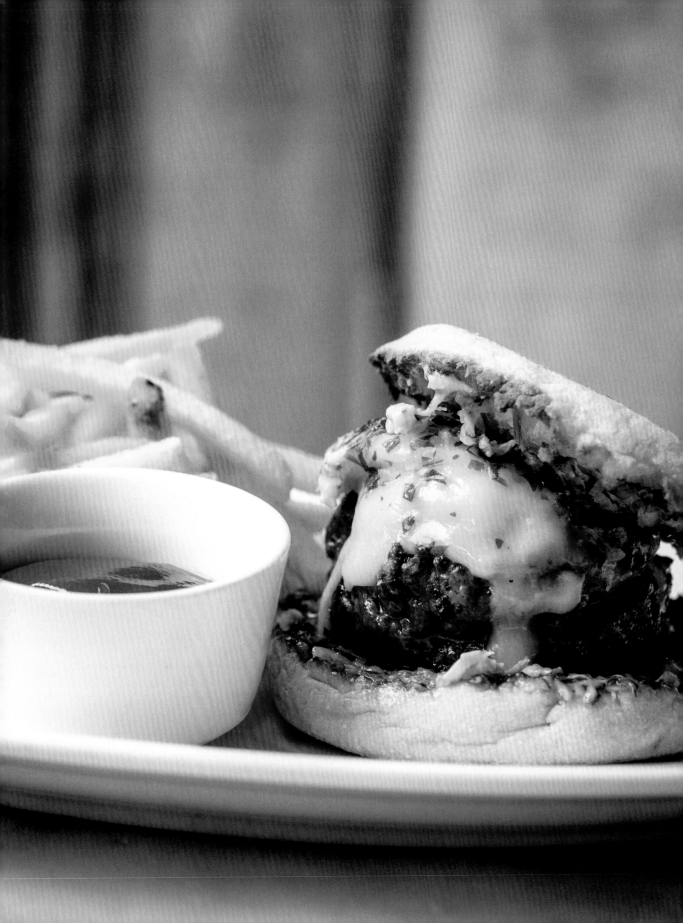

Grilled Hamburger with Cheddar Cheese on Toasted English Muffin with Parsley-Shallot Butter

Yield: 4 orders

1 pound ground chuck

½ pound ground lamb

4 ounces (4 slices) sharp white cheddar,
 sliced (use #20 setting on meat
 slicer for solid ¼-inch slices)

2 teaspoons kosher salt

2 teaspoons freshly ground
 black pepper

4 Thomas's original sandwich-size
 English muffins

Parsley-Shallot Butter (page 467)

T/W/Th	M/F
4#	8#
2#	4#
1#	2#

Run your hands under very cold water for a minute, then gently combine the two meats.

Put parchment or film on the electronic scale before weighing, please. Divide the meat into equal portions (6 ounces each) and then gently form portions into patties that are 1¼" thick and 3" in diameter.

Season each burger all over—top, bottom, and the circumference—with ½ teaspoon salt and ½ teaspoon black pepper. Hold your hands high and "rain" the salt and pepper.

Touch the patties as tenderly and as little as possible. The more you manhandle and compact the meat, the tougher it becomes.

On the medium-high heat section of the grill, place the burgers 2 inches apart from each other. Cook to accurate temperature. For medium rare, cook for 7 minutes on one side, flip, and cook for 5 more minutes. Do not turn, touch, press down on, or otherwise molest the burgers while they are cooking. Put burger on a sizzle plate, place cheese on top, and drop under the broiler until the cheese is just melted but not liquefied.

Split the English muffins by deeply pricking them along the horizontal seam with the tines of a dinner fork.

Toast well and generously schmear both the tops and the bottoms with the room-temperature parsley-shallot butter, "wall to wall" as we always say at Prune, so that every bite will be seasoned and not just the center ones.

Place the burgers on the bottoms and close with the buttered English muffin lids.

★ Monday and Friday lunch par is 30 burgers, so order meat accordingly on Sunday and Thursday nights. 15 is safe par for midweek. ★

PS Butter also used at brunch so make a x4 batch twice a week, please.
Freeze extra.
Label and date properly; label and date again when you defrost! Hope that's obvious.

French Fries

Peel russet potatoes daily. Store in cold water.
Cut fries neatly and as uniformly as possible between ¼" and ⅓" inch thick.
Blanch in the deep fryer at 275° until potatoes become translucent, about 8 minutes.
Please be fastidious about the hygiene of the fryer fat—ask the guys to change it often. We want clean fat.
Cool blanched fries by spreading out on a baker's drying rack set inside a sheet pan.
When completely cool, transfer to plastic tubs with lids.

To pick up:

Set up fry pot and basket on the stovetop and clip a fry thermometer to the edge of the pot.
Fill only ¾ with duck fat and heat to 350°.
Fry to order; crisp and golden.
Drain in stack of large coffee filters.
Turn off duck fat between orders so it doesn't burn. Pay attention to temperature.
Strain and reuse from one service to the next, but no more than 2 services.

For the burger, season with kosher salt.

For the brisket, season with Parsley-Paprika Salt (page 478).

Egg on a Roll, NYC Deli-Style

Per order

1 Kaiser roll, halved horizontally

4 Tablespoons plus 1 teaspoon sweet butter

2 eggs

1 ounce slice extra-sharp Cabot Vermont white cheddar cheese

2 slices cooked bacon

kosher salt

freshly ground black pepper

Toast each cut side of the roll until hot and crispy.

Butter each side of toasted roll with 2 Tablespoons sweet butter, using all 4 Table-spoons. Butter wall to wall.

Heat 1 small nut of butter in a nonstick pan over medium-high heat and when foamy, crack eggs into it.

Cook eggs over easy, taking care not to break the yolks when you flip.

Remove pan from flame, drape cheese slice and bacon strips on top, and pass under salamander for 20 seconds to melt the cheese and bring the bacon to life.

Season assertively with salt and pepper and slip into buttered Kaiser roll.

Order Kaiser rolls from Tom Cat and on days when we don't have a big enough order to meet their minimum, hand-shop from 1st Avenue Deli. Please do not try to improve or gourmet-up this item with homemade rolls or rolls from Whole Foods.

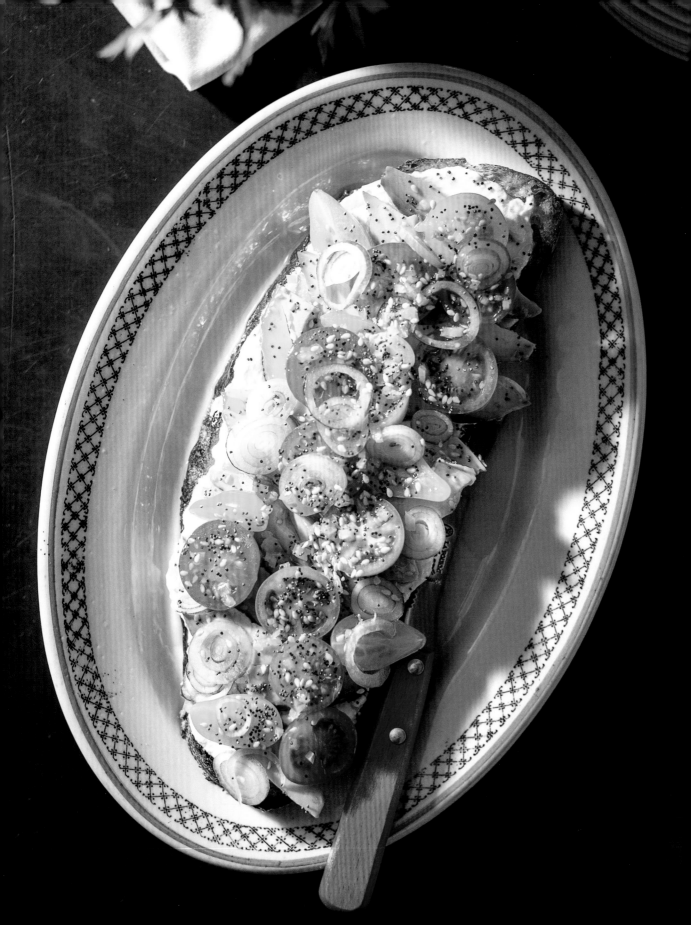

Avocado Sandwich with Lemon Ricotta

Yield: 4 orders

1 pound/scant 2 cups fresh ricotta

zest of 2 lemons

¼ cup extra virgin olive oil, plus more for drizzling

kosher salt

freshly ground black pepper

4 long, even slices peasant bread

2 large, perfectly ripe avocados—at room temperature

8 red pearl onions, thinly sliced into rounds

1 dry pint mixed-colors grape tomatoes, rinsed and cut in half horizontally

4 teaspoons toasted sesame seeds

skin of 1 preserved lemon, flesh and pith removed, finely diced

½ teaspoon toasted poppy seeds

Maldon sea salt

Mix ricotta with lemon zest, ½ cup EVOO, salt, and pepper and set aside.
Arrange slices of bread on the cutting board and divide the ricotta mixture evenly among the 4 slices. Spread into a generous even layer.
Split the avocados, remove the pits, and slice each half into even slices without cutting all the way through the leathery skin. Then, with a soup spoon or a flexible rubber spatula, release the flesh and arrange the slices neatly and evenly among the bread.
Artfully and attractively arrange the tomatoes by nesting them into the soft avocado. Then neatly arrange the red onion slices over the tomatoes.
Garnish each sandwich with sesame seeds, preserved lemon zest, and, finally, the poppy seeds.
Transfer the sandwiches to plates and then drizzle with the extra virgin olive oil. Sprinkle few grains of Maldon sea salt.

Marinated Fresh Sardine Sandwich

Yield: 4 orders

8 whole fresh sardines

1 inch grapeseed oil, in whichever pan you are using

¼ cup sliced almonds

2 cups EVOO

⅓ cup sherry vinegar

2 teaspoons fresh thyme leaves

1 Tablespoon sliced parsley leaves,
 stems saved for later

¼ teaspoon Aleppo pepper

kosher salt

black pepper

1 red onion

¼ cup fresh mint leaves

3 avocados

4 large slices day-old peasant bread

1 lemon

4 scallions, cleaned, trimmed, thinly sliced

Maldon salt

(handwritten note on tape:)

×8

16 sardine

—

½ c.

4 c. evoo

⅔ c. vin

1 T. thyme

2 T. parsley

½ tsp.

s + p

Clean and fillet sardines. Use your knife to make initial cut right behind the gills and to open the bellies but use your fingers for the rest. Twist and tug the heads and the guts will follow automatically. If they are super fresh, the meat will not cling to the spine. If they are getting past their peak, use your knife to get a clean fillet. Lay out on layered paper towels and pat to dry and to remove any blood stains.

Heat grapeseed oil to shimmering, and gently fry almonds until just golden. Remove with slotted spoon and turn off the heat under the oil.

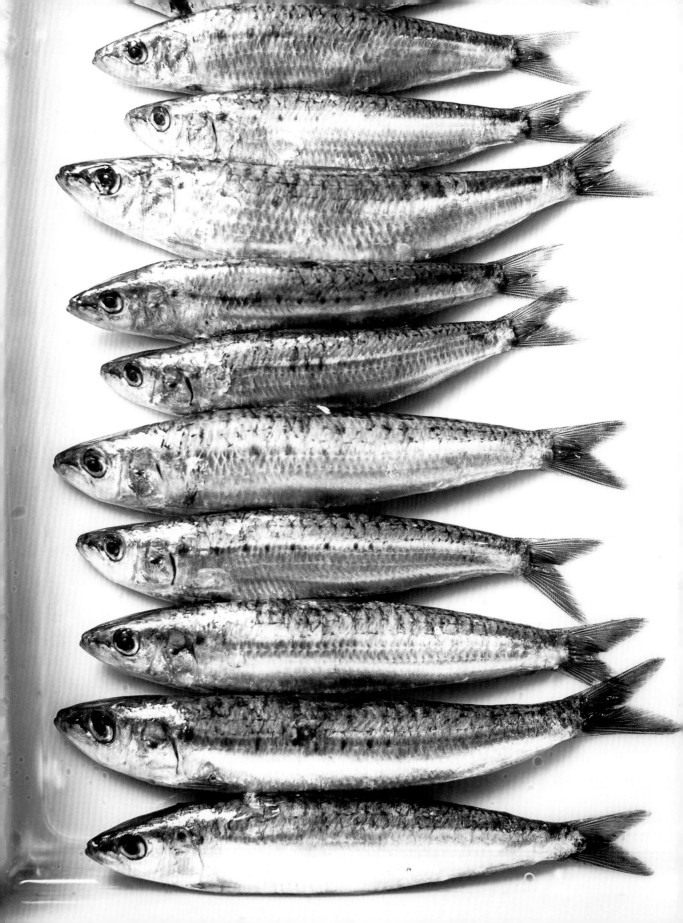

Poach sardines in that same oil—now very hot but flame shut off—until just cooked through and still moist, 90 seconds. They should turn opaque.

Remove the sardines with slotted fish spatula and drain well.

Gently fry almonds in grapeseed oil until just golden, remove with slotted spoon and turn off the heat.

Combine the hot grapeseed oil with the olive oil, sherry vinegar, Aleppo pepper, thyme leaves, parsley leaves and the fried almonds. Slip the clean, poached sardine filets into the marinade without mangling them. Do this first thing in morning to be ready by service—They need a few hours in the soak.

Shave red onion into thin strands (½ moons) and salt liberally to wilt and soften the bite.

Chiffonade the mint.

Open the avocados and see what you have inside. If unblemished and perfect, slice them; if slightly bruised, cut out the discoloration and crush the perfect parts.

Slice day old bread on the thin side—as thin as your iphone—then toast under the salamander, both sides.

To assemble sandwiches:
Work clean, please, and build each directly on the plate in this order:

Toasted bread, drizzled generously with 2 Tablespoons of the marinade.
Sliced or crushed avocado, fanned or laid or spread out entire length of toast.
Squeeze a few drops of lemon juice all over.
2 whole marinated filets per sandwich, neatly laid out on slight diagonal.
Drizzle another 1 Tablespoon of the marinade over each.
Salted red onions, scattered neatly.
A neat articulate shower of shaved scallions—whites and greens, then the chiffonaded mint and then the saved parsley stems, sliced very thin.
1 Tablespoon of the fried, marinated almonds, scattered loosely.
Season with black pepper and Maldon flakes.

Save all Sardine Spines (page 550) from butchering and run them as a wax for friends and VIP guests.

Warm Lentil Salad with Fried Chicken Livers, Poached Egg, and Smoked Tomato Vinaigrette

Yield: 8 orders

For the lentils:

½ cup celery, neatly brunoised

½ cup carrot, neatly brunoised

½ cup fennel, neatly brunoised

½ cup onion, neatly brunoised

8 ounces black seruga lentils

6 cups Chicken Stock (page 448)

1 bay leaf

salt

freshly ground black pepper

extra virgin olive oil

x 18
1 pint
1 pint
1 pint
1 pint
1 lb.
3 qt.
3 bay

For the chicken livers:

½ pound chicken livers

1 c. all-purpose flour

kosher salt

For the poached eggs:

white vinegar

8 eggs

To finish:

2 bunches watercress, woody stems removed

EVOO

peasant bread fried in olive oil

Smoked Tomato Vinaigrette (page 462)

For braising the lentils:

Rinse lentils under cold running water until the water runs clear, pick out any pebbles, husks, twigs. Maybe use the tamis so you don't lose half your lentils into the sink through the too-large holes of the colander.

In a sauteuse large enough for all the ingredients, heat olive oil on a low to medium flame.
Sweat the brunoised vegetables until just starting to soften. Keep flame gentle to not pick up any color.
Add rinsed lentils to vegetables and stir thoroughly, until the lentils are glossy and coated with the olive oil and all of the vegetables are distributed evenly, and steam starts to rise from the water of the lentils draining down to the bottom of the pan.
Add bay leaves and 1 quart of chicken stock.
Simmer the lentils on low heat, partially covered, paying attention to them along the way.

When most of the liquid is absorbed, add more chicken stock and continue simmering, stirring occasionally.
When liquid starts to disappear, add last bit of chicken stock, season with salt and pepper, and finish simmering uncovered.

We want the lentils tender, with no chalky crunch and they should be slightly brothy, not dry—add more stock as needed.

For the chicken livers:

Trim any tissue and veins from chicken livers; rinse to clean excess blood. Pat dry.
Toss the livers in unseasoned flour and deep-fry until livers feel sort of tender-firm, exteriors are golden crispy, and centers are medium–rare. 1–2 minutes.
Season with kosher salt while warm.

For poached eggs:

Keep your poaching water clean and simmering and full all night. Add white vinegar to the water sparingly—too much makes the white of the eggs chalky and pock-marked.

As always, crack the egg into a ramekin first to check the yolk is intact before you tip it into the poaching bath. Poach 90–120 seconds until whites fully set. Retrieve with slotted and drain.

To plate:

Nice ample tangle of watercress set in large, wide bowl.
Generous heaping spoonful of warm, vaguely brothy lentils.
Smoked tomato vinaigrette, stirred well, generously spooned over.
Warm poached egg and warm fried chicken livers set side by side on top of lentils.
Drizzle EVOO.
Season egg.
One modest, thin slab of peasant bread fried in olive oil set in bowl to finish.

James Beard's Onion Sandwich with Fried Chicken Livers Garnish

For the sandwich:

sweet butter, cool, waxy, and spreadable

Pepperidge Farm original white sandwich bread

Vidalia onion, peeled, left whole and very thinly sliced into large thin rounds—use the meat slicer or mandolin.

kosher salt

Hellmann's mayonnaise

parsley, extremely finely chopped

For the chicken livers:

chicken livers

all-purpose flour

kosher salt

Vidalia onion, sliced into thin ½ moons

flat-leaf parsley sprigs

Per order:

2 slices bread, buttered wall to wall.
Thin layer of onions on top of butter on one slice only.
Season with salt.
Close sandwich with second piece of buttered bread.
Neatly trim crusts, cut in half on diagonal.

Use an offset spatula and skim diagonal cut edges with modest slick of mayonnaise.
Dredge diagonal cut through very finely chopped parsley, tap off excess.
Stack on oval plate, with care.

For the chicken livers:

Trim any tissue and veins from chicken livers, rinse to clean excess blood. Pat dry.

Toss the livers in unseasoned flour and deep-fry until livers feel sort of tender-firm, exteriors are golden crispy, and centers are medium-rare. 1–2 minutes.

Season with kosher salt and, while hot, toss with a few ribbons of sliced Vidalia onion and a few parsley sprigs.

Set in monkey dish next to sandwich on oval plate.

One full "set" of livers only per order.

Grilled Tuna Pain Bagnat

Yield: 4 orders

Ingredient	×8	×16
1 pound bluefin fresh tuna, cut in two	2 #	4 #
2 Tablespoons balsamic vinegar, use the good aged kind in bottles, not the jug stuff	1/4 c.	1/2 c.
1 pound ripe tomatoes, peeled and seeded, cut into ½-inch dice	2 #	4 #
½ cup Kalamata extra virgin olive oil	1 c.	2 c.
2 Tablespoons fresh lemon juice	1/4 c.	1/2 c.
1 lemon, supremed, cut into ⅓-inch dice	2	4
2 Tablespoons capers in brine	1/2 c.	1/2 c.
½ cup chopped parsley	1 c.	2 c.
½ cup pitted, sliced Kalamata olives	1 c.	2 c.
½ cup red bell pepper, small dice	1 c.	2 c.
¼ cup green bell pepper, small dice	1/2 c.	1 c.
2 Tablespoons scallion rings, all the way up into the green as far as viable	1/4 c.	1/2 c.
¼ cup red onion, thinly sliced into crescents	1/2 c.	1 c.
4 ciabatta rolls, 8 inches each	8	16

Lightly brush tuna with oil and season with salt and pepper.

Grill on hot section of grill to solid medium rare and let cool to medium.

Use your hands and tear the tuna into 1–2" hunks and strips.

Combine all the rest of the ingredients and nestle the tuna hunks in the mixture. Bury them a bit so they have a chance to absorb juices and flavors.

Per order:

Slice ciabatta roll horizontally, hinging, without cutting all the way through.

Set in clean ¼ sheet pan.

Stuff with 1 full cup of the tuna salad, and make sure to include plenty of the condiment/marinade.

Cover with a ½ sheet of parchment and weight down with an unopened box of salt for 2 hours at least. Flip the sandwiches ½ way to let the juices run into the other half of the bread as well. Keep ahead by a couple of portions and anticipate the 1 p.m. rush.

Set whole messy sandwich and any filling that has spilled out during the press onto large oval, as is.

Silken Warm Tofu, Fresh Soybeans Cooked in Salted French Butter, Celery Seed Gastrique

Per 6 orders:

single batch soft silken tofu

3 cups fresh frozen shelled soybeans

12 ounces salted French butter

grey salt

⅓ cup Celery Seed Gastrique (page 300)

For the tofu:

single batch for daily 6 orders

2–3 teaspoons coagulant

1 pound dried yellow soybeans

9 cups filtered water

Soak the beans in 2 inches of regular water from the sink; room temp, overnight. Drain hydrated beans. Grind the now-soft beans in the Vita-Prep with 3 cups filtered water from the waiter station, as thick and smooth as a milk shake.
In clean stainless steel pot, boil remaining 6 cups filtered water.

Pour soybean puree into boiling water; stir gently and constantly with rubber spatula until a rich and silky-looking off-white soy milk develops—about 8 minutes. Drag the bottom with the spat to prevent burning. Don't walk away: it will boil over in a flash—just like cow's milk. You want to get every bit of goodness out of those ground beans—like you would with a pot of coffee from ground coffee beans. Not too weak, and not overextracted.

Remove from heat. Strain through several layers of clean damp cheesecloth set in fine-mesh china cap over clean cylindrical stainless bain.

Thoroughly squeeze cheesecloth until you have extracted every bit of milk and the dregs in the cheesecloth are dry and spent—doubled-up latex gloves help to manage while still so hot. Chuck the spent soy grounds.

Measure the soymilk—make sure of your yields.

Heat 6 cups soymilk in clean stainless pot to 165°.

Dissolve 2 teaspoons coagulant (glucono delta-lactone or powdered nigari) in ¼ cup filtered water.

Pour the dissolved coagulant into the waiting clean glass crock.

↳ DO NOT USE BALL JARS. THE MOUTHS ARE NOT WIDE ENOUGH. ✱

Pour the hot milk over the coagulant and stir quickly and briefly—3 vigorous figure-8 strokes with your spat only—and then let it set up undisturbed.

For the Celery Seed Gastrique:

8 orders ½ pint

½ cup sugar

2 Tablespoons water

½ cup apple cider vinegar

½ teaspoon celery seeds

¼ teaspoon Homemade Chili Flakes (page 474)

Cook sugar and water slowly in small saucepot to *deep amber* caramel. Don't stir. Don't undercook.

Steep the celery seeds, and chili flakes in the vinegar, then carefully add seasoned vinegar to caramel all at once, right at the point of desired caramelization. It will stop the cooking of the sugar. Take care not to get burned from the hissing and spitting.

To pick up:

Per order:

½ cup frozen fresh *shelled* soybeans

2 Tablespoons French salted butter

2 Tablespoons water

2–3 ounces warm tofu

1 shy Tablespoon gastrique
grey salt

In small saucepot, combine butter, water, and soybeans and simmer until water almost evaporates and beans are cooked through and glossy. Taste for salt, but the butter should do it unless you used too much water from the outset—adjust as needed.

Spoon luscious beans and their buttery liquid into small shallow bowl.

In one motion, dip into the soft tofu with large chef's spoon and retreat with a nice tender orb of the stuff. Slide tofu into center of bowl and drizzle gastrique around on the buttery beans, but leave the tofu pristine.
Few grains of grey salt on beans only, to finish.

Take care with the tofu—it is tenderissimo. Every time you cut into it with your spoon, you risk breaking up the beautiful silken mass. Get your portion in one motion—don't fish around indecisively in there.

* only make one batch per day and run it out.

* Make soymilk fresh daily. Add day-old to family meal bin.

* Set up all your equipment before you start the recipe, otherwise you will be scrambling.

Braised Fennel with Pernod Butter and Trout Roe

Yield: 4 orders

2 large bulbs of fennel, with tops

2 cups water +/-

2 teaspoons kosher salt

2 Tablespoons unsalted butter

Pernod Butter

trout roe

Wash fennel. Shave root end just to clean it up.

Cut off long ribs and fronds, give a few rough chops to both stem and frond, and set aside.

Cut each bulb in more or less equal halves horizontally.

Pack tightly into ½ hotel pan so they nestle up against each other.

Lay fronds and ribs in, around, and on top of the fennel bulbs.

Fill pan with just enough water to come ½ way up on the fennel.

Season the fennel generously with salt.

Drop a hunk of butter on top of each fennel bulb.

Cover pan with foil and set over burner on high.

Bring to boil and then transfer to 350° oven and braise until tender. Check them in 25 minutes, but it may take as long as 45. Top halves cook faster/sooner than bottom halves, be aware. Remove the portions that are tender and return the rest to finish. Do not treat as one-size-fits-all. If you are prepping large batch, group all bottoms in one pan and all top halves in another, to cook more uniformly.

Remove perfectly cooked bulbs from the braising liquid carefully so they keep their attractive, concentric circles. Later, when cool enough to handle, remove any very tough, stringy outer stalk to reveal just the tender hearts.

Transfer braising liquid and the parcooked stems and fronds to a pot and continue to simmer until you have gotten all the flavor out of the stems.

Strain fennel water into quart container or cylindrical bain and discard spent stems and fronds.

For Pernod Butter:

4 ounces reserved fennel water

4 ounces Pernod

cold sweet butter, cubed

kosher salt

In small stainless sauce pot, boil Pernod with reserved fennel water for 1 minute. Turn off flame but stay near ambient heat.
Whisk in cold butter, a few chunks at a time until you have glossy, emulsified, full-bodied beurre monté.

Season appropriately, keeping in mind the trout roe finish lends salinity.

To plate:

Spoon Pernod butter generously over braised fennel bulb, allowing it to seep down into the crevices and pool up slightly in the bottom of the bowl.
Drop healthy dollop of trout roe on top.

Fiddlehead Fern Salad

Yield: 5 orders

3 bulbs baby fennel
 (stems and fronds removed)
1 pound fiddlehead ferns
Shallot Vinaigrette (page 465)
¼ cup chopped parsley

> x 20
> ½ doz.
> 4 #
> shallot vin.
> 1 c. parsley
> s + p

Slice fennel into thin rounds and set aside in large stainless bowl.

Soak fiddleheads in cold water, twice. Then trim stem end of fiddleheads.
Blanch ferns in boiling, well-salted water until cooked perfectly—tender, internally seasoned, and still with that green chlorophyll taste.
Drain quickly into colander and, while warm, toss with fennel and vinaigrette.
When tepid-cool, stir in parsley and season with salt and pepper.

* make sure this is not stone cold from the walk-in when you plate. Keep small batch at room temperature throughout service.

* Be generous with the portion — these only come once a year and for such a brief spell.

Buttered Brown Rice with Rock Shrimp, Duck Crackling, and Roasted Mushrooms

Yield: 4 orders

2 cups short-grain brown rice

2 Tablespoon kosher salt

15 cups water

2 full pods star anise

4 Tablespoons butter

½ pound Honshimiji mushrooms, trimmed

olive oil

salt and freshly ground black pepper

duck skins, from 2 large breasts

⅓ cup water

1 whole star anise pod

2 Tablespoons butter

4 scallions

2 Tablespoons butter

1 pod star anise

1 pound rock shrimp, rinsed

Bring 15 cups water to a rolling boil.

Season with 2 Tablespoons salt and 2 full pods of star anise.

Add brown rice and cook, pasta style, until tender and chewy, approximately 35 minutes.

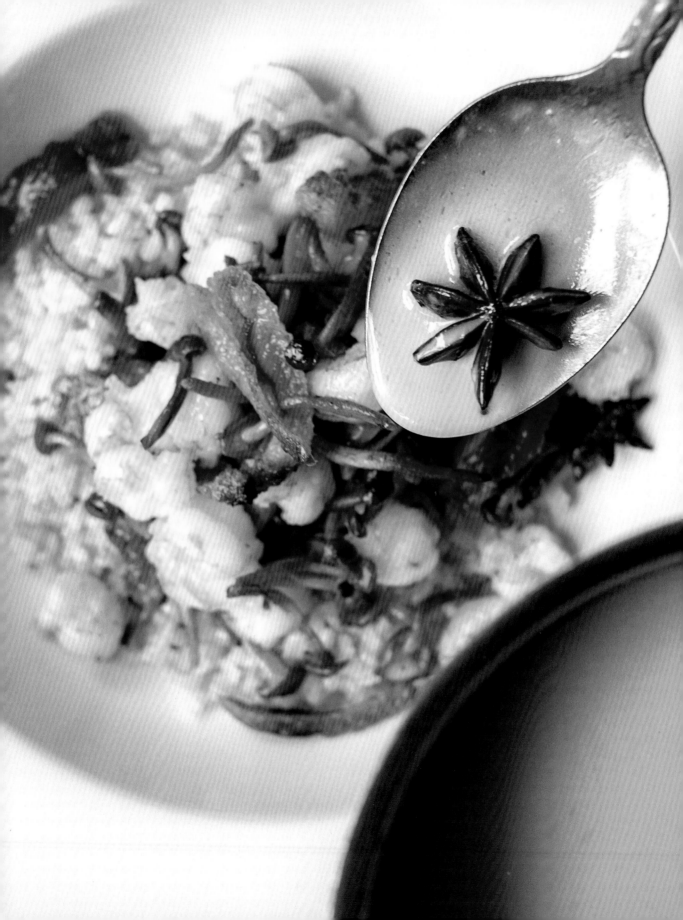

Drain like pasta in a colander, then return rice to pot and add 4 Tablespoons butter, stirring gently to coat each grain with the melting butter. Hold warm.

Trim the mushrooms—and separate the clump into manageable segments.

Toss the mushrooms with olive oil, season with salt and pepper, and roast in a very hot oven until they take on color, are fully cooked, and starting to crisp up.

Render duck skins slowly and patiently until crispy and thoroughly golden with almost no subcutaneous fat left. Drain off fat as it accumulates so they *render out* rather than *fry in* their own fat. Remove from pan and let drain in stack of coffee filters.

Season with salt while warm and, when cool enough to handle, cut into strips of crackling.

Boil ⅓ cup of water in a very small saucepot, with 1 pod of star anise. Allow to boil until reduced by a full half (less than ¼ cup) and a strong aroma of star anise has brewed into the "tea."

Turn off the heat and whisk in 2 full Tablespoons of butter, whisking constantly until fully melted and you have a loose but creamy and glossy beurre monté. Season with a pinch of salt.

Slice scallions, nicely cleaned, on the bias, but in thick, wide cuts—to end up with the same size, more or less, as the rock shrimp. Slice all the way as far as you can go up into the green as is viable, which for me is pretty much the whole way up except for the rough, dry tips.

Melt 2 Tablespoons of butter in a wide, large sauté pan over medium-high heat with 1 pod star anise.

Add scallions and rock shrimp—and sauté for about 2 minutes, until rock shrimp are cooked but still vital and juicy and the scallion is soft but still green and vibrant. Add the roasted mushrooms and give them a final toss with the shrimp and green onion.

Spoon the warm brown rice into the wide bowls, then the shrimp and mushrooms, and finish with the star anise beurre fondue and duck cracklings.

Maiale Tonnato

Yield: 8 orders

4-pound boneless pork butt, rolled and tied

2–3 quarts Octopus Braising Liquid (page 539)

2 cups tonnato sauce

lemons

salt-packed capers, rinsed, for garnish

For the tonnato sauce:

tuna puree:

2 cornichons

1 Tablespoon capers

7 ounces canned tuna (oil-packed)

½ cup octopus cooking liquid

5 anchovy fillets packed in oil

mayonnaise:

1 egg yolk

1 teaspoon mustard powder

¼ teaspoon white pepper

2 Tablespoons lemon juice

2 anchovies, packed in oil

¾ cup grapeseed oil

For the pork butt:

Season pork butt with salt and pepper. Brown on all sides in barest film of blended oil.

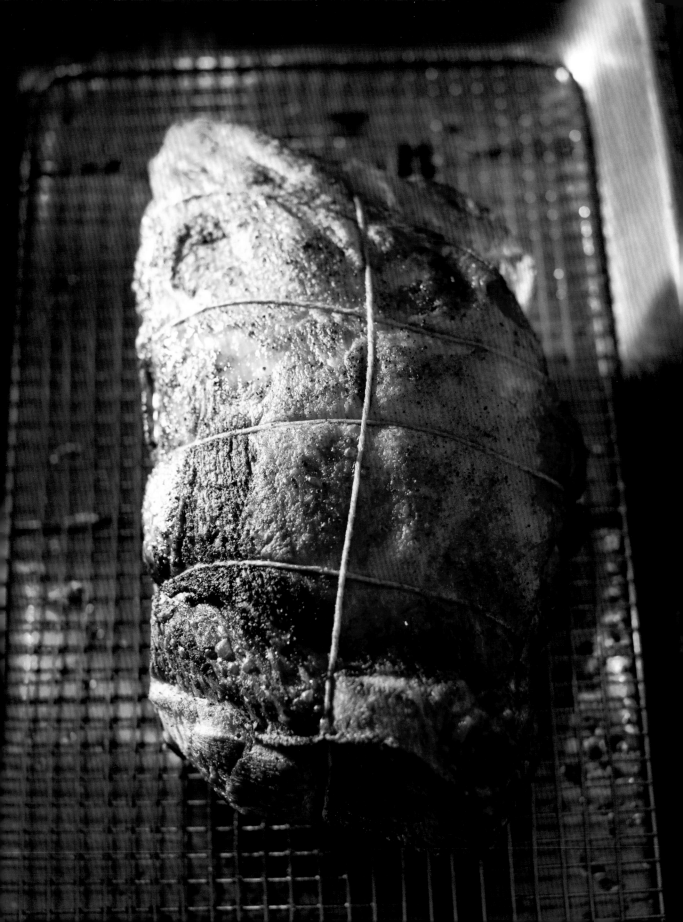

Deglaze pan with some of the octo liquid, then add just enough to submerge roast by ¾. There should be a ton of octopus braising liquid in the freezer if there is none in the walk-in; otherwise, use Mixed Meats Stock (page 454).

Take care with all of the usual braising concerns: appropriate-sized vessel, tight-fitting lid, enough liquid that the meat is just barely submerged in braising liquid, etc.

Bring to temperature on stovetop, then braise in gentle oven (325°) for 3 hours.
Cool pork in braising liquid and let it "cure" 24 hours in walk-in.

For the tonnato sauce:

For the tuna puree:

Grind tuna in Vita-Prep with capers, cornichons, anchovies, lemon juice, and the cold braising "porktopus" liquid.
Listen to the motor to be sure you are not burning out my machine. Puree to smooth and fluffy.

For the mayonnaise:

In **clean** blender canister on low speed, puree the egg yolk, mustard powder, white pepper, lemon juice, and anchovies. Increase motor speed and add grapeseed oil in quick, steady stream. Get full emulsification.

Thoroughly combine mayonnaise with tuna puree by hand. Season with salt and white pepper if needed.

Slice the maiale as thin as possible on the meat slicer; keep slices stacked neatly as you go. Make sure the butt is cold from the walk-in when you slice it—it is very fragile after the braise. Expect to lose almost ½ of yield in the slicing—it's so tender and shreds easily; contribute all lost bits to family meal.

* Remove the butcher's string before slicing, people!! *

To plate:

Carefully lay out good slices in circular fashion on the plate—3 ounces per order.
Spoon tonnato sauce liberally over pork slices to fully coat, but don't drown the layer.

Carefully lay another few slices of the pork on top, in same circular fashion. Spoon sauce over. Repeat with one more layer.
Finish with sauce. Stay clean and neat on the plate—it's already an ugly drab color to start with and will only look less appealing if you are sloppy.
Arrange paper-thin lemon ½-wheels around the circumference, like a *Gourmet* magazine cover circa 1978. Place a few parsley leaves around on top of the lemons, and several rinsed salted capers as well (not the ones in brine).

Salt-Packed Cold Roast Beef with Bread Crumb Salsa

Yield: 6 orders

For the beef:

24 ounces trimmed and clean beef tenderloin

1 Tablespoon grapeseed oil

2 pounds kosher salt (Diamond Crystal only)

2 teaspoons finely and freshly ground black pepper

1½ cups cold water

For the bread crumb salsa:

6 ounces day-old peasant bread, torn into free-form small-ish "croutons"

1 pound assorted sweet cherry tomatoes, split in half

4 small cloves fresh and sticky new garlic, thinly sliced

1 bunch scallions, sliced thinly in rings, from the white all the way up through as much of the green stalk as is edible

½ cup clean and dry flat-leaf italian parsley leaves

1 packed Tablespoon plus 1 packed teaspoon salt-packed anchovies, rinsed, filleted, and then minced

2 lemons, zested, supremed, deseeded, and all the juice from what's left of the skeleton after supreming the segments

2 Tablespoons red wine vinegar

1 cup EVOO

For the beef:

Heat the large, heavy cast-iron skillet over medium heat for 5 whole minutes and make sure the hood is on.

Rub the filet with 1 Tablespoon of oil, then sprinkle and coat evenly with black pepper.

Brown the meat thoroughly on every side and also the cut ends so that you have formed a nice crust universally around the piece of filet, creating a barrier for the upcoming salt crust. (This takes 7–8 minutes to brown correctly.)

Remove the meat from the pan and let cool on a wire rack set in a sheet pan—in order to have a cool and mostly dry piece of meat.

Mix the salt with the water to form what looks like bright white wet sand.

Spread a thin but solid and even layer of salt on the bottom of a ¼ sheet pan and set the roast on it, then pack the remaining moist salt tidily around the browned meat forming a solid case, resembling a cast on a broken leg. Where there are cracks, redistribute the salt and fix them. This should be a fun and unfussy task. If you need more salt or more water or less water and more salt, mix up whatever mortar you need to get the beef encased.

Place the salt-crusted beef on its sheet pan into 250° oven and let it cook for 45 minutes. If you weighed it properly at the outset, 45 minutes at 250° is failsafe. Otherwise, use an instaread thermometer and go in through a cut end to direct center—pull it when it hits 125° inside.

Crack the salt crust, dust the granules of clinging salt off with a clean dry side towel, and set to rest on a tray in your station. Don't refrigerate, but label properly time/date for Health Department.

For the bread crumb salsa:

In a small, deep-sided sauté pan, heat the 1 cup of olive oil over medium-high heat. The oil should be just deep enough to submerge the first tip of your index finger. Good olive oil is rarely recommended for frying so don't ever do this when you go on to work in a real restaurant, but here at Prune, I really prefer the flavor it adds.

When the oil makes its beautiful, veinous, streaking patterns in the pan, which will move faster as the oil gets hotter, drop in a test piece of crouton. When it sizzles on contact, the oil is ready.
Fry the croutons until golden brown, remove with a slotted spoon, and drain in stack of basket-style coffee filters. Set aside the frying oil to cool.
Mix together the tomatoes, scallions, garlic, anchovies, lemon flesh and zest and juice, and the red wine vinegar and toss well.

Toss in the fried bread croutons and dress with ⅓ cup of the now-cool olive oil left over from frying.

Rough up the parsley leaves briefly in your hands just to release the grassy aroma and add to the salsa.

Sparingly season with salt and pepper to taste, keeping in mind that the filet will bring its own seasoning to the plate.

To plate:

Slice the beef to order, keep portion at 6 ounces.

Shingle meat.

Drape good big spoonful of salsa over meat—but let the perfect wall-to-wall pink of the filet show—don't hide that beauty under carelessly placed salsa.

Drizzle with some of the remaining fry oil to finish.

Do not season further.

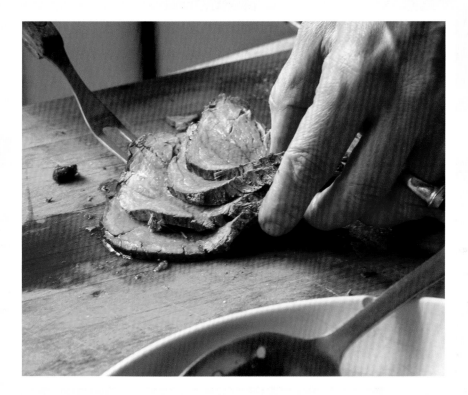

Smokey Braised Beef Brisket with French Fries

Yield: x8 orders

To brine the brisket:

1 gallon water

1 cup salt

½ cup sugar

5 bay leaves

1 Tablespoon peppercorns

1 Tablespoon chili flakes

½ bunch thyme

4 heads garlic, as is, papery skin intact, halved horizontally

1 whole brisket, trimmed but leave attractive fat cap, yielding about 8 pounds

French Fries (page 283)

Bring salt, sugar, thyme, chili flake, peppercorns, garlic, and bay leaves to a boil in 1 quart of water. Shut off as soon as sugar and salt dissolve.
Pour into 8- or 12-quart Lexan.
Add ice and cold water to reach 4-quart mark.
Add brisket and leave in brine in the walk-in for 5 days, fully submerged.
Label and date fastidiously, please.

To rub the brisket:

salt

pepper

smoked paprika

After 5 days, remove from brine and pat dry. Season the brisket generously with salt and pepper.
On the hot grill, get some good color on the brisket on as many sides as possible, without charring or burning.
Rub brisket all over with 1½ cups smoked paprika and let it sit in walk-in overnight.

To braise the brisket:

6 cups yellow onion, peeled, coarsely chopped

1 cup garlic, smashed

5 dried guajillo peppers

1 small bunch of thyme

1½ #10 cans Muir Glen whole peeled tomatoes, and their juice

1 cup maple syrup

2 quarts College Inn beef broth—don't use homemade, we want the particular/peculiar qualities of the College Inn product

2 cups red wine

Set oven to 275°.
In a large rondeau that will fit into the oven or a deep hotel pan, add all of the braising ingredients and bring to a boil on the stovetop.
Add the brisket. Turn off the burners.

Cover with tight-fitting lid; if they are all warped, cover with parchment, then film, then foil, making sure that it is securely sealed.

Cook brisket in slow oven for 4 hours, then check every 30 minutes, up to 2 more hours, until very tender and gravy is mellow and meaty. Be meticulous with the reseal after checking.

Cool brisket in braising liquid overnight.

Defat following day when orange fat has congealed and risen to surface and is more easily lifted and scraped off.

Run defatted braising liquid/gravy through the food mill fitted with fine disk.
Slice brisket WHILE COLD.
Reheat each portion in smooth gravy. Pay attention to fatty/greasy aspect when plating. Some is luscious; too much is gross.

Soupy Green Rice with Squid, Mussels, and Shrimp

Yield: 4 orders

2 dozen mussels, steamed, picked out of shells

¼ pound rock shrimp, rinsed

¼ pound squid, cut into ½-inch ribbons

¼ cup peas, frozen

¼ cup tarragon leaves, chopped

¼ cup mint leaves, chopped

4 cups cooked jasmine rice

2 cups Duck Stock (page 451)

¾ cup Green Herb Puree

¼ pound butter

pea sprouts for garnish

Green Herb Puree:

1 cup picked mint

1 cup picked tarragon

1 cup stinging nettles

½ cup green peas, frozen

Duck Stock (page 451)

ice cubes

x | qt.
4 c. mint
4 c.
4 c.
2 c.
duck +/-
ice +/-

For green herb puree:

Blanch all herbs until just soft, 30 seconds. Stinging nettles a little longer. Shock all in ice bath.

Blanch the peas in the same water.

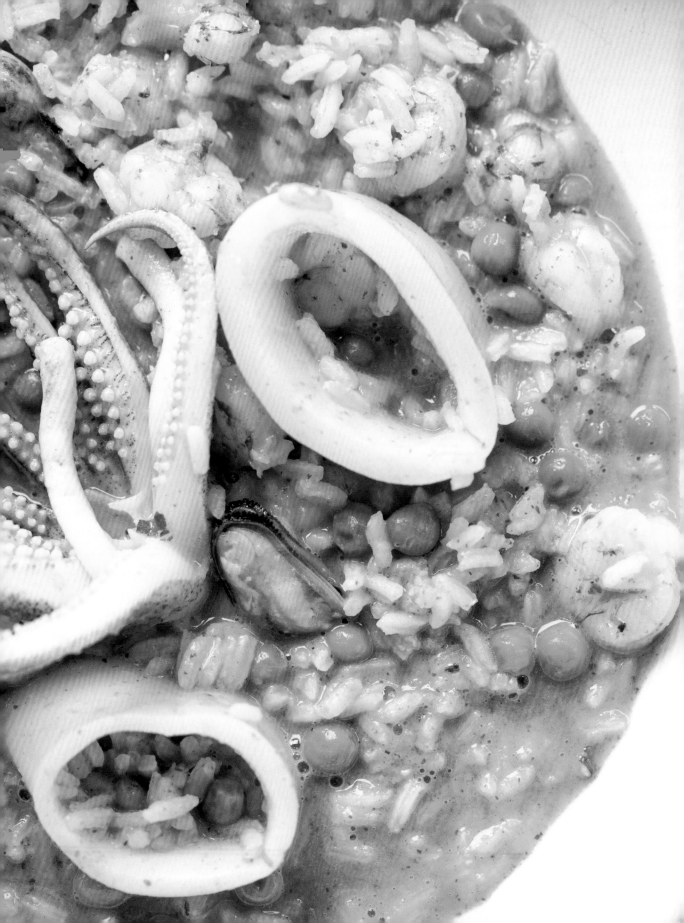

Squeeze the water out of the blanched herbs.
Combine peas, herbs, and a couple of ice cubes in the Vita-Prep and puree.
Add a little cold duck stock to allow the greens to catch the blade and start to puree.
Then add enough cold duck stock to bring it to the consistency of a fruit smoothie.
Season to taste with salt only.

To pick up:

Simmer rice with herb puree and duck stock until soupy and hot.
Add mussels to heat through.
Add rock shrimp, then add squid and cook for 90 seconds.
Remove from heat and mount in butter.
Stir in chopped mint and tarragon and pea shoots.
Season with salt and pepper.
Spoon into large wide bowl.

* sell while hot. Do not let this sit interminably at The pass, people!

Sopa Fideos, Cuttlefish
Cooked in Its Own Ink, Aioli

Yield: 8 orders

For cuttlefish:

3 pounds whole frozen cuttlefish, cleaned, ink sacs reserved

4 Tablespoons extra virgin olive oil

1 Tablespoon butter

1 medium yellow onion, finely minced

2 garlic cloves, minced

1 quart Fish Stock (page 457)

3 Tablespoons cuttlefish ink

salt

freshly ground black pepper

For sopa fideos:

2 Smoked Tomatoes (page 461) — *plain. no spice mix. just smoked.*

1 small yellow onion, peeled and finely diced

2 garlic cloves, peeled

2 ounces fatback, finely diced

2 cups #1 fideo noodles

4 cups Chicken Stock (page 448)

smoked paprika

salt

freshly ground black pepper

Tomato Skins powder (page 551)

Lemon Aioli (page 484)

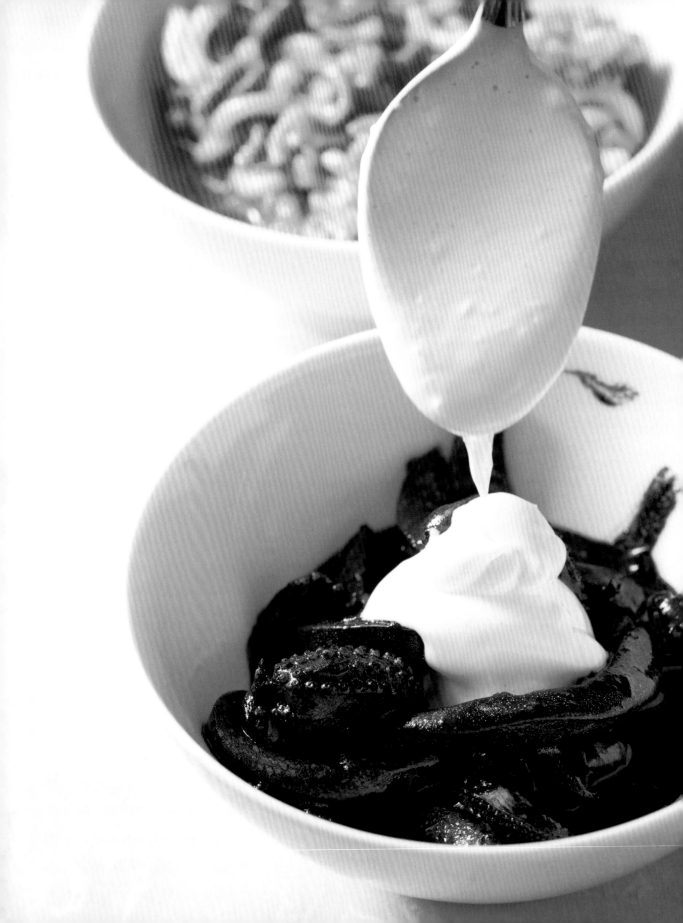

For cuttlefish:

Slice cuttlefish bodies into shy ½" ribbons or rings. Keep heads and bodies separate.

Sweat onion in deep-sided sauté pan in mixed fats.

Add garlic and all the ink and fumet and let simmer for 40+/-minutes until reduced and full-bodied and slightly viscous. Lid on/lid off as you go. Keep an eye.

Ink sacs won't yield enough ink. order jars from D'España and keep refrigerated. Please be hyper-fastidious when you label and date; it's perishable!

For sopa fideos:

Roast the smoked tomatoes in medium-hot oven (375°) for about 20 minutes and remove.

Put tomato, onion, and garlic in blender and puree to very smooth.

Strain tomato mixture and set aside.

Saute the fatback in a deep pan over medium heat to render.

Fry the raw fideos noodles to golden in the now-liquid pork fat.

Remove noodles with a slotted spoon and drain in coffee filters.

Add tomato mixture to remaining hot fatback in skillet and stir until thickened.

To pick up:

Heat chicken stock with smokey tomato mixture in deep sauté pan.

Add fried noodles. Season with salt and pepper and smoked paprika.

Cook until noodles are tender, approximately 15 minutes. Keep it moist and unctuous and tap down the flame a little as you go, kind of risotto-style.

When noodles are cooked, start the cuttlefish. Heat the inky broth in medium sauté pan. Add the heads and bodies and poach/simmer until just tender. This goes quickly! 90 seconds.

To plate:

Keep fideos and cuttlefish separate in small dishes, side by side, on large plate.

Garnish fideos with tomato skin powder and spoon 1 silky dollop loose aioli onto black cuttlefish.

Cold Chicken with Valdeón, Tomatoes, Green Onions, and Beans

green beans and yellow wax beans, blanched in salted water, shocked and drained

poached chicken meat left over from Double Stock (page 449), torn in
 manageable hunks

Valdeón cheese

seedless cucumber, diced at ½-inch

red and yellow cherry tomatoes, sliced in half

spring onions—very young, green or purple or both, shaved on bias

Bibb lettuce, in wide ribbons

kosher salt and freshly ground black pepper

small cream pitcher filled to the lip with Buttermilk Dressing (page 466)

Arrange in segments by item, butting up neatly against each other on the large football. Don't skimp—we want a real meal salad.

Season with salt and a few grinds black pepper, but let them pour the dressing at the table.

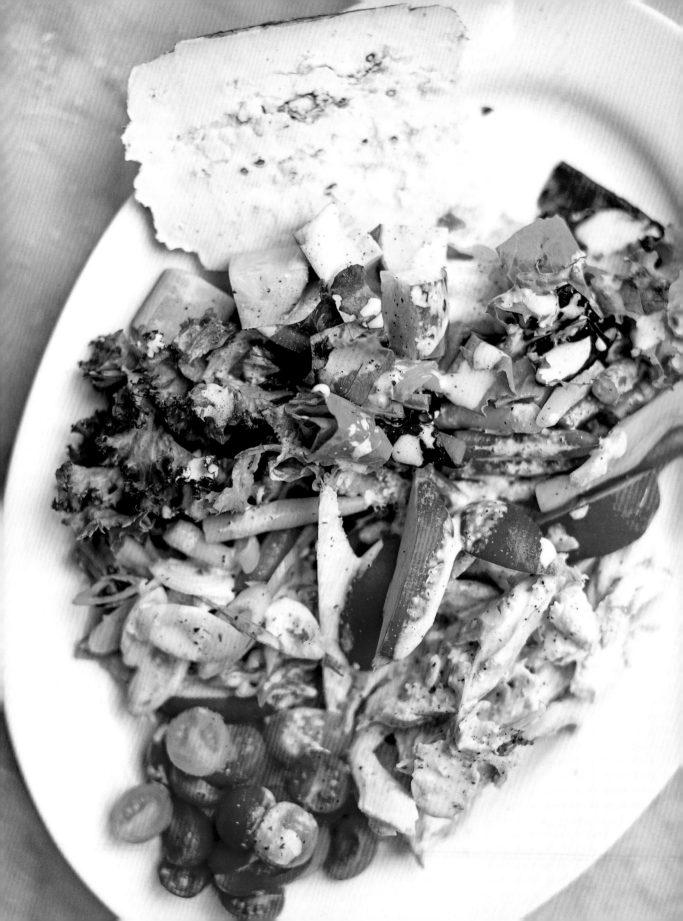

Cauliflower, Salami, and Fresh Flageolet Salad

Yield: 6 orders

1½ pounds cauliflower florets

½ pound green beans, stems
removed, tails intact

1 rounded cup fresh shelled
flageolet beans

1 cup parsley leave, tightly
packed

1 cup Shallot Vinaigrette
(page 465)

12 ounces salami, in bâtonnet

save the cores from prep
for a wax

x 12	x 24
3# cauli	6 #
1 # beans	2 #
2 c. flag.	1 qt. flag.
2 c. parsley	1 qt.
2 c. vin.	1 qt. vin
stp +/-	
24 oz. salami	3 #
	stp +/-

Bring large pot of water to boil
and season amply with kosher
salt. Taste the water to know what you are working with.

First blanch the cauliflower, and then the green beans, and then the flageolet last.

Blanch all the vegetables separately to correct doneness to allow them to cool naturally without overcooking from the residual heat—don't shock in ice bath, please.

Cut the green beans into even ⅓s, more or less.

Combine all of the ingredients except for the salami, and let marinate at room temperature for 30 minutes before service.

Season with salt and fresh pepper, if needed. Sometimes the small amount of residual blanching water leaches from the vegetables into the dressing and slightly dilutes it.

Add the salami just as you plate—the vinaigrette makes it drab and unappealing otherwise.

Muffalletta Salad

Yield: 6 orders

This deliciousness is a hairy beast of a prep project, but once you are mise'd, it is simple to plate and won't bog you down during a slammed lunch service.

Be sure you have prepped your daily pars OR you will be in severe grim misery trying to catch up during service

Ingredient	x 12-14 orders
3 large globe artichokes	6 arts.
6 ounces sweet capicola ham	12 oz.
6 ounces soppressata	12 oz.
4 ounces mortadella	½#
5 ounces aged provolone cheese	10 oz.
7 ounces roasted piquillo peppers, and the liquid from the jar	1 jar
6 ounces bright yellow-green innermost celery hearts	12 oz ♡'s
½ pound romaine hearts, washed and dried	1#
2 ounces pimento stuffed olives, sliced thin	4oz.
2 ounces Spanish queen olives and their brine, pitted, slivered	4oz.
1 red onion, medium dice	2 onion
2 cloves garlic, microplaned	4 cloves

Put artichokes in a pot and cover with cold water and season with salt. You don't have to trim or otherwise prepare the artichokes before cooking them.

Keep them submerged with parchment sheet and a lid that is one size too small for the pot and bring up to boil. Gently boil about 10 minutes until tender at the core—test with a skewer. Take care not to undercook—they'll turn black.

Drain the artichokes and set them upside down to cool on a baker's rack so all the water runs out.

Trim the black tips at the bottom of the stems. Grab several leaves at a time, and pull them off in a downward motion, taking off some of the stringy, fibrous part of the stem in the process. Pluck out the perfect dome of thorny leaves in the center in one handful and set aside. Pry the dense hairy choke away from the concave heart with your thumb rather than a spoon; it will separate with a particular, satisfying ease if you have cooked

them perfectly. If you have to tug or scrape at the hairy center with a spoon, you have undercooked them. Any undercooked meat will turn black from oxidization.

Scrape the little tongues of dark meat from the bottoms of each leaf using a teaspoon. Save the scrapings; throw away the leaves. Slice off the stems from the bottoms of the hearts and cut them into thin rings. Dice the hearts neatly. Slice the very tender purple ringed bottoms off the thorny center leaves and throw away the inedible tops. Gather all of your artichoke meat together in one container and keep it moist with a little olive oil. This is a 5-minute project. Don't get bogged down in the idea of it.

Slice the capicola thin on machine, stack the slices, then cut in wide ribbons with your knife.

Slice the soppressata thin on machine, then in wide ribbons with your knife.

Sliced the mortadella a little thicker on machine, stack the slices, then into wide ribbons with your knife.

Run a big piece of day-old bread through the slicer a few cuts, which will clean the blade very satisfactorily for now and let you move on with your monster prep project. Later though, when you have time, take the whole thing apart and scrub it down.

Cut the provolone in bâtonnet.

Julienne the piquillo peppers.

Slice the celery hearts (and their beautiful leaves) very thinly straight across the ribs.

Slice the romaine hearts crosswise in threads as thin as slaw. Include the watery, slightly bitter cores—I love them.

Combine all the salad ingredients in a large stainless bowl and comb through with your fingers, gently integrating all the items so it looks like a graceful tangle and not a patchy jumble. Transfer to a third pan in your station and keep cold during service.

To plate:

Portion in the wooden bowls. Dress each salad with:

1 teaspoon dried oregano

½ teaspoon commercial chili flake (not our homemade)

heavy grind black pepper

light sprinkle kosher salt

⅓-½ cup EVOO—long heavy pour from the bottle—you have to eyeball this

3 Tablespoons green olive brine

A brief drizzle of the smoky piquillo pepper liquid from the jar

And a good splash of our Homemade Rough White Wine Vinegar

Dress the salad but don't drown it.

Don't forget to clean the meat slicer!

Crunchy Lunch Potato Slaw

Yield: 8 orders

5 russet potatoes, peeled

½ cup blended oil

2 Tablespoons Sichuan peppercorns

1½–2 Tablespoons salt

½ teaspoon sugar

1½ Tablespoons toasted sesame oil

1½ Tablespoons Homemade Chili Oil (page 474)

1½ Tablespoons Chinese black vinegar

x 16

10 pots.
1 c.
4 T.
3–4 T.
1 tsp.
3 T.
3 T.
3 T.

Grate the potatoes in Robot-Coupe w/small teardrop attachment.

Soak grated potatoes in abundant cold water overnight, 3–4 times more water than potato.

Lift grated potato out of the soak after 24 hours, taking care not to stir up the starch that has settled to the bottom of the Lexan.

Rinse the grated potato thoroughly under cold running water in a fine-mesh colander. We want all the starch removed.

Let the potato drain well while you get your mise together.

Be sure to have a full clean sheet pan ready when you get to the stove. You will need to get the potatoes off the heat and out of the hot pan in an instant.

Over 2 burners set on high, set a large, flat-bottomed rondeau. Heat blended oil until shimmering and active but just below smoking.

Add Sichuan peppercorns and toast 30 seconds.

Add potatoes and cook over rocket-hot heat for 2 minutes, stirring constantly.

Remove from heat immediately and turn potatoes out onto waiting sheet pan. Potatoes should be crisp like jicama, translucent, and with no raw starch taste or mouthfeel.

Season with kosher salt and the sugar and the oils and the vinegar, stirring and coating each strand well, so they are all glossy and a little slick and rich.

Get the potato slaw chilled quickly in the walk-in and adjust seasoning again when cold.

Pasta Kerchief with Poached Egg, French Ham, and Brown Butter

Yield: 8 orders

For the pasta kerchiefs:

1⅔ cups + ½ cup "00" flour

2 egg yolks

1 whole egg

1 Tablespoon kosher salt

1 Tablespoon extra virgin olive oil

½ cup cold water

For the rest of the dish:

1 Tablespoon white vinegar

8 eggs

8–12 Tablespoons unsalted butter, +/-

8 slices smoked cured jambon de Paris *THIN SLICES!*

¾ cup shaved Parm

¼ cup pine nuts, toasted

best-quality balsamic vinegar

 for sprinkling

kosher salt

coarsely ground black pepper

Place 1⅔ cups flour in the food processor, turn the processor on, and add 2 egg yolks and 1 egg, one at a time, through feed tube. Mixture should have consistency of moist cornmeal.

Add salt and olive oil and, with the motor running, add cold water a couple of table-spoons at a time, until the dough just gathers into a ball and is difficult to work in the food processor. Depending on the humidity of the day, you may or may not use all of the cold water.

Transfer to a work surface lightly dusted with flour. Knead the dough for a full 10 minutes, even using a kitchen timer if necessary. The dough will start out sticky and coarse and by the end will feel silky and smooth and fine to the touch, and will not stick to your hands.

Let the dough rest on the counter lightly dusted with flour and wrapped loosely in film, for 2 hours.

Clamp the pasta machine to the far end of the prep table and give yourself some room.

Cut dough in four pieces; shape each into a vague rectangle.

Roll dough first on thickest setting, then pass the pasta through the rollers, decreasing the machine setting each time through, working your way down to the thinnest setting. (Start at 1 and move through each notch, rolling neatly, all the way to 8.) Do not flour the dough as you go. You've either got the balance right at this stage or not. Dough should pass through rollers without sticking but still have "grip."

When you have passed the dough through the machine on the thinnest setting, your sheet will be so long it takes up the entire length of the prep table and is so thin you could read the newspaper through it.

Cut the long sheet into 8" rectangles.

Wrap individually in parchment strips cut just wider and just longer than the pasta sheet, roll up like a kid's Fruit Roll-Up, and store for service in a quart container.

To plate, per portion:

Fill a wide and deep sauteuse with water and bring to a boil. Add white vinegar. Gently crack egg into a ramekin to check yolk is not already broken.

Tilt egg into the boiling water. Give the water a gentle swirl with a spoon, encouraging the raw white of the egg to encase the yolk in a nicely rounded shape. Reduce the heat if necessary to keep the water at a lively simmer. Poach the egg until the white is fully set but the yolk is still runny. You can check for doneness by lifting it out with a slotted spoon and gently prodding with your fingertip. If you see runny white, return to the simmering water. When the egg is nicely poached, remove with a slotted spoon, place in a pasta bowl, and set aside next to you in the warm area not far from the burners.

Move quickly from here to the finish, please.

Dunk a slice of ham in the poaching water, shake off hot water, and drape casually over the egg. Drop a sheet of pasta into the boiling poaching water and cook for 90 seconds.

You will see the sheet turn from yellowish to opaque and white. Using the slotted spoon, gently transfer the pasta sheet to the bowl and lay it over the egg and ham like a slightly rumpled bedsheet. Some cooks have had better success using a fish spatula, and some use the large tweezers. I don't care which, just don't tear the sheets. I use a short-handled slotted and my fingers, which burns, but works.

Let some drops of the warm poaching water accrue in the bottom of the bowl. *But don't drown it!*

Brown a good chunk of butter, about 2 tablespoons per order, and spoon liberally over pasta. Be cautious about burning the butter; it goes from brown to black in a heartbeat, but take it right up to the edge—the dish needs the nutty, toasted flavor.

Drizzle with a few drops of the good aged balsamic vinegar. Scatter with a few shavings of Parmesan cheese and the toasted pine nuts.

Season with salt and pepper.

LUNCH DESSERT

Cold Candied Oranges

x 10

10
4 c.
4 c.

Yield: 4 orders

4 small firm juicy seedless oranges with thin skins

1 cup sugar

1 cup water

Prepare a pot of boiling water, just large enough to hold the oranges submerged.

Wash and dry the oranges and channel attractively from stem to navel at ½" intervals. Simmer the oranges, turning and dunking them regularly to be sure they cook evenly, for approximately 25 minutes until they swell and soften but do not collapse or split. Include the long threads of zest.
Remove the oranges from the simmering water with a spider and throw away blanching water.

In a stainless steel pot combine the sugar and water and stir it well to dissolve the sugar. Bring to a boil over medium-high heat and allow to boil 10 minutes.
Carefully place blanched oranges and zest into the sugar syrup and reduce to a low simmer.
Simmer the oranges in the syrup for approximately 30 minutes, stirring and rotating and dunking frequently until a high gloss and kind of translucence occur. They float and will candy unevenly if you don't attend to them.

Cool oranges in their own syrup for a full 24 hours before serving. This kind of "cures" them.

Serve straight from refrigerator, very cold. One whole orange, a little of its own syrup. Waiters will set fork and knife and spoon at table.

Battered and Fried Brandied Cherries
with Chocolate Sugar

Yield: 6 orders (6 dozen +/-)

¼ pound Brandied Cherries (page 504)

1 egg yolk
pinch of salt
½ cup dark beer
2 Tablespoons sugar
⅔ to ¾ cup all-purpose flour
1 Tablespoon melted butter
1 egg white, stiffly beaten

from mimi sheraton's excellent german Book

3 ounces dark bittersweet chocolate, chilled
1 cup sugar

Beat egg yolk with salt, beer, and sugar.
Gradually add flour and beat until mixture is consistency of thin paint.
Stir in melted butter.

Let stand about 30 minutes, then fold in stiffly beaten egg white.

Use batter immediately after adding egg white.

For the chocolate sugar:

Drop very cold chunks of dark bittersweet chocolate through the grater attachment on the Robot Coupe and set a cold dry metal pan under the spout to receive the little threads.
Mix equal parts grated chocolate with equal parts sugar and keep cool and dry in your station.

To pick up:

Lightly blanket the bottom of small shallow bowl with chocolate sugar.

Dip 8–12 well-drained cherries per order into the batter and then carefully drop right into the deep fryer fat.

Retrieve when golden, drain briefly in clean stack coffee filters. Arrange neatly on the chocolate sugar, dragging them around ever so slightly, without messing up the bowl.

Be fastidious with the hygiene of the deep fryer fat and have the guys change it often. When we have a fried item on the dessert menu—which is not infrequently—be sure to keep left compartment of fryer reserved for savory and right compartment of fryer for sweet.

Label the fryer compartments for your fellow line cooks who will be inheriting the station on your days off and who may have forgotten the system.

Strawberry Milk

Yield: 4 orders

1 pound strawberries, hulled, sliced

3 cups milk

1 cup buttermilk

½ cup sugar

x 8

2 #

6 c.

2 c.

1 c.

Macerate strawberries in sugar 1 hour.
Add milks. Steep overnight.
Shake well.

Draw the juice of the berries out with sugar first. Don't add milks until you have syrupy berries.

Berries have to be excellent—don't try and compensate for shitty berries with more sugar, please.

To plate:

Jelly jar with straw, set on coffee saucer.

Cardamom Panna Cotta
with Roasted Black Plums

Yield: 6 orders

For the cardamom panna cotta:

7 Tablespoons sugar

1¼ cups heavy cream

1¾ cups milk

5 pods cardamom

1½ teaspoons granulated gelatin

2 Tablespoons cool tap water

Roasted Black Plums

× 12

14 T.

2½ c.

3½ c.

10 pods

1 T.

2 T.

Scald milk, cream, sugar, and cardamom pods and let steep 1 hour.
Bloom granulated gelatin sprinkled over cool tap water in small stainless bowl.
Re-scald cardamom cream and add gelatin to dissolve.
Pour into stainless bowl set over ice bath and bring down the temperature while stirring constantly.
Strain through chinois into 8-cup measuring cup when completely cooled and becoming viscous. Blend briefly with few vigorous buzzes of the immersion blender.

Pour into 4-ounce ramekins and chill until fully set.

If you are doubling or tripling and want to use sheet gelatin, I am fine with that but the conversions are tricky (a little uncertain and unpredictable), so taste one of the set panna cottas before you sell them to make sure you haven't made them too stiff. 4 sheets of gelatin soaked in a lot of cold water in place of 1 Tablespoon of granulated should be fine, but again, check. We want tender, blobby orbs just holding their shape when you turn them out into the bowl.

Run your offset carefully and in one confident sweep around the rim before turning out—I don't love it when you send out rough edges.

For the plums:

6 plums

1 cup sugar

8 cardamom pods

peel from 1 lemon

Cut black plums into ¼'s or ⅙'s wedges, depending on their size, and pull pits as you go.

Set up hotel pan with granulated sugar dusted evenly over the bottom.

Scatter cardamom pods and lemon peels around the sugar.

Arrange plums in neat rows on their rounded bottoms, skin side down in the sugar.

Sprinkle with water just using your fingertips.

Cover with foil and set in 350° oven for about 40 minutes—but check along the way—different fruit, different cooking time, often.

When the fruits are softening, after about 20 minutes, and the juices are loose in the pan, turn up heat to 400°, remove foil cover for 15–20 minutes, and let steamy accrued liquid turn syrupy and plums get some dry heat.

To plate:

Turn out panna cotta neatly into center of shallow bowl and spoon plums and syrup around perimeter.

Sugared Ripe Peaches
on Buttered Toast

peasant bread

sweet butter

dead-ripe peach, skin off

sugar

Clear Creek peach eau-de-vie, frozen and syrupy

Toast one slab of bread under the sally; both sides.

Butter well, "wall to wall."

Slice peach and arrange on buttered toast while still warm. Use one whole peach per order.

Sprinkle liberally with sugar, but don't create "snow drifts"—just enough to season and add texture. Set as is on plate, with **1 small shot of peach eau-de-vie, from the freezer.**

Peppermint Patties with Cold Candied Lemons

Yield: 25–30

Peppermint Patties

2 cups 10X sugar

1 Tablespoon soft sweet butter

1 Tablespoon cream cheese

1½ teaspoons peppermint *oil* (not extract)

2 Tablespoons evaporated milk

1 Tablespoon heavy cream

9 ounces semisweet chocolate shards
 (use leftover waiter scrap)

2 Tablespoons solid coconut oil

x 20 orders

1# 10x

20 gr.

20 gr.

1 T.

¼ c.

2 T.

Cream together butter, sugar, and cream cheese in mixer with whisk attachment. Add peppermint oil, evaporated milk, and cream and beat on high until fluffy and smooth and completely whipped—2 minutes. Scrape down sides, beat again 30 seconds. Scrape all mixture out of bowl onto sheet of parchment. Wrap and refrigerate to stiffen back up like a paste.

Weigh out cold peppermint paste in ½-ounce portions and roll into smooth balls, then flatten into perfect neat patties. The bottom of the 1-cup stainless measuring cup works well.
Chill the flattened patties another ½ hour in the freezer before dipping.

Melt chocolate and coconut fat together in medium stainless bowl set over simmering water. Blend very well. Turn the heat off under the water and hold the chocolate warm. Don't throw out the water in case you need to rewarm chocolate along the way.

Use the two-pronged candy fork (it's on my desk, in the pen bucket—return it when you are finished!). Drop the patties 2 at a time into the couverture, retrieve with the

fork, let excess run off, then bring to clean sheet of parchment. When cool and dry to the touch, collect and stack between sheets of plastic film and keep refrigerated. They will be matte, not glossy.

For cold candied lemons: follow Cold Candied Oranges recipe (page 339); use lemons in place of oranges.

To plate:

2 patties, shingled

1 lemon with some of its syrup pooled up in the bottom of the plate.

★ Cut a sliver off the bottom so the lemon stands steady and upright on the plate.

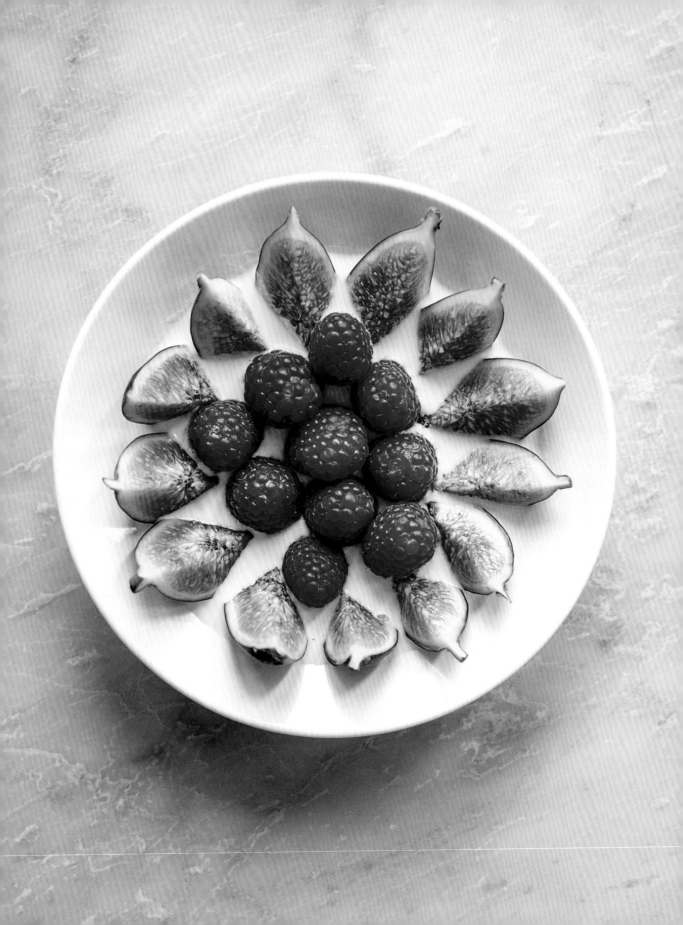

Figs and Raspberries with Steeped Lemon Cream

Yield: 6 orders

2 cups heavy cream

zest of 2 small lemons, without pith, taken in
 long spirals as possible

2½ Tablespoons sugar

2 pints figs—fresh, perfect

1 pint raspberries, also fresh and perfect

x 12
1 qt. h. cr.
zest x 4

5 T.

Grind lemon peels with sugar in clean, pastry-only spice grinder until wet, oily sand consistency.

Put mixture in quart container and pour in heavy cream.

Shake very well to dissolve sugar.

Steep 1 full day.

Shake well before using, at each use.

Keep very cold.

To plate:

Cut ripe black figs open to reveal hopefully jammy, perfect, red interiors and arrange in shallow small bowl.

Stud ripe red raspberries in and around the figs, or in a mound in center.

Shake lemon-sweetened cream in quart container and pour through small passoir to strain out bits of zest, letting cream pool up in and around fruit without drowning it completely.

Make sure fruit is room temperature and cream is cold, please.

Cold Yellow Watermelon with Lime Syrup

Yield: x6 orders

1 cup sugar

1 cup water

zest of 1 lime, microplaned *— take all there is . Don't leave bald patches*

the juice of that lime

5 pounds yellow seedless watermelons

Boil sugar and water together 15 minutes, or until viscous.

When cool, stir in lime zest.

Stir in the juice of that lime, whatever there is.

Cut yellow watermelon straight across in large even wheels, at 1½" thick.

Square (or rectangle) the wheels in 4 easy cuts, removing the rind completely and only leaving a plank of yellow fruit in front of you (save the rinds for garbage bin/dinner wax).

Cut big, even, neat cubes. Remove any seeds.

** Please show some knife skills . It drives me crazy to see this go to the table in uneven chunks **

Per order:

Stack melon on small football plate. Give them a solid 12 ounces—even close to a pound. It's summer!

Small glass beaker with 1½ ounces cold lime syrup. Set next to melon on plate, for guest to pour over.

No sticky drips, please.

Fried Mascarpone with Fennel Sugar

Yield: 6 orders

8 ounces mascarpone

3 Tablespoons 10X sugar

buttermilk

powdered milk

panko, ground superfine

3 Tablespoons ground toasted fennel seeds

3 Tablespoons granulated sugar

coconut oil

(handwritten note on torn paper:)
x 12
1 #
6 T.
buttermilk
powdered
panko
6 T.
6 T.

Whisk mascarpone with 10X sugar to blend well. Chill 30 minutes to firm back up. Combine granulated sugar and ground fennel seeds.

Set up 3 small pans for dredging and coating:

dry milk powder
buttermilk
panko

Use the small truffle scoop to form one-bite balls of mascarpone, then tap them out into the dry milk powder and roll around to coat. Handle quickly and gently, and finesse the round shape before dunking next in the buttermilk. Retrieve with fork, drop in panko, and roll to coat.
Transfer to ¼ sheet pan; line up in single layer without touching. *Freeze thoroughly before frying.*
Heat 2 inches coconut oil in small saucepot to 335°. Drop 5 frozen mascarpone marbles into the fat per order. Do not use deep fryer.
Fry to golden, about 90 seconds and retrieve with slotted spoon.

Drain in stack of coffee filters.

To plate:

Sprinkle 1 Tablespoon fennel sugar in the bottom of smallest shallow dessert bowl. Set hot fried mascarpone balls in a tight ring in bowl.

Buttermilk Panna Cotta with Cold Candied Meyer Lemon

Yield: 9–10 orders

For the panna cotta:

2½ cups heavy cream

2 cups buttermilk, well-shaken

½–¾ cup sugar

1 scant Tablespoon gelatin powder

3 Tablespoons cool tap water

Cold Candied Meyer Lemon (page 339)

× 30

7½ c.

6 c.

1½–2 c.

9 sheets

h₂0

↘ use cold candied orange recipe and substitute meyer lemons for oranges.

Put cool tap water in a small stainless bowl.

Sprinkle gelatin evenly over water and let bloom. Or soak sheets in water if you are on a big batch.

Scald buttermilk and cream with sugar. Use smaller quantity first, taste for sweetness, then add only if truly needed. We want the tang of the buttermilk to have a presence. Blend the gelatin with the scalded milks and pour into a stainless bowl set over ice bath.

Spin the bowl in the ice and hold your whisk stationary in the mixture like a rudder in a boat, to bring down the temperature of the base without creating a ton of air bubbles.

When completely cool and starting to become viscous, give the mixture a good, thorough pass with the immersion blender, and pour into 4-ounce ramekins. Chill overnight.

Don't portion while warm please—for some reason the gelatin settles to the bottom a little and when you turn them out later there is a thin line of separation, which portioning once cool seems to help.

For triple batch, sheet gelatin is fine but take care with the conversions—sometimes these have been too stiff. *We want tenderissimo!*

To plate:

Don't shred the edges with your offset spat. Turn out panna cotta in one, clean release. I can show you how if this is still troublesome for you, but mostly it's about not backtracking, and maintaining one forward motion.

Cut thin lemon wheels, stack slightly shingled, and let some of the syrup drip into the plate.

Poached Peaches with Toasted Almond Cream

Yield: 6 orders

7 peaches

6 cups sugar

6 cups water

1 cup Riesling

1 vanilla bean, split

long strips lemon peel from 1 lemon, taken with vegetable peeler

Bring sugar and water to boil in stainless steel pot. Add lemon, vanilla, and Riesling and return to boil.

Add peaches; keep submerged with parchment and a lid too small for the pot. Reduce boil to simmer.

Check in 10 minutes; skins should look a little bloated or blistered, from the air pocket trapped under the skin. Retrieve with slotted spoon and let cool on ½ sheet pan. Skins should slip off easily. Remove all the skins. Taste the 7th peach so you know what the other 6 taste like—have you poached long enough? Do the peaches have weird brown spots hidden inside? It happens. Check your work.

Cool the syrup quickly in ice bath and return cool, peeled peaches to cool syrup to store in walk-in.

for the Toasted Almond Cream:

Yield: 8 orders

¾ cup almonds—use what's in house: slivered, whole, blanched, skin-on—all are fine

¼ cup sugar

5 egg yolks

2 cups milk

heavy cream

pure almond extract

Toast almonds on sheet pan in 350° oven to fully golden and fragrant. Check after 10 minutes, but then check in 4-minute increments thereafter. They go quickly when they finally get going. Let cool completely.

In processor, grind cooled, toasted almonds with 2 Tablespoons sugar to granular—like coarse sand.

Blend the nuts with milk in stainless pot. Scald the nut milk; remove from heat and let the mixture steep for 20 minutes.

Strain through finest-mesh china cap into clean stainless pot. Contribute the soaked nut mash to family meal.

Whisk yolks vigorously with 2 Tablespoons sugar.

Rescald almond milk.

Temper yolks with hot milk, then return all to pot. Stir constantly, dragging rubber spat across bottom of pot fastidiously, and bring to 175° slowly, over medium heat.

Pour through sieve into waiting chilled stainless bowl set in ice bath. Chill quickly by spinning bowl and holding your spat steady, like a boat's rudder. Refrigerate over-night.

Loosen with a tablespoon or two of heavy cream the next day if too thick. And add a few drops of almond extract if flavor has dulled.

To plate:

¼ cup almond cream, pooled up in bottom of shallow bowl.

Perfect peach, well drained, set in center.

REMIND SERVER TO REMIND GUEST THAT THE PIT IS INSIDE

BRUNCH

Banana Bread

We need four full loaves of banana bread per weekend—28 pounds of it—for the hosts to be able to slice and hand around to the low-blood-sugar people who are kindly willing to wait an hour and a half in the brunch line. Make sure you make this on Thursday for the weekend—we cannot afford the time it takes in the ovens on a Friday given the rest of the heavy weekend prep. It tastes better anyway having "cured" a day or two.

About the loaf itself, here are some things to help get you there. I have often seen yours heave or burn or cave in. Here are some good baking practices I'd like you to adopt:

— aerate the flour before you measure.
— sift the dry ingredients together through a tamis.
— do a "true" creaming of the butter and sugar—let it go longer than you think, let the sugar dissolve, watch the butter turn from yellow to white—most of you hurry this step and it shows.
— add the eggs one at a time and allow to fully incorporate before you add the next.
— and seriously, take the time and effort to stop the machine and scrape down the sides and the bottom of the mixer periodically throughout. It matters.

— Make sure you use the dark brown, almost fermented bananas from the freezer left over from last week's brunch and not the new speckled yellow ones from this week's brunch. The dark, fermented flavor of the overripe banana makes the final product more interesting and delicious—with acidity, even, and a slight bitterness—than the innocuous creamy flavor of pristine yellow bananas.

— Because the oven gets opened and closed so many times as other cooks try to muscle in on the space and lay other things in there during the baking—the temperature fluctuates and will drag the cooking time. Allow a little over an hour and a half for it to bake thoroughly.

Lastly, the batter is heavy. These are serious loaves. To help you get the batter into the prepared loaf pans without having to wrangle the giant and heavy Hobart bowl, get an empty round cake pan and set it on the worktable, then set the heavy mixer bowl in

the cake pan, tilted like a keeling sailboat. The cake pan holds the tilted bowl steady and frees your hands, which makes getting the batter into the loaf pans effortless. With a giant muffin/ice cream scoop, scoop the batter into the prepared pans in this neat and clean fashion. If making multiples of the recipe, tare the scale after you put the prepared pan on it, then weigh out each loaf in 7-pound increments of batter.

1 loaf	×2	×3
2 cups sugar	4 c	6 c.
2 cups (1 pound) cool butter, but not straight from the fridge	2#	3#
4 large eggs, cracked into a pint container	8	12
2 cups bananas, mashed	4 c.	6 c.
3 cups flour	6 c.	9 c.
1 Tablespoon baking soda	2 T.	3 T.
1½ teaspoons ground cloves	3 tsp.	4½ tsp.
2 teaspoons ground cinnamon	4 tsp.	6 tsp.
1 teaspoon salt	2 tsp.	3 tsp.
1 cup buttermilk	2 c.	3 c.
1 cup walnuts, crushed	2 c.	3 c.

Grease a large loaf pan (13" x 4½" x 4") and line with parchment so that the bottom and longest sides are covered and have a few inches of overhang. Then grease the parchment as well.

In the stand mixer, with a paddle attachment, beat the butter for about a minute. With the motor running, add the sugar in a stream, and continue beating, stopping often to scrape down the sides. Properly creamed butter and sugar looks fluffy and white.

Meanwhile, sift dry ingredients together through the tamis onto a full sheet of parchment.

Add eggs one at a time to the creamed butter and sugar, scraping down the sides of mixer bowl between the addition of each egg. Sometimes the butter and sugar looks curdled after having added the eggs. While I don't think that's desirable, I have not seen this have an adverse effect.

Turn the motor down to slow, lift the parchment sheet of sifted dry ingredients by the two edges, funnel in ⅓ of the dry ingredients, and mix at a medium-low speed.

Add ⅓ of the banana, then ⅓ of the buttermilk.

Add another third of the dry ingredients.

Repeat this process once more, remembering to scrape down the sides throughout.

Add the walnuts.

Bake at 350° approximately 1½ hours. Check at 30-minute intervals, by inserting wooden skewer in center until it is clean when removed. Cover with aluminum foil for last 30-minute interval of baking, if necessary, to avoiding burning the tops. Loaves turn very dark brown, though, so discern between cooked and burnt by taking the pans all the way out of the dark oven for a second to check them in the light.

Allow to cool for a full hour in the pans before turning them out and peeling off the parchment.

Granola

I don't want our granola to taste like oatmeal cookies crushed in a bowl—way too sweet and like something for children. Ours should taste more like grainy toast. Make sure to take it past the golden, innocuous stage and into its darker, assertive character. Measure dry ingredients by weight or volume but please use a dry measure cup if measuring by volume. Similarly, use a liquid measuring cup for liquids if measuring by volume and not weight. The yields truly differ.

Yield: 1 quart	×3 qt.	×5 qt.	×6 qt.
1 cup (3½ ounces/100 grams) walnut/pecan pieces	2 c.	3 c.	4 c.
3 cups (9½ ounces/270 grams) quick-cooking oats	6 c.	9 c.	12 c.
1 teaspoon kosher salt	1	1	1
½ cup (1 ounce/30 grams) shredded coconut	1 c.	1½ c.	2 c.
½ cup (2½ ounces/70 grams) whole almonds, skin on	1 c.	1½ c.	2 c.
¼ cup sunflower seeds	½ c.	¾ c.	1 c.
¼ cup (1¼ ounces/40 grams) roasted flax seeds	½ c.	¾ c.	1 c.
¼ cup (3 ounces/80 grams) maple syrup	½ c.	¾ c.	1 c.
¼ cup (2¾ ounces/75 grams) honey	½ c.	¾ c.	1 c.
⅓ cup (2½ ounces/70 grams) vegetable oil	⅔ c.	1 c.	1⅓ c.

Measure all of the dry ingredients and combine in a large stainless steel bowl.

Measure the wet ingredients into a saucepan and heat over medium heat. If measuring by volume, use a liquid measuring cup and measure the oil first. Then measure the honey and syrup into the same cup with oil residue, so that the sticky liquids slide out of the cup easily and thoroughly, leaving no residual loss stuck to the walls of the measuring cup.

Stir the warming liquids until blended and loose, so that all the thick and tight viscosity has been melted, the liquid is free-pouring and loose, and the liquids are easily combined. This will allow the liquids to coat the dry ingredients evenly and uniformly.

Add the liquid to the dry ingredients and stir well—use a silicone heatproof rubber spatula because nothing really sticks to it.

Gently pack the granola into a shallow ½ hotel pan. It should be an inch deep and gently tamped down, still using the heatproof spatula.

Place granola in 325° oven and bake for 50 minutes, stirring at 5-minute intervals.

Remove from oven and press down on mixture to form a compressed block. When cool and dry, break apart into clumps and store in airtight container.

Fruit Salads

Keep 3-pound batches of the fruit salad out on the pass during brunch but have back up mise-d and ready to replenish as needed. I don't prefer the shock of ice-cold fruit salad—so keep ahead of the game and make sure some is tempered throughout each leg of the service, please.

Be sure to use the blue cutting boards, which are expressly for pastry use. I have tasted our fruit salad when one of you has carelessly used the all-purpose cutting boards, and no matter how well they were washed and sanitized, there can sometimes be a lingering, remote onion/garlic tinge. Be vigilant. Use the blue boards.

3 pounds red, black, or yellow fruits

¼ cup Ginger Syrup (page 505)

8 large mint leaves, chiffonaded

zest of 1 lime, microplaned thoroughly ✱ *please don't leave patches and bald spots. take all there is.* ✱

For the Black Fruits Salad:

black plums, sliced

black seedless grapes, halved

blackberries, halved top to bottom

For the Red Fruits Salad:

elephant heart plums, sliced

red seedless grapes, halved

cherries, pitted, neatly halved

For the Yellow Fruits Salad:

gorgeous navel oranges, supremed

small, ripe, fragrant, sugar-sweet pineapple, attractive dice—display some knife skills, please

ripe, crimson mango—do your best to work around the pit and not waste too much

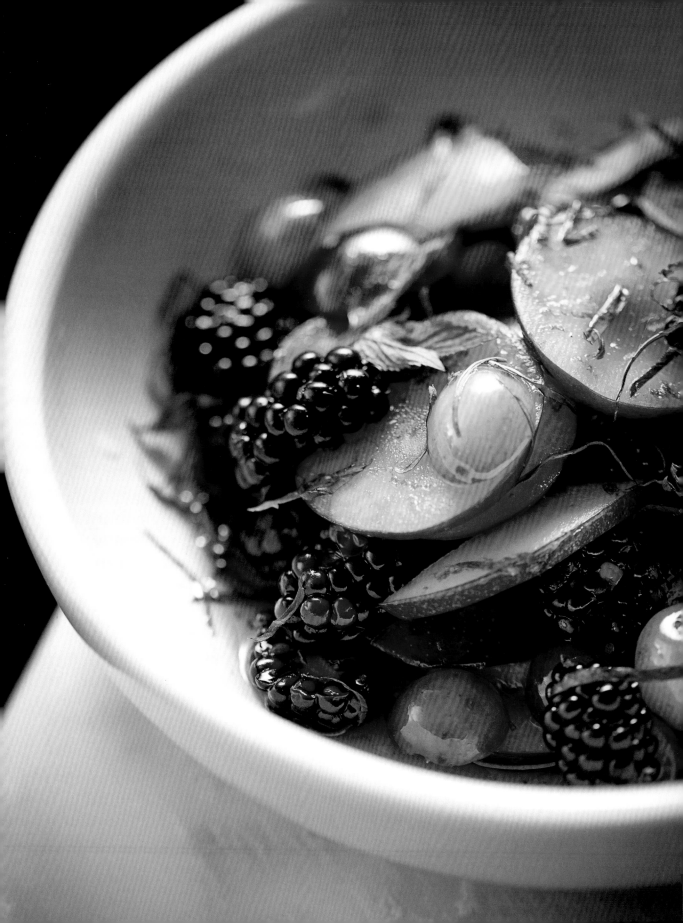

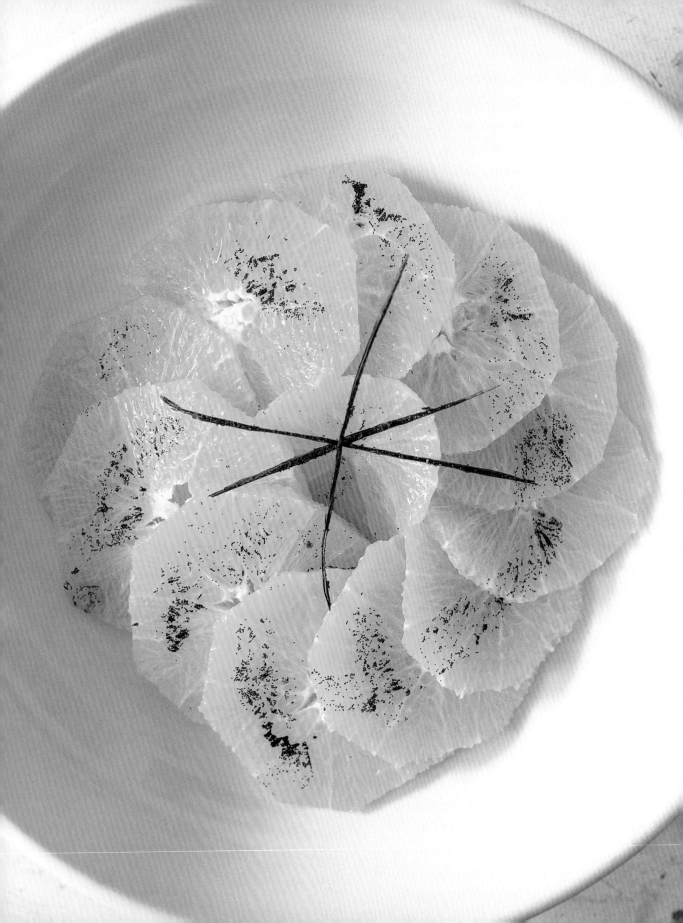

Sliced Oranges with Vanilla Bean and Rose Water

2 very sweet navel oranges
1 fresh Madagascar vanilla bean,
 split and scraped, husk reserved
½ teaspoon rose water

Slice off stem and navel end of oranges. Then remove the skin and pith with a knife in clean even strokes.

Pour the rose water onto the platter you will use for serving, and tilt plate until rose water has scented the whole surface.

Slice oranges across the membrane in thin even rounds, and arrange by shingling on the platter.

Using your fingertip, "paint" the oranges with the scraped vanilla bean seeds.

With a sharp paring knife, cut long threads from the vanilla bean husk and garnish platter with them.

Broiled Ruby Red Grapefruit with Wheat Chex Streusel

Yield: 2 orders

1 grapefruit

2 cups Wheat Chex cereal

2 ounces cold French salted butter,
 cut in small pieces

½ cup light brown sugar

Work butter and sugar together with your fingertips until marbled.
Add Wheat Chex cereal, trying not to crush it too much.
Halve grapefruit and skillfully loosen all the segments. We have a couple of those knives in the tool bins downstairs. Find them. Use them.

Pack some of the streusel gently and reasonably onto the ruby grapefruit half. Too much is too much. We want perfect fruit-to-topping ratio.

Set on sizzle plate and leave under salamander until bubbly and golden and toasted. Be careful—this can incinerate to black tar in a heartbeat.

One half per order.

You can freeze the streusel successfully, week to week, but do not over prep this item and clog up our precious freezer real estate unnecessarily.

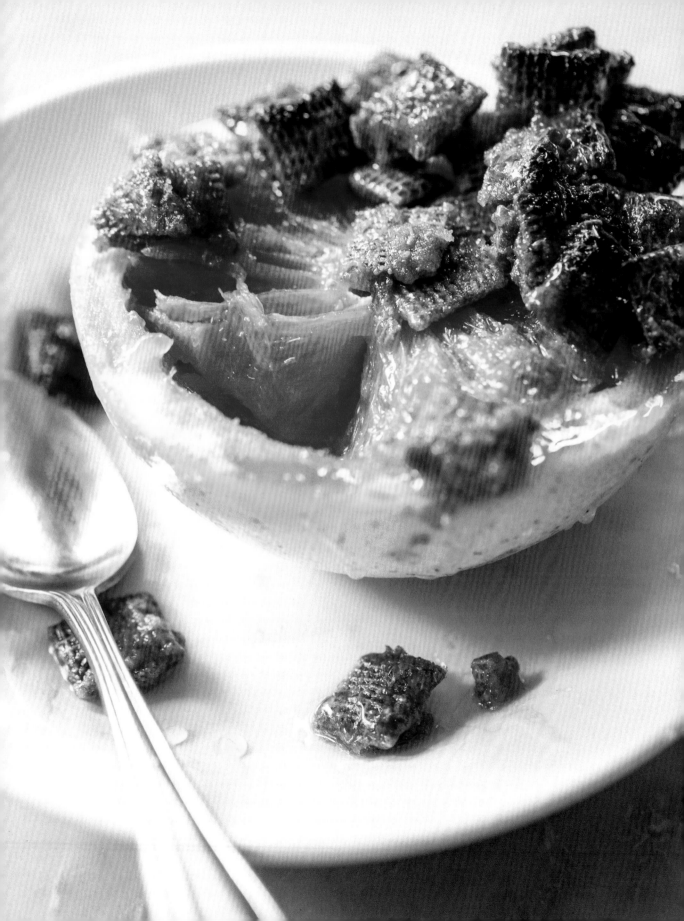

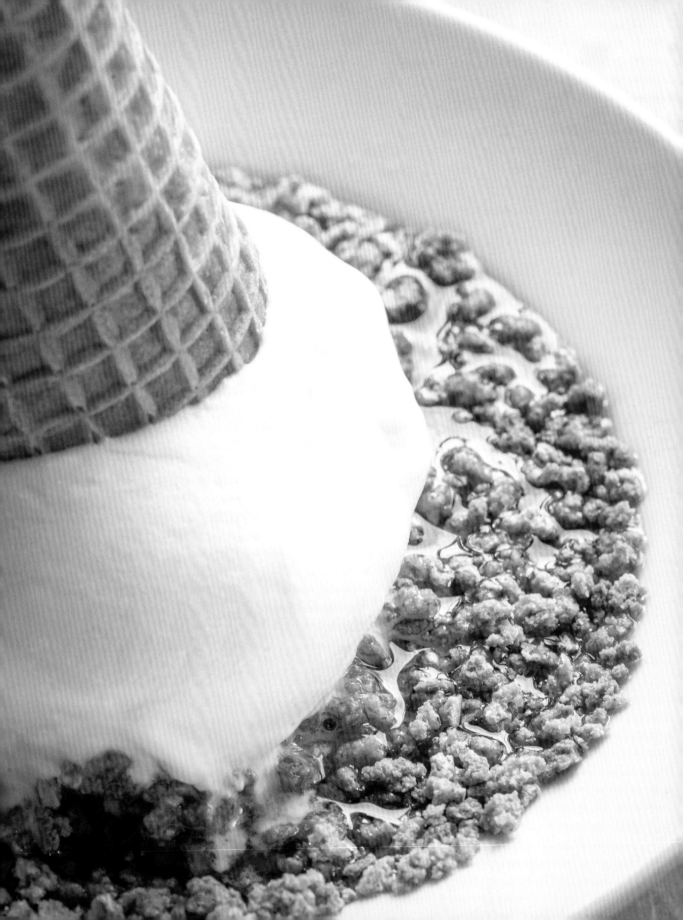

Grape-Nuts Cereal with Vanilla Ice Cream Cone and Cold Maple Syrup

Yield: 1 order

1 sugar cone
1 generous scoop vanilla ice cream
generous drizzle Grade B Vermont
 maple syrup, well chilled
½ cup Grape-Nuts cereal

In a bowl, place ½ cup Grape-Nuts cereal.

Drizzle generously with cold maple syrup.

Make a picture-perfect ice cream cone by scooping a big round scoop of vanilla ice cream onto the sugar cone.

Then invert the cone right into the cereal with syrup, so the ice cream is down and the point of the cone is up.

Serve immediately.

Les Merveilles

Start this project early in the shift as it requires a period of rest in the walk-in. You can make the dough a day in advance and roll and cut the following day, but no further in advance. The dough starts to discolor after two days in the fridge. You can freeze after cutting and before frying, but defrost in the walk-in a full day before you need it for service.

Yield: 8 orders

Ingredient	x2	x3	x4	x8
5½ cups all-purpose flour	11 c.	16½ c.	22 c./6#	12#
2 teaspoons baking powder	4 tsp.	2 T.	8 tsp.	16 tsp.
½ teaspoon salt	1 tsp.	1½ tsp.	2 tsp.	4 tsp.
1 cup sugar	2 c.	3 c.	4 c.	8 c.
1 whole egg	2	3	4	8
3 egg yolks	6	9	12	24
½ cup butter, melted	1 c.	12 oz.	2 c.	4 c./2#
zest of 1 lemons	1	3	3	6
zest of 1 orange	1	3	3	6
1 teaspoon vanilla extract	2 tsp.	3 tsp.	4 tsp.	8 tsp.
½ cup water	1 c.	1½ c.	2 c.	4 c.
3 Tablespoons rum	6 T.	9 T.	12 T.	24 T.
confectioners' sugar for dusting				
canola oil for frying				

In the stand mixer, with the paddle attachment, mix together dry ingredients. (If you are making 16 cups or larger batch, use the hook and use the Hobart.)

In a separate stainless bowl beat the whole egg and the yolks, then mix in the rum, water, vanilla, and the citrus zests.

Add the melted butter in a steady stream to the beaten egg mixture while whisking constantly to make sure the hot butter doesn't cook the eggs.

With the motor running on low, add the wet to the dry, drizzling it in while the mixer is on a low setting. Stop and scrape down the sides at least once. Let the mixer go until all the dry has been incorporated with the wet and there are balls of dough coming together.

The machine will start to work hard.

Turn the dough out onto a very lightly dusted work surface, if dusted at all. It's often not necessary on a stainless counter. Bring the dough together with a gentle kneading until no cracks remain—just a few minutes really. Shape into a neat, thick rectangle about an inch tall. Wrap in plastic film and let the dough rest in the refrigerator for at least 3 hours before proceeding.

Roll to ½", retaining rectangle shape. Then cut into 2½" squares. Pack between sheets of parchment and refrigerate again until ready to fry.

Cut squares in half on the diagonal and fry at 350° until deep golden and swollen to bursting.

Drain in a stack of paper coffee filters.

Finish with heavy dusting of confectioners' sugar.

5 PIECES per side order
3 PIECES per ricotta portion

Fresh Ricotta, Figs, Raspberries, and Merveilles with Honey and Pine Nuts

Yield: 4 orders

4 cups fresh, excellent-quality ricotta

2 pints fresh raspberries (in season)

16 fresh ripe figs (in season) or good-quality dried figs

¾ cup mild flower or clover honey (avoid chestnut or
 lavender or any intensely flavored honey)

½ cup toasted pine nuts

Les Merveilles (page 378)

Put a little ricotta in a bowl.

Slice figs and arrange nicely around the cheese, then arrange raspberries nicely in between the fig slices.

Drizzle the honey over the fruit and ricotta and sprinkle with toasted pine nuts.

Serve with just fried, warm merveilles that are heavily dusted with confectioners' sugar.

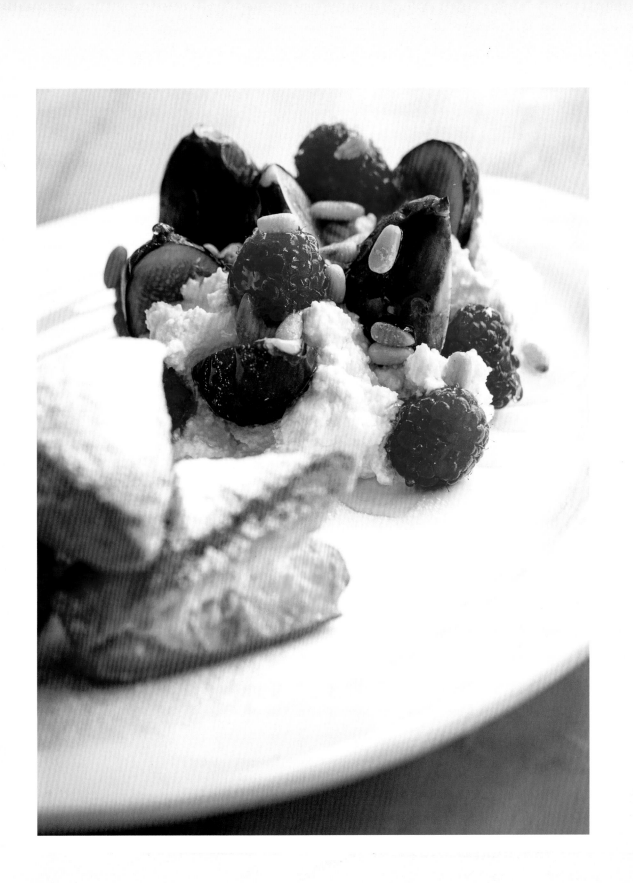

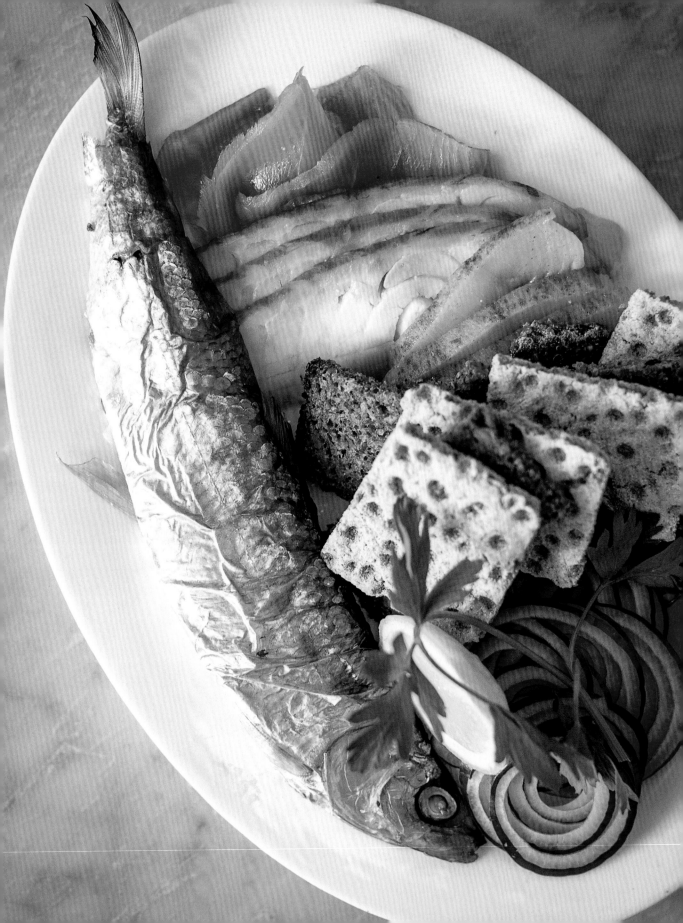

Lower East Side Appetizing

Per plate:

3 slices salmon

3 slices sable

3 slices sturgeon

½ chub

thinly sliced red onion

thinly sliced ripe tomato

lemon cheek

Ryvita crackers

coarse dark unleavened bread

cream cheese

horseradish butter

caperberries and cornichons

good branch parsley

✱ Do NOT family or throw away leftover brunch fish. It's too expensive and precious. **✱**
Find chowder recipe (page 535) and make batch according to quantity left over.

Youth Hostel Breakfast

On the plate:

3 slices wursts

1 landjaeger

sliced red onion

sweet butter

bitter orange marmalade

1 softly hard-boiled egg, split to reveal rare-cooked yolks

oil-cured Moroccan olives, pits intact

1 foil-wrapped wedge of cheese

Ryvita crackers

dark, grainy unleavened bread

1 full branch parsley

Accompanying tin of tubes:

smoked cod roe paste

herring pâté

mayonnaise

shrimp pâté

smoked salmon paste

yellow mustard

Keep the tubes very, very clean, please.

★ Remove all the caps, wipe all the spouts, roll up the bottoms like a toothpaste tube all through service. ★

Handshop cheese, wursts, landjaegers, and tubes from Schaller and Weber only.

Pancake Batter

You can keep premeasured and sifted batches of the dry ingredients—labeled and dated properly, folks!—stacked up in the prep kitchen for the whole weekend to make life easier for the brunch cooks who will inevitably be needing to mix more batter on the fly during service. But remember, you add dry to wet in this recipe, not wet to dry, and don't add the butter until you have completely combined the dry/wet. Also, whisk your eggs before you add your milk; otherwise the yolk beads up in the milk fat and doesn't blend perfectly.

Yield: 6 cups batter

	x 1	x 2
3½ cups all-purpose flour	4# 5oz	8# 10 oz.
1 Tablespoon + 1½ teaspoons baking powder	6T.	¾ c.
1 teaspoon salt	4 tsp.	8 tsp.
¼ cup sugar	1 c.	2 c.
6 eggs	24	48
1 cup butter, melted	2#	4#
2½ cups milk	10 c.	20 c.

Measure out the dry ingredients and sift through a tamis. (I am fine with just whisking the dry ingredients well if you are in the weeds and making this on the fly.)

Crack the eggs into a china cap set over a large metal bain. Use a whisk to push them through—to blend the egg and catch any shell.

Pour cracked egg into large stainless mixing bowl.
Add the milk and whisk together.
Add the sifted dry ingredients in thirds, mixing thoroughly each time. It will be thick and lumpy.

Whisk in the butter, adding in a slow steady stream. It will turn smooth and glossy and silken.

Store in green-lidded 8-quart Cambro.

Please don't store this in the 12-quart blue-lidded Cambros because they don't fit well in the sauté reach-in and are very inconvenient for whoever is working the station. Be kind to your fellow cooks and only store in the 8-quart containers.

To pick up:

Foam butter in 8" non-stick over medium-high flame.
1 full 16 oz. ladle per pancake.
Let set until bubbles form across surface.
Transfer to 400° oven until fully cooked through and springy to the touch—
8–9 minutes.
Invert onto large oval.
Dust with 10X sugar.

Spaghetti alla Carbonara

Per order:

2½ ounces pancetta, in neat 1-inch cubes

4 ounces spaghetti (dried weight)

1–2 egg yolks

¼ cup grated Parmesan

1 teaspoon freshly ground black pepper

kosher salt

SATURDAY
PAR

3# pancetta
5# pasta

SUNDAY
PAR

4# pancetta
6# pasta

Evenly scatter cubed raw pancetta into cold large cast-iron skillet.

Set over medium-low flame and render slowly, stirring occasionally until crisp and golden on all sides and sitting in significant amount of its own rendered fat, and cubes reduced in size by half.

Transfer to metal ⅙ pan, including fat, and leave in warm area of your station.

Cook spaghetti in big stockpot of boiling salted water—stir during cooking to be sure strands are separated.

When pasta just bends without snapping but is still significantly undercooked, drain immediately in large colander and hose down thoroughly with cold water, running your hands through each strand and making sure you have stopped the cooking process. Pasta needs to be cool to the touch throughout. Drain very well; store in your reach-in.

For the pick up:

Drop parcooked pasta portion into boiling water.

Move swiftly from here to finish—pasta only needs 90 seconds—2 minutes at most—in the reheat.

In clean stainless bowl, put two yolks and a hearty spoonful of rendered pancetta and some of its fat.

Sprinkle black pepper over the egg and fatty pancetta until light dusting obscures the yolks.

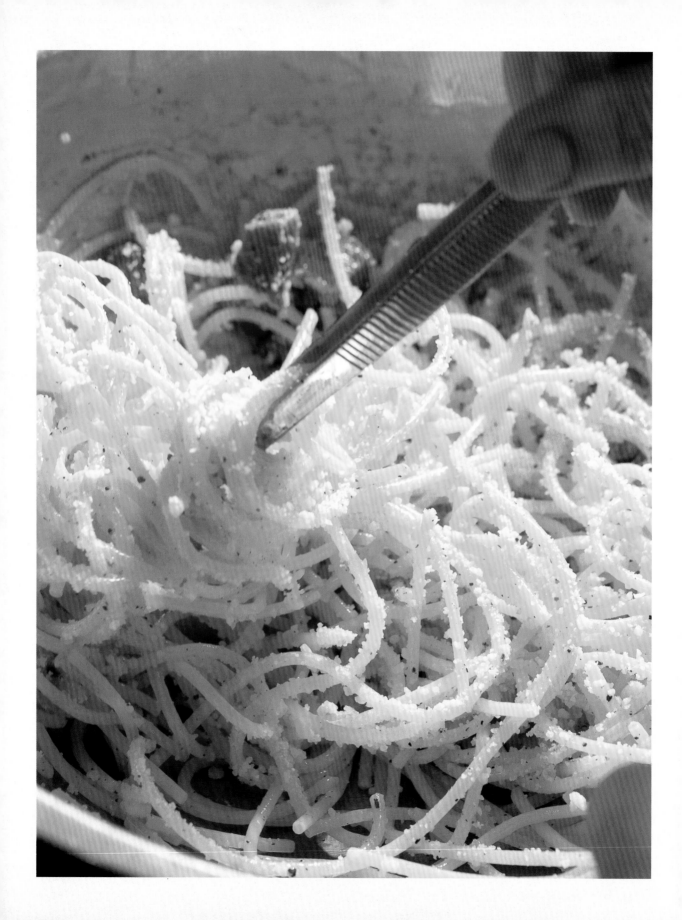

Pull hot pasta, drain briefly over pot, turn out onto the yolks/pancetta, letting some of the cooking water drip in, too.

Stir rapidly and vigorously to cook yolks with the residual heat of the pasta and to coat each strand with egg and fat.

Season with salt and generous/liberal sprinkle of grated parm and continue stirring to evenly distribute cheese and salt.

Make neat spiral in center of pasta bowl as best as you can when plating.

Plate quickly.

Don't let this sit in the pass.

Given that this is already a bastardy version of a real Spaghetti alla Carbonara, pulled together to accommodate the realities of busy brunch and the confines of the sauté station, please take care not to compromise the dish any further than we've already had to to make it work in the restaurant setting.

Pay attention to the toothsomeness of the pasta—don't get lost in your timing and let this just boil away in the pickup until it is flabby and bloated and disgusting.

Don't "creamy up" the yolk and parm with extra hot pasta water or extra cheese or by adding the cheese early so it melts—sometimes I have been dismayed to see it go out looking like creamy white pasta alfredo.

Ideally, we want the strands slick with yellow, eggy egg yolk and smoky, salty, uriney pancetta fat, with all the granules of sweet, nutty grated parm clinging to the strands. You want to see the black pepper, taste the floralness of it, and feel the warm heat of it in the dish—but don't obliterate.

Soft Scrambled Eggs

Yield: 4 orders

8 large eggs

4 Tablespoons heavy cream

2 Tablespoons sweet butter

kosher salt

freshly ground black pepper

2 teaspoons chopped flat-leaf parsley

Crack the eggs into a quart container with tight-fitting lid and shake vigorously until completely blended.

Add the cream and shake again to incorporate.

Heat the butter in a nonstick skillet over low heat until the butter starts to foam. Pour in the egg mixture.

Stir the eggs rigorously and continuously with a heatproof rubber spatula until they are set and softly scrambled, with very small curds.

They should look creamy and moist.

To plate:

Season with salt and pepper, and sprinkle generously with the freshly chopped parsley.

Add toasted English, ½ roesti, 3 strips bacon per order.

Eggs Benedict

Yield: 4 orders

2 quarts water

1 Tablespoon white vinegar

8 eggs

4 well-toasted Thomas's English muffins, generously buttered

8 slices Canadian bacon

Hollandaise Sauce

For Hollandaise Sauce:

½ pound butter, melted just before use

3 egg yolks

2 Tablespoons fresh lemon juice

1 teaspoon kosher salt

¼ teaspoon cayenne pepper

3#
20 yolks
¼ c. juice
salt +/-
cayenne +/-

Bring water to a boil in a wide, high-sided sauteuse.

Add white vinegar; reduce heat to a healthy simmer.

Crack each egg into a ramekin, then tip the ramekin into the simmering water. Swirl the water gently with your spoon to create motion.
For grade A, large eggs right out of the refrigerator, poach for 2 minutes and 30 seconds.
Arrange the English muffins in matched pairs (one top, one bottom) on the plate.

Warm the Canadian bacon on the griddle and set on each English muffin.

Retrieve the eggs with a slotted spoon, rest your spoon briefly on a folded dish towel to drain, then set the eggs on the muffins.

Drape each egg with a generous spoonful of the hollandaise sauce.

If you are working the egg station, take care with your poaching water throughout the shift. Clean it frequently and go easy on the vinegar—it makes the whites chalky and sour and the eggs have a pockmarked appearance if you put too much acid in the water. Snip the long white tails of cooked egg white so your eggs don't look like pollywogs/sperm. And please use the ramekin for tipping each egg into the water bath—there is no episode more crushing during the middle of insane brunch than to crack an egg directly into the water only to discover the yolk is already broken, making egg drop soup of your poaching bath.

For the Hollandaise Sauce:

Put the yolks in a stainless steel bowl.
Whisk in the lemon juice.
Secure the bowl on a damp kitchen towel, and pour the hot melted butter into the yolk mixture in a steady stream, whisking constantly, always keeping the emulsion.

As it thickens up, it will feel thick and heading toward pasty, but at the very end, whisk in all the watery and separated milk solids from the bottom of the melted butter and it will thin out to a ribbony and silken sauce. Please don't deviate from this method by clarifying the butter or by whisking it over a double boiler or by melting the butter in the microwave—-this is really how I want it and also I have never broken a batch of hollandaise in 15 years of Prune brunch.

Hold your hollandaise warm in a bain inside a hot water bain, but change it out regularly during service and keep it as far away from the heat of your burners in your station as you can. This is a pretty sturdy version, but still, hollandaise is a fragile sauce and that blasting heat in the sauté station can break it. If you need to thin during service, use 1 Tablespoon of lukewarm water and whisk vigorously. If you need to re-emulsify during service, add a squeeze of lemon juice and whisk briskly. But then taste if it needs a little reseasoning.

When seasoning, please keep in mind that the sauce will be dulled significantly by the runny egg yolks of the poached eggs as well as the buttered English muffin in the finished dish, so be sure to season high and bright with lemon and salt and cayenne. The cayenne, however, should only provide "warmth," not heat—we are not a southwest restaurant.

Huevos Rancheros with Warm Tortillas, Avocado, and Chihuahua Cheese

Ranchero Sauce (page 485)
Black Beans for Huevos Rancheros (page 486)

Per order:

5" corn tortillas, ¼'d, deep-fried at 350° until golden, crispy; salted
3-ounce ladle Ranchero Sauce
2 eggs
¼ perfect avocado
3 stems cilantro
lime cheek
½ cup shredded Chihuahua cheese
½ cup black beans

To pick up:

Ladle ranchero into 8" nonstick pan. Simmer over medium heat.

Add eggs one at a time. Let set about a minute, until whites become opaque.

Sprinkle cheese evenly. Set under sally 1 minute, or until golden blisters form on cheese but yolks are still runny. Take the cheese past gooey, melted, and flabby, please; get golden brown blisters on it. _BUT DON'T OVERCOOK THE YOLKS._

Release edges with rubber spat; slide out gently onto large plate.

To finish:

black beans, small handful warm tortillas, ¼ avocado, lime cheek, cilantro branches.

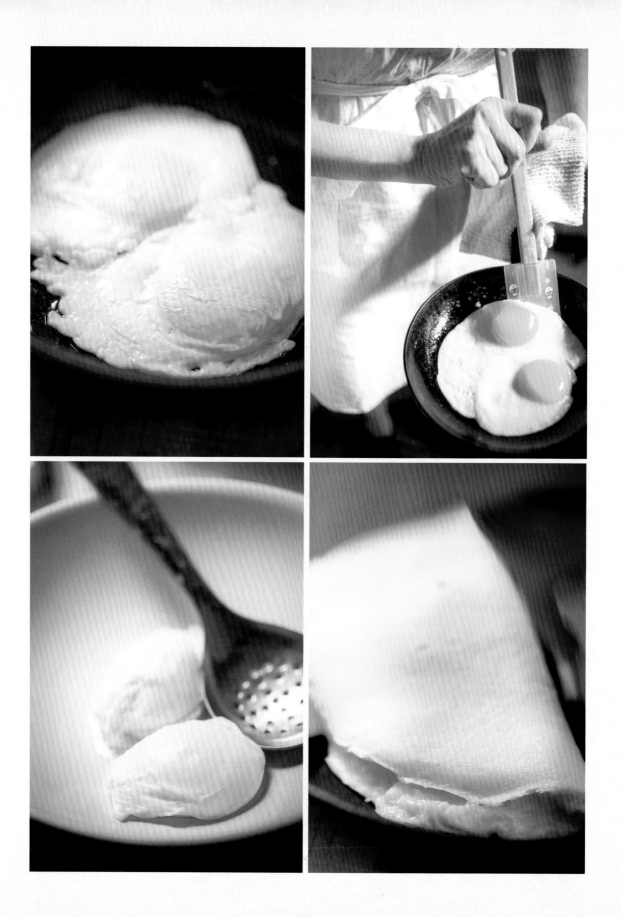

Brunch Omelette Base

By the time you are working the brunch egg station, you have been here a year and have worked your way through every other station. The omelettes at brunch are completely different than dinner—much more uptight, French-technique, smooth as glass, with no browning or color. Stay on top of it.

The pace and volume are a radical departure from dinner. Enjoy the ride!

Per omelette:

2 large eggs, beaten with 1 Tablespoon heavy cream

Foam butter in 8" nonstick sauté pan over medium heat.

Pour in beaten egg and allow to set for 5 seconds. With a heatproof rubber spatula, agitate the egg and the pan simultaneously and vigorously, preventing the curd from setting as effectively as you possibly can. Use a circular motion with your spatula and also work around the pan like a clock face, from noon to midnight, passing your spatula through all of the "hours." As the egg cooks and begins to set, the spatula will leave a clean streak once the egg thickens and isn't loose enough to run back into the path left by the spatula. Spread the setting egg evenly and uniformly across the bottom of the pan, gently tuck and tamp down the edges of the omelette to avoid dry lacy edges, and vigorously tap the pan on the burner top a few times, then turn the flame off but leave the pan on the hot burner, allowing the residual heat to continue cooking the egg without coloring it.

Fill omelette accordingly. Fold in half and turn out onto the plate, with the curved edge of the omelette following the curved edge of the plate.

Sour Cream and Toasted Caraway Omelette

Per order:

2 large eggs

1 Tablespoon heavy cream

2 teaspoons caraway seeds, toasted for 1 minute in a dry sauté pan until fragrant and turning color, then crushed briefly

1 Tablespoon butter

2 Tablespoons whipped sour cream, left out of the fridge to take the hard chill off

salt

freshly ground black pepper

Crack eggs, add cream, beat well.
Foam butter in a nonstick sauté pan, over medium heat.

Pour in beaten egg and allow to set for 5 seconds.

With a heatproof rubber spatula, agitate the egg and the pan simultaneously and vigorously, disrupting the curd from setting as effectively as you possibly can. Use a rapid and tight circular motion with your spatula and also work around the pan like a clock face, from noon to midnight, passing your spatula through all of the "hours." As the egg cooks and begins to set, speed up.

The spatula will leave a clean streak as the egg thickens and isn't loose enough to run back into the path left by the spatula. Stop immediately and spread the setting egg evenly and uniformly across the bottom of the pan, gently smooth down the edges of the omelette to avoid dry lacy edges, and vigorously tap the omelette pan on the burner top a few times. Turn the flame off but leave the pan on the hot burner, allowing the residual heat to continue cooking the egg without coloring it.

Fill omelette with 1 Tablespoon sour cream, 1 teaspoon ground caraway, salt, and pepper. Fold in half and turn out onto a warm, waiting plate. Top with the rest of the sour cream and the remaining toasted caraway seeds.

Fried Oyster Omelette with Tabasco Slurry

Per order:

For omelette:

2 eggs

1 Tablespoon heavy cream

2 Fried Oysters (page 27)

2 Tablespoons Tartar Sauce (page 481)

For tabasco slurry:

confectioner's sugar

Tabasco sauce

Sift the sugar into a bowl and make a well in the middle.
Pour Tabasco sauce into the well and mix thoroughly.
The ratio is 4:1 sugar to hot sauce. Keep it super hot and super sweet, as you scale up or scale down.

To assemble:

Make standard brunch omelette and place 1 Tablespoon tartar sauce and one fried oyster inside.

Fold omelette in ½, turn out onto plate, and garnish with second fried oyster set on 1 Tablespoon tartar sauce.

Serve with a ramekin of Tabasco slurry and garnish with lemon cheek and good branch of flat-leaf Italian parsley.

Monte Cristo

When you are making 40 of these at a stretch, wait until the end of the day when the prep kitchen is quiet and lay them all out, like an assembly line. It goes so much faster and will spare you sinking down into the hopeless despair that can sometimes overtake the lone brunch prepper.

Per order

x2 sandwiches:

5 Tablespoons butter, softened

4 slices French ham

4 slices Swiss cheese

4 slices roasted turkey breast

6 slices white Pullman loaf

clarified butter

> x 30
>
> 5# ham
> 5# turkey
> 3# swiss
> 3# butter
> 3 loaves Pullman

For the batter:

2 eggs

1 cup milk

> SATURDAY PAR:
> 8 eggs
> 1 qt.

> SUNDAY PAR!
> 12 eggs
> 6 c. milk

To assemble:

Butter all six slices of bread "wall to wall."

Neatly and within the confines of the bread, lay down the ham on 2 of the slices. Follow with the cheese.

Place a piece of buttered bread, butter side up, on top of the cheese.

Add the turkey in the same fastidious manner.

Place the last slice of bread on top of the sandwich, butter side down.

Neatly trim the crusts, cut in half on the diagonal, and pack neatly away between parchment sheets.

To pick up:

Blend egg and milk well.

Let each sandwich sit in the batter long enough to really drink in some of the custard, but not so long as to become soggy and unmanageable on your griddle.

Slick the hot griddle with a small ladle of clarified butter and set the soaked cristo on it quickly. Do not flip until full golden crust has formed—otherwise it will tear. Griddle second side until golden and then deep-fry at 350° for 1 minute to 90 seconds. Drain well.

Please be sure to check the temperature in the very center—I have seen some of them looking perfect on the exterior but the centers have been cold and not melted.

To plate:

Warm Cristo, cut in half, stacked.

2 over-easy eggs, seasoned with salt and pepper.

Small ramekin red currant jelly.

Light dust of 10X sugar on sandwich only.

Eggs en Cocotte

Yield: 8 orders

For the savory chicken:

2 cups Chicken Stock (page 448)

2 chicken thighs, bone in, skin on

5 Tablespoons unsalted butter

5 Tablespoons all-purpose flour

¼ teaspoon cayenne pepper

salt

freshly ground black pepper

For the cocotte:

4 Tablespoons butter

salt

freshly ground black pepper

8 eggs

½ cup heavy cream

Set oven to 375°.

In a saucepan, heat the chicken stock with the chicken thighs and simmer until fully cooked.

When cool enough to handle, remove the thighs, discard the skin and bones, and dice the chicken meat and set aside.

In a separate saucepan, melt the butter and whisk in the flour over medium heat.

Whisk in the stock gradually, to avoid clumping, and bring to a boil. Remove from heat.

Add the diced chicken meat to the sauce.

Season with cayenne, salt, and pepper.

To assemble:

Butter, salt, and pepper the insides of the cocotte cups or ramekins.

Divide the chicken mixture evenly among the eight cups.

Crack an egg in each and top with 1 Tablespoon of heavy cream each.

Lightly salt and pepper.

Cover tightly with plastic film, individually.

Place in a deep baking dish and fill ⅓ of the way with boiling water.

Put in oven at 425° and bake for 9–11 minutes, or until whites have fully set and yolks are still soft.

Potatoes Roesti

Yield: 1 order

2 peeled russet potatoes
4 ounces clarified butter

WEEKEND PAR

180
20#

If you can make these look as unnaturally perfect as a McDonald's hash brown, you have succeeded, which is oddly not nearly as easy as it should be, given the simplicity of the task.

Some common snags I have seen that set you back:

— the centers don't cook enough or cook quickly enough and they turn gray/black from the starch oxidizing. Make sure your fat is very hot in the pan.
— the centers can be sodden and greasy—again—fat not hot enough in the pan at the outset.
— they are too thin and crunchy—not enough grated potato per roesti and you end up with all crispy exterior and no creamy white interior. Always use 2 potatoes per 1 roesti.

Be sure to grate to order and never store the excess grated potato in water—you will wash away the needed starch.

Get the shredded potato into the hot pan immediately, before it starts to brown from oxidation. You can't use regular butter; the milk solids have to be removed. Use clarified.

Be sure to turn out onto a baker's rack to cool before stacking for service, else they will steam and glue together and become soggy.

★ ★ Only work ten at a time if you are experienced enough to manage it—I'd rather you worked only 6 at a time until you are surefooted enough to not burn any. ★ ★

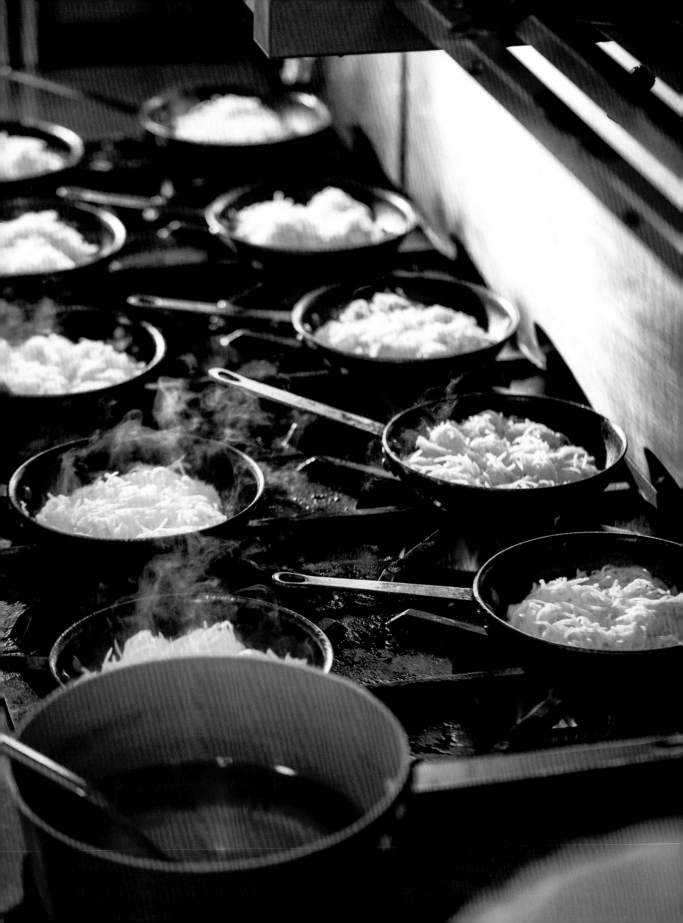

Set the pan over medium-high flame, and add 4 ounces of clarified butter.
The fat in the pan must be very hot, almost smoking, when the potatoes are added.
Shred 2 potatoes into a colander set inside a bowl to collect all the messy liquid.
Add the shredded potato to the hot pan and spread out gently in even thickness. Take care—the fat will spatter and hiss angrily from the water in the potato.
With a slotted fish spatula, turn when the bottom is golden and crispy like a hash brown. Remove when both sides are golden and crispy, and allow to drain on a baker's rack.

Do not season these; expediter will season at the pass.

* 2 potatoes per 1 roesti

* 4 full ounces of clarified per roesti.

* 8" non-stick pans ONLY — don't use the crappy aluminums.

** Have the guys peel 180 potatoes for the weekend and be sure you have 20# of clarified butter in the house by Friday.

Stewed Chickpeas, Butter-Crumbed Eggs, Homemade Flatbread, and Condiments

X 12 QT.

2 e # 10

1 e # 10

12 T.

4

12

1 c./1 T.

4 qts.

salt

For the chickpeas:

Yield: 6 orders

1 15-ounce can chickpeas,
 drained and rinsed

14-ounce can Muir Glen whole peeled
 tomatoes, liquid reserved

1 Tablespoon harissa paste

¼ Salt Preserved Lemon (page 479)

1 garlic clove, smashed

1½ Tablespoons ground cumin

1 cup water

kosher salt

Combine all of the ingredients in a nonreactive pot. Crush the tomatoes vaguely with a spoon. Squeeze the lemon for the juice and add the spent lemon to the pot as well. Reserve the liquid from the canned tomatoes for later, if needed, and add all of the remaining ingredients except salt. Stir together and bring to a simmer over medium heat. Lower heat and let it go, covered, for 45 minutes, until the appearance is stewy and not watery and the flavors have melded deeply. Add tomato liquid as necessary.

Taste carefully before adding salt; sometimes the preserved lemon with its inherent saltiness is enough.

Keep in mind that the butter-crumbed eggs will ooze their dulling yolks into the dish, softening the bite of the harissa and the salt equally. The flatbread, olive butter, and olive oil finish will do their parts as well.

For the Butter-Crumbed Eggs:

Yield: 6 servings

12 whole eggs

1 Tablespoon white vinegar

ice water

4 eggs, beaten

3 cups panko crumbs, ground with a few pulses in the Robot Coupe to make finer

1 pint clarified butter, melted

Poach the 12 whole eggs in gently simmering water with white vinegar until the whites are fully set but the yolks are not cooked at all, 90 seconds–2 minutes. Remove from poaching water with a slotted spoon and shock in ice water to stop cooking.

Gently remove eggs from ice bath after chilled, and drain on kitchen towels until completely dry.

Put the beaten eggs in a shallow pan and the panko in another shallow pan. Carefully take 1 dry poached egg and dip into the beaten egg. Remove from beaten egg and dip into panko, rolling gently until it forms a crust over the entire egg. Leave to set and dry a bit in panko crumbs. Repeat with the rest of the eggs.

Place the panko-covered eggs in the walk-in and allow the crust to set for 30 minutes.

To pick up:

Heat the clarified butter in a sauté pan over medium-high flame until shimmering. Gently place crumbed eggs into the clarified butter, and fry for approximately 3 minutes, turning once with a slotted spoon until golden all over.

Place spicy stewed chickpeas in the bottom of the large wide pasta bowl and arrange the hot crumbed eggs on top. Schmear the eggs while warm with a good hit of the Black Olive Butter (page 469).

Scatter liberally with the garnishes:

torn parsley leaves
slivered oil-cured olives
slivered Pickled Turnips (page 491)
finely minced Preserved Lemon peel (page 479)
Drizzle with EVOO.

Set warm slices Flatbread (page 487), slathered with Black Olive Butter (page 469), attractively into bowl. Don't obscure the eggs.

Iced Ovaltine

For customers:

2 heaping Tablespoons Ovaltine

1 cup whole milk

large tumbler, ½ full ice cubes

stir completely, don't let it settle at the bottom

For line cooks:

6 heaping Tablespoons Ovaltine

3 cups milk

plastic quart container, filled with ice, straw

ALDA!

Burrata

Remove any wrapping, paper, and twine from the necks.

Set cheese (directly from reach-in) in bowl of very warm water and let it rest there 10 minutes. Drain well and set on clean towel before plating.

Put whole burrata—1 pound +/- —in shallow small bowl. Generously pool extra virgin olive oil around the base—keep cheese pristine white, don't drizzle the oil all over the cheese.

Grill bread, both sides, to good char. Stack on small plate, separately.

You have to be vigilant with the temperature and the freshness. Burrata sours so quickly. Be sure your product is ultrafresh. And make sure it sits in the warm water long enough to lose the refrigerator chill at its creamy center.

Don't goo this up with salad or condiments or "added value" crap, please. Let's just let the big gorgeous milk-white orb speak for itself.

Alda's Braised Octopus with Potatoes

Yield: 8 orders

1 octopus, 4–6 pounds, head and beak removed
⅓ cup extra virgin olive oil
1 cup sliced red onion
6 garlic cloves, smashed
3 chiles de árbol, whole
16 small waxy potatoes, peeled
few good branches fresh thyme
1 quart water
salt to taste

×16

2
¾c.
1 pt.
12
6
32
thyme
h₂o
salt

In the enameled Dutch oven, gently heat the EVOO and warm the onions, garlic, chilies, thyme, and potatoes.
Stir the vegetables until they start to give up steam and look alive.
Sweat down a bit but do not get any color, just 2–3 minutes.
Nestle the octo neatly in the pot.
Add enough cool water to not quite cover the octopus.
Season accurately with salt, keeping in mind that the octopus will render its own sea-watery liquid into the pot during cooking.
Cover with the heavy, tight-fitting lid and bring up to a boil.
When steam comes jetting out of the pot, turn down heat to a very, very gentle low simmer—and let her go undisturbed for 45 minutes.

Check in on the octopus then, stir things around, feel the firmness/tenderness of the thickest part of the legs, re-cover, and let it continue to simmer.

Check occasionally for doneness by piercing the creature with a skewer.

At first it will turn bright purple-red and swell up considerably, but when it is nicely tender it will have shrunk and become bluish purple.

This can take up to 3 hours, so check along the way and use your judgment.

When cool, portion the legs (if skin and suction cups look good, leave as is; if they look skanky and stringy, peel and discard), crack the potatoes open to reveal the yellow interiors and their purple-stained edges, and serve with some of the broth.

Save the liquid for next batch of octopus.

✸ Freeze the octo liquid if we are in surplus, but don't throw it out. ✸

Plain, Well-Boiled Vegetables
with Olive Oil

small, if not baby, zucchini, trimmed but whole, if small enough
escarole, cored, roughest outer leaves discarded
haricots verts, stems removed, tails intact
baby fennel, quick trim of brown spots at root end, feathery fronds lopped off at top
EVOO

Boil water. Season heavily with salt. Taste it.

Boil vegetables, one type at a time, until soft at core but not dead.

Beans need about 10 minutes, escarole needs only 3, fennel and zucchini approximately 4.

Remove with spider and drain on a baker's rack. The aim is: soft but well-cooked vegetable; not dead and not al dente.

Do not shock in ice bath!

When cooled to room temp, arrange portions on plate and almost drown in excellent olive oil.

Do not further season.

Salt and Pepper Pork Chops

sirloin chops, not loin, cut at ¾ inch—10–12 ounces each
kosher salt
freshly ground black pepper
softened butter

Hot, dry, heavy steel pan: give it 5 full minutes over medium flame to fully heat.

Season chops both sides, liberally. Snip a few notches in fat and muscle with scissors to prevent curling when they hit the heat.

Set in hot pan, increase heat to high, and don't touch for 5 minutes. Flip and cook other side 8 minutes.

Remove immediately and stack on plate; let juices accumulate on plate. Smear with soft butter while warm.

Do not garnish.

Pizza Rustica

8 ounces (1½ cups) flour, plus additional as needed

1 large egg

6 Tablespoons butter: 2 softened, 4 melted

1 pound fresh mozzarella, cut into ¼-inch slices

salt

freshly ground black pepper

egg white, lightly beaten

Set before you a cup of cold water.

Mound flour on your work surface and make a well in center.

Crack egg into well and add 2 Tablespoons softened butter.

Beat egg and butter with a fork, gradually incorporating flour from edges of well.

Add just enough sprinklings of water to make a cohesive dough.

Form dough into soft ball, and knead briefly to make smooth and pliant.

Scrape work surface clean of debris and dust lightly with flour.

Roll dough as thin as possible, turning it occasionally to make sure it does not stick to work surface, and shaping it into a rectangle.

Liberally brush entire surface with some melted butter. (Alda used her fingertips; you can use a pastry brush.)

Starting with edge closest to you, roll dough away from you as if rolling up a sleeping bag, to make a long serpentine shape.

Divide dough in half, then coil each piece like the shell of a snail and place in freezer for 15 minutes.

Set oven to 350°.

Brush bottom and sides of a 12" round cake pan with melted butter.

Remove one coil from freezer and roll out to size and shape of pan, then place it neatly in bottom of pan.

Arrange mozzarella in a single layer on top of dough to within ½ inch of edges, and season with salt and pepper.

Remove remaining coil from freezer and roll out to fit pan.

Place neatly on top of mozzarella and seal edges by pressing them together, firmly, with your fingertips.

Brush top with egg white.

Bake until lightly golden on top, about 30 minutes.

Allow to cool, then maneuver onto a cutting board so that side brushed with egg white is up.

Cut into 8 wedges.

Eggplant Parmesan

2 pounds standard eggplant

kosher salt

1 28-ounce can San Marzano whole peeled tomatoes

1 garlic clove, peeled and minced

extra virgin olive oil for sauce and frying

freshly ground black pepper

½ cup fine dry bread crumbs, ours, not panko

½ cup all-purpose flour

8 eggs, beaten

canola oil for frying

1½ pounds fresh mozzarella, sliced into ¼-inch rounds

1 cup grated Parmesan

1 packed cup fresh basil leaves

6 hard-boiled eggs, peeled and cut into ¼-inch slices

Cut eggplants lengthwise into ¼" slices.
Arrange one layer in bottom of a perforated hotel pan and sprinkle evenly and generously with salt.
Repeat with remaining eggplant, salting, until all eggplant is in the pan.
Weigh down slices with another pan set inside and let drain for 2 hours.

While eggplant is draining, combine tomatoes, garlic, and ⅓ cup olive oil in the food processor. Season with salt and pepper to taste and set aside.

When eggplant has drained, press down on it to remove excess water, and lay it out on paper towels to remove all moisture.

In a shallow container, combine flour and bread crumbs; mix well.

Pour beaten eggs into another shallow container.

Place a large, deep skillet over medium heat, and pour in a ¼" of canola oil and then enough olive oil to make oil about 1" deep.

When oil is shimmering, dredge eggplant slices first in flour mixture, then in beaten egg. (It seems backward, but this is how she does it.)

Working in batches, slide coated eggplant into hot oil and fry until golden brown on both sides, turning once.

Drain on paper towels, also keeping any lacy bits of egg that have formed in pan.

Set oven to 350°.

In bottom of a ½ hotel pan, spread 1 cup tomato sauce.

Top with one third of the eggplant slices.

Top eggplant with half the mozzarella slices.

Sprinkle with one third of Parmesan and half of basil leaves.

Make a second layer of eggplant slices, topped by 1 cup of sauce, remaining mozzarella, half the remaining Parmesan, and all the remaining basil.

Top with egg slices.

Add remaining eggplant, and top with remaining sauce and remaining Parmesan.

Bake until cheese has melted and the top is lightly browned, about 30 minutes.

✶ Allow to rest at room temperature for at least 20 minutes before serving. It needs to cool and meld and settle slightly. ✶

Escarole Salad in the Roman Puntarelle Style

Yield: 4 orders

¾–1 pound Belgian endive

4–5 cloves burning, sticky fresh garlic, peeled

3 Tablespoons fresh lemon juice

10 anchovy fillets in oil

2 serious pinches kosher salt

¼ cup + 2 Tablespoons EVOO

freshly ground black pepper

1 cup crushed ice

Trim the brown bit at the base of each head of endive. Cut into long thin strips, top to bottom, like straw.
Place in metal bowl and scatter the ice on top.
Mince the anchovies very fine.
Microplane the garlic, wasting none.
Whisk together garlic, anchovies, lemon juice, EVOO, salt, and many grinds of black pepper. Drizzle all over the endive and toss well to blend with the cold water from the melting ice.

This replicates about as precisely as I have ever managed the classic puntarelle salad I've had a couple hundred times in Rome and in Milan. Finally figured out to give up on American dandelion as a substitute. Be sure it has all its accumulated dressing when you portion—the garlic is ferocious and needs to be tamed by the water.

Also, some customers will be weird about the ice if a few slivers remain in the tangle, as if you made a mistake. Remind the servers to remind the customer that the shaved ice is intentional.

Fennel Baked in Cream

Yield: 6 orders

3 large bulbs good clean fennel, stalks removed

2 cups heavy cream

1½ cups grated Parmesan

kosher salt

freshly ground black pepper

4 Tablespoons sweet butter, cubed

x 24

6 #

6 c.

4½ c.

S + P

½ #

Set oven to 425°.

Cut fennel into neat wedges, 6 per bulb, and arrange in hotel pan, rounded bottoms down, cut angles up.

Stir cream and half of Parmesan together, season with salt and pepper, and pour neatly and evenly over all of the fennel, letting it pool up and totally drench the fennel.

Dot with the cut butter.

Cover with parchment and foil; seal well.

Braise in the cream for 1 hour.

Remove foil and parchment; sprinkle with remaining Parmesan and return to oven for last 30 minutes until fennel is tender, cream mixture is thick and bubbly, and top is catching good color—golden to toasted brown in patches.

To plate:

This is a scoop and serve, practically.

Put 3 wedges in your pan, with luscious sauce, gently reheat on stovetop, and pass under salamander before tipping into shallow bowl.

✶ Don't be sloppy. It's already kind of ugly to start with. ✶

Sgropino

Per drink:

1 small scoop lemon ice cream

1 ounce Lemon Vodka (page 501)

chilled Prosecco to top off

In a blender mix ice cream and vodka and a splash of Prosecco and blend until smooth and frothy.

Spoon into a champagne flute and top with cold Prosecco.

Be careful topping it off with the Prosecco—it foams and bubbles wildly.

* immersion blender works well, too, and makes less noise during service. Be mindful of tables 9 through 14 on the banquette who will have to live through your blender frenzy every time you sell a sgropino. *

Alda's Zucchini Tian

Build this in the round heavy Le Creuset casserole and take the time to make it nice, please. This is another one of those ultra-simple Italian dishes from my mother-in-law that leaves you nothing to hide behind if you don't just do it right. When you build it sloppy—too-thick cut; careless, hasty layering—I notice it looks and tastes sloppy. But when you take care—beautiful slices; neat, concentric circles; the right heavy pan; even and gentle seasoning at each layer; firm, shiny small-seeded zukes and not the blown-up pulpy ones—you end up with a serious beauty.

This was one of the things we made when we won our Iron Chef battle, so that's how good it can be when you take the care. Don't use cast iron—it discolors and adds too strong a flavor.

This yields twelve portions, cut at 8 ounces each, which is generally an OK par for midweek, but make two per service on the weekends, please. Day old is delicious too—better, even—so you can carry leftover from Sunday to Monday if you have it.

Yield: 12 orders

2 large russet potatoes, peeled

1 or 2 red onions, peeled

4 pounds mixed, firm zucchini and summer squashes, with small
seeds and tight pores

2 on-the-vine tomatoes in winter, or large ripe beefsteaks in summer

½ cup bread crumbs (real stale bread kind, not panko)

3 Tablespoons melted butter

1½ cups olive oil

Set oven to 375°.

In heavy, round, low-sided casserole—the Le Creuset that Ned left here is perfect—add a few Tablespoons of olive oil.

Thinly slice the potatoes into rounds on mandolin or on meat slicer set at #5. The rounds should be flexible and ribbony, and not so thick as to be rigid.

Arrange the potato slices in neat, fastidious, concentric and just slightly overlapping shingle pattern around bottom of the oiled casserole. Season briefly with salt and set in oven for about 20 minutes, until the potatoes start to bubble and brown at the edges and become translucent.

Wash the zucchini and squash thoroughly under running water and use your hands to rub off the sand that often clings tenaciously. Then take the extra step of drying them with a clean kitchen towel—there's something about the fuzzy skin of zucchini that really doesn't want to give up the grit.

Slice onions, zucchini, and summer squash in rounds also on the mandolin or the meat slicer set at #5. The difficulty of the mandolin is that sometimes the channel is not wide enough to accommodate certain onions or certain squashes—pattypan in particular. It also has a tendency to shred the vegetables a little at the end of the slice, no matter how often we sharpen the thing. I prefer you use the meat slicer. Keep the vegetables grouped separately after slicing.

Score a crisscross x at the bottom of each tomato before blanching in boiling water for less than a minute—just until the skin blisters. Shock the tomatoes in ice water, then peel and set aside.

To build:

In same neat, fastidious domino pattern, create a layer of zucchini on top of the cooked potato layer.

Season with a drizzle of olive oil and some salt and pepper. It's easier and you'll have more control if you use the olive oil bottle with the liquor pour spout.

Lay in a layer of summer squash in the same way, and season equally.

Continue with layer of red onion, by loosely scattering rings across the whole dish, overlapping. Season again with olive oil, salt, and pepper.

Repeat layers, in same order—zucchini, squash, onion—seasoning each, until all the sliced vegetable is used. Occasionally press down to even out the "doming" that happens in the center.

With a sharp knife, or on the meat slicer (though it gets a little wet and slings drops of tomato juice), slice the tomatoes into thin rounds without shredding. Make a neat, overlapping shingled layer of tomato on top.

Sprinkle generously and evenly with the bread crumbs.

Melt the butter and drizzle all over the tian before baking.

Give it 3 hours in the oven and allow to set/cool for at least half an hour after you take it out, before portioning. It needs the time to "settle."

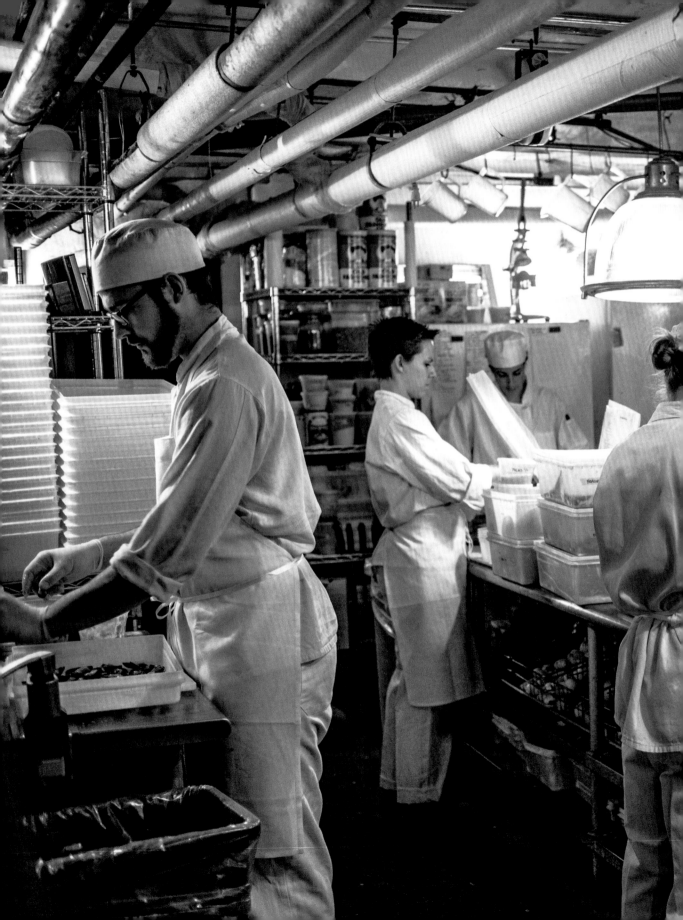

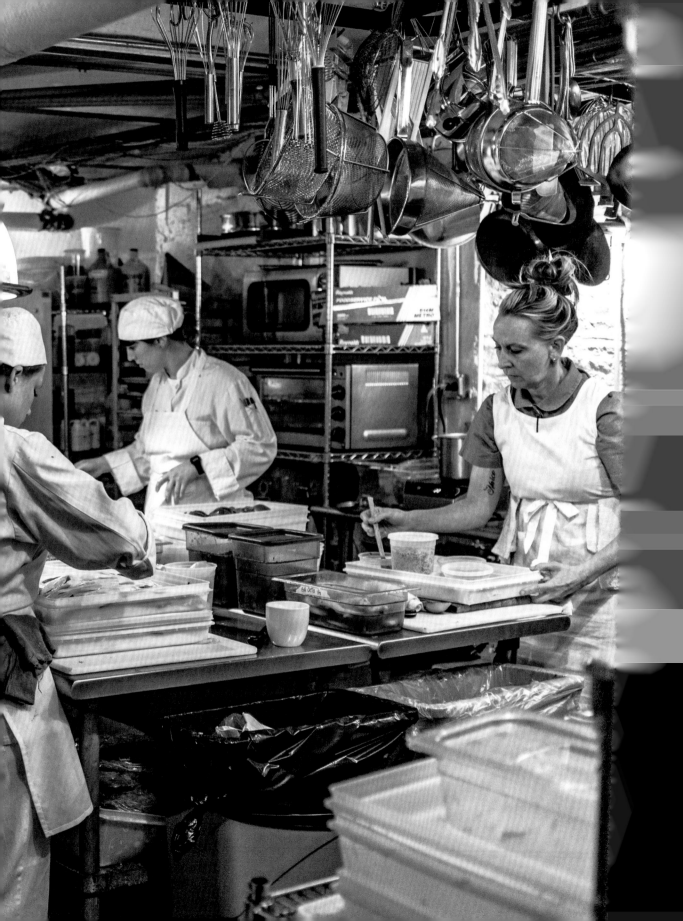

Beef Stock

Yield: x12 quarts

20 pounds beef bones, rinsed

1 full quart celery, coarsely chopped

1 full quart peeled yellow onion, coarsely chopped

2 Tablespoons black peppercorns

12 bay leaves

handful parsley and thyme leaves *use whatever's leftover and wilting from last night's waiter's herb bowl. *

Brown bones in a 400° oven until dark brown but not burnt. Don't overcrowd on the sheet pans.

Put carrot, celery and onion, herb stems, bay leaves, and peppercorns in large stock-pot with a good hunk of butter. Use low flame and just sweat to fragrant and soft.

Move roasted bones to stockpot and discard fat in roasting pan. If you have roasted well and the fond looks good, pour some water into the sheet pans and get all the goodness by stirring and scraping with a wooden spoon. You can set them directly on the stovetop and let the heat from the pilot lights help to melt the fond. Add this to the stockpot.

Add cold water to the stockpot to just cover the bones.

Bring to a boil and skim fat and foam.

Lower heat to a very gentle simmer and cook undisturbed until stock is reduced by a full third, is attractive brown, and tastes like something. 6–7 hours. Check on it regularly—your fellow cooks are always jockeying pots around on the stove looking for available burners and inevitably your stockpot gets unwittingly shut off or driven at a hard boil unattended for who knows how long. Protect your work.

Strain stock through china cap.

Rapid chill.

Defat following day when fat cap has fully congealed and is easily lifted off.

Oxtail Broth

Yield: x12 quarts

10 pounds oxtails

10 pounds veal bones

1 calf's foot, split

mirepoix (1 large carrot, 2 stalks celery, 1 large yellow onion)

peppercorns

2 bay leaves

6 cloves

1 bunch thyme

whole star anise

one large bottle white cooking wine

Roast the veal bones and calf's foot to golden brown in a hot oven.

Sweat the aromatics in a stockpot using butter, not oil.

Add the roasted veal bones and calf's foot and any deglazed fond from the roasting pan if it looks viable and delicious. Deglaze with some of the white wine.

Add the rest of the white wine and enough cold water just to cover bones. Bring to boil and then reduce to simmer immediately. Skim any fat and foam.

While stock gently simmers, season oxtails well with salt and pepper and brown well on all sides on the stovetop in a rondeau that can hold them comfortably.

Add nicely browned oxtails—and any deglazed, delicious fond from the pan to simmering beef stock and add just enough cold water to account for their addition, if necessary—just barely covering.

Gently simmer the oxtails in the developing stock, partially covered, until tender. Approximately 2 hours.

Fish out the oxtails with a spider when their meat is perfectly cooked.

Cool them down quickly and, as soon as you can handle them, pull the meat off the bones and pack it for service, in a little of the stock to keep it moist.

Return the picked-clean bones/cartilage to the simmering broth for the duration of the

cooking to get as much as possible out of them. Stock wants a full 6 hours at gentle simmer, uncovered except during the cooking of the oxtail.

* If any of you who went to cooking school can think of a more clever way to do this, I am wide-open to a better system.

We want as much flavor and gelatin as we can get out of the oxtail without totally over-cooking the meat.

For now, simmer the oxtails in the stock, pick off the meat when it is tender and then return the picked bones to the stock pot, like remouillage (sp?).

It's awkward to fish out the oxtails in the middle of the process but do your best and let me know if you think of a smarter way.

Pho-Style Oxtail Broth

Yield: x1 gallon

5 pounds oxtails

1 medium onion

4-inch piece ginger

10 star anise

3 bay leaves

2 cinnamon sticks

10 cloves

1 Tablespoon sugar

3 Tablespoons fennel seeds

2 Tablespoons white peppercorns

⅔–1 cup Vietnamese fish sauce (to taste)

Season oxtails with salt and white pepper.
Brown oxtails well and evenly on stovetop in rondeau.
Halve onion and ginger horizontally, skin on, and char directly on burner until black and blistered.
Combine all of the ingredients except for fish sauce in a stockpot and add cold fresh water to cover.
Deglaze rondeau of any fond—using water—and add to stockpot as well.
Bring to a boil, reduce heat, and let simmer 4 hours.
Strain and add fish sauce to taste.
Refrigerate overnight and remove fat the following day when it can be lifted in one solid congealed tablet, more or less.

Chicken Stock

Yield: x12 quarts

This is not a "set it and forget it" project. Please give it care and attention. Everybody here shoves stockpots around looking for burner space, and your stock will get scorched or inadvertently shut off if you don't fend for it.

20 pounds raw chicken bones

¼ pound sweet butter

1 full quart celery, coarsely chopped

1 full quart peeled carrot, coarsely chopped

1 full quart white onion, coarsely chopped

2 Tablespoons black peppercorns

1 bunch parsley

12 bay leaves

Rinse raw bones under cool running water to wash away any blood and poultry juice.

Put clean bones in a large stockpot and add cold water just to the top of the bones, no more than that.

In a separate, small rondeau on a low flame, melt sweet butter and sweat celery, carrot, and onion slowly until tender, with no color on the vegetables.
As the vegetables are sweating, bring water and chicken bones to a boil. At the boil, lower the flame, and skim fat and scum for the next 5 minutes.

When vegetables are soft, add them to the stockpot with the peppercorns, bay leaves, and parsley and adjust to a low simmer.
Keep on a low simmer uninterrupted until the stock is golden and chickeny, not watery at all (approximately 5–6 hours).
Cool and strain stock.
Refrigerate overnight and pull the fat cap off the following day.

Double Stock

Yield: 8 quarts

2 chickens

Chicken Stock (page 448)

Put two whole rinsed chickens in a stockpot that will hold them and cover with chicken stock by 6 inches.

Bring to a simmer and poach the birds until the chickens are loose and falling apart.

Strain the stock through a triple layer of clean damp cheesecloth.

You should yield about 8 quarts.

Season with salt while warm to bring it into focus.

Contribute poached meat to family meal.

Pigeon/Quail Stock

Yield: 8 quarts

15 carcasses/5 pounds with necks and backbones from quail or pigeon, or both
1 carrot, peeled
2 celery branches, cleaned up
1 large onion, peeled
unsalted butter
parsley stems
black peppercorns
1 bay leaf
kosher salt

Cut vegetables in neat, even chunks for mirepoix.

Sweat mirepoix to glassy and translucent in small amount of butter. Include stems, peppercorns, and bay leaf in the sweat. Gentle heat. No color.

Add bones. Cover with 12 quarts cold water. Bring to boil, then immediately reduce to simmer. Skim crap from the surface as you go.

Let go at gentlest simmer you can manage—straddle the gap between two burners with the stockpot, if necessary, to get gentle indirect heat. At least 4 hours. Strain and discard bones.

If you have more than 8 quarts when you strain, return stock and continue reducing to 8 quarts. It hits its deepest flavor/best potential here.

Skim fat following day, after it's fully chilled, so you can lift it out in one convenient tablet. Like removing a cake from a pan, run your knife around the edges first to release the fat cap.

Duck Stock

Yield: 12 quarts

10–15 pounds duck bones, rib cages, wing tips, and carcasses from whole roasted ducks
1 onion
1 small carrot
3 celery ribs
parsley stems
leek tops, well washed
peppercorns
bay leaf
butter

Peel the onion and the carrot. Wash the celery.

Cut the veg neatly.

Sweat veg and aromatics in butter, not oil.

Roast the bones well—don't crowd, don't steam.

Get fond off the roasting pan to add to the stockpot, please.

Cover with cold water.

Bring to boil. Reduce to simmer. Skim foam all day, if it appears.

Get it on early so it can have at least 6 hours before dinner crew needs the burners.

Strain.

Chill overnight.

Defat when cold.

Capon Broth

Yield: 12 quarts

3 capons
2 carrots, cut, trimmed, organized for mirepoix
2 stalks celery, cut, trimmed, organized for mirepoix
1 onion, cut, trimmed, organized for mirepoix
3 bay leaves
scatter peppercorns
handful parsley stems
3 to 4 3-inch veal marrow bones

Slowly sweat mirepoix with parsley stems, peppercorns, and bay leaves in butter.

Add capons and marrow bones.

Cover with cold water.

Bring to boil, reduce to simmer.

Let it go, gently, for 5 hours. Skim off any foam and scuzz along the way.

Pick all valid meat from capons, in large hunks, and pack away in some of the broth to stay moist.

Strain broth. Rapid chill and refrigerate. Do not defat until following day.

Mixed Meats Stock with Walk-In Detritus

Yield: 12 quarts

10 pounds accumulated bones
2 celery ribs
1 onion
1 carrot
parsley stems
peppercorns
bay leaf
unsalted butter

Don't throw the dribs and drabs of accumulated bones away, please—the chines from the lamb racks, the occasional ribs from pork belly, accumulated chicken, duck and, especially not the capon carcasses. I know our daily prep doesn't always yield enough bone to warrant a stock each and every day, but by the end of a few prep shifts—lunch and dinner services combined—there is certainly enough material to put together a stock.

I never object to the mutt stock and am always glad to have it around—just be sure to label properly so it isn't confused for any of the "purebred."

As with all of our stocks, take care with the mirepoix. Don't use a vegetable so gross it is ready for the compost bin—use wilted but still edible veg.
Peel the onion and carrot. Wash the celery. Cut the veg neatly; there is no valid reason not to.

Sweat all in a little butter, rather than oil; it gives a tiny bit of body and flavor to the stock, whereas oil somehow remains filmy.

Roast the bones well—don't crowd, don't steam.

Add bones to the stockpot. And get any fond worth using off the roasting pan to add to the stockpot, please. Just cover with cold water. Don't self-defeat at the get-go by using so much water that you will never yield anything but diluted, wan crapola.

Bring to boil, then reduce to simmer. Skim foam as it appears. And take care of your simmer—you know how pots get shoved around here during the course of the day and how burners get blasted or shut off inadvertently.

Strain after 6 hours. Remove fat the following day in one chilled easy-to-lift tablet.

* LOOK OUT FOR AND PROTECT YOUR WORK!

Fish Stock

Yield: x4 quarts

3 pounds white fish bones

3 cups white wine

3 bulbs fennel, cut into quarters

3 stalks celery, cleaned up and cut for mirepoix

1 yellow onion, peeled, cut into sixths

1 teaspoon salt

bay leaves

black peppercorns, a few

Rinse bones of blood, in salt water if necessary. Remove gills as needed and break spines in two. Rinse again if snapping spines reveals more blood.

In a stainless steel pot, add bones, lay vegetables on top, and add wine. Be sure you have not grabbed a crappy aluminum pot in haste. ✱

Add cold water to cover by 2 inches.

Add bay leaves, 1 teaspoon of salt, and a few black peppercorns.

Bring to a boil and reduce to a bare simmer. Simmer for 30 minutes. Let settle and partially cool. Strain through several layers clean, damp cheesecloth set inside fine-mesh chinois. Give it the time it needs to drip clear.

← ✱ If clarifying: Beat egg whites to tight and foamy. (Like shaving cream.) Then pour/spoon into simmering stock to form the raft. Let it go 15 minutes. Spoon off the dirty, scummy raft BEFORE straining. Repeat if necessary.

Prune Vinaigrette

Yield: 3 cups

3 cloves fresh, firm, sticky cloves
 garlic, peeled just before using

¼ cup plus 1 Tablespoon Dijon
 mustard

½ cup red wine vinegar

2½ cups blended olive oil

2½ teaspoons salt

½ teaspoon freshly ground black pepper

2 teaspoons water

x 1½ QTS.	x 2 QTS +/–
9 cloves	14
½ c.	¾ c. +/–
1 c.	1½ c. vin
4 c.	6 c. oil
s+p	s+p
h₂0 +/–	h₂0

Add garlic and salt to the bowl of a food processor and start it running.
Add the mustard, then the vinegar, and, when the contents of the bowl are fully blended, slowly pour in the oil in a steady stream to emulsify.
Season with pepper.
Stop the motor, taste for balance between acid and salt and garlic, and, with the motor running, add the adjustments as necessary.

This is not a shy vinaigrette but still, there should be balance—you don't want the attack of the vinegar too forceful or the aggression of the garlic to make anybody sit back uncomfortably. Equally, the black pepper needs to be ground to the right flake so that a customer does not end up with half a peppercorn lodged in her tooth, burning away.
Often, a couple teaspoons of cold water added at the end brings the whole package into shape—taste-wise and texture-wise. Because some batches of vinegar are mellower than others and because *the size and force of garlic cloves vary,* adjust as needed by adding oil to calm it if it is too bright, adding a clove of microplaned garlic if it is too subtle, or adding a little water if it is too assertive in general.

*EVOO is too strong — use the 70%/30% blended oil.

*Keep ratio 4:1 oil to vinegar.

Brown Butter Vinaigrette

Yield: 2 pints +/-

1 pound unsalted butter

1 garlic clove

1 whole shallot

2 Tablespoons Dijon mustard

1½ teaspoons salt

2 Tablespoons plus 1 teaspoon red wine vinegar

x 2

2#
2 clove
2
4 T.
1 T.
¼ c.

Put butter, cut into large chunks, in stainless steel pot, over low heat, and carefully brown to nutty perfection. (Not black. Not yellow.) Be sure to use stainless steel so that you can better see the solids as they brown against the light color of the bottom of the pan. It will take about 20 minutes to get the butter where we want it—take your time and pay attention. It will foam and simmer and then eventually start to separate and then the milk solids will start to toast once they have fallen to the bottom of the pan. Stir occasionally during the process but, once you hit your mark, remove from the heat immediately and stir constantly to keep the milk solids from burning. Pour the butter into a waiting metal bain set in an ice bath to rapidly cool. Let cool to tepid but still liquid—don't allow it to congeal.

In the food processor or the blender, work garlic and shallots with the salt into a smooth and sticky paste.
Add mustard and thin with red wine vinegar.
With motor running, add browned butter in a slow stream to base mixture to emulsify. Scrape every bit of the browned milk solids into the vinaigrette. Pack in pint containers and refrigerate.

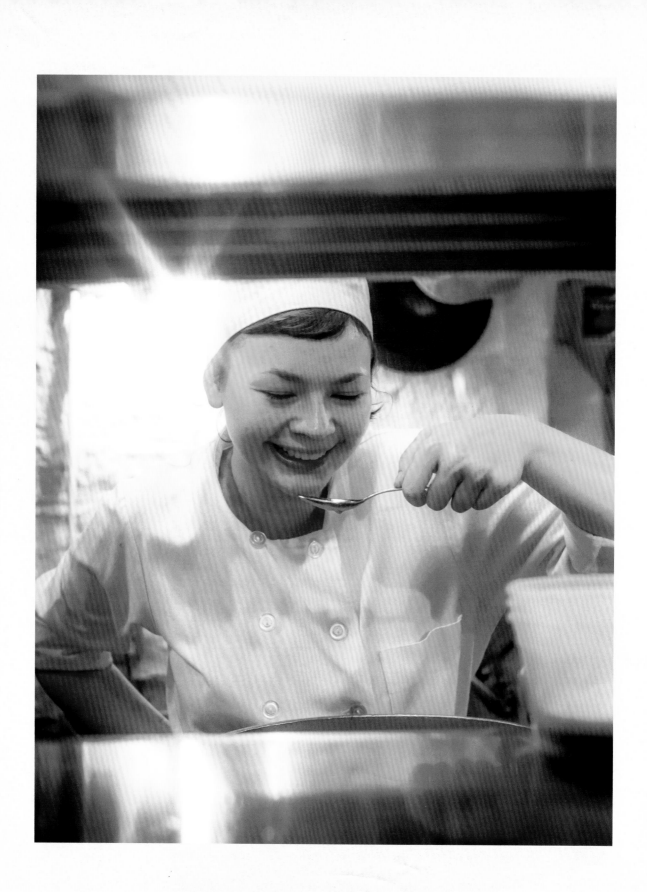

Smoked Tomatoes

1 pound Muir Glen whole peeled tomatoes

¼ cup Berbere Spice Mixture (page 477)

¼ cup light brown sugar

Drain tomatoes carefully without crushing or piercing them. Lay tomatoes out on baker's drying rack that will fit perfectly inside our deep hotel pan smoker contraption. Mix berbere spice with brown sugar and blend thoroughly. Season tomatoes all over with berbere-sugar mix. Turn the tomatoes over to season all sides.

Scatter a healthy handful of wood chips in bottom of the smoker hotel pan, set over two burners on full blast, and allow the chips to smolder and glow at the edges, uncovered. You don't need to ignite them; the heat from the bottom of the pan does the trick. Get help from one of your fellow cooks if it's your first time. Use the same pan we always use so we don't keep ruining hotel pans, please.

Set the seasoned tomatoes on their baker's rack inside a shallow perforated hotel pan, set the perforated hotel pan into the improvised smoker, and tear an ample sheet of aluminum foil long enough to loosely tent over the tomatoes but still seal tightly around the entire perimeter to trap the smoke.

Turn the heat way down and check on them in 15–20 minutes.

When you have slightly caramelized, still plump but starting to deflate, smoked tomatoes, shut the contraption down. Handle the tomatoes gently when packing so you don't lose whatever juice is left inside them.

Smoked Tomato Vinaigrette

Yield: 1 quart

x 16 c.	
7	2 shallots, peeled and sliced into very thin rings
#10 can	1 pound Smoked Tomatoes (page 461)
4 c. evoo	1 cup extra virgin olive oil
2 1/2 c.	½ cup Sacramento tomato juice
3/4 c.	¼ cup balsamic vinegar
1/2 c.	2 Tablespoons aged sherry wine vinegar
1/4 c.	1 tablespoon fresh lemon juice
s + p	kosher salt
	freshly ground black pepper

Toss the shallots with a few pinches of salt in stainless steel bowl. Use your fingers to break up the rings and let the salt briefly tame their bite.

Dice the smoked tomatoes, taking care not to lose their smokey juices, adding all to the shallots.

With a spoon, not a whisk, stir in all of the vinegars, and then all of the olive oil.

Stir in tomato juice and lemon juice.

Season with a good dose of black pepper and a careful bit of kosher salt.

*** use crappy balsamic from the jug NOT our expensive aged stuff for finishing ***

Pickled Tomatoes

Yield: x12 quarts

8 pounds grape tomatoes

1½ bunches scallions, whites
and greens, sliced diagonally

10 jalapeños, whole with seeds, sliced stright
across into thin slivered rings on the mandoline

4 cups white wine vinegar

1⅓ cups brown sugar

5 Tablespoons kosher salt

¾ cup thinly sliced ginger

¾ cup thinly sliced garlic

5 Tablespoons yellow or black mustard seeds

5 Tablespoons cracked black peppercorns

5 Tablespoons ground cumin

bay leaves

3 Tablespoons + 1 teaspoon cayenne pepper

2 Tablespoons + 2 teaspoons ground turmeric

4 cups blended oil (70% olive/30% canola)

from my friend Misty Callies in Michigan but I think she got it from the super-talented Border Grill gals in Los Angeles.

Slice tomatoes in half vertically. Reserve in a large stainless steel hotel pan with scallions and jalapeños. Be sure to use stainless steel throughout this recipe, please.

In a stainless steel saucepan, bring vinegar to a boil, add brown sugar and salt, and cook until dissolved, about 5 minutes. Remove from the heat and reserve.

Measure ginger, garlic, mustard seeds, peppercorns, cumin, cayenne, and turmeric into a bowl and place near stove.

Over medium heat, heat oil in a large saucepan until hot. Add spices and cook, stirring constantly with a wooden spoon, until aromas are released, about 2–4 minutes.

Remove from heat and carefully stir in vinegar mixture. Immediately pour over reserved tomatoes and vegetables. Mix together gently but thoroughly and refrigerate at least 3 days before using.

* ALWAYS MAKE FULL BATCH, PLEASE. THE PICKLE KEEPS WELL IN THE WALK-IN AND WE CAN ALWAYS USE IT.

Shallot Vinaigrette

Yield: x1 quart +/-

juice of 4 very juicy lemons

¼ cup very finely chopped fresh garlic

½ cup finely minced shallots

1½ cups extra virgin olive oil

½ cup red wine vinegar

½ cup thinly sliced parsley leaves

½ cup thinly sliced fresh mint leaves

salt

fresh cracked pepper

Just stir together. Do not emulsify.

Buttermilk Dressing

Yield: 1½ quarts

2 shallots, sliced

1 garlic clove, chopped

1½ cups buttermilk

2 cups (generous) Hellmann's mayo

1 teaspoon freshly ground black pepper

pinch kosher salt

juice of 1 lemon

1½ cups mint leaves, roughly chopped

1 scallion, trimmed, roughly cut

Blend all in blender.

Parsley-Shallot Butter

Yield: 2½ cups

2 garlic cloves, peeled

¾ cup peeled and coarsely chopped shallots

2 cups picked-clean parsley leaves

1½ teaspoons salt

1 pound unsalted butter cut into 1-inch cubes,
 at coolish room temperature

x3

8

2c.

3c.

salt +/-

3#

In food processor chop garlic.
Add shallots and chop finely.
Add parsley and salt, process to coarsely chopped, then add butter.
Process to smooth and emerald green.

Preserved Lemon Butter

Yield: 4 pints +/-

2 pounds butter, softened

8 Salt Preserved Lemons (page 479)

½ cup rough chopped shallots

5 garlic cloves, coarsely chopped

1 cup fresh lemon juice

1 cup chopped basil

In processor, grind shallots and garlic. Add lemon juice, then transfer mixture to the Kitchen Aid.

Remove collapsed flesh of preserved lemons and throw away.

✷ Only use the skin. ✷

Make sure to remove pith. Finely mince preserved lemon skin.

Combine butter, garlic-shallot paste, minced preserved lemon, and basil and mix using the paddle attachment until fully combined.

Black Olive Butter

Yield: 1 pint

½ pound butter, roughly cut into cubes

¼ cup pitted Kalamata olives, well drained

$\times 4$

2#

1 c.

$\times 8$

4#

2 c.

Make sure there are no pits in the olives. Pulse the olives by themselves in the processor to a very coarse consistency and then add the butter cubes. Process continuously until fully integrated, with an appealing purple-brown color and no remaining streaks of plain butter.

Freeze what's leftover and remember to use first the following weekend.

* only pack in pints. the quart containers are not practical. K

Horseradish Butter

Yield: 2 pints

2 cups unsalted butter

1 cup grated horseradish

1 Tablespoon fresh lemon juice

1 teaspoon salt

¼ teaspoon freshly ground black pepper

$\times 2$

2#

2 c.

2 T.

s+p

$\times 4$

4#

4 c.

$\times 1$ lemon

s+p

Beat with paddle in mixer.

Sable Butter

Yield: 2 pints

1 pound butter

¼ pound smoked sablefish

1 teaspoon freshly ground black
 pepper

Work softened butter in mixer with paddle attachment.

Add flaked sable and pepper—process lightly. (Do not overwork—stop machine,
scrape down edges to incorporate completely.)

Form butter into long logs/rolls and wrap in parchment, then plastic film. Chill to
firm. (Ask me or anyone here who has done this to show you if you don't know how
to form a neat cylinder.)

For service—slice ¼"-thick disks while cold and keep separated with parchment pa-
per for easy pickup.

* LABEL AND DATE PROPERLY — SMOKED FISH IS PERISHABLE. *
LET'S NOT FOOD POISON ANYONE, PLEASE.

Anchovy Butter Sauce

Yield: x1 quart/15 orders

20 anchovy fillets packed in oil

¼ cup heavy cream

1½ pounds sweet butter, cold, cut into ½" cubes

Heat the anchovies in a wide, deep sauté pan with a few drops of the clinging oil they were packed in, mashing with a whisk or back of a wooden spoon to break them down.

When the anchovies are broken down into very small pieces, like a dry paste, and starting to turn deep golden brown, add the cream all at once, whisking vigorously; it will thicken up right away. Remove from the heat as soon as it coats the spoon or leaves a track in the pan when you run your whisk through it.

Whisk in the cold cubes of butter, 4 at a time, over very low, steady heat. Don't let the sauce break by trying to go too fast or too hot. Whisk vigorously and continuously—don't pause. When the butter is completely incorporated, you will have a glossy, creamy, deep and salty and balanced butter sauce. (The heavy cream acts as a stabilizer, but if you use too much, it deadens the salty bite of the anchovy.) Hold warm in a double bain with warm water in a warm place in your station.

THIS WALK-IN MAKES ME BREAK OUT IN HIVES, PEOPLE!

PLEASE:
* cooked above raw.
* proper lids — no film!
* stack eggs properly.
* FIFO!
* store like with like. ham + yogurt on same shelf??!
* legible labels

↑ Totally Acceptable.

Homemade Chili Oil

Yield: 2 cups

½ cup toasted, coarsely chopped chiles de árbol

1 toasted guajillo pepper, coarsely chopped

2 cups peanut oil

2 pieces star anise

2 coins fresh ginger

Put chili flakes into heatproof mason jar.
Heat oil, with the ginger and star anise, over high flame until smoking hot.
Remove from the heat and allow to cool for about 10 minutes, to 225°–250°.
Remove ginger so it doesn't spoil the oil later on the shelf.
Pour hot oil onto the chilies, stir up the chilies, and allow to cool completely before sealing.

Homemade Chili Flakes

¾ ounce quajillo

½ ounce chile de árbol

¼ ounce ancho

Lay out chilies on ¼ sheetpan and heat them through in 375° oven for 8–10 minutes, just to open up their fragrance but not to color or toast.
Let cool until completely dry and brittle again.
Pull off the stems and tap out the seeds—you don't need to be anal retentive about this.
Pulse in spice mill to fine flakes.

Chili Paste

Yield: 12 cups

24 dried guajillo chilies	$\times\ \frac{1}{2}$
24 dried ancho chilies	12
18 pasilla chilies	12
1 Tablespoon ground cumin	9
½ Tablespoon dried oregano	2 tsp.
1 Tablespoon fresh thyme leaves	1 tsp.
18 cloves	2 tsp.
6 bay leaves	9
12 garlic cloves	3
6 Tablespoons white vinegar	6
3 Tablespoons salt	3 T.
	salt +/-

Remove stems and seeds from all the dried peppers. (You should wear gloves to do this, unless you want spicy hands for the rest of the day.) Cover with boiling water and let them soak and soften for an hour.

Drain chilies from water, reserving ¾ cup of the water. Grind softened chilies together with the rest of the ingredients with the reserved water in the Robot Coupe to make a thick paste.

Gremolata

Yield: 3 cups

5 lemons, zested with small-eyed zester that makes little curls, not microplaned

2 large, sticky burning fresh garlic cloves

1 cup chopped parsley

salt

EVOO, enough to build to rather loose paste without losing the punch

Combine all ingredients. Make fresh daily. Contribute any day-old to family meal.

Homemade Old Bay

10 dried bay leaves

2 Tablespoons mustard seeds

1 Tablespoon allspice berries

1 Tablespoon celery seeds

1 cinnamon stick

1 Tablespoon cardamom pods

1 cup kosher salt

¼ cup paprika (not smoked)

6 branches fresh thyme

1 head of garlic, unpeeled

Measure out all ingredients and pack in quart container. Make 6 quarts at a time—measured individually—and store in dry goods on spice shelf, labeled properly. One quart (1 recipe) seasons 5 quarts of water.

Berbere Spice Mixture

Yield: 1 quart + 1 pint

⅓ cup coriander seeds

1⅓ cups cumin seeds

¼ cup cloves

⅔ cup cardamom pods

⅓ cup black peppercorns

2 Tablespoons + 2 teaspoons allspice berries

⅔ cup fennel seeds

1 ounce dried chiles de árbol, remove stem, seeds are fine

⟵ ——— *add ¼ c. fenugreek!*

⅓ cup ginger powder

2 Tablespoons + 2 teaspoons turmeric powder

⅔ cup kosher salt

In very large sauteuse, dry toast the first 9 above ingredients together until fragrant. Stir and shake during the toasting.

As soon as you get strong pleasant aroma—don't allow it to get acrid and burnt—turn out onto a full sheet of parchment to cool.

When thoroughly cool, lift edges of parchment to neatly funnel seeds into spice grinder, in manageable batches.

Grind all to fine, mix well with the final 3 ingredients above. Store in pint containers; label and date.

Parsley-Paprika Salt

Yield: 1¼ cups

¼ cup kosher salt

½ cup smoked paprika

½ cup chopped parsley

Make fresh each day for french fries.

Smoked Paprika Butter

Yield: 2 cups

½ pound sweet butter, softened

1 Tablespoon sweet Spanish pimenton

1 Tablespoon smoked Spanish pimenton

2 teaspoons coarse kosher salt

Blend together thoroughly, with no white streaks.

Salt Preserved Lemons

48 lemons, washed

kosher salt, 3 pound box

fresh lemon juice, at least a quart

12-quart Lexan container works best.

Cut the lemons almost all the way through into quarters, keeping them attached at the stem end.

In the bottom of the Lexan, pour an even ½-inch bed of salt.

Set the lemons in to the salt, cut sides up and open, packing tight side by side.

When you have nestled in 1 layer (¼ of the lemons, +/-), pour salt heavily into all the open cavities of the lemons of the 1st layer.

Set in another layer of lemons, in soldier rows, on top of the others. Again, cavities up and open.
Really blanket them in salt at each layer.
Pack all the lemons in the same way, then pour lemon juice over at the end.

Cover and store in the refrigerator, agitating occasionally for the first few weeks to moisten the lemons with the accumulating brine. The lemons need to eventually become submerged in this brine; if it doesn't cover them after a month, get in there with your hands and give them a little help. Add more fresh lemon juice, if necessary.

KEEP AHEAD ON THESE FOR BRUNCH.

✳ ✳

START NEW BATCH EVERY MONTH

Salsa Verde

Yield: 6 cups

2 packed quarts picked parsley

8 ounces picked mint

3 branches tarragon, leaves stripped

8 salt-packed anchovies, rinsed and deboned

8 garlic cloves, peeled, sliced

6 Tablespoons capers

kosher salt

2 cups EVOO

2 cups blended oil

2 teaspoons freshly ground black pepper

In the molcajete, pound anchovies, garlic, and capers to paste. Add a little salt and a splash of oil to help break it down. Add herbs, keep pounding. I know. Sorry. But just keep going until your arm is about to fall off. Add a few grains of salt and another splash of oil to help it along.

Transfer herb mixture to stainless bowl and stir in the rest of the oil.

Season with pepper. Taste. Adjust as needed.

Tartar Sauce

Yield: 1 pint

	×8 pts.	½ BATCH
1 garlic clove	6 cloves	3
1½ peeled shallots	2 c.	5 shallots
2 Tablespoons plus 2 teaspoons capers and juice	1 c.	½ c.
2 Tablespoons + 2 teaspoons cornichons and juice	1 c.	½ c.
kosher salt	salt	salt
1 shy cup Hellmann's mayo	5 c. mayo	2½ c.
⅓ cup sour cream	4 c. sr. cr.	2 c.
juice of ½ lemon	3 lemons	1½
1½ Tablespoons chopped parsley	½ c.	¼ c.
salt, to taste	s + p	s + p
freshly ground black pepper to taste		

Chop garlic with a couple pinches of salt in the processor.
Add shallots, capers, and cornichons and pulse together. Reserve caper and cornichon juice.
Scrape mixture into a stainless bowl and add the mayo, sour cream, lemon juice, and parsley. Blend well and whisk in the caper and cornichon juices/brines.
Season with freshly ground black pepper and salt to taste.

Tomato Sauce

Yield: 12 cups

1 10-pound can Muir Glen whole peeled tomatoes
1 large yellow onion, sliced
8–10 garlic cloves, smashed
butter

Sweat onions and garlic in butter.
Add tomatoes and their liquid and simmer for 30 minutes.
Puree in Vita-Prep to super smooth.

Use leftover brunch stewed tomatoes if we have a lot. Freeze in quart containers so we can pull only what we need when we are running braised bacon skins.

Aioli

Yield: 1 full pint

1½ cups blended oil

juice of 1 lemon

1 whole egg

1 egg yolk

4 garlic cloves

2 generous pinches salt

1 Tablespoon water, as needed, to loosen to the right consistency

In the Vita-Prep, puree garlic with salt. Add egg and yolk, then lemon juice, continue at a moderate whizz. With motor running low, in slow steady stream, pour in oil through the hole in the blender top.
Get a milk crate and stand up on it so that you have a bird's-eye view of the oil as it emulsifies—hardly any of you are tall enough to see into the canister from your ground height. See what you are doing.

You can hear a mayo about to break—it starts to sound wet and sloshy in the blender and if you don't stop adding oil immediately, it will be a goner. Listen to what you are doing.

This recipe tends toward the firmer and thicker so use a few drops of water at the end to thin it out to luscious and loose, please.

If it needs more garlic you can always microplane in an extra clove. It is easier to add more garlic than it is to tone down too much garlic. The ferocity/mildness of different heads can vary pretty wildly so taste along the way to see what you are working with. We want it to be garlicky—it's an aioli—but you don't want to burn the customer or make it look like you don't know what you are doing.

Makes a full pint. You can double but don't triple. Make in batches if you need large quantity and use clean dry blender canister at each new batch—seriously! It will break if you don't start clean each batch.

Lemon Aioli

Yield: shy 3 cups

4 sticky, burning lively garlic cloves, peeled

2 egg yolks

1 whole egg

¼ cup + 1 Tablespoon fresh lemon juice

1¼ teaspoons kosher salt

1½ teaspoons Dijon mustard

2 cups blended olive oil

Grind garlic and salt together in Robot Coupe until sticky and pasty.
With motor off, add egg yolks and whole egg and Dijon mustard.
With motor running, add lemon juice through the feed tube.
In a slow stream with the motor on, add olive oil.
Pay attention that the emulsion is building. Stand on a milk crate if you have to so you can see what you are doing and catch it in time if it looks and sounds in danger of breaking.
Taste and adjust for salt, lemon, and garlic.

Ranchero Sauce

Domestic batch

1 28-ounce can Muir Glen
 whole peeled tomatoes
1 serrano chili, coarsely chopped
1 guajillo chili, stems and seeds removed
½ cup packed cilantro, washed
 and chopped, stems included
2 garlic cloves, peeled
1 teaspoon achiote paste
salt to taste

WEEKEND
BRUNCH
PAR
2 10# cans
8
4
2 bunches

2 c. cloves
2 T. paste

salt t/_

½ BATCH
1 10# can
4
2
1 bunch

1 c.
1 T.

salt

Combine everything and simmer for 1 hour, adding a little water if it becomes too thick. Be careful not to scorch the bottom.
Transfer to a bain and rapid chill before pureeing.
Puree in the Vita-Prep and check seasoning.
Transfer to quart containers for brunch service.
Freeze any leftover and pull first for following week.

Black Beans for Huevos Rancheros

Domestic batch

1 28-ounce can cooked black
 beans, rinsed thoroughly

1 small onion, diced

1 teaspoon ground cumin

salt to taste

2 ounces cilantro, washed
 and chopped, stems included

blended oil

BRUNCH PAR

2 10#

2 lg.

2 T.

salt

1 bunch

blended NOT croo

½ BATCH

1 @ 10#

1 onim

1 T.

salt +/-

½ bn.

oil

In a small rondeau, sauté onions in a glug of blended oil until translucent and not browning.

Add the rinsed beans and the cumin.

Add cool water to just cover the beans and bring to a boil.

Season with salt.

Reduce heat; gently simmer about 45 minutes, until soft but not mushy.

Add chopped cilantro during the last ½ hour of cooking or in the brunch reheat.

** BRUNCH PREPPER — please take the time to break down all the cans properly! Rinse them. Remove tops AND bottoms. Crush and flatten. That recycling area is out of control on Fridays — please reduce the chaos and flatten all the cans. WE NEED EVERY INCH OF REAL ESTATE WE HAVE.*

Also — check in the spice bins for already toasted and ground cumin seeds. We have too many odd containers floating around. CONSOLIDATE! FIFO!

Flatbread

Yield: 5 pounds

1½ teaspoons active dry yeast

1¼ cups lukewarm water (110°)

⅛ teaspoon sugar

1 cup warm water

3 cups AP flour

1 teaspoon salt

1 Tablespoon + 1½ teaspoons olive oil

½ cup AP flour for dusting

sesame seeds

paper-thin lemon slices

parsley leaves

Maldon sea salt flakes for seasoning

x 10 #

10 gr. yeast
670 gr. h₂0
10 gr. sugar

520 g. h₂0
1000 g.
20 g. salt
40 g. evoo

Stir together the yeast, the sugar, and lukewarm water in a small metal bowl and set to proof in a warm place. (Prepper, please use the top of the espresso machine. And make sure the yeast has become foamy and bubbly—if it doesn't proof, it is dead. It may be the yeast or you may have used scalding water, which can burn it. It doesn't happen often but I've done it; please take care.)

Add 1 cup of warm water to the proofed yeast, stir together well, and transfer to a large stainless bowl. Mix together oil and salt and add to proofed yeast.

If measuring by volume and not weight, aerate the flour well before measuring. In true, aerated, and leveled cupfuls at a time, sprinkle flour over the yeast slurry, stirring after the addition of each cupful. It's messy and sticky and stiff. Add the last cupful judiciously, considering the conditions of the day—humidity and heat particularly—you may not need the entire cup.

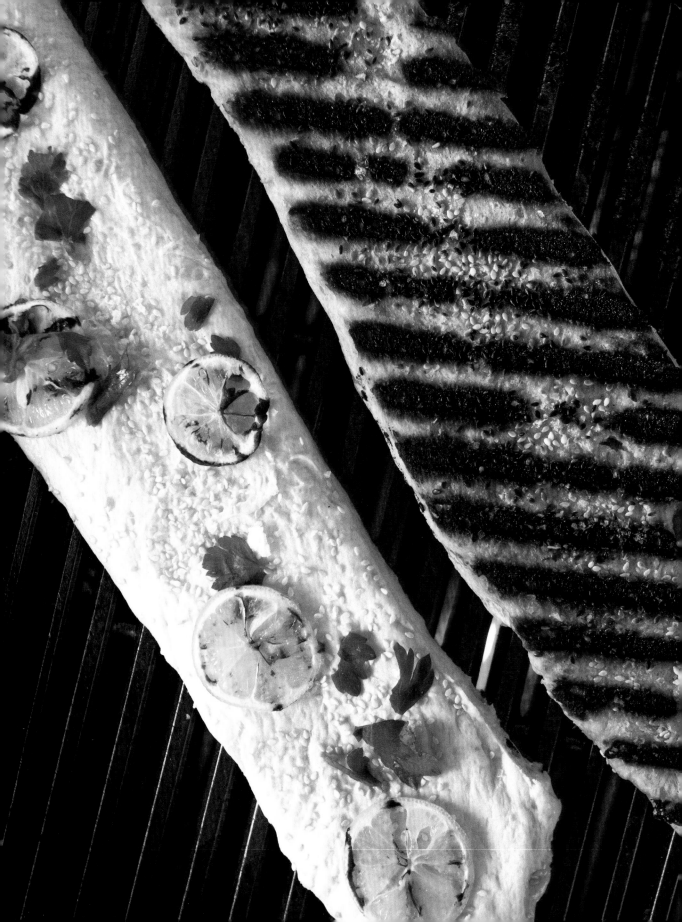

Scrape and gather the dough and turn out onto the work surface. Have a small container of bench flour in front of you. Knead for a full 25 minutes; set the timer, don't give up; knead until the dough becomes elastic and smooth, and finely pored.

Keep in a lightly-oiled container—oil the lid too, so it doesn't stick—and let it retard in the walk-in overnight. Use virgin olive oil; I prefer it. Only pull out what is needed per service.

Cut off hunks and stretch into 4 x 8-inch rectangles, ½ inch thick. Touch gently, work quickly, and handle manageable portions.

Season with sesame seeds, paper-thin boiled lemon slices, parsley leaves, and Maldon flakes on top only, then quickly set on the grids of the hot grill. When a dark grill mark has set on the bottom, gently lift flatbread with tongs or spatula and turn 180 degrees, finishing cooking on the grill top. Getting the raw dough from your work top to the grill requires confidence and decisiveness; just go for it and don't let it smell your fear.

If doughy, with any raw quality at the center, finish in the oven.

Matchbox Pickles

Yield: 4 portions garnish

(from Misty Callies in Michigan)

¼ pound each of Brussels sprouts,
 green beans, radishes, and
 baby turnips
4 burning fresh sticky garlic cloves, peeled
 and barely crushed with the flat side of
 knife, but still whole
1 teaspoon red pepper flakes *commercial, not homemade*
4 teaspoons dill seeds
4 Tablespoons kosher salt
2½ cups white wine vinegar
2½ cups water
2 pinches sugar

X WEEKLY BRUNCH PAR

VEG:
5# each
Brussels
Beans
Radishes
Turnips
1# garlic

6 T. chili
1½ c. dill
5 c. salt
3 gal. vin
3 gal. h2O
¼ c. sugar
+/−

Trim Brussels sprouts. Remove stem end of beans, leaving tips intact. Neatly peel baby turnips. Wash radishes very well, leaving a bit of green tops.
Blanch Brussels sprouts, then green beans, then baby turnips, and then radishes—briefly in one pot of salted, boiling water. Keep vegetables separated by type.
Shock in ice bath and remove as soon as cooled. Don't waterlog the veg.
Separate vegetables into individual containers.
Combine remaining ingredients in nonreactive saucepan and bring to full boil.
Pour over vegetables. Vegetables should be fully immersed in the pickling liquid.
Cool and refrigerate for a week before using.

Strain and reuse vinegar/pickle liquid repeatedly, adding fresh aromatics, from batch to batch, week to week. Taste scrupulously. When it's finally too spicy, too salty, too strong, retire it down the drain and start fresh.

Pickled Turnips

2½ cups water

2½ cups distilled white vinegar

¼ cup salt

4 teaspoons dill seeds

1 teaspoon chili flakes

4 cloves garlic, lightly crushed

1 full healthy branch of thyme

16 baby turnips, peeled and blanched

Place all ingredients (except turnips) in a nonreactive saucepan and bring to a boil.

Pour pickling liquid over turnips in an airtight container and refrigerate 1 week before using. Keep ahead on your pars for brunch. ✳

Pickled Eggs

Yield: 20 garnishes

2½ cups beet water (recipe below)

2½ cups red wine vinegar

¼ cup salt

10 peeled, hard-boiled eggs

Bring first three ingredients to a boil.
Pour over eggs.

For the Beet Water:

Yield: 2½ cups

2 large beets, scrubbed clean and free of sand/grit

3 cups water

Cover beets with water in small pot. Bring to a boil, then reduce heat and simmer 1 hour.
Strain out beets. Save water for pickled eggs.

Pickled Pearl Onions for the bar

2½ cups water
2½ cups distilled white vinegar
¼ cup salt
1 teaspoon white sugar
1 teaspoon piment d'espelette
1 quart mixed-color pearl onions

Blanche whole onions in boiling water for 90 seconds and drain.

Snip root ends with very sharp paring knife and pinch/squish each one between your fingers to pop the onion from its skin.

Bring the water, vinegar, salt, sugar, and chili powder to a boil in stainless steel pot and then shut off the heat.

Pour hot pickle liquid over peeled onions in a 6-quart container. Rapid chill.

Keep refrigerated.

Rosemary Lollipops for Pear Brandy Champagne at Brunch Bar

Yield: 15

1 cup sugar

¼ cup water

15 skewers

1 rosemary branch

small pot with handle that you feel comfortable holding while spooning sugar onto
 rosemary—if it's too heavy, your wrist will give out

Silpat mat

1 teaspoon for spooning out lollipops

candy thermometer

The prep table over the onion and garlic bins is not level. Don't do your candy work here. Your lolli's will run out into misshapen forms.

Set up your Silpat on a very flat, level surface.

Space out skewers on the Silpat about 1½ inches away from each other. Place clusters of 3-4 rosemary needles at tip of each skewer, splayed flat so that candy can cover them.

Combine sugar and water in the small pot and set on medium heat.
Cover the pot with a well-fitting lid so the condensation will collect and drip down to moisten sides of pan and avoid crystallization. Also, be meticulously sure that the pan is clean and dry when you start.
Leave the candy alone for about 10 minutes, when the bubbles will start to come up much more slowly, sluggish, and the mixture will look more syrupy, thick, and heavy, but still very pale and clear.
Take the lid off and start to pay attention. Let it go for another 5–10 minutes, with your attentive shepherding. When you start to see some color around the edge of the pan, swirl the pan a little to integrate the caramelization with the still-clear rest of the syrup.

We want the final product to have an amber color, similar to the color of honey. You will need to take the pan off of the heat about a shade before the one you are looking for because it will continue to cook after you take the pot off the heat. Pull the sugar off the heat when it reaches 130° in any event. It should have reached the right stage of amber by then.

Let the sugar rest for 1–2 minutes. This makes it easier to control the shape of the lollipops, to make them rounder and more attractive because the candy will cool slightly and run slower when you are spooning it over the skewers to form the nice free-form—but recognizable, please!—lollipop shape we are aiming for.

Use a teaspoon, dip into the candy, and, starting from center of lollipop—right on top of the rosemary—drizzle the hot candy in a continuous tight spiral while gradually moving outward to make a nice circle. They need to fit upside down into our champagne flutes so please keep the diameter just under 2 inches.

Cool lollipops completely—don't hasten—and store in airtight, dry container in single layers between parchment sheets.

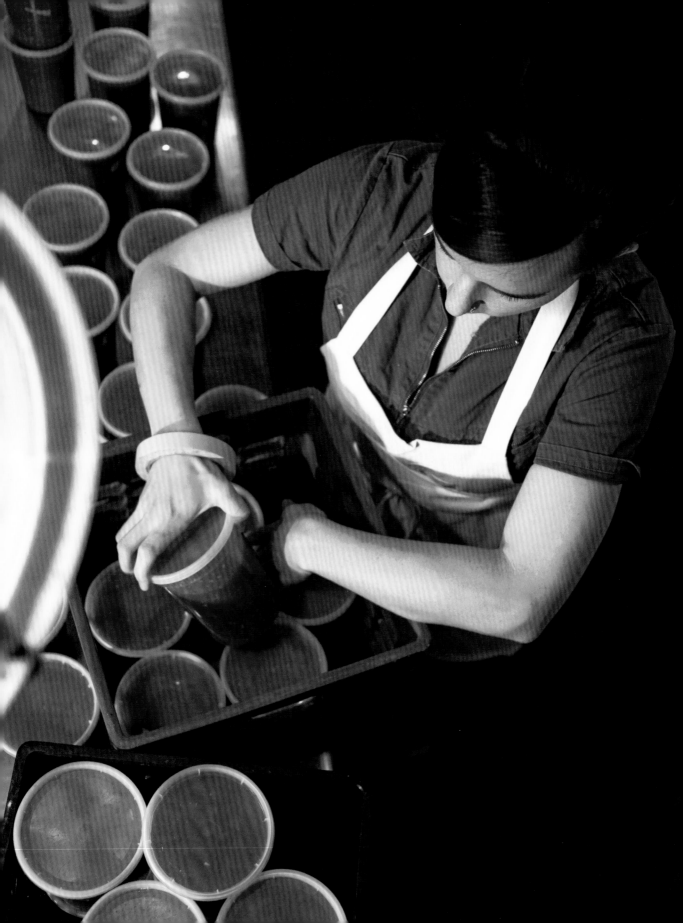

Prune Bloody Mary Mix

Yield: 6 drinks

1 46-ounce can Sacramento
 tomato juice

½ cup (about 4 juicy lemons)
 fresh lemon juice

¾ cup plus 1 Tablespoon Gold's
 prepared horseradish

2 teaspoons freshly ground
 black pepper

2 teaspoons kosher salt

½ cup Lea & Perrins
 Worcestershire sauce

1½ teaspoons Tabasco
 sauce

×8

8 cans

4 c. lemon

3 c. horse

¼ c.

¼ c.

4 c.

¼ c.

DAILY
BRUNCH
PAR

16 tomato
8 c. lemon
6 c. horse
8 T. salt
8 T. pepper
8 c. worcest
½ c. Tabasco

The brands matter immensely. As do the pars. Be sure to inventory properly midweek and keep the house fully stocked so that we are not having to make Bloody Mary mix over the weekend with some crappy organic tomato juice or "artisanal" "small-batch" Worcestershire handshopped in an emergency at Whole Foods.

Sacramento. Lea & Perrins. Gold's. Tabasco. *Do not substitute.*

On Monday morning, strain any Bloody Mary mix leftover from weekend brunch through multiple layers of clean damp cheesecloth set inside the very fine-meshed chinois. Let it take all the time it needs to slowly, slowly drip, leaving you clear Bloody Mary "water." Don't rush it by not using enough layers of cheesecloth or by pressing and agitating. Give to lunch bartenders to use for "Ghost of Mary."

3-Rum Punch Base

Yield: 2 gallons

5 pineapples

5 vanilla beans, split

zest of 5–6 limes, in long curlicue ribbons

2½ cups sugar

1 gallon + 1 quart Ron del Barilito amber rum (equals 6 bottles)

1 quart + 1 pint Goslings Black Seal rum

1 quart + 1 pint Bacardi original white rum

Wash and scrub the whole pineapples under warm water to remove wax and debris.

Top and tip the pineapples just enough to expose flesh. Make sure your pineapples are perfect and golden and fragrant and sweet and ripe. I have seen you rush this with deadly green pineapples, which offer nothing but acid.

Cut each pineapple in quarters, top to bottom, and pack the quarters standing up in a very clean 5-gallon bucket. No need to remove fibrous core—they make a delicious snack when you strain in 3 weeks.

Tuck the split vanilla beans in and around and between the pineapple.

Gently rinse limes under warm water to remove wax—but don't scrub lest you remove oils.

Scatter your long, single-cut curlicue lime zests around and on top of the pineapples.

Sprinkle the sugar evenly all over the fruit.

Pour in all of the rums, making sure to wash all the sugar down into the crevices between the fruits.

Spin and jostle the bucket a few times to make sure fruit and sugar and all the rums have integrated.

Cover with cheesecloth and tight lid.

Soak 3 weeks at room temperature. Be sure to label and date and include both the date made and the date to strain. If Health Department comes, don't worry about it being at room temperature—the alcohol content is more than legal, but do not forget the cheesecloth. The brew inevitably attracts fruit flies and they will want to see that there is a protective screen. Never mind the Health Department; I, too, would like to see you have the good sense to use a protective screen.

After 3 weeks, strain through china cap into very clean 3-gallon bucket, press and crush the solids thoroughly, waste none of the liquid.

Refrigerate after straining.

Make sure you communicate frequently with the bartenders so you don't fall behind. It needs a full 3 weeks to brew and can't be fudged/rushed.

Bartenders—please taste the brew at every new batch. Depending on all of the usual variables—the fruit used, the prepper who made the batch, forces of nature—some batches are on the money and have an incredibly sophisticated, adult-palate, butterscotch quality. But sometimes it's a little pale and astringent, in which case top each drink with fresh Coca-Cola and not club soda.

* This comes from Misty Callies who I worked for when I lived in Michigan and I think she got it from Mark Miller at Coyote Cafe. So freaking delicious.

Lemon Vodka

Yield: 16 portions

Peel of 1 whole lemon, managed in one long curlicue, please, with little to no pith.

Add to 1 liter of Tito's Vodka.

Let steep for 2–3 weeks. Stay ahead on your pars.

Orange Vodka

1 medium orange peel, in neat curls
1 bottle Tito's Vodka

Let steep 2 weeks. Stay on top of your inventory.

Spicy Lemonade

Yield: shy 2 gallons

1 quart fresh lemon juice

2 quarts Mint Simple Syrup (recipe follows)

4 quarts water (depending on acidity of lemons)

½ cup ginger, peeled and sliced into coins

1 Tablespoon cayenne pepper (or more to taste)

* SPICY BUT NOT DEADLY, PEOPLE. TASTE YOUR FINISHED PRODUCT! **

Mix well and refrigerate.

Mint Simple Syrup

Yield: 2 quarts

1 quart sugar

1 quart water

8 ounces mint, stems and branches alike

Bring water and sugar to a boil. Boil 5 minutes only.

Remove from heat.

Add mint. — Let steep 2 hours.

Cool and strain.

Buttermilk Ice Cream

Yield: x2 full pints

2 cups buttermilk

2 cups heavy cream

½ cup + ¼ cup sugar

8 large egg yolks

Combine buttermilk, cream, and ½ cup sugar in stainless pot. Scald, don't boil.

Combine ¼ cup sugar and yolks in mixer. Beat until pale and ribbony—about 2 minutes on medium high.

Temper hot milk mixture into the eggs. Then return the mixture to the pot. Bring up to 180° over medium heat, stirring continuously. Don't walk away or get distracted. Use a rubber spat and drag the floor of the pan fastidiously.

Strain through fine-mesh china cap into waiting chilled bowl set over ice bath. Spin the bowl and hold your spat steady in the mixture to cool it down quickly. Chill custard overnight and give custard a buzz with the immersion blender before churning. Keep close eye on texture—it forms butter flecks sooner than other ice creams.

Brandied Cherries

×1/2
BATCH

2 1/2 #
2 c.
5 c.

5 pounds Bing cherries

4 cups sugar

10 cups Greek Metaxa brandy

For the brandied cherries:

Be sure to use a pastry-only blue board so there is no chance of onion/garlic taint.

One by one, press down firmly on the cherries with the flat side of your blade, and split the fruit. Try to retain the stems.
Then go back and flick out the pits with the tip of your blade. Sometimes you need to use your fingers. *DO NOT USE PITTER GADGET — IT DESTROY. THE FRUIT.*

This goes faster if you do all the splitting and then all the pitting. If there are extra bodies in the house, make it a buddy project—one splits, the other pits. Keep the fruit as unmolested and intact as possible, still looking like a cherry on the stem, but magically, with no pit inside.

In large stainless steel pot, bring 5 cups Metaxa and 4 cups sugar to a boil.

Add fruit and, as soon as the mixture comes back up to boil, remove from the heat.

The fruit wants to swell and deepen in color. Stir in last 5 cups of raw Metaxa.

Taste the brew and, depending on the sweetness/tartness of the cherries, add a little more brandy or a little sugar. These want to end up on the bracing end of the spectrum—to please adults, not children.

Chill quickly and pack in clean Lexans and bury in the back of the walk-in—label and date properly, please, with date made and date available to use.

Do large batches and keep ahead—they need 4 weeks in the soak.

Ginger Syrup

Yield: 1 pint

4 ounces ginger

1 cup sugar

1 cup water

<u>× 1 qt.</u>

1½ #

3 c.

3 c.

<u>× 2 qts.</u>

3 #

6 c.

6 c.

Make sure this has some good "burn" from the ginger. This is the same syrup used interchangeably on all the brunch fruit salads: black fruits, red fruits, and orange fruits equally. So be sure there are always 4 quarts of it in the walk-in—it keeps forever, sort of.

Don't forget to use a pastry cutting board when smashing the ginger so there is no possible residual onion/garlic scent from a savory board and, as always, smell the quart containers to make sure they don't carry the residual odor of their previous contents.

Cut unpeeled ginger into coins and smash to release juices. Combine 1:1 ratio of sugar to water in a stainless steel saucepot and bring to a boil. Add the smashed ginger and any juices from the cutting board. Reduce heat and simmer for about 1 hour, to reduce by about ½. Strain and keep refrigerated.

just shy of ½.

Use 1½ pounds ginger per quart of syrup.

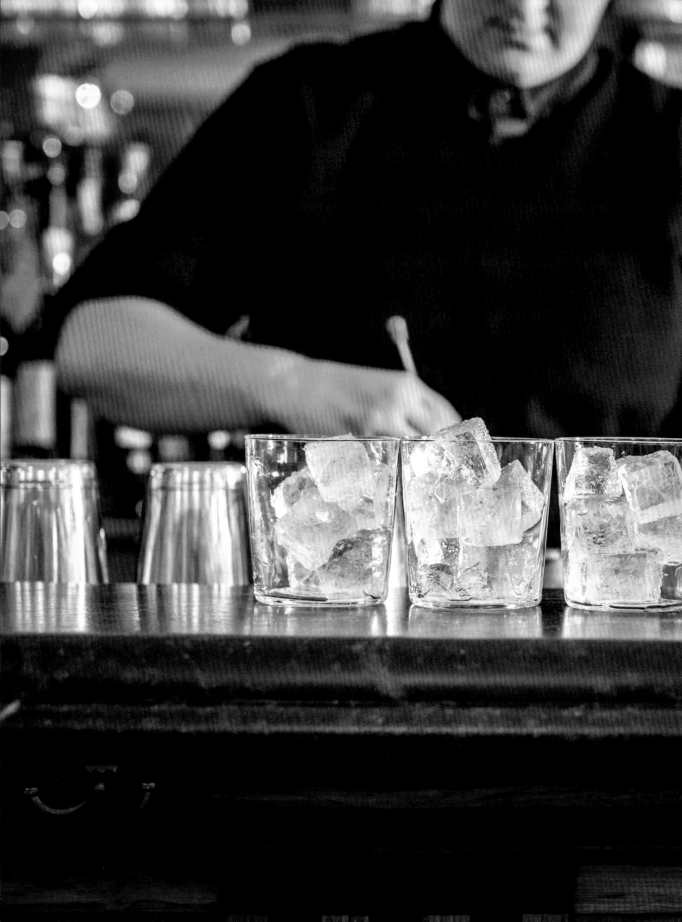

Ice Cold Martini, a Little Wet, a Little Dirty

Yield: 1

In a shaker add:

½ ounce dry vermouth

3 ounces gin or vodka

1 spoon olive brine

ice

If vodka—shake vigorously. If gin—stir until outside of shaker is frosty.

Strain into a chilled martini glass.

Garnish with olive.

Negroni

Yield: 1

In a mixing glass pour:

1 ounce Campari

1 ounce Noilly Prat sweet vermouth

1 ounce Plymouth gin

Add ice and stir.

Strain and pour into a rocks glass over 5 fresh ice cubes.

Garnish with orange ½-moon slice.

I like the Carpano Antica, too, but only if the customer specifies. I want our statement to be classic and traditional. Do not flame the peel or upgrade the vermouth or serve up martini-style unless the customer directs you to take that route. I do not wish to clip your bartender/mixologist wings, but

here, in this restaurant, we want straightforward, reliable, recognizable drinks at all times.

Brandy Sidecar

Yield: 1

In a shaker add:

¾ ounce fresh lemon juice

1 ounce triple sec

2 ounces brandy

ice

Shake and strain into a chilled martini glass with a thinly sugared rim.

Garnish with lemon wheel.

If you ever get the opportunity to have this at The Boat House in my hometown, made by Christine herself, don't pass it up. In the meantime, this is her recipe and we should stick to it.

Pimms Cup

Yield: 1

In a collins glass add:

2 ounces Pimms

1 ounce Boodles gin

ice

top with ginger ale

Garnish with a spear of cucumber that stands ½ inch above the rim of the glass and a lime squeeze.

Corpse Reviver

Yield: 1

¾ ounce Boodles gin
¾ ounce fresh lemon juice
¾ ounce Cointreau
¾ ounce Lillet Blanc

Build in ice shaker with ice.

Rinse coupe glass with Pernod and drain.

Pour in corpse reviver.

Garnish with long orange twist.

Junipero Gibson with Pickled Red Onion

Yield: 1

½ red onion, very thinly sliced into ribbons
kosher salt
¼ cup red wine vinegar
dry vermouth
4 ounces Junipero gin

Place onion in a bowl, and season with salt. Let sit for 10 minutes. Sprinkle vinegar on top, and let sit 10 minutes more.

Rinse the inside of chilled martini glass with vermouth and drain.

Place a few ribbons of salted, pickled onion in the glass.

Fill shaker with ice and pour gin over it. Shake vigorously. Strain into glass.

Long Island Iced Tea

Yield: 1

¾ ounce Sauza tequila
¾ ounce Tito's Vodka
¾ ounce Boodles gin
¾ ounce Bacardi white rum
1½ ounces Bols triple sec
¾ ounce Coca-Cola
¾ ounce fresh lemon juice

Pour all ingredients into a pint glass filled with ice and stir. Let sit for 5 minutes. Stir again.

Pernod on ice, with Water Back

Yield: 1

1 large cube ice, in the short tumbler
2 ounces Pernod
4 ounces water—make sure it's cold, too, please

Pour Pernod over the cube.

Serve cold water back in the small beaker.

3-Rum Punch

Yield: 1

Into an ice-filled collins glass:
Pour rum punch until glass is ¾ full.

Top with club soda and garnish with long, thin sliver of fresh vanilla bean.

Bartenders—diplomatically cut off anyone who orders a third. And do not allow this for staff shift drink unless they want to pay full price.

"Diet" Fresca Soda

Yield: 1

In a pint glass, over ice:

tear one mint leaf

add 1 shallow scoop sugar

2 ounces fresh grapefruit (not the jugged stuff)

2 ounces Tito's vodka

Shake vigorously and pour in collins glass.

NO GARNISH.

Top with tonic water until glass is ¾ full. Stir.

Mojito

Yield: 1

In a pint glass muddle:

1 teaspoon sugar

1 splash bitters

10 mint leaves

And then add:

¾ ounce simple syrup

1½ ounces fresh lime juice

2 ounces Bacardi white rum

ice

Shake and put contents into collins glass, top with club soda, and garnish with lime wheel.

I feel strongly about the Bacardi—originally Cuban, regardless of current production.

Aperol Spritz

Yield: 1

In a mixing glass:

1½ ounces Aperol

½ ounce fresh lime juice

3 ounces cava

Shake Aperol and lime juice; pour into a collins glass.

Top with cava.

Stir.

Garnish with a large lemon twist and almond-stuffed olive.

Bourbon Old-Fashioned

Yield: 1

Build in a mixing glass and muddle:

1 teaspoon sugar

1 cherry

1 orange slice

few dashes of bitters

Add:

3 ounces Knob Creek bourbon and ice.

Stir a full 25 seconds.

Rocks glass. Twist.

Black Rum Old-Fashioned

Yield: 1

In a mixing glass with ice add:

1 teaspoon sugar

2 dashes orange bitters

2 dashes Angostura bitters

3 ounces Gosling's Black Seal rum

Stir a full 25 seconds.

Pour over fresh ice.

Lemon and orange twist.

Caipirinha in a Coffee Cup

Yield: 1

In a coffee cup muddle:

1 lime, cut into quarters

2 teaspoons sugar

Add:

2½ ounces cachaça

ice

From beautiful Brazilian Apollo, back in the shitty catering days, who obliquely made these for us disguised in coffee cups before we went into the back of the van for the long drives to various hell gigs. I am sure it is purely the nostalgia, but I still think it tastes better in a coffee cup. Please indulge me, but if the customer objects, of course . . .

Prune Boiler Maker with Hard Cider and Calvados

Yield: 1

1 shot Calvados Pays d'Auge

1 cold Etienne Dupont hard cider

Let the customer drop the shot into the glass or drink as a chaser according to their preference.

Italian Greyhound

Yield: 1

Build in a mixing glass:

2 ounces fresh grapefruit juice

2 ounces Tito's Vodka

splash of Campari

Add ice and shake vigorously.

Pour into a collins glass and garnish with a rosemary sprig.

Vodka Stinger

Yield: 1

2 ounce Tito's Vodka

½ ounce white crème de menthe

Stir with ice, strain into a martini glass, and garnish with a mint sprig.

If anybody ever orders one of these, please come find me and introduce me; I would love to meet them.

Rose's Gimlet

Yield: 1

In a shaker add:
½ ounce Rose's lime juice
splash of fresh lime juice
3 ounces gin or vodka
ice

Shake and strain into a chilled martini glass.
Lime wheel.

Gin and Schweppes Bitter Lemon

Yield: 1

In a collins glass:
2 ounces Beefeater gin
ice and long skewer

Individual small bottle Schweppes bitter lemon
is on side. Let the server crack the bottle at the
table to show customer it is fresh.

Old Pal

Yield: 1

¾ ounce rye whiskey
¾ ounce dry vermouth
¾ ounce Campari
ice
thin lemon wheel

Stir.

Spicy Lemonade with Orange Vodka

Yield: 1

In a shaker:
4 ounces Spicy Lemonade (page 502)
2 ounces Orange Tito's Vodka (page 501)

Shake and pour into a collins glass.

Gin and Tonic with Mint

Yield: 1

2 ounces Tanqueray gin
1 bottle Schweppes tonic water
4 mint leaves, opened up between your hands
2 lime wheels, cut thick

Fill tall glass with ice and wooden skewer.

Stir in gin.

Drop in mint leaves.

Add lime wheels.

Let the server crack the Schweppes tonic water at
the table, to let the customer know it's fresh and
to give them that ultra-satisfying sound. But allow
customer to pour their own tonic according to
their own desired strength.

Bitter Orange

Yield: 1

Build in a pint glass:
1½ ounces fresh orange juice
2 ounces Cynar
ice

Shake vigorously. Pour into collins glass, top with club soda, stir, garnish with an orange half-moon.

Bourbon Sour

Yield: 1

In a shaker add:
¾ ounce simple syrup
¾ ounce fresh lemon juice
¾ ounce fresh lime juice
¾ ounce fresh orange juice
2 ounces Knob Creek bourbon
ice
Shake and garnish with cherry and orange ½ moon.

Rye and Ginger

Yield: 1

2 ounces Michter's rye whiskey
Canada Dry ginger ale

In a collins glass with ice and wooden skewer.
Stir rye.
Let server crack soda bottle at tableside in front of guest.

Hot Toddy

Yield: 1

Build in a 12-ounce mason jar:
juice of 1 lemon
2½ Tablespoons honey
tiny pinch of cayenne pepper
2¾ ounces Jim Beam

Fill with hot water from the espresso machine to the 10-ounce line, about ¾ full.
Stir and garnish with a lemon wheel.

Irish Coffee with Shaken Cream

Yield: 1

In a Ball Jar:
1 Tablespoon sugar
2 ounces Jameson Irish whiskey
5 ounces hot coffee

Top with heavy cream, shaken in a small shaker with loosely coiled spring from strainer, until soft peaks form.

Brandy Stinger

Yield: 1

1½ ounces brandy
1½ ounces green crème de menthe
ice

Build in rocks glass and stir. Give me a heads up if anyone orders this; it's rare that anyone does but I'd like to meet them.

Prune Bloody Mary and All Variations

CLASSIC:
Yield: 1

2 cups ice

2 ounces Tito's Vodka

4 ounces Prune Bloody Mary Mix (page 497)

lemon wedge

celery rib

small chaser of very cold Red Stripe beer in a
 glass on the side

MARINER:
Yield: 1

2 cups ice

2 ounces homemade Lemon Vodka (page 501)

½ ounce clam juice

3½ ounces Prune Bloody Mary Mix (page 497)

green olives

lemon wedge

beer back

CAESAR:
Yield: 1

2 cups ice

2 ounces Boodles gin

½ ounce clam juice

3½ ounces Prune Bloody Mary Mix (page 497)

½ Pickled Egg (page 492)

lemon wedge

beer back

MARIA:
Yield: 1

2 cups ice

2 ounces Sauza tequila

4 ounces Prune Bloody Mary Mix (page 497)

celery stalk

lime wedge

beer back

GREENLAKE:
Yield: 1

2 cups ice

2 ounces Tito's Vodka

4 ounces Prune Bloody Mary Mix (page 497)

prepared wasabi

1 piece beef jerky

lemon wedge

beer back

DANISH:
Yield: 1

2 cups ice

2 ounces aquavit

4 ounces Prune Bloody Mary Mix (page 497)

1 slice fresh fennel

marinated white anchovy

lemon wedge

beer back

SOUTHWEST:
Yield: 1

2 cups ice

2 ounces Herradura Añejo tequila

4 ounces Prune Bloody Mary Mix (page 497)

1 teaspoon adobo sauce from can smoked chipotle pepper in adobo

celery branch

lime wedge

beer back

DEADLY:
Yield: 1

2 cups ice

1 ounce Tito's Vodka

1 ounce Sauza tequila

4 ounces Prune Bloody Mary Mix (page 497)

celery branch

lime wedge

beer back

BULLSHOT:
Yield: 1

2 cups ice

2 ounces Tito's Vodka

3½ ounces beef bouillon

½ ounce Worcestershire

3 shakes Tabasco

salt and pepper

celery branch

lemon wedge

beer back

BLOODY BULL:
Yield: 1

2 cups ice

2 ounces Tito's Vodka

1½ ounces beef bouillon

3 ounces Prune Bloody Mary Mix (page 497)

celery branch

lemon wedge

beer back

CHICAGO MATCHBOX:
Yield: 1

2 cups ice

2 ounces homemade Lemon Vodka (page 501)

4 ounces Prune Bloody Mary Mix (page 497)

Matchbox Pickles (page 490)

lemon wedge

beer back

Ghost of Mary
Yield: 1

2 ounces strained, clear Bloody Mary "water" (page 497)

2 ounces homemade Lemon Vodka (page 501)

ice

Shake. Strain into chilled martini glass. Old South brand Tomolive garnish.

Keep an eye on Tomolive inventory—we have to get them shipped from Arkansas.

Only serve this on weekdays, obviously, when the brunch Bloody Mary menu is not available; otherwise the name is only half as clever as it can be.

GARBAGE

Parmesan Rinds

Our Parm bill is about a thousand dollars a month, which is why I get so cranky when I see you using it carelessly in family meal. Please. Ours is the real, expensive deal. Ease up on the Parm.

Please don't throw away the many hard-as-wood rinds we generate. When we have a good clutter of rinds accumulating in the walk-in, pull them out and cover them with water in a soup pot and simmer for an hour or so until you have a rich and distinctly Parm-y broth. Big beads of milky fat will rise to the surface and signal the richness. You can then chew on the soft rinds, if you like, or just toss them.

Strain the broth and freeze it. It's excellent for cooking the Rice Beans with Green Herbs when we run them, or for poaching the Gnocchi with Prune Butter on Valentine's day.

For the average weekday/workaday use, make stracciatella and run it as an addition at lunch. Even in warm months this use is fine—I love hot soup in summer.

Parm Rind Broth Stracciatella

This item that can be made entirely from the waste bins, and run at lunch. We always have Parm rinds, loose yolks, extra whites, and leek tops idling in the walk-in to make use of. The single ingredient that doesn't come from the garbage is the pinch of toasted and ground fennel seed.

This makes a rich and silky soup that has the same body and depth as a chicken stock–based one. If you are asked about its appropriateness for vegetarians, explain that there is surely animal rennet in the production of Parmesan cheese, and let them decide if that's sufficiently vegetarian or not.

Collect from the day's waste bins the following:

1 cup Parm broth (page 520)

2 or 3 heavy, tough dark green outer leaves of the leeks from the garbage bin, well
 washed and sliced into thin slivers (about an overflowing ¼ cup of leek shavings)

extra yolks

extra whites

And from the spice shelves:

toasted ground fennel seeds

kosher salt

Bring the Parm broth to a rolling boil in a small saucepot.
Add the leek top shavings and allow to cook until tender, about 1 minute.
Meanwhile, beat whatever yolk and white combination you were able to gather, but make sure to include at least one white, otherwise the "straccia" of "stracciatella" won't form as nicely.
Reduce heat to a solid, active simmer and in a steady thin stream pour the beaten egg into the soup slowly.
Do not stir. Allow the ragged raft to form, and when the egg is cooked through, turn off the heat.
Gently tip into a wide soup plate, keeping the egg raft intact and centered.
Season with toasted fennel seeds and kosher salt.

Serrano Ham Broth

Spanish Garlic Soup with Smoked Paprika Butter

Serves 6

1 quart Chicken Stock (page 448)

1 quart cold water

4 Tablespoons sweet butter

a hunk or bone end of serrano ham

3 heads of garlic, mostly peeled but intact, sliced horizontally

6 garlic cloves, peeled and whole

6 small yellow waxy potatoes, diced

6 slices stale bread

6 Tablespoons sweet butter, at room temperature

2 Tablespoons Spanish smoked paprika

6 eggs

For the broth:

In a large, deep soup pot, melt 4 Tablespoons sweet butter. Sweat horizontally cut garlic heads, cut side down, until soft and aromatic. Add diced potatoes and sauté briefly until coated and softening. Add serrano ham hocks, chicken stock, and water and bring to boil.

Immediately reduce heat and simmer, covered, for 2 hours. Remove serrano bone and pick any viable meat from bone. Discard spent bone.

For the soup:

Mash 6 Tablespoons butter with 2 Tablespoons of sweet Spanish pimenton, until the butter is the color of bricks. Toast the stale bread. While toast is warm, rub both sides with a clove of garlic until the garlic is ground into nothing, the bread is glossy, and garlic covers the entire surface, about 1 clove per slice of bread.

Place 1 slice garlic toast into bottom of each bowl.

Crack an egg into a small ramekin, put the lip of the ramekin close to the soup, tilt the egg into the simmering liquid, and let poach 1–2 minutes. (Repeat for each serving). Place the poached egg, garlic, and some potatoes over the toast in the bowl, and spoonfuls of soup until brothy but not awash. Swirl in 1 Tablespoon of paprika butter to each bowl, and correct seasoning, adding kosher salt and freshly ground black pepper to taste.

If there was soft meat from the ham bone, add to the bowls before serving.

At some point I had to write This recipe for civilians with domestic use/ portions in mind, so The quantities won't work for us, but follow The protocol and scale up appropriately for our purposes.

Run This as an addition whenever you start a new Serrano ham and have a spent leg retiring in The walk-in taking up precious real-estate in There.

Zucchini Tops

Please save all of your zucchini stems whenever we have various zucchini dishes on the menu and run this as a wax.

2 cups cold water
1 teaspoon salt
14 zucchini tops

Trim the dry and grubby tip of the stem with a quick snip of your sharp paring knife. The idea is to not lose any more of an already scarce piece of stem.

Place tops in a small saucepot and just cover with cold water.
Season well with salt.

Bring to a boil, turn down to simmer, and cook for about 10 minutes, or until tender and easily pierced with a wooden skewer or the tip of your blade.

Drain gently and neatly arrange in a small, shallow bowl in a single layer.

They can be crowded but not stacked on top of each other, please.

Drench with the good olive oil until it just begins to pool in the bottom of the bowl as soon as you take them out of the water, so that they can sort of drink the oil into their warm bodies.

Give them a final few grains of salt and make sure you get them to the table while they are still warm.

Cauliflower Hearts

Save all the cores you cut out of the cauli during prep and give to whoever is leading the line for waxing.

Place hearts in a small saucepot and just cover with cold water.

Season well with salt.

Bring to a boil, turn down to simmer, and cook for about 10 minutes, or until tender and easily pierced with a wooden skewer or the tip of your blade.

Drain gently and neatly arrange in a small, shallow bowl, looking like icebergs.

They can be crowded but leave a sliver of negative space between them, please.

Drench with the good olive oil until it just begins to pool in the bottom of the bowl as soon as you take them out of the water, so that they can sort of drink the oil into their warm bodies.

Give them a final few grains of salt and make sure you get them to the table while they are still warm.

Limp/Dead Celery

If you are the one assigned to clean out and reorganize the walk-in on Fridays, please don't toss that huge container of the week's accumulated outer stalks of celery. It is still useful. Use some for all of the weekend stocks, obviously, but that will only put a minor dent in what is usually left piled up in that bin.

I know it's tempting to just dump that debris, given the huge deliveries clunking down the stairs all day and your rush to check in their products. And I know you are desperate to carve out real estate in that absurd walk-in as we bury you under all that additional weekend brunch mise on top of the regular dinner madness, but just don't do it.

Get that bin onto the prep table and make everybody take a fistful of stalks to help you out. If you get everybody to do the prep work on the stalks, you can put the rest together rather quickly. And once it's on the stove, it's more or less a set-and-forget project.

Since we always have unpredictable amounts of pancetta scrap and leftover bits and scraps of meat, don't worry about hitting the meat quantities in the recipe below exactly—just use what we have but keep the meat-to-celery ratio intact.

Cook it long and slow and until the meat and celery look almost sticky.

2 pounds pancetta

2 pounds sweet Italian sausage—no casing

2 pounds cubed beef

2 pounds pork butt or shoulder, cubed

10 cups white wine

1 cup onion, finely dice

10 garlic cloves, finely chop

1 cup parsley, chopped

10 canned tomatoes, crushed

40 stalks celery, de-ribbed and cut into 3" pieces

Grind all meat separately and combine.

Sweat out meat, onions, and garlic. Add wine and parsley and reduce by ⅔. Add tomatoes and celery, cover, and cook gently (stirring occasionally) until celery is tender. Season with salt and pepper.

Remove cover and allow to continue simmering gently until reduced to moist, almost sticky, and just beginning to tighten up.

Salmon Carcass

When we are running salmon, use all of those heads and skeletons leftover from the butchering of the fillets for family meal, please. I don't like seeing those end up in the trash.

The skins should be deep-fried separately to make excellent, crunchy, super delicious topping for scallion/rice/cucumber salad. Include the skin in the marinade step and let it dry as long as you can before dropping in the deep fryer. I realize in those few minutes just before family meal things get rushed, but try to fry as last-minute as possible.

Also, don't crowd the bodies on the sheet pan or they will steam. Separate out some of the soy-sauce mixture to use for brushing the raw fish bodies before and during roasting so it won't commingle with the rest of the sauce—(raw fish on your brush)—which you'll use for dipping and dressing during the meal.

2–6 (what've we got?) salmon carcasses
soy sauce
ginger, peeled, then grated on a microplane } mix together and taste for balance.
sugar
rice wine vinegar

Arrange the salmon bodies and heads on a full sheet pan, either on parchment or a Silpat mat. Don't forgo the nonstick surface because there is sugar in the dressing, which, once roasted, makes everything stick to the sheet pan.

Brush and mop the hasty, improvised teriyaki sauce all over the skeleton and the head and cheeks and collar of the fish—include the tail and the long "evening gloves" of skin, too, please. Turn the carcass over and brush the other side as well.

Remove the skin from the sheet pan and set aside to dry, unfurled, on a baker's rack while the salmon carcasses roast in a high oven. If you are trying to muscle in on the ovens during the end of lunch service, use the 400° one on the left, but keep an eye— it will be done in about 20 minutes, and do not, obviously, think of double-tasking

with any baking in there at the same time. I understand the egregious lack of oven space here, but let's do things right anyway.

Drop the skins into the deep fryer for 2–3 minutes.

Serve the roasted carcasses with hot steamed rice and raw scallions, scattered with toasted sesame seeds.

And if we have plenty—check with the bartenders first—shave cucumbers and dress with the usual—sesame oil, rice wine vinegar, etc.—and crumble the fried hot salmon skins over top.

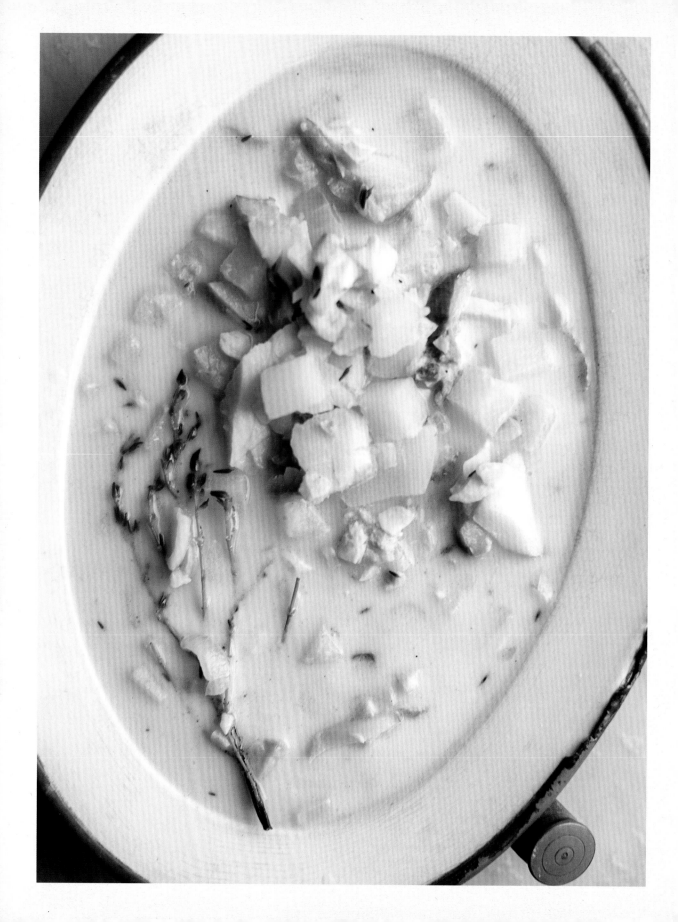

Smoked Fish Scraps

If there is smoked fish leftover from brunch on Monday morning, make this chowder and run it at lunch, please. The quality of the fish (Russ & Daughters!)—and the expense (this is not product to be used in family meal, people) is such that I'll kill you if you waste it.

We charge a lot for this at lunch, considering it is made of our leftovers—please show that you know how to neatly and uniformly dice a potato, and that you have a sense of balance between the brine of the clam juice and the unctuousness of the cream.

smoked sturgeon and sable, as is, and some of the chubs, removed of skin and bones
 and bloodlines—equaling 1 pound of useable meat
1 yellow onion, small dice
1 russet potato, peeled, perfectly diced the size of your thumbnail, held in water
2 Tablespoons sweet butter
2 cups heavy cream
1 cup clam juice, strained through dampened and wrung-tight cheesecloth (check
 brunch bar bin in walk-in for open clam juice from Bloody Mary menu and use
 first before opening new)
1 cup dry white wine—stay away from the Rieslings and other fruities
thyme leaves, stripped from one full branch
cayenne pepper, 1 pinch
salt and freshly ground black pepper

Sweat onions in butter.
Add white wine and simmer to cook off bright alcohol taste.

Add clam juice, thyme, and potatoes and bring to a boil and then simmer until potatoes are just cooked, 4–5 minutes. Gently add in fish, keeping it in nice flakes, without becoming shredded, and finish with cream and a pinch of cayenne.
Add water if it seems salty.
Season with salt and pepper if necessary at pickup. **⭐ TASTE YOUR FINAL PRODUCT ✦**

Bacon Rinds

Ask the guys to let you know when they have accumulated too many of the hard, smoked, full belly sheets of rind that they pull off of the sides of bacon when they do the brunch bacon slicing, and run this as an addition on the bar snacks menu to use up some of our garbage. Make sure you take it to sticky, tender, and on the verge of gelatinous.

Tomato Sauce (page 482)

bacon skins

grated Parmesan

chopped basil

salt

freshly ground black pepper

parsley

Put bacon skins in a pot of cold water and bring to a boil over high heat.
Reduce heat to medium and simmer until rinds soften, about 45 minutes.
Drain.
Put some tomato sauce in the bottom of a hotel pan. Layer rinds into hotel pan, covering each layer with tomato sauce, keeping sheets flat.
Finish with tomato sauce.
Cover rinds with parchment and set a baker's drying rack on top to pin them down and to prevent them from curling up while cooking.
Cover with foil and a lid and braise in a 350° oven.
Check after 30 minutes, but let them go an hour if needed—the rinds should be tender, but not falling apart.
Cool in their sauce.

To assemble:

Working one at a time, lift a sheet of braised bacon rind from tomato sauce, as neatly as you can, scrape off the sauce that clings back into the hotel pan, and lay the sheet on your cutting board fatty side up.

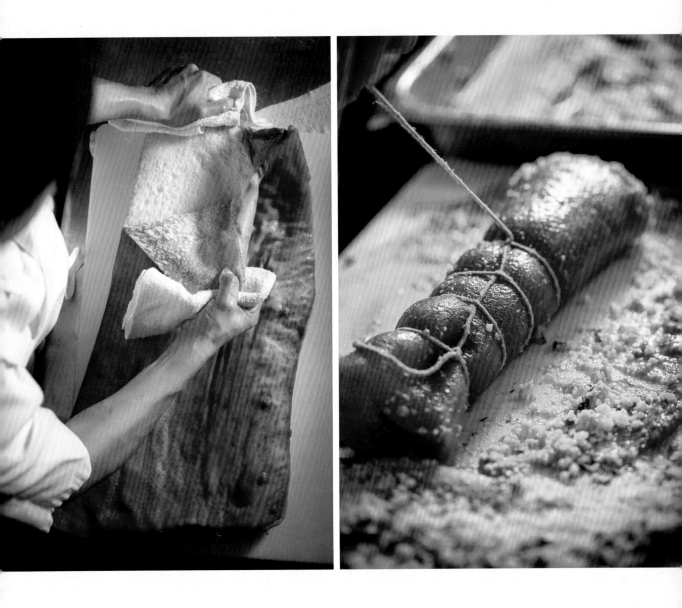

Sprinkle entire sheet, evenly, with a generous amount of grated Parmesan, chopped basil, salt, and pepper. Roll tightly and tie with kitchen twine. Cut the rolls into 4" to 5" logs, as possible, so we can reheat as close to a portion at a time in the pickup. Pack the tied rolls back in the tomato sauce.

To plate:

On the pickup, warm through in some of the tomato sauce, check seasoning, remove string, and slice in ½" spirals. Let some of the sauce pool up on the plate. Go easy on the portion—no one can eat more than a few bites of this.

Sliced parsley to finish.

Octopus Braising Liquid

Am worried that this is taking things too far on the frugality front, but the deliciousness is undeniable. Save the broth leftover from braising Alda's octopus, and use it to braise the pork butts for the Maiale Tonnato. Then, incredibly, save it again and use it one more time to make the chorizo broth when we are running periwinkles.

OMFG. So delish.

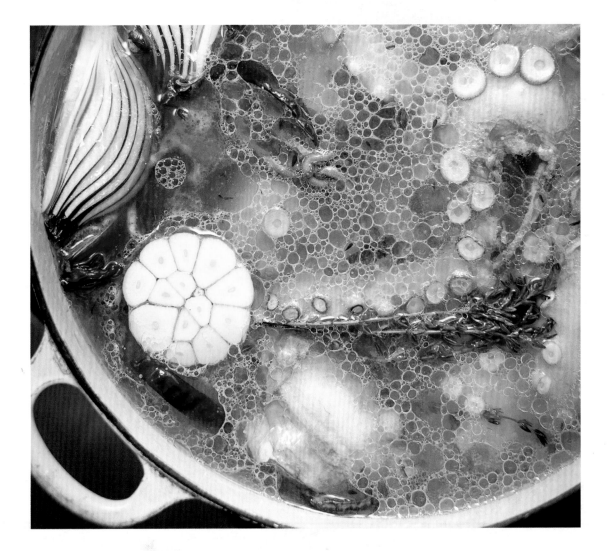

Oysters

You really have to take care with these. They are totally the wrong oyster for this type of treatment, but you can pull it off with care. Barbecued oysters in the South are a common thing but they use those giant oysters that grow in clusters and it really works. To repurpose our delicate brunch Malpeques in this way is not that swift from a culinary standpoint, but they are certainly tasty and I am always happy whenever I eat here and you send me a couple of these as a wax.

Lay them curved side down directly on hot dry grill and as soon as they hiss, pull them.

Pop them open and retain all of the just-warm liquid inside.

Spoon a dribble of warm melted butter spiked with Tabasco into each one.

Set in mounded salt so they don't tip over on the way to the table.

★ you still need to sever the adductor muscle with your knife so customer can slurp easily.

Stewed Chickpeas

Puree the leftover brunch stewed chickpeas in the Vita-Prep with water and olive oil until you have an emulsified, tasty puree as thin as crème anglaise.

Spoon into shallow bowl and let pool up.

Boil fresh green chickpeas in salted water and drain, then nestle in neat fashion on top of puree, leaving a wide ring of puree at the perimeter.

Season with cumin-salt very lightly and a few drops of lemon juice and a drizzle of Arbequina extra virgin olive oil.

Plate with care to achieve three rings in the bowl—fresh chickpeas in the center, reddish puree, then golden olive oil.

Fried, salted chickpeas to garnish.

*use This for vegetarian Wax

Expired Heavy Cream

At medium-high speed whisk cream. After 2–3 minutes you have perfect whipped cream. A few minutes later, it starts to look like whipped butter. Be sure to scrape sides of bowl down as the cream thickens and sticks to the sides of the bowl. When the cream is very thick, you can turn the mixer up to high without worrying about getting cream everywhere, after about 10 minutes. After 14 minutes the liquid and fat begin to separate. Butter looks like little pebbles in liquid. Turn off mixer.

Rinse and wring out several layers of clean cheesecloth, drape inside a china cap set in a cylindrical bain, and transfer the whole butter mixture into the cheesecloth. The whey will collect in the bain. Gather the cheesecloth into a bundle and twist a wooden spoon around and around and around until you have a tight orb like a hobo's sack tied to a walking stick. Remove the china cap and set the wooden spoon across the mouth of the bain, letting the butter dangle—its whey dripping slowly into the bain. Set in the refrigerator for a full day and come back and twist occasionally to retighten the ball of butter/cheesecloth.

1 quart of cream yields 14 ounces butter.

If you are cleaning out the walk-in, it is your responsibility to constantly monitor the dates on the dairy. Health Department will not appreciate past-date dairy. It hardly happens here as we go through it so quickly and replenish so often, but when you find past-date cream that is still perfectly tasty, whip it up and make this butter. If you are on pastry prep and have left cream to whip in the Kitchen Aid and gotten distracted and left your cream too long, you can also recuperate the loss in this way. Anything past stiff peaks should be turned into butter by just continuing to whip it until it separates and becomes pebbly. Don't throw your mistake away.

*Don't use this butter for anything but cooking or family meal — it is not special enough to be featured in any way.
It's just a way of not throwing money and perfectly good product into the trash can. *

Leek Bottoms

Set aside all of those gorgeous hairy leek bottoms from leek prep and soak well in cold water repeatedly.

Arrange attractively on small coffee saucers with a tea light in the center and use on the tables for decorating large parties. *← Crowd Them a bit so it doesn't look too precious or martha stewart-y!*

Or fill all three of the large plates on the cake stand at the pass but don't use candles. The pinspots overhead will shine down on them in dramatic fashion.

If you are going to use these as your display, do all three tiers of the cake rack so that it makes an intentional statement. If you put it between a platter of red onions and a plate of pears, it looks weak and somehow sloppy. Not impressive.

Lastly, chuck them after a couple of days when they dry out, or remember to pack them away each night in soaking wet towels. They look best when fresh.

Wine Dregs

Keep the stone kegs on the shelf under the spices and above the cooking wines where it is relatively dark, cool, and out of the way.

Be sure to transfer the filmy slippery mothers from the big commercial jugs of vinegar into the stone kegs every time you drain and finish a commercial jug, please.

Add red wine dregs to the red wine vinegar keg and white wine vinegar to the white keg, obviously, but I really don't mind if you get white in the red sometimes.

Keep the cheesecloth clean—replace with new when you do the weekly deep clean in the prep kitchen.

Don't shake, stir, or jostle the kegs excessively when adding more wine.

Taste it periodically—I do not mind new wine on top of older fermentation—I actually like the taste of the blend and the way it can lighten up the intensity, so just keep adding new wine whenever there are bottle dregs—stay in touch with bartenders and servers about this.

If the vinegar you draw out from the bottom is just too terribly viscous, add a few splashes of the filtered sparkling water from the waiters' water station to your bottle but leave the large mother batch undiluted.

Sardine Spines

Do a good job with the butchering and filleting of the sardines in the first place and do not leave sloppy amount of flesh on the bones. The fun part of butchering fresh sardines is in how clean and easy it is to lift the skeletons out without tearing the flesh. This also gives you a very good bearing on the freshness of the sardines.

Soak all the spines with their intact heads and tails in milk for an hour. Any you don't sell during service, keep stored in milk, refrigerated. Date well and clearly from service to service.

Drain and dredge through AP flour. Tap off excess.
Deep-fry until golden and crispy/crunchy, a full 5 minutes. 335° is good for the fryer temperature.
Drain, season with smoked paprika salt, and plate in a little tower on torn brown butcher paper.
Send these out as a wax to very special good customers—if you see industry folks, line cooks, chefs—they will appreciate it fully.
Do not sell these. These are just a cook's treat and to be used as a special wax for good friends and the right people. Don't waste it on anyone who won't get it.
Also, make sure they have fried through. Like a potato chip.

Tomato Skins

After blanching and peeling all of those tomatoes, whether for Alda's Zucchini Tian (page 435), or Sliced Jersey Beefsteak Tomatoes with Warm French Salted Butter (page 159), save the skins and dry them out in the oven, very slowly.

Heat the oven to 200°.

Lay out the skins on a Silpat mat on a ½ sheet pan.

They only dry thoroughly and evenly if you lay them out fastidiously without clumping or overlapping.

Set them in the oven and let them dry for at least 4 hours.

Pull them when they are papery and dehydrated but still retaining their color. If you take them too long or turn the heat up to rush them, you lose the beautiful burnt red color and get something more yellow-tinged, which is not what we're after.

The little convection toaster downstairs is also good for the job.

When they are as dry as winter leaves, grind them in the spice mill, and save the powder.

Chard Stems

Swiss chard stems, in all colors, trimmed more or less into 8" ribs—don't be anal, but
 tidy them up a bit
kosher salt
raw fresh garlic, peeled and finely minced
extra virgin olive oil

Bring large pot of water to boil.

Season water with salt.

Stir garlic and oil together with salt.

Add the chard stems to the boiling water and blanch for a couple of minutes, until
tender and al dente and the color has just started to turn from bright to drab.

Drain stems and spread out to cool and drain well.

Lay stems down on hot grill—don't season or dress or slick them with oil. Just lay
them down dry right onto the hot grill.

When nicely blistered and with some black char in spots, remove from the grill and
drizzle amply with the garlic oil.

Day-Old Breads

Hard to believe we need a recipe for this, but I have seen the bread crumbs made poorly here.

Also, because we use them for different things, we make them in different ways.

For pebbles:

Run the day-old, not powerfully dry leftover bread through the Robot Coupe with the blade attachment. Work in manageable batches—that container can only hold about 6 cups.

For actual crumbs:

Let all the leftover bread, sliced, dry out in even layer on sheet pans for at least 2 days.

Do not wrap drying bread or else we will just be throwing it away in a couple of days, covered in green mold.

When completely dry, feed through grater attachment in the Robot Coupe.

Make sure your receiving container is tall and wide to catch all of the wildly flying debris of bread crumb production.

This is a lot like a backyard wood chipper and makes as much dust.

Squint, hang a dish towel around the project, and make sure your receiving container is adequate. Otherwise you will be blowing bread crumbs all over the prep kitchen.

Store the crumbs in the freezer, labeled and dated properly.

For very fine crumbs:

Grind the already grated crumbs in the processor with the blade attachment after you have passed them through the grater attachment.

Label accordingly.

Do not toast the crumbs! All calls for bread crumbs in our recipes here ask for untoasted crumbs. And do not remove crusts. We want that color and texture and taste from crusts.

Cheese Scraps

Keep a collection of all the cheese stubs in one place in the walk-in, please.

At any given service we always have Valdeón, Cambozola, aged and young Gouda, sharp Cheddar, Feta, Vacherin, Camembert, Garrotxa, Chihuahua, and Swiss between dinner, lunch, and brunch cheese use.

Remove hard rinds, paper, soft blooming rinds, any white or unintentional molds, cypress leaves, and give yourself clean, manageable chunks of cheese leftovers. If there is Vacherin, leave the skin behind and just get the interior.

Grind to smooth with raw burning garlic cloves, a small knob of sweet butter, and a few good splashes of dry vermouth; also, any leftover brunch Cava is good.

Season with white pepper, and taste for salinity before adding salt—it will depend on what cheeses you have used. We want smooth, delicious spreadable consistency.

Pack in the small jars with lids.

Make a condiment from all of the leafy watery herbs stems—parsley, cilantro, chervil—do not obviously use anything woody or branchy—no thyme, no rosemary—and cut the clean stems into small rings, add finely minced shallot, and a few drops of walnut or pistachio oil to keep the condiment from looking like lawn mower debris.

To plate:

Small jar fromage fort, small saltcellar herb stems condiment, 3 slices warm, toasted baguette.

Leftover Brunch Fruit Salad Dregs

leftover brunch Fruits Salad (page 370)
Ginger Syrup (page 505)

Let the fruit salad sit a couple of days in the walk-in and get kind of "ripe," and on the cusp of fermented. Not rotten—but "interesting," or "mature." Don't know how else to say it.

Puree all the fruit salad in the Vita-Prep to ultrasmooth.

Per every 2 cups puree, add ¼ cup ginger syrup. Mix well. Chill well.

Churn in machine.

*** Be sure to pre-chill machine before churning. Cold machine / Cold product. Always.**

To plate:
Several small, neatly formed scoops in glass tumbler

Pour over a little cold club soda to make a mini "float."

Add exactly 1 drop of pure mint extract and exactly 1 drop of lime oil.

Set tumbler on coffee saucer.

Hollow Bones

Marrow bones, retrieved from dish pit during service.

Boil the empty bones until stark white and immaculate.

Set on sides at each place for knife rest or place card.

Set on end and fill with flowering thyme for place décor.

ALTERNATE BOTH AT SAME TABLE SO IT DOESN'T LOOK SO RIGIDLY ANAL-RETENTIVE OR "CUTE-SY".

Only for parties of 6 or more.

Shrimp Shells

shrimp shells, tails, and heads from prep
onion skins, tops, trimmings from vegetable prep
celery tops, bottoms, and debris from vegetable prep
tomato paste
bottled clam broth
colatura
white wine

To make the stock:
Sweat the onion and celery scraps briefly in a pot with a short glug of olive oil.

Stir in the shrimp shells and tails and heads.

Add the tomato paste, stirring and mixing until warmed through.

Add clam juice, colatura, water, and white wine.

Allow to simmer as long as you've got time for.

Strain and reserve liquid; discard solids.

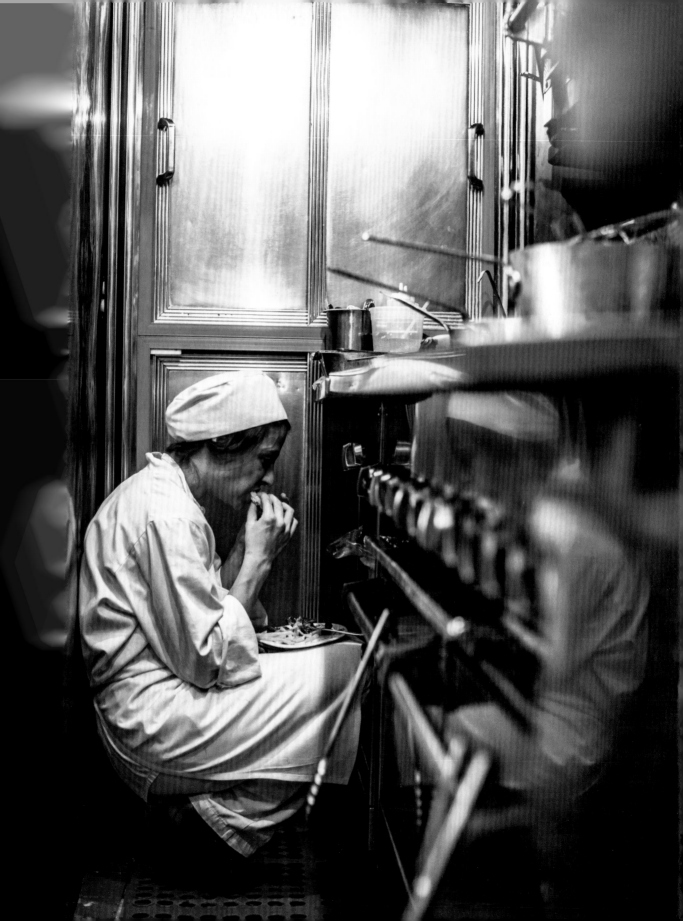

FAMILY MEAL

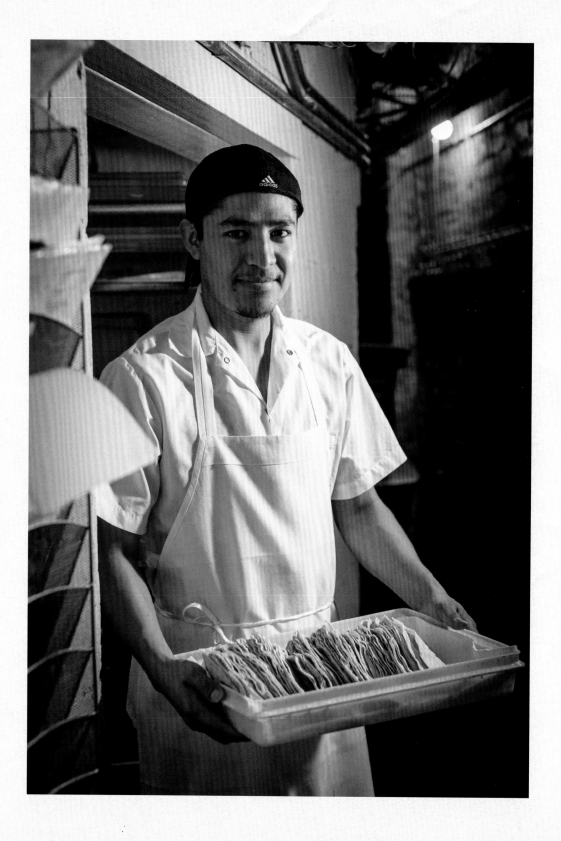

Family Meal is the line cook's opportunity to cook creatively, to show the world what got you into this business in the first place. It also resembles uncannily the children's folktale "Stone Soup." You start with nothing but a cauldron of boiling water and a stone, and by the end of the story you have a rich meal filled with all of the little bits that each villager was able to contribute.

In our version of that story, you go into the walk-in and see nothing but a ½-full fish tub of green beans starting to rot and you have to build your meal up from there. It seems grim and impossible, but it can be done. Think of each section of the walk-in, the dry goods, the freezers, the speed racks of ripening produce, and all of the stations on the line—sauté, grill, front—as the equivalent of your villagers—each able to make a little contribution to the soup pot. Can you take a couple of eggs from the dairy shelf, an anchovy or two from the sauté bin, a few potatoes from the dry goods, a handful of olives from the bar bin, and the dregs of the pancetta leftover from brunch? You can and you must.

You need to be **resourceful, imaginative,** and **knowledgeable**. What dishes feature green beans that you know of? There's gado-gado, the Indonesian cold vegetable dish with the peanut sauce and hard-boiled egg. There's salade niçoise from France, which uses a few potatoes, olives, canned tuna, and a hard-boiled egg. There's the American mom green bean casserole that uses onion soup mix and mushrooms.

Once you have your hook, your starting point, your geographic pinpoint on a map, you should build your meal *coherently* from there. We don't want to eat green bean tacos with chipotle mayonnaise with a little tomato basil salad on the side—Mexico and Italy do not go together in the same meal. Ever. If you are going the Indonesian route, then you need to skewer up a few chicken bits and make satays to go with your gado-gado and grind up that last overripe mango left on the speed rack with some ice cubes and ginger and make a fresh drink to go with. If you decided on the south of France and a salade niçoise, then you need to steam a good handful of mussels in white wine or make a little French onion soup—we have onions, canned beef broth, etc.—and a buttered baguette with a few ham slices on it to round out the idea. Hopefully you didn't go with the American mom green bean casserole thought, but if you did, then you need to make a little mac and cheese or tuna melts and some potato chips and put out a pitcher of Iced Ovaltine.

Find your idiom and work within it.

**Breakfast serves 4–7 people at 10:00–10:30 a.m. Monday–Friday
and 9:30 a.m. on the weekends.
Lunch serves 4–7 people at 1:00-1:15
Dinner serves 10–12 people at 4:45 p.m.**

We encourage you to be creative; make a dessert or a punch or your grand-mother's secret sauce. But move fast and get it done; do not turn family meal into your own little personal baking workshop. You can do that at home on your day off with your own ingredients.

You may plan ahead and order an inexpensive protein for family. Note and order the night before on the prep list, and double-check with a manager.

Be aware of staff allergies and dietary concerns and honor them as much as you can, but don't design an entire meal around one person's issue. Label containers accordingly when putting away extra family meal (vegan, garlic, no garlic, wine/alcohol) so that it can be reused safely without killing anyone.

Prune will reimburse you for any component of a meal you were thoughtful enough to handshop on your way in: Torpedo rolls? Tortillas? Peanut butter? Rice paper wrappers? Miso paste?

Try not to repeat meals; be aware of what was made the previous day and during the week. A careless 2-week stretch of pasta with pancetta scrap and canned tomato is revolting. It's also unimaginative, uncreative, and ignorant—please make a list of ten things you can do with canned tomato, pancetta, and pasta other than just heat it up and shove it on a platter. I can think of twenty dishes off the bat, and you should be able to also—that's why you decided to become a chef.

Keep it tight and light and right.
With all of these meals you want to keep in mind that we all have a long shift ahead of us. Weighing down the staff will only make them lethargic and slow. Starving them, on the other hand, doesn't help out.

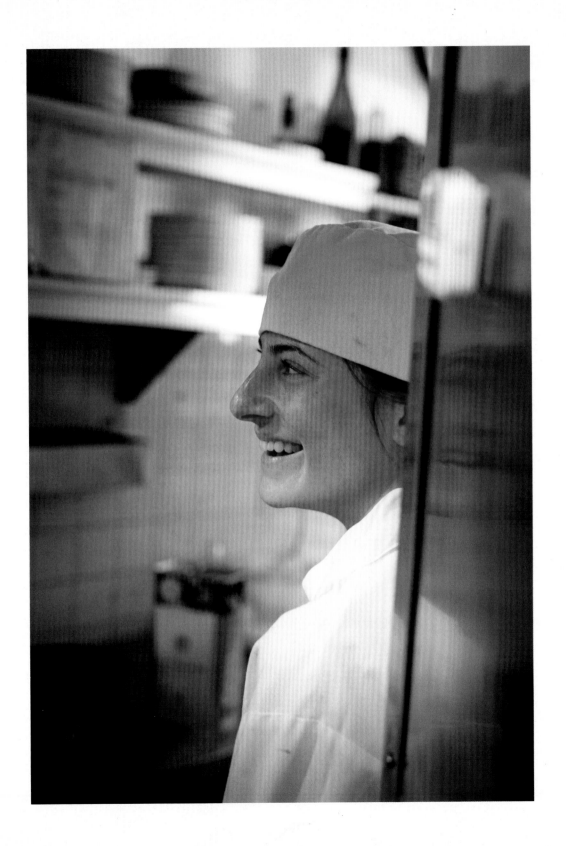

FORBIDDEN LIST FOR FAMILY MEALS

(with caveats — sometimes what's forbidden isn't always forbidden.)

Expensive cheese—particularly Parmesan—unless in family bin. A handful, yes. A bowlful, left out for the staff to self-serve, and then toss without thinking: no.

Freshly squeezed juices unless expired, but then you have to do some thing to the juice—make a smoothie, etc. A warm ½ gallon of past-date grapefruit juice sitting in the g-spot all day is not a fun, appetizing part of family meal.

Expensive cuts of meat

Brunch pickles

Balsamic vinegar on salad is forbidden, always and forever.

Mise en place

Serve-yourself bowls of condiments and ingredients—I seriously frown upon this—prepare and dress the food the way you want to present it. I don't want to end up with twelve little half-pints of dribs and drabs of "family Dijon" and "family ketchup" and "family sour cream" cluttering up the walk-in, only to be thrown in the trash. It's wasteful and annoying.

Set up your meal thoughtfully, thoroughly, and timely and then announce it.
This is your opportunity to express your work ethic—a sloppily, carelessly presented family meal will not quickly get you promoted. Get the plates, the spoons, the glasses, the serving pieces that the meal requires; find a serving platter that is the appropriate size for the item. Put a towel down under hot soup pots. Don't be a slouch. If you are in the weeds, kindly ask for some help. Everybody here knows how to pitch in and is eager to do so.

Clean it up.
Dinner front staff will put away and clean up family meal, but breakfast and lunch needs to be handled by us—make sure everyone in house has had a chance to eat—and then clean it up. Don't let the meal sit out rotting and congealing all afternoon, please. **Moving it from the g-spot to the back prep kitchen and letting it rot there all day instead does not count as cleaning it up.**

Finally, enjoy yourself. If this isn't one of the highlights of your day, you are in the wrong industry. To feed ourselves and each other is the name of the game and should bring you great, thundering pleasure.

	
Cecily Upton	busser/brunch server
Cesar Matias	porter
Charlie Spencer	host/manager
Chloe Osborne	cook/consultant
Chris Grill	sous
Christina Thurston	server/bus/brunch/din
Christine Buckley	cook
Christine Howard	server
Christine Lau	cook
Christopher Borunda	cook
Christopher Gunther	server/busser
Clinton Thorman	server/busser/bar
Cynthia Rojas	server
Damiano Marchetti	server/busser/bar
Daniel Melia	brunch/lunch/dinner
Daniella Malfitano	busser/manager
Danielle Saladino	cook ✦VEGAN✦ busser/bar
Dara Tesser	chef
David Currence	manager
Deanna Maher	server
Deidre Bird-Kelly	bartender
Diana Y. Greiner	!! NO CATFISH !! cook/host
Duncan Gamble	cook
Dustin Chabert	server/busser
Efrain Reyes Cruz	porter
Elena Blount	pastry/cook
Eliza Glaister	cook
Emilie Esders	cook
Emilie Kosse	server
Emma Lipp	server
Eric Korsh	cook
Eric Mann	cook
Erica Ffolliott	cook
Felicity Fenton	server/busser
Francesco Marino	porter
Francine Breen	cook
Francisco Javier Montiel	server
Frederic Eliot	cook
Gabrielle Hamilton	chef/owner
Gina Kinstle	server/bar
Ginevra Iverson	cook
Julie Sproesser	manager
Juliette Karch	server
June Russell	server
Juniper Berolzheimer	bartender
Karen Miller	cook ✦ NO SMOKED FISH ✦
Karl Goward	cook
Kate Morris	serve/bus/brunch host
Katherine Miller	cook
Katherine Bingham	cook
Katherine Yang	office/specialty cakes
Katumba Alighandi	brunch/server
Kelli Adamczyk	✦ ALWAYS... server/busser/bar
Kelli Simpkins	server/busser/bar ✦VEG.
Kendra Lansing	server/bus/bar/host
Kenneth Kiehl	manager
Kevin Burg	cook
Kimberly Pesta	cook
Koren Feinstein	cook
Kristan Swafford	cook
Kristyne Bouley	cook/pastry
Kyla Bucholz	!! WINE serve ALLERGY !! host/brunch/dinner
Laura Kochansky	busser/manager
Laura O'Flynn	busser
Laura Shank	server
Lauren Davidson	cook
Lauren Fremont	manager
Lauren Kois	server/busser/bar/
Lauren Souther	manager
Lily Chan	cook
Lisa Frisari	handyman
Livia Newman/Scott	office
Liza Greifinger	cook
Loren Baldwin	chef
Mariana Velasquez	cook
Marie Angelique Julien	server/host/host
Mariyam Nayeri	server/host/bus/bar
Marlene Halter	cook
Marselo Rendon	porter
Mary Bonner Baker	server
Mary K. Robinson	server/bar
Mary Nolan	cook/server/busser/ brunch/catering
Robin Schrimpf	server/host
Ryane Waterton	office
Samantha Knopf	host/server
Samantha Seier	server
Samantha Skillin	office/GH assistant
Sara Whitman	cook
Sean Callender	cook
Sean Marquand	bartender
Servando Romero Garcia	porter/cook
Shane Walsh	cook
Shanti Carson	server/busser
Shanti Grumbine	server/busser/bar VEG.
Shari Stadel	server/bar/host/ brunch/dinner/office
Soleil Ball Van Zee	cook
Star Black	server/host/brunch
Susan Thompson	manager
Tamara Reynolds	server
Tammy Hart	bar/busser/server
Tatjana Vujosevic	manager
Teresa Mejia	porter
Terry Dean Bartlett	server
Theresa Chu	phones/office
Thomas Georgalas	cook
Tirzah Stashko	cook
Tyla Fowler	GH assistant/ Boss JR! Lady
Valentin Pacheco	porter
Vincente Garcia	porter
Vincent Carlson	bar/server
Virginia Bush-Vineberg	cook/sous
William Russell Salmon	brunch/dinner/busser/office!
Yael Silverman	cook
Yvette Diaz	office/phones
Zachary Krieger	busser/server
Zora O'Neill	cook

Employee Name	Job Code
Adam Baumgart	cook
Adrienne Goering	office
Alex Grossman	server
Alex Raij	cook
Alexandra Wilson	server
Alexandra Lecube	server/host *NO WHEAT* →
Alexis Remillard	manager
Alexis Tanen	cook
Alfia Muzio	cook
Allison Brendel	host-brunch
Alyssa Wendt	server/host
Amanda Lawton	server/busser
Andrea Kapsales	pastry
Andrea Craig	manager/host
Andy Scurlock	cook
Ani Weinstein	server/bar
Anita Eisenhauer	chef
Ann Miller	cook
Anna Konkle	server
Anna Painter	cook
Anya Abrams	cook
Ashley Archer	cook
Barbara Tsumagari	pastry
Barbara Austin	cook
Bartley Gillard	server
Becky Scott	busser/server
Belquis Thompson	office *DOESN'T EAT.* →
Bianca Piccillo	server/host
Blaze Lamper	busser/brunch
Brendan Keegan	cook
Breye Mata	server/host
Brian Leth	cook
Brianna Capozzi	busser/server/brunch
Bryn Grey	server/busser
Cara Brooke	office
Cara Fitzpatrick	cook
Carlos Gonzales	porter
Carlos Rivera	cook/sous */ events!*
Caroline Denham	server/busser
Cassandra Holbrook	server/busser
Cassie Mey	server/bus/brunch/din
...	cook

Employee Name	Job Code
Halee Buecler ♡♡♡	cook
Halle Petro	server/brunch
Heather Kravas	server/host
Heidi Dorow	busser
Helen Johnston	cook
Ian Morgan	bartender
Inna Shats	bartender
James Kelly	server/busser
Jamie Yuenger	server/brunch host
Jay Guerrero	cook
Jeffrey Weber	server
Jennifer Chin	server/host
Jennifer Jackson	cook
Jennifer Kapellas	cook
Jennifer Lee	cook
Jennifer Marshall	bar/server
Jennifer Smith	cook
Jeremy Salamon	cook
Jesse Hoffman	busser
Jessica Baesler	busser
Jessica Kansiz	busser/server
Jessica Lorence Schuman	busser/server
Jessica Wilson	sous
Jesus Hernandez	porter
Jill Baron	server
Johanna Cabrera	server/host
Johanna Dadian	server
John C. Bussler	bartender
John Carter	intern
John Logsdon	cook
John Roode	cook
John Wepking	cook
John Nickolaus Typaldos	server/busser
Jon Vidmar	bar/server
Jorge Ramirez	porter
Jory Pomeranz	cook
Jose Garcia Lopez	porter
Jose Gonzaga	porter
Jose Matias-Tavera	porter
Joshua Del Valle	sous
...	server/busser/brunch

VEG. BUT AVOCADO ALLERGY / ALREADY ALLERGY / BUT FISH OK. — Gwen Evans

Employee Name	Job Code
Mashana Bailey	chef
Matt Aulicino	cook
Matt Deliso	cook
Matthew Brill	cook
Matthew Grant	server
Matthew Hamilton	sous
Merica Moynihan	server/bar/brunch
Michael Bodel	busser
Michael Hagerty	design/build
Michael Lacy	bar/server/busser
Michael Moore	cook
Michael Stokes	cook
Michele Vedernack →	manager *NO SHELLFISH*
Michelle DeLorenzo	office/GH assistant
Misti Lopez-Lecube	server/host
Molly Breidenthal	cook
Morgan Hanley	server
Nathan Greene	server/busser
Ngina Johnson	cook
Nicolas Reyes	porter
Oliver Pastan	cook
Pamela Laws	server/bar
Paola Mesadieu	cook
Patrick McGrath	chef
Paula Disbrowe	bartender
Paula McDade	cook
Penelope Gil	server/host
Perry Fuchs	cook
Phoebe Chung	brunch server
Rachel Piazza	bar/server/busser
Rachel Weinreb	cook
Ramy Zabarah	server
Rebecca Kaufmann	busser/server
Rebecca Raisley	cook
Rich Ervin	bartender
Richard Gilman	english teacher
Rick Marcello	bus/server/eng. teacher
Rikki Korkowitz	brunch server
Robert Sachse	busser
Robert Youngs	server
Robin Hudson	bar/server

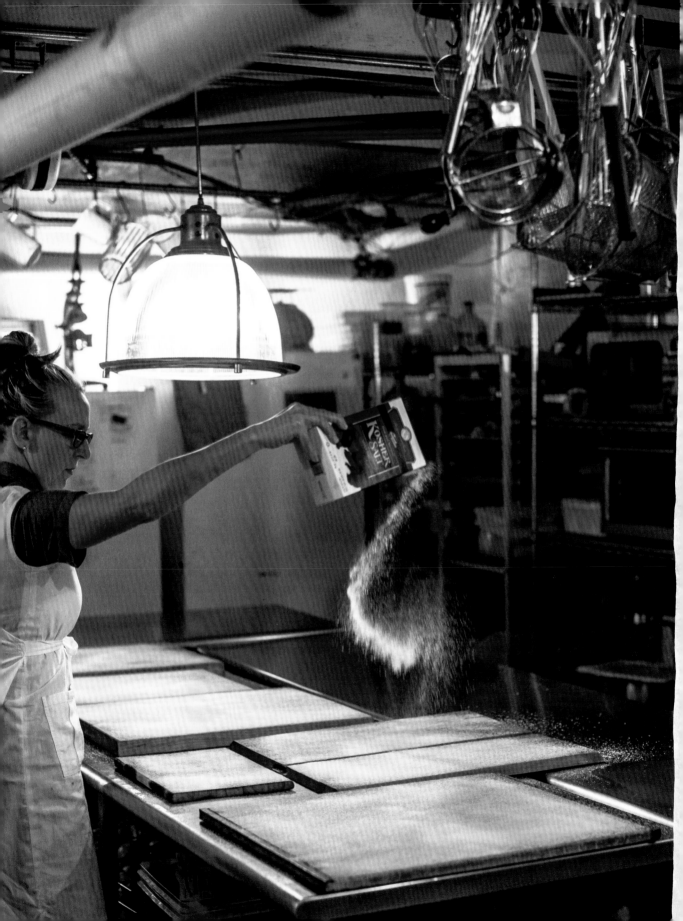